DIGITAL PHOTOGRAPHY
**THE COMPLETE
PHOTOGRAPHER**

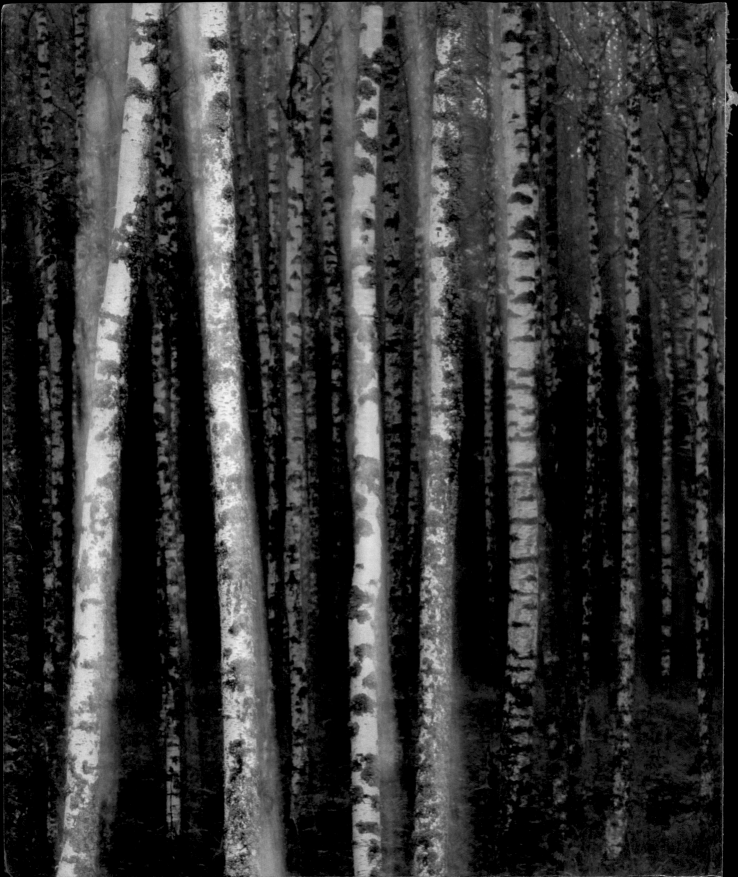

TOMANG

DIGITAL PHOTOGRAPHY
THE COMPLETE
PHOTOGRAPHER

Project Editor Nicky Munro

Project Art Editors Sarah-Anne Arnold, Sharon Spencer

Editors Ros Walford, Diana Vowles, Scarlett O'Hara

Design Assistants Joanne Clark, Laura Mingozzi

Jacket Designer Duncan Turner

Production Editor Jennifer Murray

Production Controller Sophie Argyris

US Editor Chuck Wills

Managing Editor Stephanie Farrow

Managing Art Editor Lee Griffiths

This edition published in 2016
First American Edition 2010
DK Publishing
345 Hudson Street
New York, New York 10014

20 19 18 17 16 10 9 8 7 6 5 4 3 2 1
001—178341—April/2016

Copyright © 2010, 2016 Dorling Kindersley Limited
Text copyright © 2010 Tom Ang
All rights reserved

Published in Great Britain by Dorling Kindersley Limited

A catalog record for this book is available from
the Library of Congress

ISBN 978-1-4654-4757-9

DK books are available at special discounts when purchased
in bulk for sales promotions, premiums, fund-raising, or
educational use. For details, contact: DK Publishing Special
Markets, 345 Hudson Street, New York, New York 10014 or
SpecialSales@dk.com.

Printed and bound in China

A WORLD OF IDEAS:
SEE ALL THERE IS TO KNOW

www.dk.com

contents

PORTRAIT PHOTOGRAPHY

contributors

BREAD AND SHUTTER

BERT TEUNISSEN

LANDSCAPE
PHOTOGRAPHY

FASHION
AND NUDE
PHOTOGRAPHY

WILDLIFE
AND NATURE
PHOTOGRAPHY

DAVID ZIMMERMAN

LUCA CAMPIGOTTO

TARUN KHIWAL

SYLVIE BLUM

STEFANO UNTERTHINER

THOMAS MARENT

SPORTS
PHOTOGRAPHY

DOCUMENTARY
PHOTOGRAPHY

EVENT AND MILESTONE
PHOTOGRAPHY

TIM CLAYTON

ADAM PRETTY

NATALIE BEHRING

SALVI DANÉS VERNEDAS

JEFF ASCOUGH

CARRIE MUSGRAVE

TRAVEL
PHOTOGRAPHY

ARCHITECTURE
PHOTOGRAPHY

FINE ART
PHOTOGRAPHY

DHIRAJ SINGH

DENIS DAILLEUX

JEAN-CLAUDE BERENS

ALES JUNGMANN

CIRO TOTKU

AKIRA KAI

introduction

Digital photography in its late teens entered precociously the era of its maturity, both technically and culturally. It then took not only a rightful position, but pride of place, as the preeminent and dominant means for visual expression. In the same sweep, millions of eager photographers—the early adopters who embraced digital photography in its first years—have graduated from asking for help on the choice and use of camera or lens. They no longer ask about which settings to make or even how to photograph. The questions now concern how to develop their new-found skills into a personal and fulfilling practice, how to build their growing knowledge and experience of photography together with their appreciation for their subject into a satisfying whole.

Clearly, we find ourselves now in an altogether more fascinating, ultimately more rewarding era. This book aims to help you on the journey to photographic self-fulfillment. We share with you numerous ideas about how to approach a wide range of different subjects, how to match technical means to creative ends, and how extract the full potential from a subject. We feature in detail the work of twenty superlative photographers—chosen from around the world for their individual styles and fascinatingly personal approaches. They have generously allowed us a peek behind the closed doors of their work to watch their creative processes because they, too, love photography and believe in its mission to make the world a better, lovelier place.

This book aims to help you to raise your photographic game and develop a rounded, personally satisfying vision. It assumes you have some photographic experience and that you know how to use your camera. It aims to inspire you make the most of all the equipment and skills at your disposal and to find ever-fresh, and endlessly rich, ways to communicate visually. In short, it aims to help you become a complete photographer.

about this book

the dimensions of photography

Those who understand photography as an essentially two-dimensional medium—with width and depth—impose unnecessary limitations on themselves. And they miss out on a lot of the fun. In this book, we explore different genres of photography such as sports, nature, landscape, wildlife, and travel by showing how the way you develop your own visual style is based on handling no fewer than seven dimensions of the image … and that's in addition to the image's physical aspects. Some dimensions operate equally on every subject and irrespective of its qualities: these are said to be subject-independent.

Other dimensions operate according to the subject and its nature: these are the subject-focused dimensions. In the course of this book, we will return repeatedly to the fundamental notion of the dimensions of photography, as it helps map out the choices for you. This model of photography turns bewildering options into a simple set of artistic decisions.

subject-independent dimensions

The first four dimensions of the image could be dismissed as merely the features of the image. But they're much more interesting than that. Think of using technical controls not as a way to get the image right—modern cameras mostly take care of that—but to get the expression right, to get your images to speak in just the right "voice."

The first of the subject-independent dimensions is that of Exposure. The brightness of any displayed image or the density of any print will lie somewhere between extremes

of plain white and dense black—usually, of course, they lie somewhere in the middle. But the farther away from the middle, "normal" exposure—as moody low-key or breezy high-key—the more strongly expressive an image can be.

Next comes the dimension of Tonality. At one extreme, you have just two tones: black or white, with nothing in between. At the other extreme you have—not millions of tones as you might expect—but only one. That is, it is flat—either white, black, or any gray in between, but only a single tone. Needless to say, almost all of the interesting things occur somewhere in between: all images work with a gradation of tones. A gradation near one extreme gives you a racy high-contrast image,

while nearer the other extreme you enjoy the softness of low-contrast tonality—with corresponding softening in the visual impact.

Color, of course, offers another dimension of control. This extends from neutral colors of black and white at one end, to highly saturated colors at the other—with "normal" colors occupying the middle ground. Exactly how an image handles color is not merely a question of accuracy, but is also dependent on the emotion you wish to convey. Vivid colors stimulate sensations that are altogether more aggressive and demanding of attention than pastel or near-neutral colors with their quieter "voice."

Focus defines our fourth dimension. You can choose to have nothing sharply in focus or, at the other end of the scale, you can render everything perfectly sharp, with your choice depending on the visual statement you wish to make or the response you wish to evoke. It's interesting to note that the photograph becomes its most two-dimensional when every visible element is perfectly sharp.

ff Think of using technical controls not as a way to get the image right...but to get the expression right, to get your images to speak in a just the right "voice" **JJ**

subject-focused dimensions

Images are, of course, not meaningless mashes of color and tone. They signify something to us: they invite response or evoke feelings, and may also convey information and emotion. Your approach to the subject-focused sphere of the image sets the stage for your viewer's response to your image: you knowingly try to shape and manipulate their thoughts and feelings. At the same time, understanding the dimensions in which you work will help you to refine your own expressive or interpretative style.

The easiest dimension to understand is the axis that runs between the Constructed and the Found image. A fully constructed image would be a still life created in a studio, or tableaux settings using models and staged lighting. Every element is deliberately created and styled; all carefully planned beforehand. In contrast, the Found image is one over which the photographer exercises no control, and the examples are obvious: coverage of war, news—even travel. A portrait photographer who exploits the surroundings he happens to find his subject in could be said to be working somewhere between the extremes of the Constructed and the Found.

In the dimension of Objectivity, the photographer's intention—whether consciously expressed or unconscious—is crucial. At one end of the scale, an image may be wholly objective, with no requirement beyond a factual record: a photograph of gas meters to document their readings; a shot in situ of an archaeological find. As we slide toward the other end of the scale, images become more subjective: we move from making factual records to setting out to influence our viewer's minds by arousing sympathetic emotions. We could photograph gas meters to convey the profligacy of modern society. Or we could present the archaeological find as unearthing the secrets of a dark past. Much of the time, we operate in the middle ground: wishing to show the subject accurately, but simultaneously conveying some of our feelings or our attitude toward it.

The third subject-focused dimension measures the Complexity of the image. At its most basic, the photograph records a static arrangement of elements.

> **" In a world of globally available media, photographers need to be aware that images will be viewed in cultural contexts … that may be far removed from their own experience "**

But we can stack up layers of meaning and emotion, using visual, compositional, and extra-photographic means. We can compose the shot to exaggerate spatial relationships, or use blur to suggest motion. And we can juxtapose unexpected elements—both in-camera or by compositing with image manipulation tools—to surprise the viewer or articulate a narrative. And we can add text to create commentary on the image and manipulate the context in which it is viewed. This dimension differs from the Objectivity-Subjectivity axis in that an essentially scientific (and objective) image can also be an elaborate complex: showing, for instance, a composite of elapsed time while also carrying textual labels.

viewer responses

So far, the factors I've described are those that you yourself can determine, the many dimensions that shape your control over its content. The fun really starts when someone views your image. The viewer brings a varied panoply of factors to their perception of, and response to, your image. It may be as fundamental as the quality of their eyesight—perhaps color-blind or hazy from cataracts—or it could be as complicated as their superstitions or religious beliefs. Responses can range from failing to understand what the image is about, to being profoundly moved. The same image may be barely acknowledged by one person yet seared into the memory of another. There are few, if any, assurances on the response an image may evoke.

In a world of globally available media, photographers need to be aware that images will be viewed in cultural contexts and perceived within frameworks of understanding that may be far removed from their own experience. This opens the door to exciting possibilities of new ways of communicating, of expanding the repertoire of our response to images. But the foundation should be your awareness as a photographer of how you are constructing meanings with your images; in short, we photographers need to know what we are doing.

Tom Ang

PORTRAIT
PHOTOGRAPHY

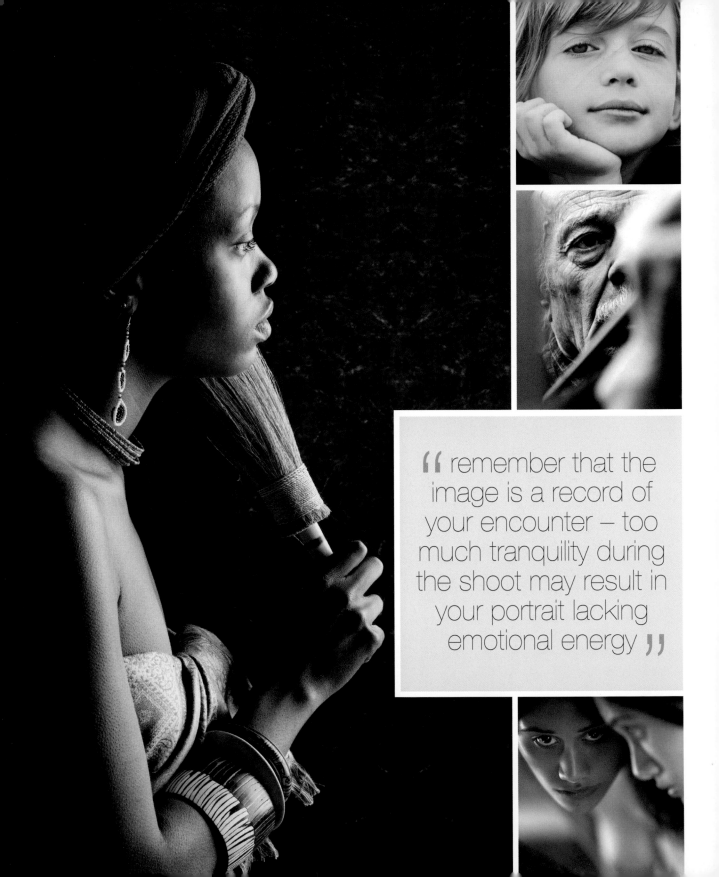

" remember that the image is a record of your encounter – too much tranquility during the shoot may result in your portrait lacking emotional energy **"**

Portrait photography is at its peak of popularity today, yet is less highly regarded as an art form than ever before. In barely more than a decade, the carefully crafted portrait photograph has largely fallen out of favor, except as a means of recording special occasions, while everyone with a camera continually and casually takes pictures of friends and family.

Portrait photography could be said to be a currency for interpersonal exchange: we share with our friends, often by instant electronic transmission, pictures of ourselves dining, enjoying a beach vacation, or simply fooling around at home. It could be argued that such social photography is not truly portraiture, but simply a means of identification on blogs and social networking websites. Even so, this type of informal image has now become the dominant form of portrait photography.

Ever since the middle of the 19th century, when *cartes de visites* made carrying a portrait hugely popular, people have given photographs of themselves to friends and loved ones. Today, the problem for any photographer who wants to take portraits that are interesting in their own right is how to make headway against the tide of compact camera and phone snapshots.

Portrait photography can sometimes be regarded as a battle of egos; on one side is the photographer and on the other the subject. In some cases, the character and spirit of the subject gains ascendancy as their personality shines from the image. In others, the

key moments

1838	**Louis-Jacques-Mandé Daguerre** takes the first photograph of a person.
1840	In New York, US dentist **Alexander S. Walcott** opens the world's first portrait studio.
1840	**Josef Max Petzval's** f3.6 portrait lens reduces exposure times to less than a minute.
1840s	David Octavius Hill and Robert Adamson make **portrait studies** in Edinburgh.
1854	The photographic *carte de visite* is invented in Paris and leads to a massive rise in the number of portrait studios.
1863	**Julia Margaret Cameron** earns her reputation for closely framed portraits of artists, writers, and other notable figures of the day.
1930s	**Angus McBean** revolutionizes celebrity portrait photography, using elaborate backgrounds and lighting.
2002	**Yousuf Karsh**, one the world's greatest portrait photographers, dies aged 93.
2009	In the UK, **Jane Bown** notches up 60 years as portrait photographer for the *Observer* newspaper, with a portfolio ranging from Bertrand Russell to Björk.

photographer's unmistakable style dominates—easily recognizable despite being exercised on many different types of personality.

In the best outcome both win. The sitter's character is expressed with strong visual identity through a team effort in which empathy and technique create a work of art—a portrait bursting with personality captured with the utmost visual virtuosity.

Once we understand that a portrait is a record of the photographer-subject relationship, it becomes easy to recognize the difference between a snapshot of friends and a more formal shot, or between a model photographed at a fashion shoot and that same person portrayed by a friend. One lacks any depth of involvement, while the other is imbued with the photographic encounter.

In this chapter, we explore the ways in which you can express your own visual style while ensuring that your sitter's personality becomes a major part of the image. The forces of your photography and your sitter's identity don't have to be at war with each other, but remember that the image is a record of your encounter—too much tranquility during the shoot may result in your portrait lacking emotional energy.

tutorial: posing your subject

The word "pose" comes from the Latin *pausa*, meaning "to rest, cease, pause." So when we pose our portrait subject, we are asking them to rest or pause; these are words conveying a sense of relaxation and ease, which implies that the portrait sitter is comfortable both with themselves and with the photographer.

posing essentials

The fact that your subject has agreed to pose for you means that you already have the advantage of their co-operation. However, this may be a limited resource. Many people are reluctant subjects, nervous about being photographed and more often than not extremely sensitive to the slightest hint that they won't look good in the picture. They may also have more important things to do, in their view, so take care not to squander their goodwill.

Remember that many people aren't aware of how to present themselves to best advantage and will feel unsure of what to do. Your first task is to establish a rapport and make them feel at ease, after which you should give them clear instructions in an encouraging voice, explaining which direction you want them to look in and how they should place their hands. Examine the face minutely for all the subtle clues about their inner feelings, which can be done through the viewfinder without causing any offense.

transitions

Often, good poses lie between two positions, so ask your subject to move slowly and smoothly from one to another and watch them carefully while they do so. Look out for body language cues, such as tension in the fingers and hands or the angle at which the legs are held, to ensure they are appropriate to the image you wish to record and the personality you aim to convey.

In general, the best-looking poses are those that your sitter has adopted voluntarily and feels most comfortable holding. If they are stiffly posed, waiting for direction from you, encourage them to experiment with different positions to find one that they feel relaxed in. Then you can refine the turn of the head to suit the camera position, for example, or make an adjustment to the hands.

formal portraits
Valued for its semblance to objective record, the formal portrait, with its unflinching eye contact, can look easy to do. In fact, it takes skill to carry it off persuasively.

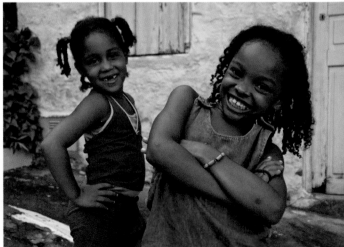

smiling portraits
Most people are taught from childhood to smile and pose for the camera and it can be hard to deter them. However, the viewer can often find undercurrents in the shot.

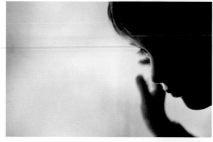

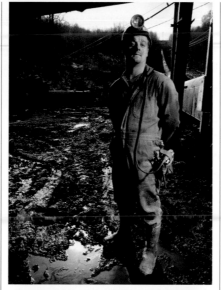

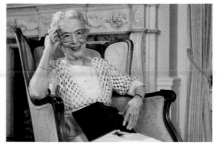

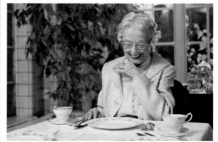

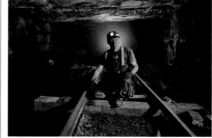

self-posed portraits

Subjects too young to pose on instruction are best left to their own devices while you follow discreetly, quietly shooting all the while. Quiet compact cameras are ideal for this work.

posed location portraits

Posing subjects in their own environment calls for you to be both landscapist and portraitist. A useful pointer is that a good landscape composition will also provide a good background for a portrait subject.

staged portraits

You can manage a portrait's meaning completely if you create a stage-set and use props. Everything that you introduce into the shot must be dictated by the meaning you intend for the image.

It also helps to ask your subject to have thoughts appropriate to the personality you wish them to convey: their expression will change and subtle changes will take place in their body language. For example, if you wish to make your subject look dominating, ask them to think commanding, "Big Boss" thoughts; if your aim is for them to look vulnerable, ask them to imagine a scenario in which they would feel anxious and uneasy.

mannered posing

Modern visual styles may call for lively poses with exaggerated gestures and positions. This is possible only with highly cooperative and outgoing subjects. It also calls for energetic and rapid changes of pose. To ensure that you obtain sharp images, you will need to use flash. On-camera units are best for very rapid movements, since flash duration is extremely short. If you use studio flash, ensure they are short-duration units designed for action, since the duration of some studio flash units is too long. Set a small aperture for good depth of field, allow plenty of room around the subject for movement, and take a lot of shots from which to select the best image later.

You can also add props and stage the shoot to enhance the portrait's message. Both props and staging are useful not only to fill the image but also to ease the sitter into the mood or feelings you wish to convey.

tutorial: modeling light

Lighting for portraiture is, paradoxically, not about lighting the face but a matter of removing light. Perfect lighting is achieved with the least amount of light that models the face to reveal the features you wish to show, whether these are wrinkles and blemishes or young skin over a beautiful bone structure.

one or more

Our planet is illuminated by a single sun, so it's natural that the instinctive standard of lighting is a single lamp. However, a photographer has a range of options to hand and can go for something much more complicated. Therefore, your lighting style can develop in two directions: working with a single light—using light-shapers and subtle alterations in lighting to achieve variety—or setting up a number of them, with different capabilities.

If you use many lights on your models, you can pick up highlights in the hair, spotlight jewelry, and isolate elements in the background. You can also vary the colors of the lights. You will have your work cut out for you: Adding to the number of lights you use will increase exponentially the amount of adjustment and balancing required.

minimal lighting

Working as economically as possible is not merely about minimizing work. Using a single light not only gives you excellent results easily, it allows you to concentrate on your subject and work with them to find expressive and natural poses. If you think a single light source must be restrictive, look at the images shown along the bottom of these pages: all but one uses just a single source.

The reason for the variety possible is that you have control over three different dimensions: the brightness of the lamp, its position, and its size. In addition, you possess an independent, in-camera control of exposure.

By varying the brightness of the lighting, you alter the relationship between the subject and the background. Experiment by using the lowest possible level for dramatic effect. High light levels mimic sunny conditions and make the image feel more airy and relaxed. Light levels midway between the extremes tend to give an everyday effect.

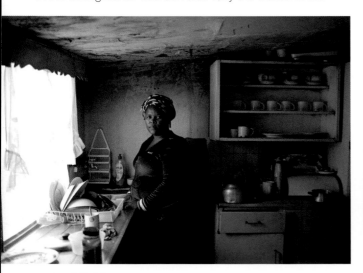

natural light
Guaranteed to be a useful light source, windows illuminate the nearest part of the room with daylight while the rest remains relatively dark, providing a modeling contrast.

back lights
Normally considered unsuitable for portraiture, back-lighting offers the potential for exploiting optical effects, such as flare and internal reflections.

focus on technique: flash outdoors

The most common use of flash is to make portraits at night. It is also the source of the worst that photography can offer: harsh light that leaves images both over-exposed (in the flash-lit areas) and under-exposed (in the background). Use a sheet of paper or other diffuser in front of the flash tube to soften the light, or bounce to a reflector or nearby wall. Ensure that backgrounds have plenty of their own light (**1**) to balance the flash exposure. In daylight, slightly underexpose the flash (**2**) for a good balance with the ambient light.

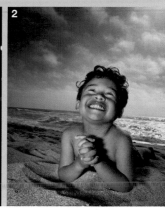

The single light source is most often positioned to one side of the face. For variety, try placing your light source (or your model, if your light source is the sun in other positions. When placed to one side and just behind the head, light rakes the face at very oblique angles, revealing textures against large areas of shadow. Placed right behind the head, the light appears blinding and fills the image with light. One result of this is lens flare, which degrades shadows and colors while adding internal reflections. These are not technical errors if you exploit the effects to imbue your images with a visual signature.

light size

It's well known that the larger the source of light, the softer the light falling on the subject. This doesn't refer to the physical size of the source but its size as it appears from the subject's position. If a large source, such as a lamp with a reflector bowl, is angled so that only light from the bowl's edge reaches your subject, the light and shadows will appear defined. By the same token, a relatively small source will appear larger—and cast a softer light—when it's placed closer to the subject. The key is to experiment with position (see also pp.114–15, 118, 266–67).

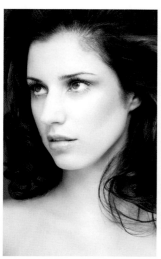

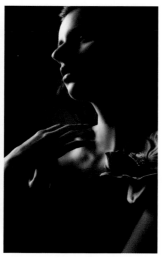

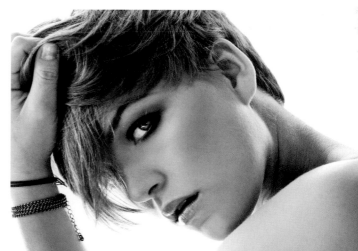

studio lighting

This pair of images shows how varied lighting from a single source can be, from soft and shadowless to dramatic contrasts of highlight and dark tone.

white-out

With one lamp on the background to turn it white and light the subject from behind, plus a large soft light to light from in front, you can create a bright and airy effect.

image analysis

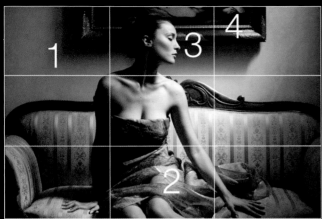

80MM ISO 100 1/125 SEC F/11

The boundary between a beautifully executed portrait and a fashion image has never been clear. It's often defined by what we know of the subject. In this image by Barbara Taurua, it's the subtle details that make the difference.

1 soft lighting
Delicate shadows, subtle color, and shade gradations result from careful lighting and the use of reflectors to fill shadows. This shapes the smooth human form in a way that accentuates sculptural elegance, but may also indicate a sleek fashion image.

2 sensual clothing
Gently draped, the sheer material suggests an association with fashion or design, which would be appropriate for the portrait of, say, an interior designer or fashionista. Fabrics are draped casually but never untidily—a delicate balancing act.

3 elegant profile
The look away from the viewer is a refusal to make eye contact, which emphasizes beauty over engagement. At the same time, this pose renders the sitter vulnerable to the gaze, inviting praise and critical examination in equal measure.

4 serendipity
Small details can help "wrap" an image with magic. The little feet peeping out of the oil painting reflect the model's feet, which are cropped out, tying the two parts of the image together. The effect may be subliminal, but is nonetheless present.

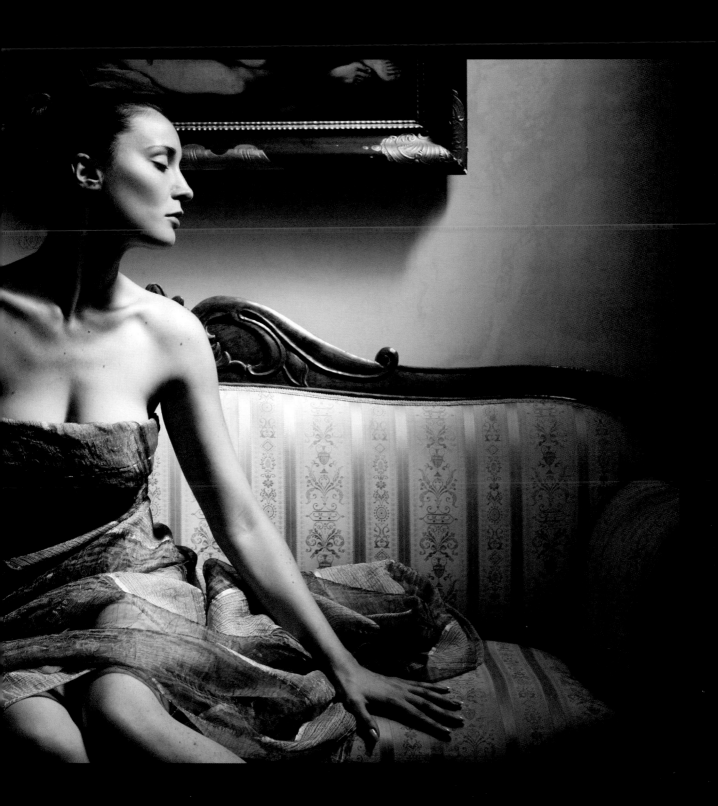

assignment:
self-portrait

The art of self-portraiture received a great boost from the invention of photography. The mechanical nature of photography not only freed self-portraitists from the need to be capable painters, it opened up new ways to treat the genre: from photographing in mirrors to catching rapid action or dressing up in order to play different roles.

the brief

Photograph yourself to portray yourself in a role, for example, as a fantasy character, in heroic mode, or in a particular mood (good or bad) using suitable props or dress and in an appropriate location.

bear in mind that you can shoot using mirrors, shutter cables, or remote controls, or be assisted by a friend. Use a tripod to hold the camera while you try different poses with the same composition.

try to capture a character that is not your own, obtained through play-acting, use of props and lighting, and the like. Try to ensure the image appears to be a genuine portrait of someone.

must-see master ▶

Miss Aniela
United Kingdom (1986–)

As a student, Leeds, UK-born Miss Aniela (a.k.a. Natalie Dybisz) lacked willing models so she decided to appear in her own photographs. Through image manipulation she began to produce her *Multiplicity* series in which she appears several times in the same photograph. Aniela was offered a raft of exhibitions when her work became a worldwide web sensation with millions of views on photo-sharing website Flickr. Her work has a dreamlike quality and has been described as "stills from a film that doesn't exist."

career highlights

2007 Debut solo exhibition in Brighton.

2008 Graduates from University of Sussex, UK, with a First Class degree in English and Media.

2009 Appears on the cover of *American Photo* magazine.

Spin Cycle, 2009: One of the later "clone" scenes, *Spin Cycle* is one of the artist's favorite photographs from her *Multiplicity* set. It is rare for her images to feature a modern appliance.

think about...

1 personal location
Use your living space, but change it to change the sense of your character: if you're normally neat and tidy, make the place a mess.

2 baring all
Explore issues of personal or cultural identity by experimenting with being partially clothed, or by dressing in clothes that you don't normally wear.

3 changing poses
Use self-portraits to express your moods, which don't always have to be upbeat: mount your camera on a tripod so that you can try different poses.

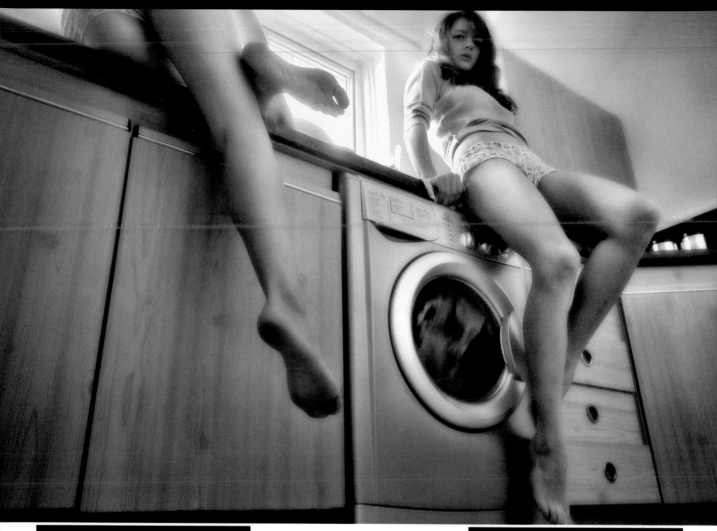

4 lighting character
Use strongly directional and contrasted lighting to set the stage for expressing mood or atmosphere. Try using colored lights for variety.

5 reflections
Look for an innovative way to photograph yourself in a mirror: use an old camera or toy camera, or experiment by lighting yourself with flash or lamps.

6 capturing action
Ask a friend to make the exposures or use a self-timer to catch yourself in action—running, jumping, falling—to add energy into what are usually static shots.

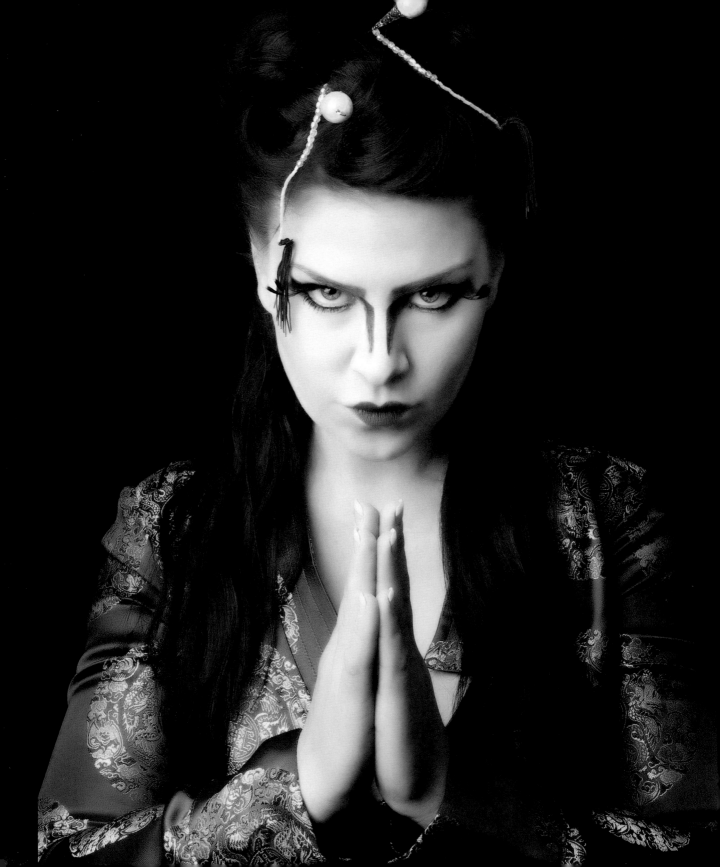

bread and shutter

Working under the name Bread and Shutter, Barry Read has been a lighting technician for film, TV, and advertising for 20 years. Recently he has begun to work in still photography, specializing in portraits.

nationality
British

main working location
London

website
www.breadandshutter.com

◄ for this shot

camera and lens
Nikon D700 and 50mm lens

aperture and shutter setting
f/25 and 1/200 sec

sensor/film speed
ISO 200

for the story behind this shot see over …

in conversation…

What led you to specialize in portrait photography?
For me, shooting portraits is about love—a deep connection that I can make between subject and camera. I try to see into a person's soul and capture it in the photograph. To quote Cecil Beaton, "Be daring, be different, be impractical, be anything that will assert integrity of purpose and imaginative vision against the play-it-safers, the creatures of the commonplace, the slaves of the ordinary."

Please describe your relationship with your favorite subject. Are you an expert on it?
Talking and listening is part of getting me into the mood and helping me to reveal the subject's inner self in the finished product.

Do you feel you have succeeded in being innovative in your photography, or do you feel the shadows of past masters over you?
My past masters are directors of photography on movie sets, so it's a different field really. I learned a lot from Freddie Young, Stuart Harris, and Terence Donovan.

How important do you feel it is to specialize in one area or genre of photography?
I think all photographers can shoot anything, but there are areas that people excel in more. When you find your area of photography, grab it with both hands and enjoy it.

What distinguishes your work?
I don't really know. There are some amazing photographers out there. All I know is I love my photography and hope people get some enjoyment from it.

As you have developed, how have you changed?
I've found that I'm always dreaming up new concepts. A big part of my photography is the idea behind the image.

What has been the biggest influence on your development as a photographer?
Music is the biggest influence on my photography. I spend a lot of time connected to my iPod, getting into the zone. I'll listen to a track over and over again. I also send the track to the model with a few ideas. As for the music, it can range from Evanscence to Kate Bush, Metallica to Nine Inch Nails. All forms of music inspire ideas.

What would you like to be remembered for?

The man with a camera in his hand and music in his head. And for being a good dad.

Did you attend a course of study in photography?

You can't teach someone to see. I had a great upbringing in the film industry learning lighting, which has been a great help. I'm biased, but I think being taught "You have to shoot like this and like that" stinks. Rules are there to be broken. Get a camera, go out there and shoot, shoot, shoot, until the camera becomes a part of you. A great learning tool, I think, are the photography websites where you upload an image and fellow photographers critique it, giving you different points, tips, and tricks. This is a fantastic way of improving—and of helping others too.

How do you feel about the tremendous changes in photographic practice in the past 10 years? Have you benefited or suffered from the changes?

In the past 10 years it has changed and in 10 years time it will have changed again. Photography is moving in the right direction for many, but not so for others. Personally, I like the way it's moving. I find some artists out there very inspirational so, yes, bring it on. Lighting is changing fast, too. New ideas and new lights are always coming out. Some are not so good, others are fantastic.

Can photography make the world a better place? Is this something you personally work toward?

An image can say a thousand words. It doesn't matter what part of the world you come from or what language you speak; a photograph speaks a universal tongue that the whole world can understand. An image can make people cry, get angry, or fall in love. It can capture a moment in time to be kept forever.

Describe your relationship with digital post-production.

Editing photographs is a necessary evil. I would much rather be out there shooting than chained to a computer.

Could you work with any kind of camera?

I use Nikons and Hasselblads as a rule, so I'm biased toward them, but I'm sure a camera is a camera.

Finally, to end on a not too serious note, could you tell us what non-photographic item you find essential?

My iPod is on almost 24/7—before, during, and after the shoot.

behind the scenes

A great portrait comes from the eye and mind of the photographer. You don't need to have expensive equipment—this shoot was done in a home studio, using very reasonably priced lights and accessories.

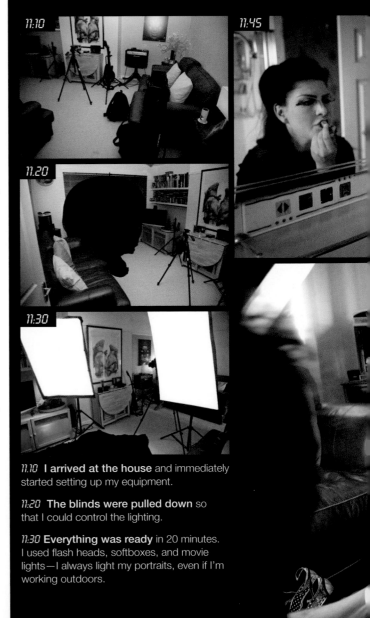

11:10 I arrived at the house and immediately started setting up my equipment.

11:20 The blinds were pulled down so that I could control the lighting.

11:30 Everything was ready in 20 minutes. I used flash heads, softboxes, and movie lights—I always light my portraits, even if I'm working outdoors.

11:50

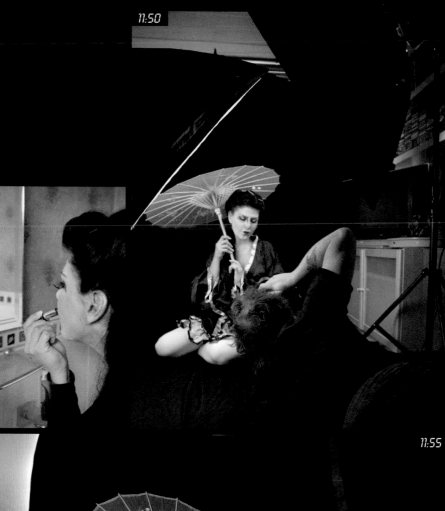

11:55

11:45 Before she arrived, Emma's look had been beautifully crafted by make-up artist Laura McIntosh. All Emma needed to do before the shoot was to retouch her lipstick.

11:50 The shoot started. I directed Emma and offered her encouragement while music blared from my speakers.

11:55 I stopped to check the pictures and they seemed to be coming out well.

12:05 Emma had a quick look at the photographs to check her make-up before we continued.

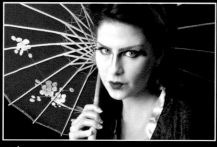

◁ in **camera**

12:05

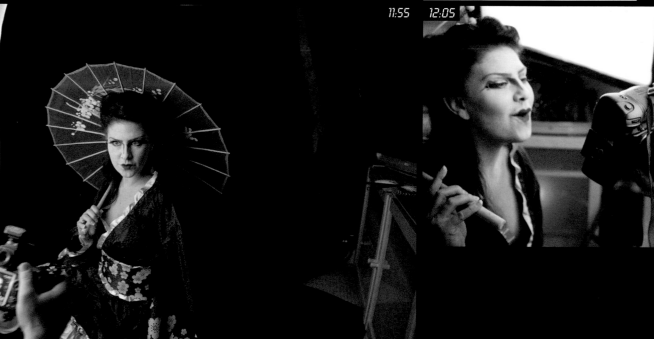

▶

12:10 **Sometimes it helps** to gently move the model into position, so I tilted Emma's head to adjust the angle very slightly.

12:20 **I adjusted the dimmer** on the lights in order to pull out more color in Emma's eyes, then shot from a new angle.

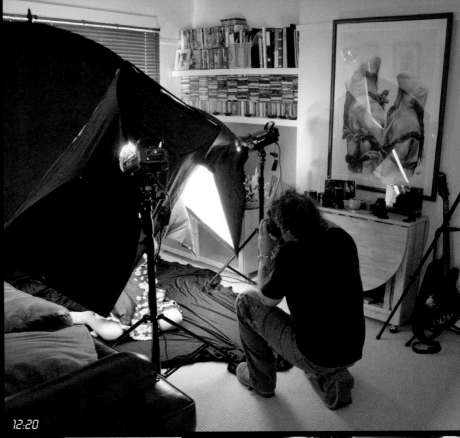

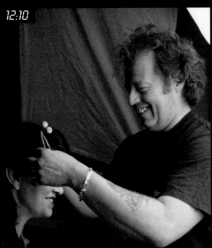

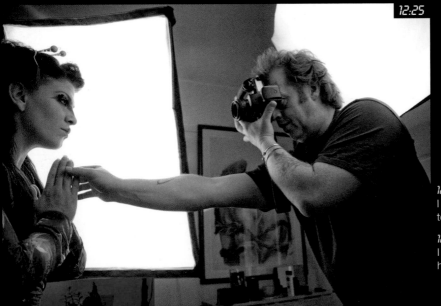

12:25 **After Emma's quick change of outfit,** I switched from my Nikon VR 24–120mm lens to a 50mm lens to get a closer shot.

12:30 **Checking the viewfinder again,** I thought this could be the shot I'd been hoping for.

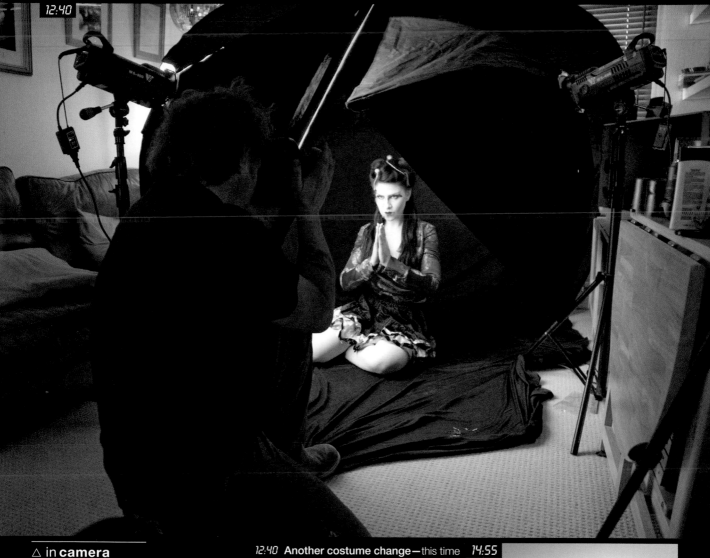

12:40

△ in **camera**

12:40 **Another costume change**—this time into a red kimono, and I was sure I had my shot. I loved the way the red emphasized Emma's strikingly blue eyes.

14:55 **Later in the afternoon**, I went through the images on my computer. I experimented for a while with composites, replacing the black background with a shot of a Buddhist temple from my archive.

14:55

portfolio

▷ still waiting
When I took this photograph, a very stormy sky was moving in fast behind Cindy and the dog, so I added some beautiful lighting to keep it looking natural. I used two 500w studio flash heads with soft boxes powered by an electrical generator.

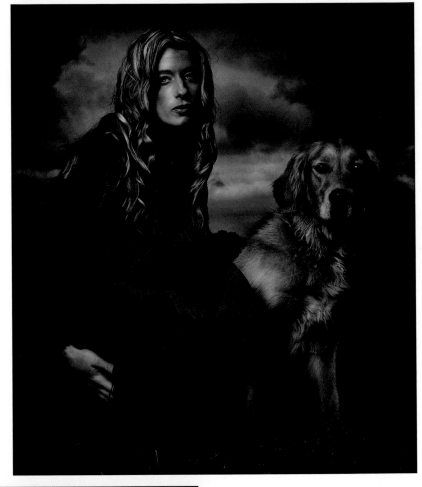

▽ why do dogs always get the blame?
When the human models were ready, I made a noise to get Zimba's attention—I had a plastic bag behind the camera with dog treats in it. I finished the shot with a bit of dodge and burn and some desaturation.

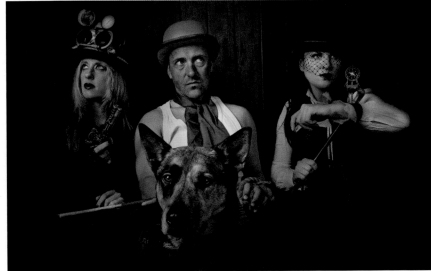

▷ dream of sleep
Here I used HMI movie lighting to punch through the water from above. If you look up at a model underwater and get the angle right, you can capture some amazing under-surface reflections.

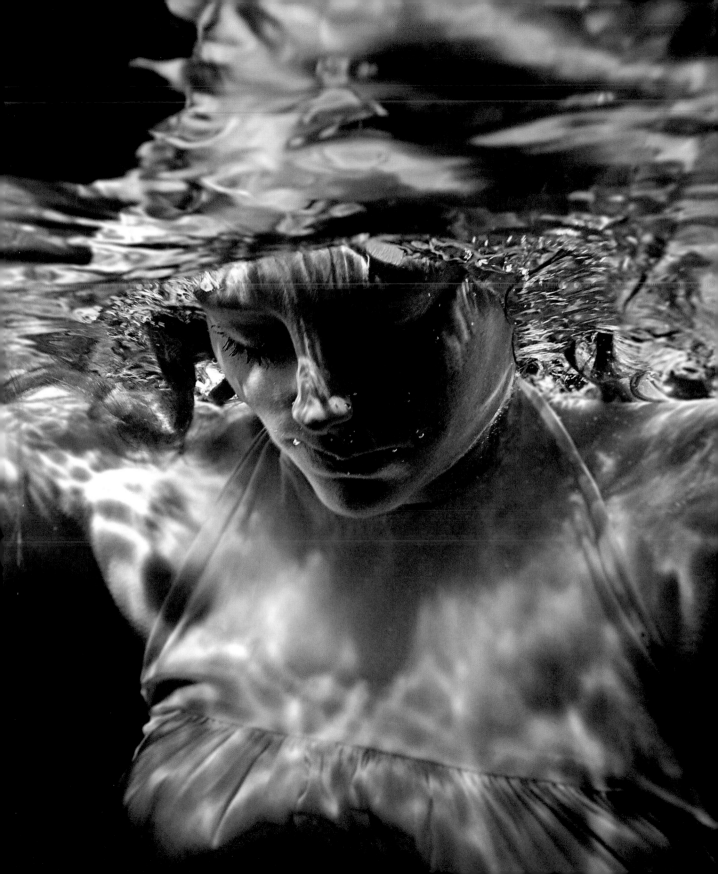

tutorial: viewing the person

In a portrait session your subject stands at the center of your photographic universe, defining the space in which you must operate. You orbit around them to create the context and background for the shot, and to choose a viewpoint that brings all the elements gracefully together.

managing viewpoints

Viewpoints are more than merely a position in space. They carry a meaning, which may be implicit or culturally determined, but it is one that nonetheless helps the viewer to read the image. This is because viewing the image replicates the position to the subject that you took up when you made the picture; and the position that you took results from your relationship with the subject.

Three factors are at play. First, elevation (the height of the camera) decides whether you look at eye-level to your subject or whether you are higher or lower. Elevation relates subliminally to the relative status of photographer

and subject: for example, it is hard to find a picture of royalty or head of state taken from above, since it would imply the photographer was literally "above his station."

Secondly, the physical distance between photographer and subject is a measure of the degree of intimacy and trust between them. Since people are generally similar in size, we know we are physically close to someone because we see only a portion of their body or face. Some photographers specialize in working within their subject's personal space in order to ensure a high level of emotional engagement in the photograph. Others keep their distance in order to foster a sense of objectivity.

focal length

Closely related to controlling physical distance—although the two can operate independently—is the final factor in managing viewpoints: your choice of focal length.

A long focal length lens does not fully reproduce the sense of being near a person if you have actually shot from a distance. This is because the perspective depends on your distance, so it gives away the separation. In practice, for full-face portraits, a moderately long focal length lens of

peeping through
Framing devices that fill the near field help to concentrate attention upon the person, but often convey a sense of alienation or voyeurism.

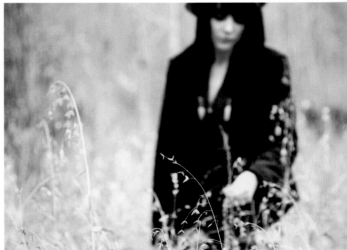

soft focus
Your subject doesn't have to be perfectly sharp if you wish to convey a mood or comment on the person rather than show the recognizable details of their face.

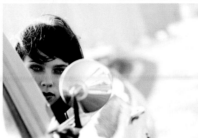

viewing angles

The potential viewpoints that can be used for portraiture range from a comic extreme close-up with a wide-angle lens to a distant pose that hovers between intimidating and formal. In between are poses that invite one-to-one interaction. For all these viewpoints, a normal focal length lens offers the most versatility.

1.5x to 2x the normal focal length (65mm to 100mm for full-frame 35mm) appears to offer the best compromise between perspective and the size of the person in the image. For portraits showing the upper body, the normal focal length usually works well.

It follows that you can exaggerate perspective by, for example, using a short focal length lens close up to give a humorous (but easily overdone) enlargement of the nose.

considering the background

A little experience of framing a portrait while on location will show that every move you make creates a corresponding change in the background. Some photographers find this tremendously frustrating (and usually turn to working in studios), while others relish the challenge. Unless you work with an entirely featureless background, the backdrop to your portrait offers you yet another factor

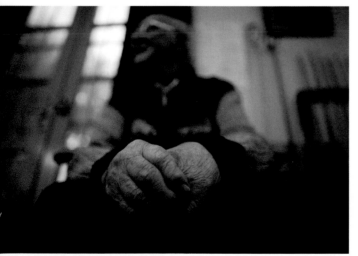

exaggerated perspective

Mixed messages intrigue and draw in the viewer. In this image, the very low point of view suggests a dominant sitter, which contrasts with the arthritic hands.

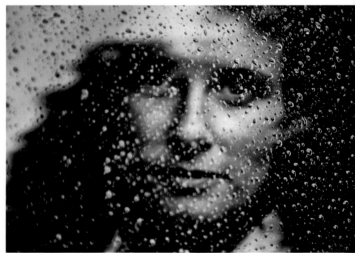

natural filters

Portraits taken through reflections on glass strongly imply separation from a subject who occupies a different world. The raindrops add to the sense of estrangement.

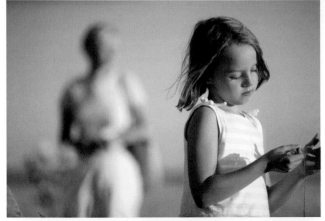

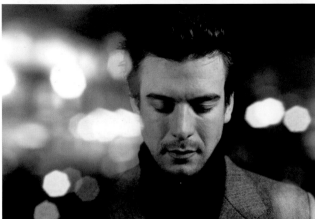

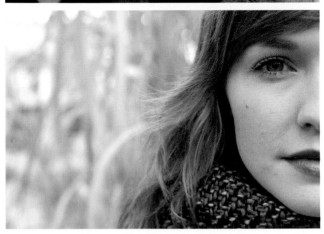

blurring the background
Use shallow depth of field to articulate the relationship between your subjects and their context, whether this is other people or their environment. For the smoothest highlights and transitions, set full aperture.

to control, which in turn gives you another creative dimension. Apart from your choice of the background itself, which we shall look at below, there are two important elements to consider.

The depth of field that you permit the image to display tells viewers how much they are expected to enter into the image. Extensive depth of field invites people to walk into the scene, to explore the details because they are sharp and clearly visible. In contrast, shallow depth of field keeps the viewer at arm's length, stuck at the plane of sharp focus, because it casts a blurry veil over the details elsewhere.

The other element at play is highlight dominance, which refers to the fact that the viewer's eye tends to be drawn to the brightest area of the image. Photographers like to arrange for a specular highlight (an image of a light source) to be caught in the sitter's eye—the so-called catchlight— because that speck of light draws attention to the eye, encouraging a certain intimacy between viewer and picture. However, a bright window or lamp in the image will play havoc with this careful plan. Even a bright white patch, such as a sheet of paper or a reflection, can be equally troublesome.

suppressing highlights
The best way to handle unwanted highlights in portraiture is to avoid them altogether. If you can't frame your shot to eliminate the highlight, try to position your subject so that their head or body obscures the lamp, window, or other object that is creating it.

If it's impossible to avoid the highlight, use your lens at maximum aperture, set a long focal length, and place the camera as close to your subject as possible, since this will blur the highlights to the greatest extent. As the maximum aperture of many zoom lenses is reduced as focal length increases, it may be best not to set the very longest focal length (see p.153). Nonetheless, a bright light will look bright however blurred it is, so it will always be most effective to reduce its brightness rather than try to ameliorate its effects and make do with blur.

One trick that on-location specialists use is to carry dimmer switches, which are interposed between the lamps and the power supply so that the brightness can be controlled directly. Another trick is to use neutral-density

compare and contrast: character in context

The distance between you and your subject determines the balance between an encounter with the person and a view of their life. A close-up of a face (**1**) loses many clues about their life but gains insight into their personality. Stepping back (**2**) reveals more, but at the cost of closeness to the person.

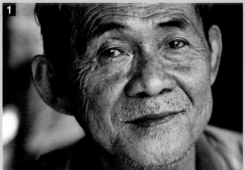

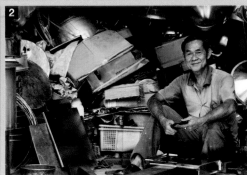

gels, which can be wrapped around the inside of a lamp shade to reduce its brightness. (See pp.20–21, 114–15, 266–67.)

environmental control

The handling of bright light is an example of the balancing act between demonstrating respect for the subject's environment and meeting the requirements of good photography. You may not wish to eliminate a lamp, for example, but it should not draw attention away from the main subject. Solution: dim the light.

Likewise, you should not interfere with your subject's living or work space, but if there are elements that are out of character or distract from the sitter, it makes sense to move them. Objects in the scene that tell the viewer about the subject—the tools of their trade, their favorite pastime, a precious picture of a lost child—can take a prominent position, and even compete with the sitter for attention.

One frequently encountered problem is that people will tidy up their spaces in preparation for photography. Handling this may call for as much tact as persuading people not to wear their best clothes.

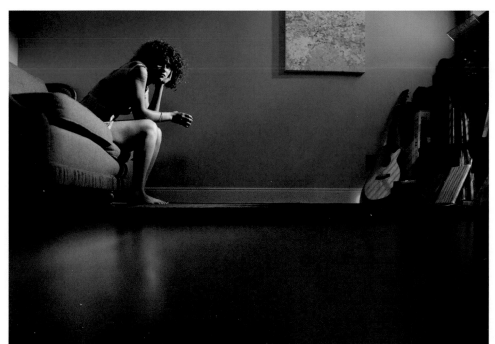

significant environments

How much you rearrange the environment is similar to how much make-up you wish your subject to wear or the control you exert over their pose; the more you alter, the more the image becomes less a record of the person and more a statement of your views about them. It should be a collaborative effort, so seek the sitter's views while also ensuring the image works. In this image, the room has been carefully tidied: the expanse of empty space in the center may indicate an individual who feels alone, off-center from human relationships, or it may simply show a shiny, clean floor.

image analysis

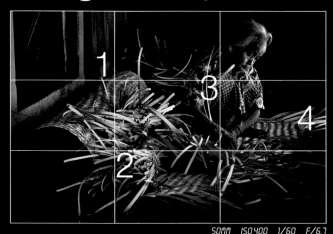

50mm ISO 400 1/60 F/6.7

The portrait is vital to many genres of photography, from sports to documentary through to travel. The emphasis may be personality-driven or, as in this photograph by Junaidi Sudirman, may center on an activity.

1 soft background

The cool, soft, neutral colors, straight lines, and spaces devoid of distraction create an ideal background for the active and detail-laden parts of the image. The open door leading into darkness encourages the viewer to look toward the light.

2 balancing act

The jumble of rattan canes could have easily overwhelmed the features of the weaver but, through careful use of the available light, the photographer has ensured that all of the details are evenly balanced.

3 delicate patterns

The textures all around the artisan—from bamboo in the background to dress print—complement and emphasize her face, framing it indirectly through contrast. However, the sharp lines of cane near her face may be thought to offer too much contrast.

4 offstage lighting

Central to the success of the image is the soft light emanating from an overcast sky. By allowing for a little post-processing to lighten some parts, the lighting can appear to be equally bright across the image, which helps to unify all the elements.

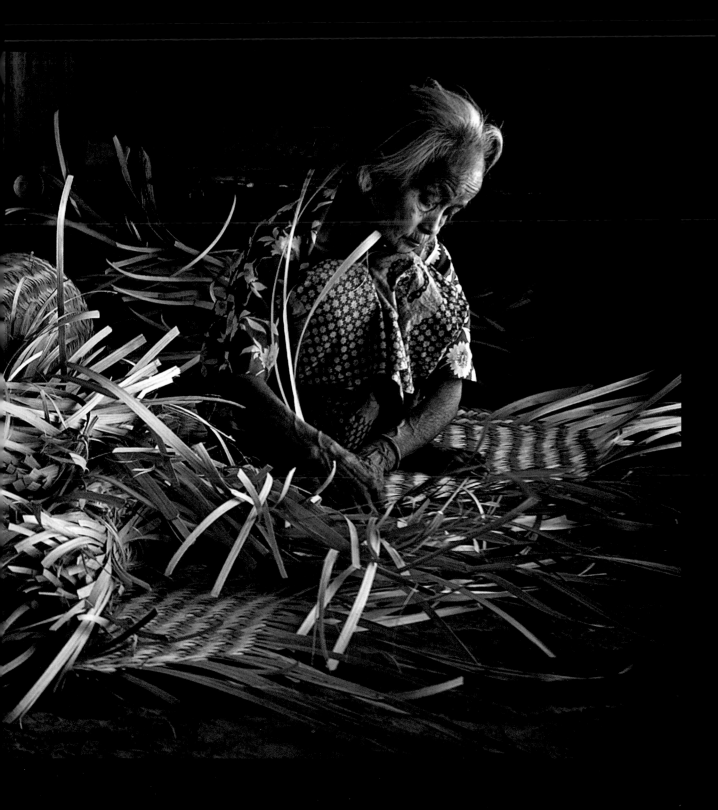

assignment:
environmental portrait

The environmental portrait is photography's special contribution to the art of portraiture. It combines the ability of a painting to convey a space and, with it, the personality and occupation of the subject. Unlike a painting, however, it doesn't need days to create but can be made in a very short time, sometimes taking only minutes to prepare.

the brief

Choose a subject that would benefit from an environmental portrait—such as an artist, musician, gardener, factory or office worker—and photograph them so that their work, personal space, and character are depicted.

bear in mind that while black and white reduces distractions, color carries more information. A wide-angle view captures more space, but you'll need to ensure the subject's face isn't too small.

try to capture an image that requires the minimum of textual or caption information. Don't be too obscure—your photograph should be able to speak for itself.

must-see master ▶

Arnold Newman
USA (1918–2006)

Newman is arguably one of the greatest portrait photographers of the 20th century. Forced to quit art school due to financial hardship, he took a job making 49-cent portraits in Philadelphia. Taking thousands of portraits, he discovered the importance of interacting with people in front of the lens. Newman is widely credited with inventing environmental portraiture— placing subjects in settings that capture their personality and their work, such as actors on set or writers at their desks.

career highlights

1941 Beaumont Newhall and Alfred Stieglitz champion his work.

1945 Works for *Life*, *The New Yorker*, and *The New York Times*.

1999 Wins the International Center of Photography Infinity Award for Master of Photography.

Milton Avery, New York, 1961: Newman has photographed many artists, including the abstract painter Milton Avery (1885–1965), pictured here with his artwork on display behind him.

think about...

1 size and scale
Find a balance between capturing your subject's living or working space but still allowing their facial features and other details to be seen clearly.

2 a long shot
If you want to include an extensive view of the surrounding environment, use a long shot and shoot from a distance, but place the subject closest to you.

3 significant details
You may not need to show the entire face. This miniature ship, though held close to camera, is small enough not to render the face unrecognizable.

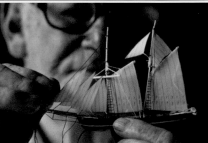

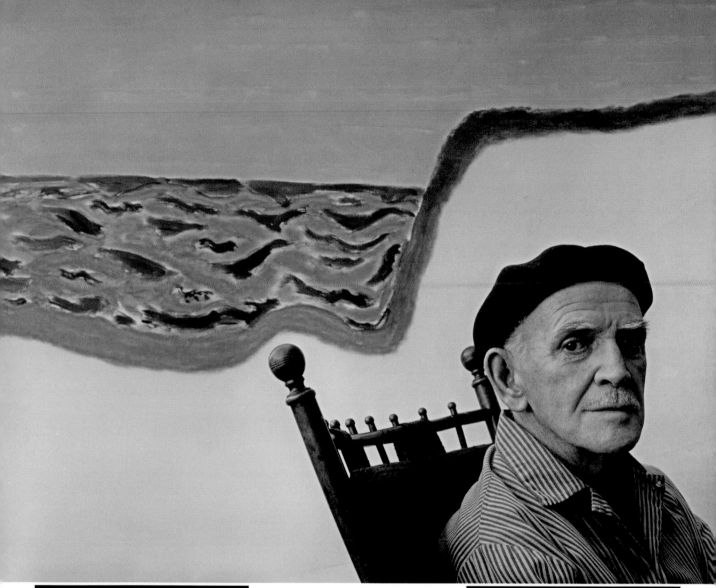

4 leading in
Arrange objects around the subject and compose the shot so that he or she is at the center of the composition—and therefore of the viewer's attention.

5 mono mastery
It can be more effective to work in black and white, especially when a colorful environment would distract from the main subject of the portrait.

6 projection distortion
Unless you want to achieve this stretched effect, avoid placing your subject at the edge of the image frame when using a wide-angle lens.

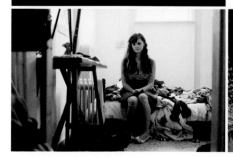

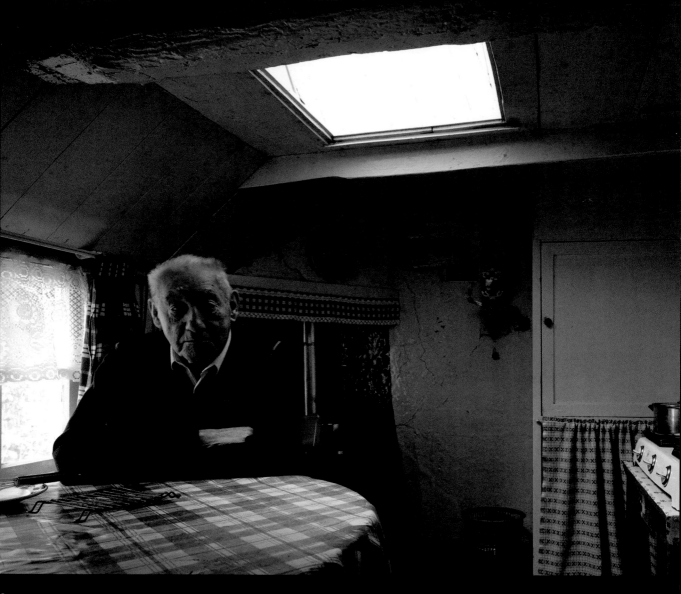

bert teunissen

Bert was born in the Netherlands in 1959. In 1996, he began photographing people in their homes, using only natural light. This project has taken him around the world and led to his book *Domestic Landscapes: A Portrait of Europeans at Home*.

nationality
Dutch

main working locations
domestic interiors worldwide

website
www.bertteunissen.com

▲ for this shot

camera and lens
Cambo Wide DS 4x5 and Schneider Super Angulon 5, 6/65mm lens

aperture and shutter setting
f/22 and 8 seconds

sensor/film speed
ISO 400

for the story behind this shot see over ...

in conversation...

What led you to specialize in portrait photography?
I am intrigued by the way in which people, through facial expression and body language, can express themselves in a different way every second. I like to play with that character and the position I give it within my frame. You always have to earn a good portrait; everybody needs to be won for the shot. It's always a challenge and it never gets boring.

Please describe your relationship with your favorite subject. Are you an expert on it?
I don't know. I never considered myself an expert. Every photograph is a new one. After I have finished one I start all over again. People are my favorite subject because there are no two alike, so my work never becomes routine.

Do you feel you have succeeded in being innovative in your photography, or do you feel the shadows of past masters over you?
Oh, there are many shadows of past masters over me. Thank God, I would say. Where would we be without them? Have I succeeded? That's for the audience to decide. I just follow a very strong gut feeling.

How important do you feel it is to specialize in one area or genre of photography?
Speaking for myself, because one area is already so comprehensive, I can't imagine doing a little of everything. I need depth, so for me specializing is important.

What distinguishes your work?
If anything, I would say it is the personal connection to the subject and the fact that I have been working on this same theme for such a long time.

As you have developed, how have you changed?
I think I have changed more as a person than as a photographer, although I have become much more focused on what I'm doing. That has given me peace of mind.

What has been the biggest influence on your development and maturing as a photographer?
Probably my children. They are one of the biggest reasons why I am doing this project. I want them to understand that if you really want something, you can achieve almost

anything by focusing on the subject and never letting go. I also want them to understand that depth is always more interesting and more satisfying than superficiality.

What would you like to be remembered for?
For being a good father and a loving husband.

Did you attend a course of study in photography?
No, I didn't. I strongly believe in taking pictures and in looking at other photographers' work. Photography is about awareness and about looking.

How do you feel about the tremendous changes in photographic practice in the past 10 years? Have you benefited or suffered from the changes?
I look at it with great interest but also with a lot of scepticism. I am really stunned by the ease with which people are changing to digital techniques and throwing an established and reputable industry overboard. By doing so we're creating a big gap in our documented history; generations after us will have to do a lot of guessing about our motives, I'm afraid.

Can photography make the world a better place? Is this something you personally work toward?
I like to think it can. I hope my work will help people to understand that despite our differences, we are much more alike than we think. Actually I like variety a lot more than similarity. I hate it when I run into the same fast-food outlets and furniture stores after having traveled for three days by car or flown to the other side of the world.

Describe your relationship with digital post-production.
It's a bit of love/hate. Like I said, I think it's interesting and in a way I do need it; it does have advantages, but I strongly feel that analog photography should stay. I still use film and I still print in the darkroom. I don't own a digital camera. The virtual digital file still gives me a very unpleasant feeling. I need the negative that gives me peace of mind.

Could you work with any kind of camera?
As long as it is a camera that takes film I'm OK with it. I have my favorite brand, of course, but anything analog goes.

Finally, to end on a not too serious note, could you tell us what non-photographic item you find essential?
Good food and good company.

behind the scenes

This shoot was done at a house in the east of Holland. I had already photographed Jan, a 97-year-old farmer, a decade earlier; this return visit to his home produced the image entitled *Ruurlo #7R 7/11/2009 12:16.*

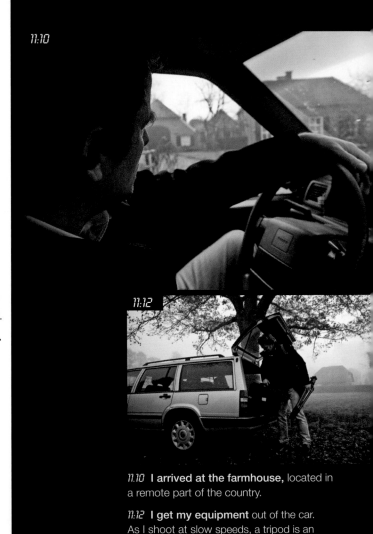

11:10 **I arrived at the farmhouse,** located in a remote part of the country.

11:12 **I get my equipment** out of the car. As I shoot at slow speeds, a tripod is an essential part of my gear.

11:20 Jan's house is tiny and I have trouble squeezing through the low doorway.

11:40 We have a cup of tea and a chat. It is important to establish a rapport with the subject before taking a portrait shot.

11:50 Covering my head and the top of the camera to block out the light, I frame the image and focus my lens.

12:00 I set the shutter speed and aperture.

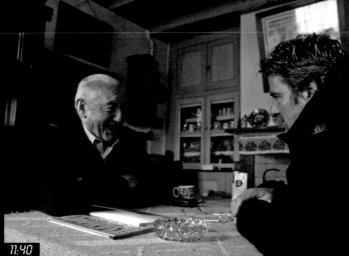

11:20 11:40

11:50 12:00

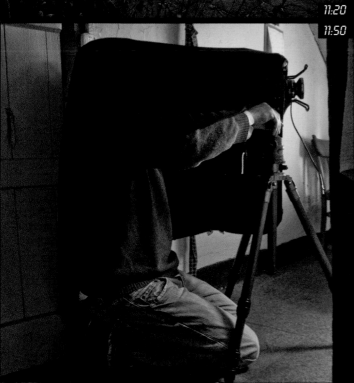

▶

12:05

12:07

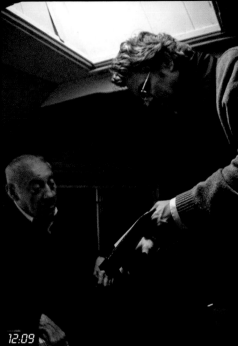

12:09

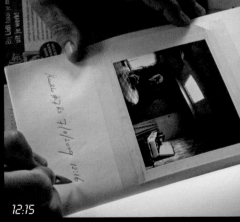

12:15

12:05 I removed the Polaroid from the film holder; I was using black-and-white Polaroid 57.

12:07 Peeling away the negative sheet, I checked the image on the positive layer to make sure the exposure was correct.

12:09 I showed Jan the Polaroid so that he could see how the portrait would look.

12:15 The title of each photograph is the location, date, and time, so it is important to note it immediately on the Polaroid.

12:30 **I made a final check** on the aperture and shutter speed settings.

12:31 **I put in a film cassette,** using Kodak 400NC 4x5 sheet film.

12:30 12:31

12:32

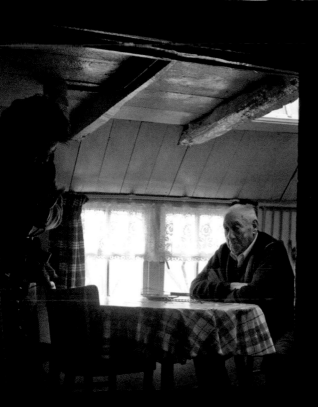

12:33

12:32 **I took the final shot,** using a long exposure of 8 seconds because of the low light levels in the room.

12:33 **The last step** was to remove the film cassette and pack it away safely.

◁ in **camera**

portfolio

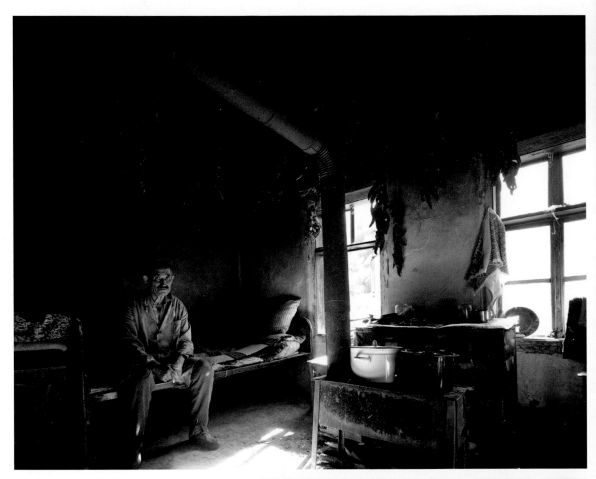

△ **Rakovo**

The moment I entered this house in Bulgaria I knew the beautiful quality of the light was exactly what my project was about. The peppers had been harvested from this man's field and were hung up to dry in his kitchen.

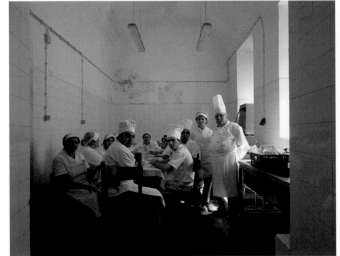

▷ **Estremoz**

I ran into this group of chefs on my way out of the military barracks at Estremoz, in Portugal. They had just cooked for the regiment and were now enjoying their own meal. I wasn't allowed to photograph the barracks, so I was pleased to get this shot.

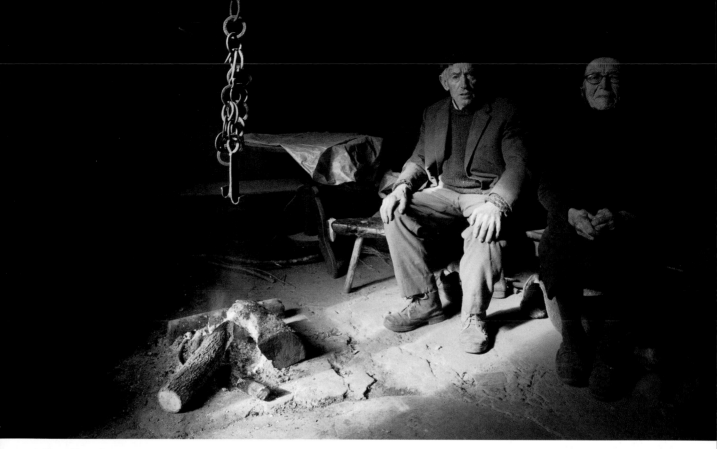

△ Rao Faquis

In the Spanish mountains that form the border between Galicia and Asturias I met this couple in a house that must have been hundreds of years old. The interior was pitch black from decades of smoke; the fire was probably lit right after the house was built and has been burning ever since.

and
finally ...

1 unique mannerisms
To convey a sense of character and personality, body language and pose can sometimes say more than a face.

2 careful framing
Frames within the image, such as windows, archways, or trees, can offer contrasts to the sitter's body shape and often help to convey meaning.

3 ambivalent mood
You can create a sense of ambiguity by lighting from an unusual angle, avoiding eye-contact, and by positioning the face very close to the picture frame.

4 gentle light
Every face is beautiful and deserves careful treatment. Light the portrait with thought and creativity to make the most of the subject's features.

5 instilling confidence
Many people are shy unless they have something to do, so photograph them at work, or indulging in a hobby.

6 all expressions
Portraying children as all smiles and grins is only part of the story: other expressions not only round off their character, they are often more interesting than a smile.

7 separating planes
Using fast lenses at full aperture for minimal depth of field separates model from background, allowing you to work just about anywhere.

8 anonymity
With modern sensitivities, there may be times when you need to portray people in a non-recognizable way: use back-lighting, head position, and pose to conceal identity.

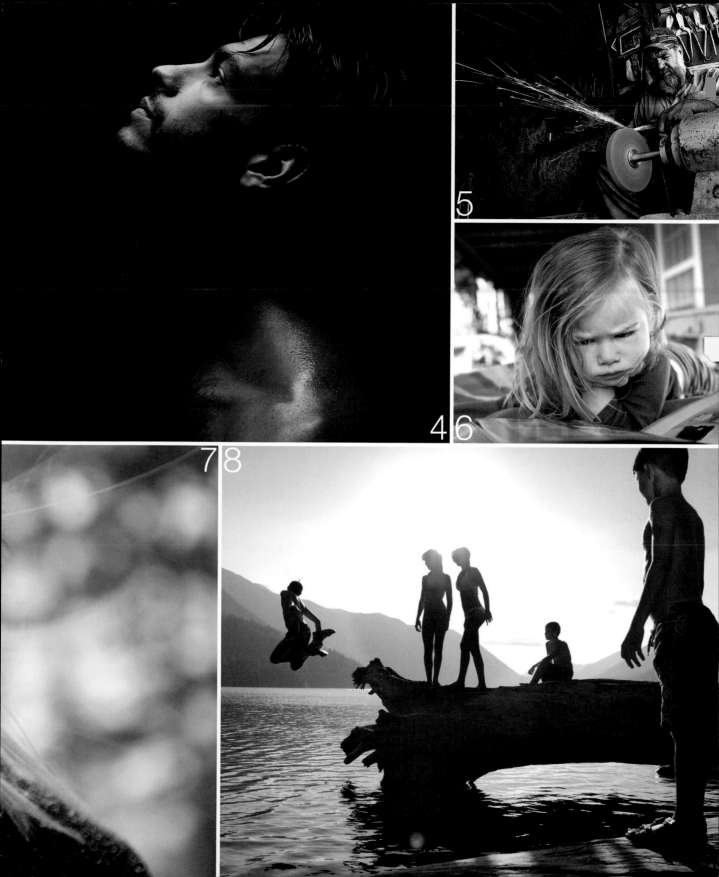

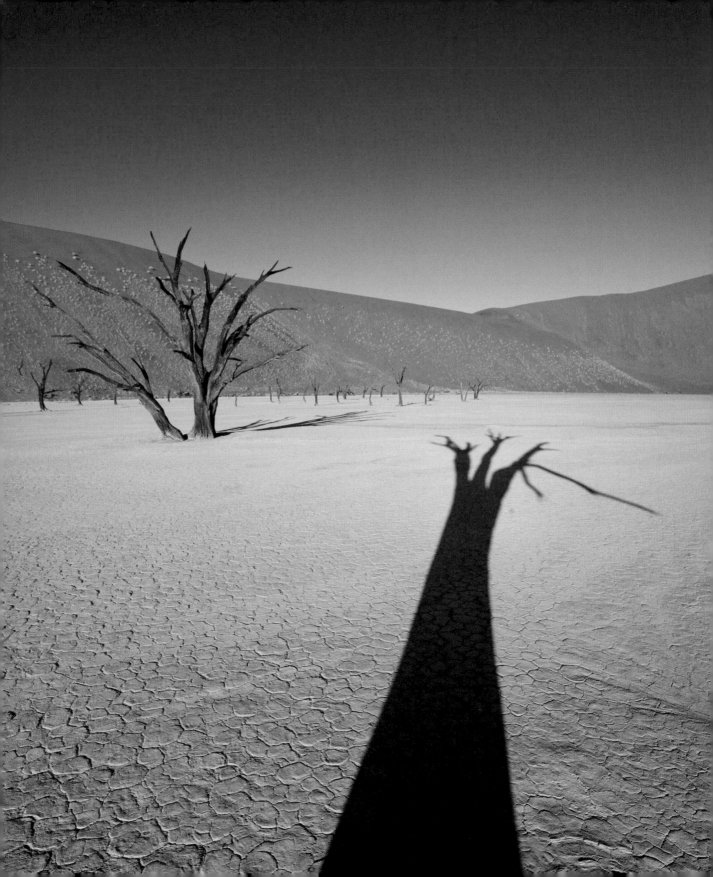

LANDSCAPE
PHOTOGRAPHY

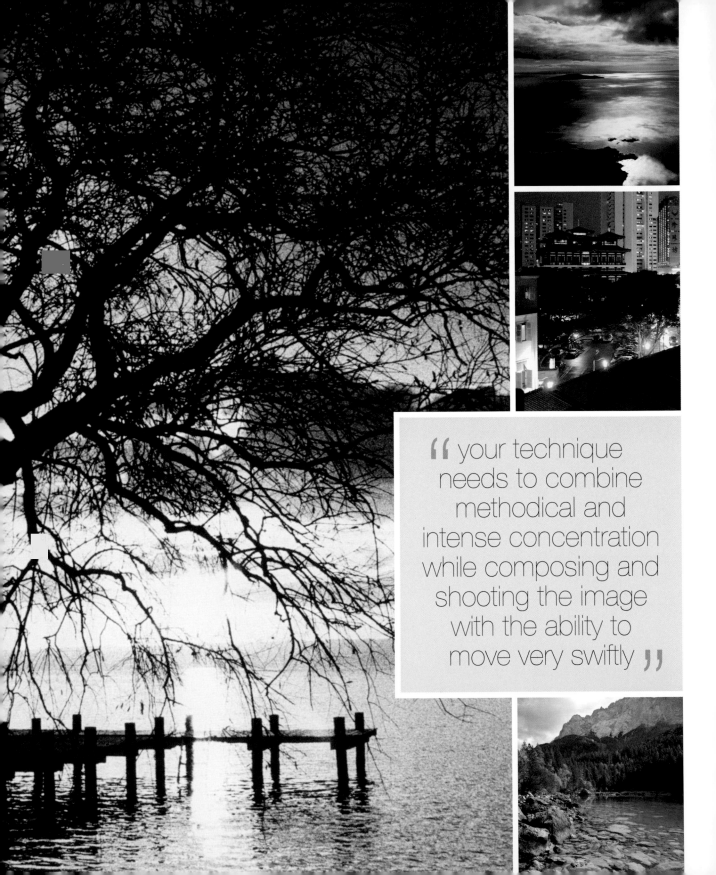

❝ your technique needs to combine methodical and intense concentration while composing and shooting the image with the ability to move very swiftly **❞**

Landscape photography has struggled more than other genres to find its own voice. Unable to tear itself away from the literal, it sometimes seems to have little freedom to be subjective or to be used to express a personal vision. Compared to landscape painting, it feels limited and simplistic, still struggling to grow and find its own vocabulary.

The freely expressive ways in which the Impressionist and Expressionist painters depicted landscapes can make photography's vocabulary seem desperately limited. Yet, despite its narrowly representational scope, landscape photography is more popular than ever.

Working in black and white is the first choice for those wishing to approach landscape photography in an artistic way. Removing the variety of hues translates a picture-postcard copy of a view into an interpretative statement.

There is, however, some scope for creativity. Look at how popular high dynamic range (see p 324) and tone-mapping manipulations became when photographers discovered they could turn a scene with a wide range of brightness into one with largely mid-tone values.

Other ways to build a personal style include the stylistically consistent use of shallow depth of field, and exploitation of motion blur through long exposure. Another exposure-based approach is to use over-exposure in flat lighting to obtain high-key results.

Some photographers choose to concentrate on views that are rich in detail while others favor those that are minimal in content. You can work with the highest-resolution cameras and finest lenses to capture every leaf and grain of sand, or look for broad brushstroke scenes and quiet composition to achieve an articulate, poetic image cut back to its essentials. Many people find the highly aberrated images you get from cheap "toy" cameras with undercorrected lenses, such as the Holga range, a refreshing change from the norm.

The approach you adopt may alter with each situation you encounter, but one aspect of landscape photography doesn't vary. Whether you work on a mountainside, on a beach, or in an urban environment your technique needs to combine methodical concentration on composing and shooting the image with the ability to move swiftly. Light can change quickly—you often have to find the best spot and set up in a hurry. At the same time, you need to possess an inexhaustible source of patience to wait for just the right revelatory and glorious light.

The key to rewarding landscape or cityscape photography is to walk: you need to explore the subject, even if your viewpoint is limited. Miniscule changes in position or height can make the difference between a revealing image and one that's unsurprising and ordinary.

key moments

1827 French photographer Joseph Nicéphore Niépce creates the first **permanent image** entitled *View from the Study Window.*

1843 Austrian Joseph Puchberger patents the **panoramic camera**.

1860s **Francis Bedford** begins extensive travels around Britain, taking hundreds of photographs along the way.

1860 The oldest surviving **aerial photograph**, a view of Boston, is taken by James Wallace Black.

1864 Scottish photographer **George Washington Wilson** sells half a million prints of scenes from around the world.

1888 **Panoramic photography** becomes accessible following the invention of film rolls.

1932 First **Group f/64 exhibition** in San Francisco, whose style becomes highly influential on landscape photography.

1970s The Linhof 617 camera popularizes dramatic 3:1 **letterbox panoramas**.

1984 **Ansel Easton Adams**, the grand master of landscape photography, dies, aged 82.

tutorial: using color

The wise landscape photographer has a love/hate relationship with color and understands that a lot of color can be too much of a good thing. While we derive huge enjoyment from the parade of colors in a landscape, this variety of hues can distract the eye and play havoc with the composition.

limit your palette

It may seem rather contrary to reject multi-colored scenes and look for views with fewer colors, but if you exercise restraint with regard to the extent of your color palette you will be rewarded with images that are far easier to compose, simpler to expose, and that reveal the landscape with greater clarity.

This might seem counter-intuitive but the reason why a variety of bright colors is attractive to the eye is exactly the same reason why they don't work well in an image. The array of colors catches the viewer's attention but distracts their eye, which then flits in an uncontrolled way all over the image. As a result there is no rest point for the eye, and no resolution. The color is appealing but ultimately confusing.

subtle errors

Somewhat subtle technical issues may also contribute to the disruption. An exposure that is correct for one color may be incorrect for one at the other end of the spectrum. For example, if yellows are rendered at the correct brightness, blues and purples may look too dark. Conversely, the correct exposure for dark blues may cause reds and yellows to look too light.

Slight inaccuracies in color-based exposures can shift the balance of an image in ways that are slight but hard to control. For example, in the image below, the purple flowers in the foreground look a little too dark: if they were as bright as they were in real life, the balance of the image would be improved.

Another aspect to take into account is the effect that your final output has on colors. Work on the assumption that colors reproduced on paper tend to be duller than on screen, with blues and purples losing most intensity.

intense hues
Spots and small areas of vibrant color can be held in and contained by large areas of relatively even tones. This is an effective way to compose with bold colors.

arranging colors
A large palette of colors can be arranged into separate regions in which just one color dominates. This process can successfully organize a full range of colors.

digital dark room: vibrance control

When we increase the saturation of an image but don't wish to over-saturate tones, we need the Vibrance control. (**1**) is the original scene, lacking in saturation. Increasing saturation (**2**) makes the red leaves too red. Increasing vibrance deepens the sky (**3**) without the reds becoming too rich. And it is very useful for skin tones too. We need, in effect, to be weak on skin tones. Digital photography took 10 years to grasp a fact long known to video—skin tones fall into a very narrow range of hues.

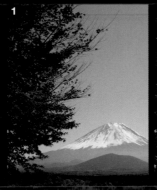 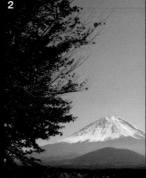

monochrome mastery

It may seem like a negative strategy, but you will be delighted when you discover that the fewer the colors you work with, the stronger your images become. Ultimately, the process of simplifying may take you to only one or two colors. Essentially, then, you are creating toned black-and-white images, which takes us full circle to the classics of early landscape photography.

The elimination of color variety enables you to work with the broad brushstroke elements of the scene—tonal variation—allowing form to describe volume, articulation of space, and detail to be expressed through line. An important result is that your images then become legible at any scale—they are attractive whether at poster size or postage-stamp size.

This is an essential design issue when, as is most likely, your images are seen on a monitor screen. The first appearance of your picture will probably be as a thumbnail on a picture-sharing site or on your own website. You want that thumbnail image to draw the viewer in so that they want to see more and click for the larger image; in this case, it's vital that the image is legible at a small size.

pale and simple
A lack of strong color tends to be associated with calm, reflective moods so simple compositions containing only a few elements work well.

tonal subtlety
The colorless scene may not look promising, but it's always worth a trial capture. Often you obtain a pleasing image that is effective through quiet tonal variations.

tutorial: articulating space

Surely it is a gigantic conceit for photography to even attempt to record a landscape? It must convey detail, yet blurs intricacies to a cipher of the original. It makes only a passable attempt at recording the subtleties of tone and color. Finally, while it should cover vast spaces, it only squashes them flat.

tricking eye and memory

An effective way to approach landscape photography is to work out how to articulate space within the confines of the picture frame. A common error is to tackle the scene as if you were making a tiny scale model of the view. However, a model is designed to show accurate detail throughout, with all the elements in proportion to each other—but this is not how the human eye perceives a landscape.

The key to mastering landscape photography is to learn how to manipulate the relative scale of elements in the scene to create a sense of space. For example, flowers in the foreground appear as tall as mountains in the

distance, and pebbles in a riverbed are the size of trees further upstream. Your viewers share your experience of the world and the distorting effects of perspective, so they understand the real relative sizes of objects. What they see in your image leads them to reconstruct the area of the landscape in their minds, but guided by you.

taking a walk

It may seem to be stating the obvious, but walking is the most powerful control you have over the way your images describe space. If you watch people get out of their car at a scenic spot you will notice what a short distance most of them walk before taking their picture. Yet a little more effort could make all the difference, bringing in a tree to frame the shot, uncovering detail in the foreground, or finding another viewpoint altogether. At the very least, moving away from a viewpoint or off the path means that your picture will instantly be different from all those taken by people who are too lazy to walk a little further.

If there are no fences to bar your way, walking closer to an interesting feature often brings superior results to those you would get from using a zoom because image clarity is

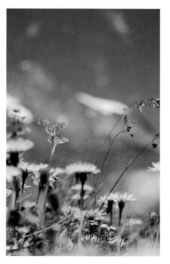

low angle
Images in which more than a quarter of the frame is taken up by the foreground should feature something interesting. By getting down low, you create an involving landscape.

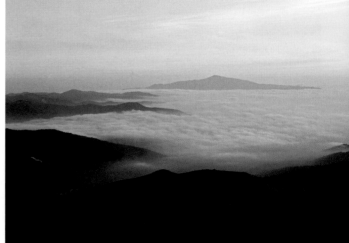

distant perspective
With very faraway landscapes, the sense of distance is conveyed by decreasing contrast. The colors are subdued by the dust and moisture in the air.

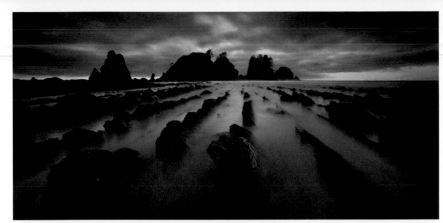

leading the eye

The most successful landscape photographs appear to take viewers for a walk through the scene. This is done by guiding the viewer's eye, using cues such as lines and frames. Foregrounds with strong sets of converging lines or sweeping curves—often obtained by shifting the lens downwards to capture more foreground—can be effective but tend to make the background relatively small. Framing devices in the foreground sharply differentiate near space from distant space and may also help to pull compositions together.

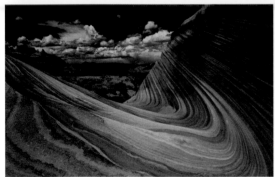

improved by getting nearer to your subject. Alternatively, you can walk to a higher viewpoint that is clear of foreground distractions, or that provides leading lines to guide the eye into your composition. In short, the best way to improve your landscape photography is to use your legs.

tilt and shift

For the serious landscape photographer, a tilt and shift lens is essential because it increases control over the dimensions of the image, providing effects that no simple change in focal length or your position can fully replicate. Shift movement displaces the center of the image, allowing you to see more at the side, top, or bottom of the image without changing position. It's invaluable for providing extra foreground or sky without your having to point the lens down or up respectively.

The tilt movement rotates the plane of best focus. If you tilt to line up focus with the ground, you obtain extensive depth of field even at wide apertures. Tilt the other way and you reduce apparent depth of field, even at small apertures (see also p.75).

focus on technique: overheads

With increasing access to light aircraft and helicopter flights, there are more opportunities for aerial photography. As the perspective is two-dimensional you need to concentrate solely on composition, using lines, patterns, and blocks of color rather as an artist would, searching for dynamism and balance.

image analysis

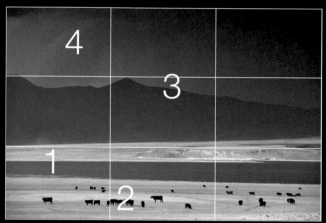

200MM ISO 64 1/250 SEC F/5.6

Should the epithet "painterly" come to mind when viewing this image by Galen Rowell, it's a reminder that landscape painters have long sorted out the key problems of the genre, and we can learn from them.

1 color bands
Constructed almost entirely from areas of flat tone—"wash," in painters' terms—the image can be said to contain nothing but bands of nearly identical colors with a couple of equally flat bands of contrasting hue.

2 random rhythms
The sole details are the cattle scattered in a helpfully haphazard manner across the lowest layer of the image. While randomly placed, they are all variants of the same shape, which helps to give rhythm to their positioning.

3 tonal line
Employing a technique much used by painters, the boundary between two blocks of tone defines a line, which suggests form and bulk through its sharp corners and gently undulating waves.

4 moving skies
The brilliant element in the timing of the shot is the capture of the falling rain, which modulates the blank sky just sufficiently to give it movement and to enliven what would otherwise be an excess of washes of blue.

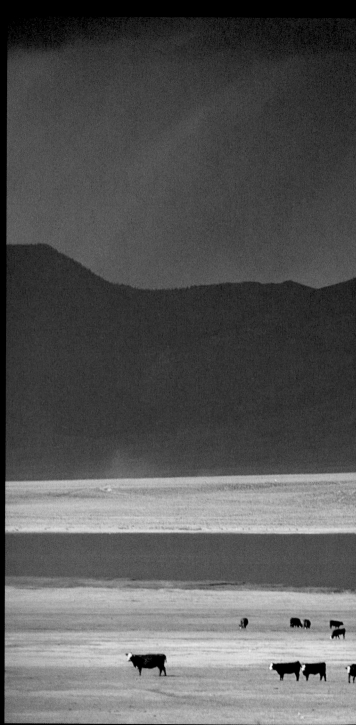

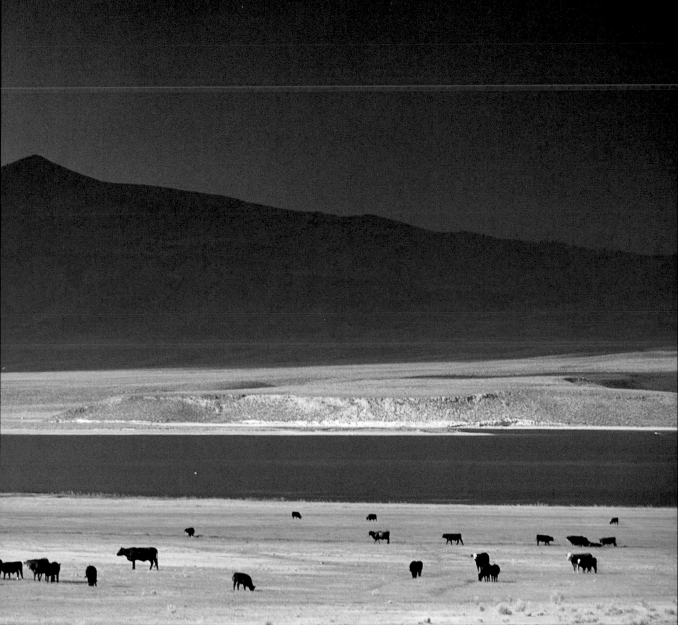

assignment:
essentials

Photography automatically generates a summary of a scene: it turns extremely complicated landscapes into two-dimensional maps that lack fine—and inessential—details. However, we can simplify and summarize a scene still further if we wish to create images that say the most with the least means: turning visual prose into visual poetry.

the brief

Depict a landscape by employing the fewest visual elements but without turning it into an abstract composition. Look for the minimum needed to describe the location and characterize its qualities, and eliminate all unnecessary features.

bear in mind that every feature of the image (including blur, color, and shade) is a contributing visual element. Eliminating unnecessary blur is often a crucial step.

try to capture the scene in overcast conditions for flat lighting lacking in shadows, and shoot head-on to the subject to eliminate perspective cues.

think about...

must-see master ▶

Edward Burtynsky
Canada (1955–)

Born to Ukrainian immigrant parents, Burtynsky grew up amid the bleak industrial landscapes of the General Motors car plant in Ontario where his father worked. His work always finds beauty in the most unusual places—oil refineries, shipping ports, mines, quarries—and his large-scale prints vividly depict sweeping landscapes forever changed by industry.

career highlights

1966 His father buys a secondhand darkroom, complete with cameras.

1982 Graduates with a BAA in Photographic Arts from Ryerson Polytechnical Institute, Toronto.

1985 Establishes Toronto Image Works.

2006 *Manufactured Landscapes*, an award-winning documentary about his work, is released.

Rock of ages #10, Abandoned Granite Quarry, Barre, Vermont, 1991: Looking like a Cubist painting, nature reclaims this quarry, adding rusty lines to the granite. The ladder gives an idea of scale.

1 minimal work
Less may be more work, but if you eliminate too much, the resulting abstract fails to convey the spirit of the place— it becomes an emotional expression.

2 extracting pattern
Long views compress objects which are far apart into adjacent planes, which reduces the sense of space while emphasizing shape and pattern.

3 aerial views
Shooting from a high viewpoint flattens perspective, and distance cues are eliminated, although interesting graphic shapes are generated.

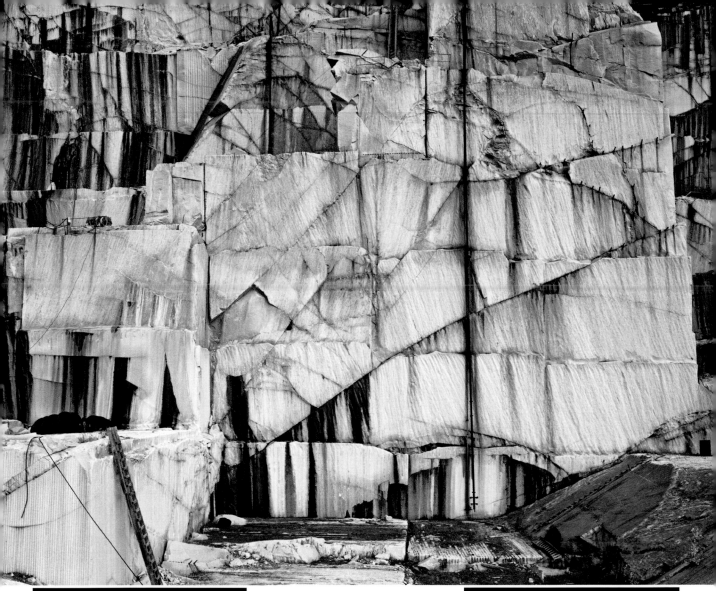

4 limiting with light
One way to restrict your view is to use limited lighting. At night a flash lights the foreground but falls away quickly to leave a dark background.

5 ambiguity
Eliminating clues about the size of objects puts them into an ambiguous space: now interpretation can go in different directions.

6 removing color
An obvious element to remove is color, but give yourself the widest range of options by shooting in color before converting to black and white.

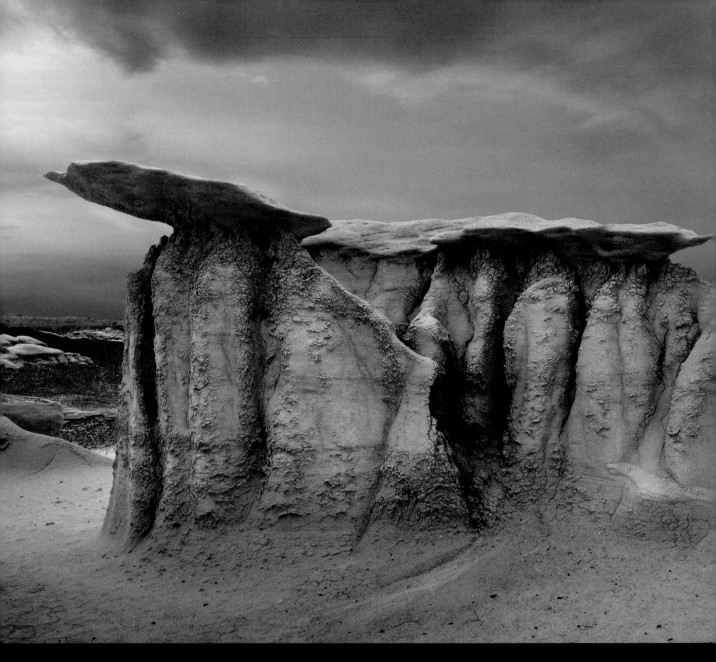

david zimmerman

David was born in Milwaukee in 1955. After assisting
several top editorial and advertising photographers
in New York, he turned to landscapes in 1985. His
many awards include the L'Iris d'Or Prize at the
Sony World Photography Awards in 2009.

nationality
American

main working location
southwest USA

website
www.davidzimmerman.com

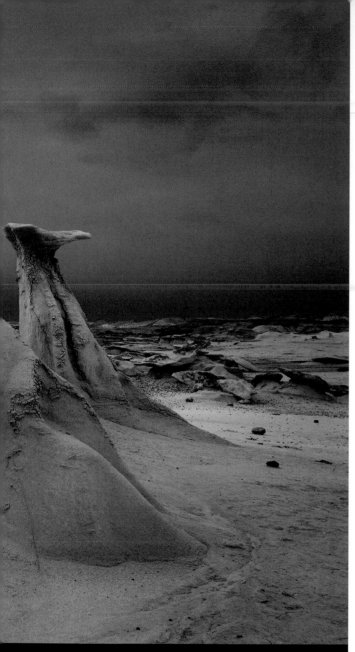

in conversation...

What led you to specialize in landscape photography?
I was raised in the US and in my early twenties I began traveling, primarily in Europe and the Middle East, where I lived for a number of years. This is where my interest in landscape photography developed.

Please describe your relationship with your favorite subject. Are you an expert on it?
My favorite subjects all share one common element. They all make me feel something new or teach me something about myself or the world around me.

Do you feel you have succeeded in being innovative in your photography, or do you feel the shadows of past masters over you?
I'm inspired by past masters but at the same time I realize that what they did has now been done, and it's essential for a photographer to explore new territory. Whether in concept, subject, or materials, exploring the new is a key to good work, and fresh ideas and ways of execution are essential elements of innovation. Walker Evans once said, "It's the way to educate your eyes. Stare. Pry. Listen. Eavesdrop."

How important do you feel it is to specialize in one area or genre of photography?
I think every situation is unique and often it depends on the stage of one's career. I've always had many interests and, although I did tend to specialize, I also continued to pursue my other interests. It's often a matter of how much time one is willing or able to devote.

What distinguishes your work?
I believe it's important to train your eye to see everything around you and to see it in your own unique perspective—things from the everyday, like a kitchen utensil, to the spectacular, like a mountain vista. We all react differently to the things we see and we need to capture that personal, individual reaction in order to make a unique image. This is what I try to do.

As you have developed, how have you changed?
Having worked as a photographer for many years and become fluent with the process, from large format to medium format to darkroom to digital, I have been able to

▲ for this shot

camera and lens
Contax 645 with Leaf digital back and 55mm lens

aperture and shutter setting
f/16 and 1/90 sec

sensor/film speed
ISO 50

for the story behind this shot see over ...

concentrate more and more on the visual aspects and the concept of a photograph and less on the technical requirements of the process.

What has been the biggest influence on your development as a photographer?
My own interest in exploring new ways of making images and my continued interest in the stories around me.

What would you like to be remembered for?
I'd like my work to have an impact on an issue, whether social or environmental, and I'd like to be remembered as someone who contributed a unique vision.

Did you attend a course of study in photography?
I studied at Brooks Institute in California and received a degree in photography. I've always felt that my early immersion in photography was beneficial.

How do you feel about the tremendous changes in photographic practice in the last ten years? Have you benefited or suffered from the changes?
From a creative perspective, the changes in photography have been the greatest leap forward in history. Gelatin film was a leap forward, the roll-film camera, color materials, and Polaroid were great technical advances, but nothing compares to the advances made by digital desktop technology.

Can photography make the world a better place? Is this something you personally work toward?
I think art in general absolutely makes the world a better place. Painting, film, writing, photography, and so many art forms all play a part.

Describe your relationship with digital post-production.
I like the traditional processes but find the realm of digital to be many times better for my own work.

Could you work with any kind of camera?
I prefer certain formats but don't have a strong preference for any particular manufacturer. I now shoot primarily medium-format digital and some 6x12cm film.

Finally, to end on not too serious a note, could you tell us what non-photographic item you find essential?
I have a small camper van that allows me to drive to virtually any location and stay there until I've got the photographs I'm looking for. I can carry enough food and water for several weeks and the camper is solar-powered, allowing me to recharge batteries and run a laptop.

behind the scenes

This location in the American Southwest is notable for its extraordinary geology. The rhythms of its unendingly variable rock forms under a giant sky offer a landscape I could spend many days exploring in photographs.

07:00 **Arriving at this remote landscape,** I knew I could work undisturbed by curious passersby.

07:30 **The camper van** makes it easy to set off at any location as soon as I see that the light is right.

08:00 **My assistant accompanied** me to help with logistics.

08:05 **It was a chilly morning,** and I was already glad that I had brought along my battery-heated socks!

08:30 Finding a rock formation I wanted to photograph, I used the viewfinder from my camera to check camera position and composition before setting up my tripod.

08:40 I prepared my Horseman 6x12cm film camera and Rodenstock Apo-Grandagon 45mm lens.

08:45 I loaded the 120mm film, which in this camera takes six exposures.

08:40

08:45

08:30

08:55

09:05

△ in **camera**

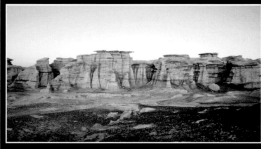

08:55 I pulled the dark slide from the Horseman. This is a completely manual camera with no auto advance, light meter or in-camera focus ability. I had now decided to use a 90mm lens.

09:05 A tripod and cable release are essential for sharp and critically composed photographs.

▶

10:30 **I decided to change to my Contax 645 camera** and took a photograph of a gray card held by my assistant to act as a color balance reference.

10:40 **I set the ISO and color balance** I wanted on the LCD screen of the Leaf digital back.

10:50 **Using a Zeiss 35 Distagon lens,** I photographed a rock formation.

10:30

10:40

10:50

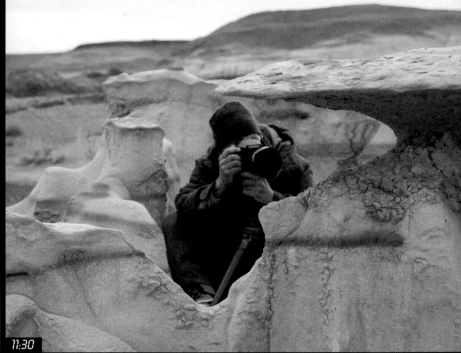

11:30

11:50

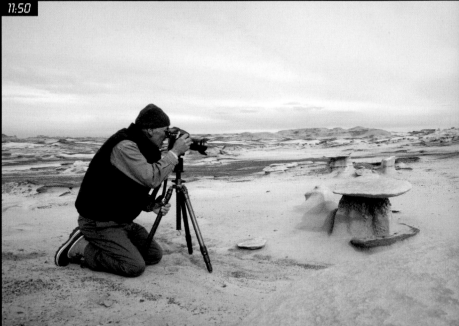

11:30 **It was sometimes necessary** to adopt cramped positions to get close to particular rocks—but it was worth it.

11:50 **Without a sense of the surrounding scale,** this table-shaped rock could be made to look monumental or miniature in size.

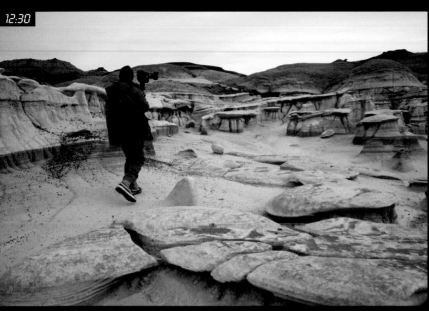

`12:30`

12:50 After waiting for some heavy clouds to drift across and add to the drama, I took a shot of this tremendous formation of rocks, using my Zeiss 55mm Distagon lens.

▽ in **camera**

`12:50`

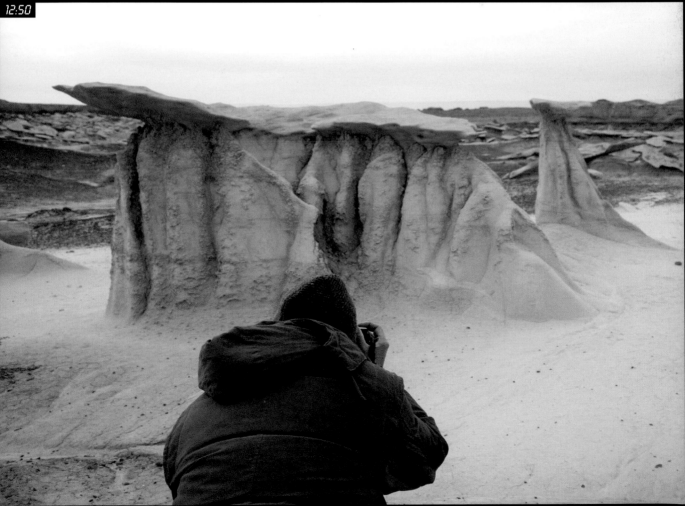

portfolio

▽ **untitled (desert 60), 2008**
This image is part of an ongoing personal project documenting the remarkable deserts of the American southwest. It was taken in New Mexico under a full moon.

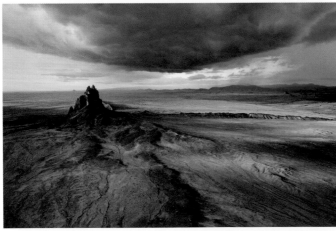

◁ **Shiprock, New Mexico**
To the native Navajo people, Shiprock has great cultural significance. To convey the sense of scale and the spiritual quality of the place, I photographed from a helicopter.

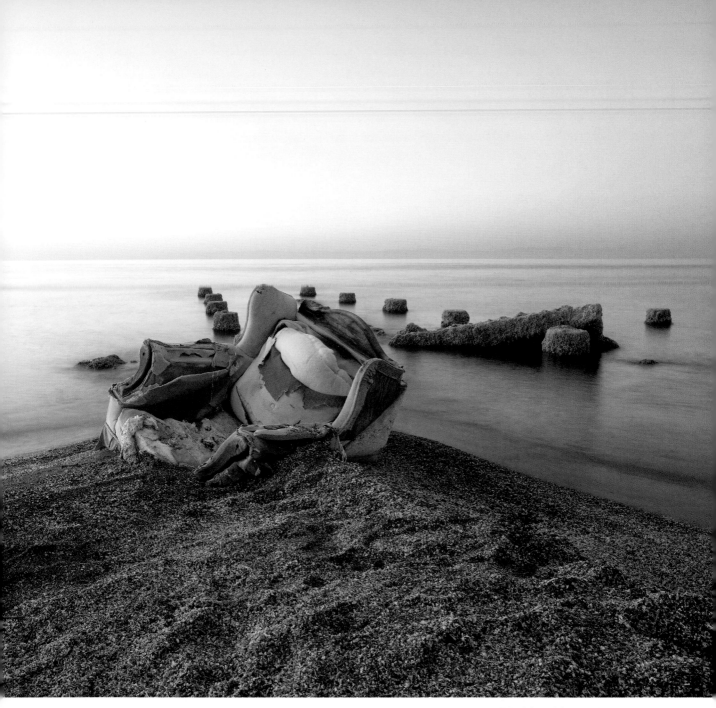

△ **untitled (chair), 2008**
I began photographing the Salton Sea,
California's largest inland body of water, in
2006. It's an eerily beautiful place, but one
where birds and fish die by the thousands.
Its demise began when the fresh water of
the Colorado River was diverted to feed the
state's booming, thirsty cities.

tutorial: magical moments

The best moments in landscape photography are when a combination of light, sky, and atmosphere create a transcendent beauty— one which seems impossible to capture, yet the image will simply appear in the camera. It is the ideal of photography; and all you have to do is to be there and be ready.

patience and perseverance

One thing you can be sure of when you see a glorious landscape photograph is that it's no accident. It's sure to be the result of a photographer returning to the same spot again and again, sometimes over a period of years. From time to time they may obtain a good shot, but they know there will be a better one. On other occasions they return to base without making an exposure. And, over time, these photographers also refine their viewpoint and composition until one quiet and perfect moment, it all comes together.

This reveals a vital and little-known truth about great landscapes: that anywhere can look amazing at some point in time. Treat the landscape, whether it be a nature reserve or the center of a city, as a vast possibility waiting for the key elements to come together to stunning effect— just be sure to be there for the occasion.

planning ahead

In the good old days, planning for photography was rather hit-and-miss, with much reliance on local knowledge. Now that you have constantly updated weather forecasts on your computer, you can track the times and compass points of sunrise and sunset and use satellite images to judge the changing effects of the sun's trajectory across a landscape. All without stepping out of the house.

Look out for fog and mist warnings, as they are good opportunities to find landscapes transformed from the prosaic. A light dusting of snow often provides more interesting images than thick drifts—because of contrasts with the still-visible underlying colors and shapes. So listen

digital dark **room**: converting to monochrome

Digital methods of creating black-and-white images are highly subtle and versatile, fully able to imitate the effects of colored glass filters. Capture in full color (**1**) for the most options. A grayscale conversion (**2**) usually gives acceptable results. Favoring blues (**3**) brightens the sky, closer to a recording by black-and-white film. Giving weight to reds (**4**) makes blues very dark, and brings dramatic contrasts similar to using a red filter.

for the forecasts for the first snow. Shooting while snow is falling is frequently very rewarding too. Of course, weather forecasts can also help you avoid rain and storms. But remember to venture out after the rains, especially for urban views, as water lying on the ground pulls a great deal of light back into foregrounds through the reflections on its surface.

In the longer term, the seasons of transition—spring and fall—are the most likely to produce magical moments. This is because variations in air and earth temperatures create interesting atmospheric effects.

seize the moment

When the moment comes, you may need to be fully prepared, for it may not last: the deep reds of a dawn can move from not bright enough to too bright within seconds. Use a tripod for sharp images, and to hold the camera while you wait. And don't be ashamed to bracket exposures: you may only get one chance, so be sure exposure and focus are spot-on.

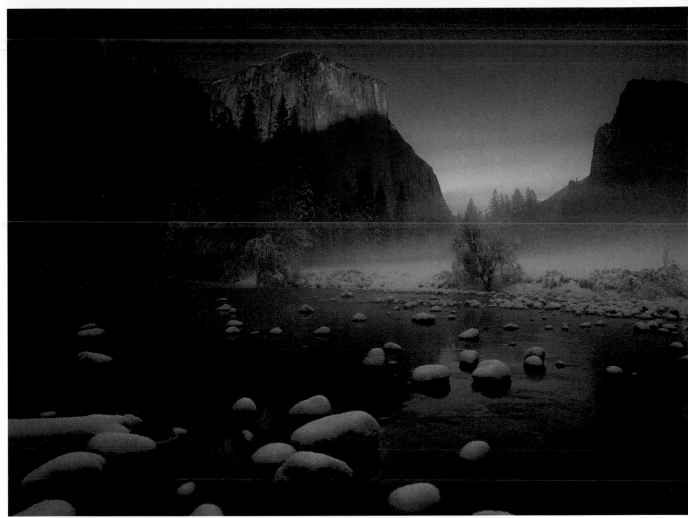

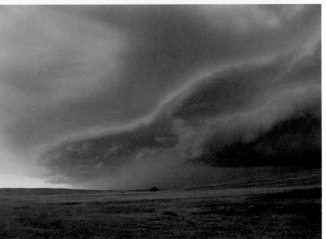

working with the light

For remarkable images, shoot in RAW (unprocessed) format (see p.112), use your best lens, and bracket your exposures. The correct exposure for the dawn (**above**) would make the scene too light, while underexposure creates strong contrasts. With quickly changing situations such as smoke, mist, or clouds (**bottom left**), shoot a series and choose the best later. The right light and cloud can transform a dull scene into something special, so don't rule out anything (**bottom right**).

tutorial: urban landscapes

If you believe "urban landscape" is an oxymoron because "proper" landscapes shouldn't contain man-made structures, you may be missing a great opportunity. The built environment creates new topographies: these can be photographed in the same way as traditional landscapes, or in new ways.

a blank canvas

As a relatively young genre, urban landscape photography can invent its own rules. No conventions have developed here, nor are there areas that are off-limits. In part, this is because urban landscapes have evolved into their present form at precisely the same time as photography's own development.

Starting with the celebration of grand buildings such as cathedrals and castles, photographers went on to explore the byways of cities, finding worthy subjects in humble shops and street corners. In that process, the distinction between architectural and urban photography became clear: the urban photographer takes no interest in a particular building for its own sake, but is concerned instead with its position in the wider environment and its relationships with buildings around it.

vertical integration

One approach is to concentrate on the abstract patterns created by the juxtaposition of elements of the urban environment—for example, the vast apartment blocks of Hong Kong provide infinitely variable grids of color and shifting patterns. You can photograph such features formally—straight on and avoiding any distortions in shape—or more subjectively, looking for lighting effects from the sun and shade, or working at night to exploit the colors from windows and street lighting.

You might also look at the relationship between people and the built environment, much as photographers working in the countryside might watch the shifting patterns of herd animals. Again, formal or objective approaches—for example, depicting patterns from a distance—can be as fruitful as subjective approaches that operate more at street level and cross over into documentary photography.

compression

Urban landscapes are usually much busier than natural landscapes. With a long focal length to magnify the subject from afar, you can compress the jumble of detail.

moving patterns

There are strong graphic shapes in urban landscapes. You can work with these alone or seek ways to provide a contrast, such as including crowds of people.

focus on technique: reverse tilts

In the normal camera set-up, the surface of the sensor lies parallel with the lens' plane of best focus. Focusing is the process of adjusting the lens so that a sharp image of the subject is made to lie on the sensor. This assumes the subject is flat and that it lies parallel to the sensor's surface. However, most of the time, especially in the case of landscapes, the subject's plane lies at an angle. If you use a lens that tilts on its axis, so that the plane of best focus lies at an angle, you can dramatically change the depth of field. If the lens tilts forward, by setting the correct angle, depth of field on the ground can be made to extend all the way from the foreground to the distance even at full aperture. If you tilt the other way, depth of field is dramatically reduced. This makes a view look like a scale model, viewed close up.

new visual language

One feature of the urban landscape not shared by its country cousin is the question of white balance. In cities, there are many different types of light source—sodium vapor lights, fluorescent tubes, incandescent lamps, neon signs, and so on. Some are deliberately colored, and highly so, while others emit a white light. When all of these are illuminated at night, the variety gives a quality to urban landscapes that is completely new to the visual arts. It has added a great deal to our visual language, although so far it seems to have been overlooked by art historians.

Another important factor is that cameras are able to see more at night than we can. In dark conditions, our eyes adapt to the lack of light by becoming less sensitive to color but more sensitive to brightness (known as "scotopic adaptation"). The result is that images taken in low light always seem far more colorful than we remember, even if the images are dark. You can work with this to great visual advantage, especially with the new generation of digital cameras that possess extended low-light sensitivities. Now you can photograph where other cameras cannot see—even, indeed, where you yourself cannot see.

city nights

Digital cameras record city lights in unpredictable ways, depending on their sensor design, signal processing, and white balance algorithms. For the most flexibility, record in RAW format and in a wide range of bracketing exposures. Working when street and office lights are first turned on but while there is still color in the sky makes it easier to avoid blank expanses. It is best to work with a tripod, although you may attract unwanted attention. Remember to be cautious when working by yourself at night with an expensive camera.

image *analysis*

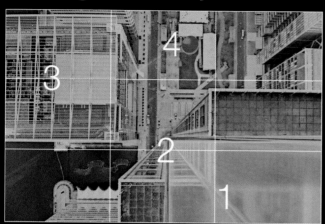

17MM ISO 100 1/50 SEC F/5.6

The search for fresh viewpoints never stops, and persistence will always bring something new. This image by André Lichtenberg is a perfect example of the rewards of going where others fear to tread.

1 crucial diagonal
This strong line is almost entirely responsible for conveying the vertiginous yet elegant quality of the image. Leading to the center, its convergence defines the rapidly receding space and the rest of the image seems to hang from it.

2 converging parallels
If converging lines strongly suggest distance, repeated elements diminishing in size—such as railroad ties between converging tracks—reinforce that sense. Here we have no fewer than four sets of lines that take the eye inexorably down.

3 geometry preserved
There are so many diagonals within this urban image that it's almost a relief to be presented with a solid, four-square, regular set of lines. It's important that this grid isn't distorted either by the lens or by image projection and that it lines up neatly with the frame of the image.

4 bright spot
Without the vivid spot of color from the dome and its contrast with a patch of green at ground level, the image—while still effective—would not be so eye-catching.

assignment:
city complex

Compared to a natural landscape, a cityscape may lack subtle detail and organic forms—but this is made up for by the complexity of lighting effects, contrasts of forms, and an enormous amount of color. These attributes afford plenty of opportunities to express your personal vision and style through the choice of lighting, subject matter, and treatment.

the brief

Capture urban landscapes or cityscapes in a pre-planned, specific style or approach of your choosing. Develop a concept or style of photographing rather than exploring your subject matter.

bear in mind that you can photograph to emphasize, for example, the darkness of spaces or to express emptiness. Alternatively, you could work with graphic shapes or concentrate on night-time lighting.

try to capture images that have a consistent approach and style despite being shot in different cities and even in different countries. You are learning to use a visual vocabulary of color, form, and exposure to express your vision.

think about...

1 minimalism
Reducing the multifarious elements to a minimum, either by choice of framing or viewpoint, often leads to strong and visually immediate images.

2 color palettes
Careful control of your color palette, such as setting strong hues against a background of neutrals, is a tactic that wins time and time again.

3 scale
Contrasts in scale need to be strongly exaggerated when images are seen at relatively small sizes. Keep in mind the final image use when you frame.

must-see master ▶

Peter Bialobrzeski
Germany (1961–)

Bialobrzeski worked as a photographer on a newspaper in Wolfsberg before returning to college to study photography in Essen and London. As an international photojournalist his work has appeared in many magazines and he has worked for corporate clients, such as Daimler-Chrysler, Philip Morris, Siemens, and Volkswagen. More recently, he has published images in four books that document urban history and take viewers on fascinating journeys through citiscapes around the world.

career highlights

1989 Begins career as a photojournalist.
2000 Founds virtual gallery photosinstore.com
2003 Receives World Press Photo prize.
2004 Exhibits his best-known work, *Neon Tigers*, in New York.

Shanghai 2001, #27: This image is taken from *Neon Tigers*, which explores the growth of Asian megacities. The lights in a Shanghai street give a reality to the old town as ghostly high-rises loom beyond.

4 rhythmic lines
Make a virtue of urban features such as repeated rows of lights or windows. Try to frame to minimize converging parallels.

5 symbolic parasitism
Make unashamed use of the graphic signs and symbols that pepper urban environments: they are free gifts from designers to photographers.

6 creating mood
As ever, remember that working in monochrome offers an enhanced mood and atmosphere plus a clearer articulation of light.

luca campigotto

Luca was born in Venice in 1962. With a degree in
modern history, he has been photographing both
natural and urban landscapes internationally since
the 1980s. He has exhibited at the Venice Biennale
and in Paris, Rome, and Miami.

nationality
Italian

main working locations
worldwide

website
www.lucacampigotto.com

in conversation...

What led you to specialize in landscape photography?
It was a natural tendency. When I printed the 300 images I shot during the first trip I ever took, I noticed I had photographed just natural and urban landscapes—not a single person in a journey lasting almost two months.

Please describe your relationship with your favorite subject. Are you an expert on it?
Three main subjects—historical places, ancient ruins, and archaeological sites—are part of my instinctive attraction to history. I think of photography as a time machine, as though I were at the scene of a reconstructed period drama. I also love metropolitan scenes, the urban chaos of architecture and lights. Finally, I love looking at wild landscapes. The slow contemplation of natural settings is linked with my love of adventure movies, comics, and literature about great voyages.

Do you feel you have succeeded in being innovative in your photography, or do you feel the shadows of past masters over you?
I consider myself a coherent photographer, and I'm aware that my projects feature expressions of my very personal tastes—and obsessions. I am pleased if my images recall the magic of some past masters I feel close to: Carleton Watkins, and the frontier post sense of his images; the exotic charms of the Beato brothers and Maxime du Camp; or O. Winston Link's unbelievable night lighting.

How important do you feel it is to specialize in one area or genre of photography?
When you do something creative you should follow your own deeply felt wishes. In pursuing them you find your truth, and the work benefits from this honest approach.

What distinguishes your work?
I love dramatic visions with great impact—no minimalism at all. I try to make images that are powerful and timeless without following current trends—poetic but strong.

As you have developed, how have you changed?
For years I thought the only possible authentic photography was in black and white. I always shot on black-and-white film and printed my negatives myself.

▲ for this shot

camera and lens
Hasselblad H3D-39 and 28mm lens

aperture and shutter setting
f/11 and 32 sec

sensor/film speed
ISO 100

for the story behind this shot see over ...

Then I discovered digital post-production and inkjet printing and now I enjoy color photography as I can make "my colors" in Photoshop. I like making changes in contrast and light, just as I did in the darkroom. The philosophy is just the same.

What has been the biggest influence on your development as a photographer?
Movies, movies, and movies again. And, of course, the books of masters of photography. I think it's important to know and to have assimilated the works of the greats.

What would you like to be remembered for?
A very embarrassing question! Well, as I said, strong, timeless images.

Did you attend a course of study in photography?
No; I studied modern history in college and learned photography on my own. I was fortunate enough to meet established photographers who gave me advice and taught me the importance of making books on specific themes.

How do you feel about the tremendous changes in photographic practice in the past 10 years? Have you benefited or suffered from the changes?
I have certainly benefited. Today I feel freer to explore, and to experiment with daring new solutions.

Can photography make the world a better place? Is this something you work toward?
My photography is not based on witnessing. It's just my personal way of escape and I don't pay attention to whether it has a social value. But I'm sure that culture and any creative work can make people's lives better.

Describe your relationship with digital post-production.
I spend up to 12 hours a day at the computer, trying to make my photos better. It's definitely my thing.

Could you work with any kind of camera?
I love sharpness, so I've always worked only with large-format cameras and now with big digital backs. I like using a tripod, going slowly, and choosing a precise viewpoint. It's sort of an old-time way of shooting.

Finally, to end on a not too serious note, could you tell us what non-photographic item you find essential?
When I travel I take with me a flask of very good whiskey. I love being warmed up by its taste while watching the news or listening to music when I have finished shooting.

behind the scenes

This shoot took place in an area of Milan that is undergoing rapid transformation. I like the mixture of the old city and modern buildings in the process of construction—it gives the idea of the stage set that is always in my mind.

18:30 **I packed my usual equipment** in my Domke F-2 bag: a Hasselblad H3D-39, a 50–110mm zoom lens, a 28mm lens, batteries, and lens hoods.

19:15 **I looked at a view** I was interested in through both the zoom and the prime lens—sometimes 28mm is too wide and looks overextended.

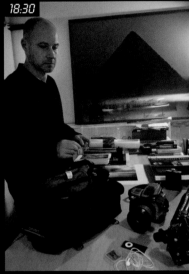
18:30

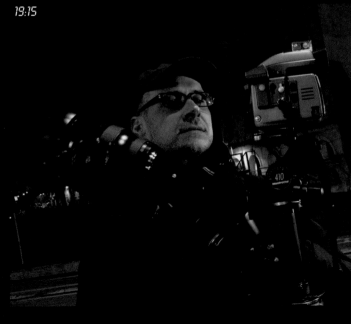
19:15

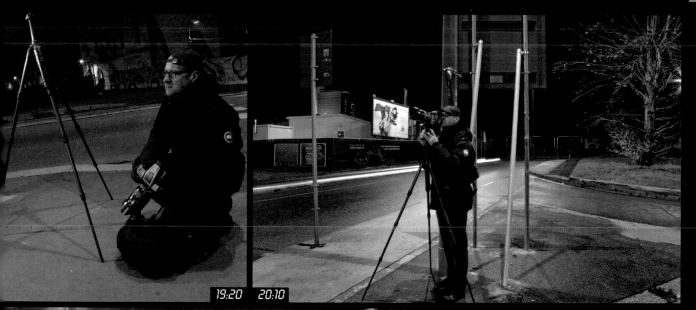

19:20 **Deciding on the zoom,** I looked at the buildings from a low angle—it's always worth considering different viewpoints.

20:10 **I spent time wandering around** an area close to a construction site and an overpass, always setting up my tripod in a place that was safe from traffic so that I could concentrate on my work.

20:50 **I liked the lighting and atmosphere** of this area that was undergoing some redevelopment, it was full of cranes and roadwork, and I worked there for a while.

◁ in **camera**

21:10

21:20

21:10 **After taking a few wide-angle shots,** I swapped back to my zoom.

21:20 **To me, careful framing is essential.** With the advent of digital, some photographers have begun to take many more shots to make sure they have got what they want. Editing them afterward can waste many hours!

21:25 **I checked the level** on top of the camera before taking the shot.

21:25

in **camera** ▷

21:40 I used an underground passage to reach the other side of the overpass and a higher vantage point, where I felt I would find some good images.

21:50 I was right—the higher level gave me a long view of the street and overpass.

21:40

21:50

21:55

△ in **camera**

09:30

21:55 Using the wide-angle lens gave me the scope to include a broad sweep of the overpass and give dramatic perspective to the view.

09:30 Next morning: I sat down to start on the post-production work. The monitor hood ensures that the colors I can see remain undistorted by ambient light.

portfolio

▷ Bangkok, 2006

As a movie fanatic, I often shoot in the city at night looking for "my" *Blade Runner*. I love the tremendous visual impact of certain environments. The power of dazzling light is magnificent and it helps me to find otherworldliness in an ordinary place.

▽ New York City, 2004

A summer night on Canal street. I was particularly excited about working in New York. The city has always been a kind of dream for me—it's the mythical "perfect place." When I walk around New York, it feels like I'm in a movie.

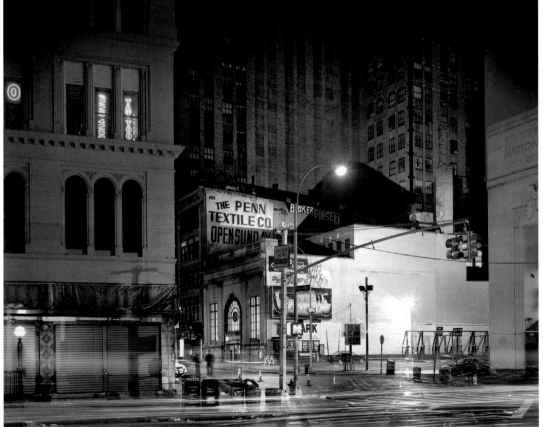

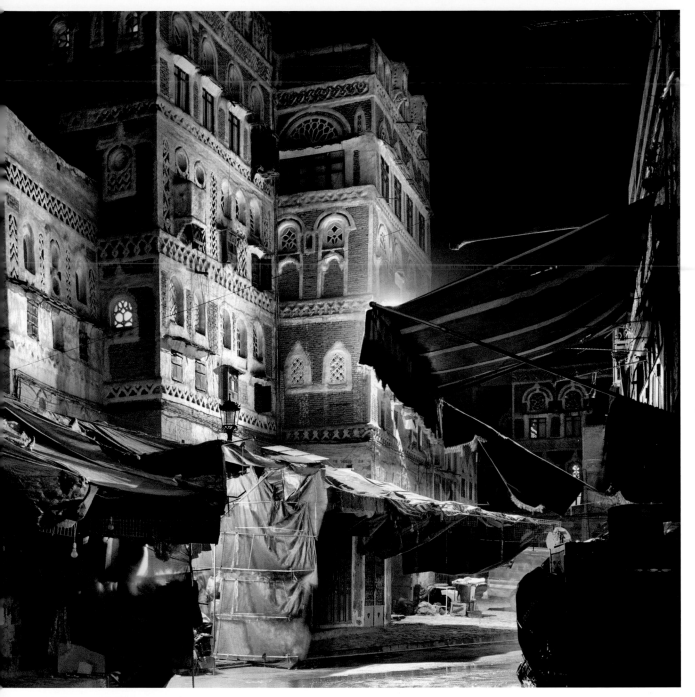

△ **Sanaa, Yemen**
I love places full of history—they are like
time machines for the photographer. Here,
I have captured a market at closing time,
which looks like an abandoned movie set.
The streetlamp is hidden so you can't
immediately tell where the glare comes from.

and finally...

1 compressing space
Use long-focal-length lenses to render distant objects closer together, to control space and minimize contrast of sizes.

2 flat planes
Soft lighting and plain areas of tone can evoke large spaces with the aid of converging parallels that lead to a distant vanishing point.

3 tone painting
Where the subject provides lots of material to work with—curves, patterns, parallels—reducing the range of colors may strengthen impact.

4 intensity
You can concentrate the impact of an image by simplification: under-expose to lose shadow detail, compose to show the bare minimum of outlines and shapes.

5 letter-box views
Look out for the long, narrow crop (letterbox or pseudo-panorama) that can dramatically increase the impact of even commonplace views. Work with vertical as well as landscape-format panoramas.

6 avoid smallest apertures
Use mid-range apertures to obtain the best from your lenses. Setting minimum apertures gives greatest depth of field, but usually also lowers sharpness overall.

7 beautiful ugliness
Any event in a landscape is worth photographing: look for oppositions such as beautiful light and industrial ugliness.

8 straight lines
It's as important for trees as for buildings that they appear upright, not leaning back, unless for special effect.

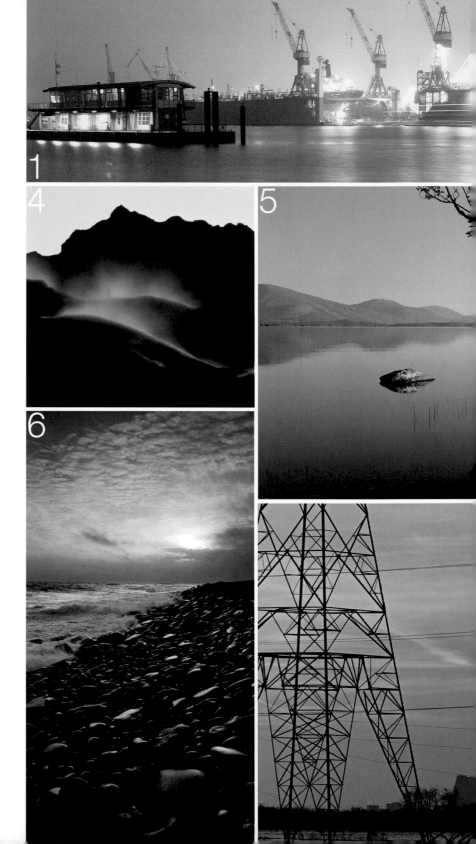

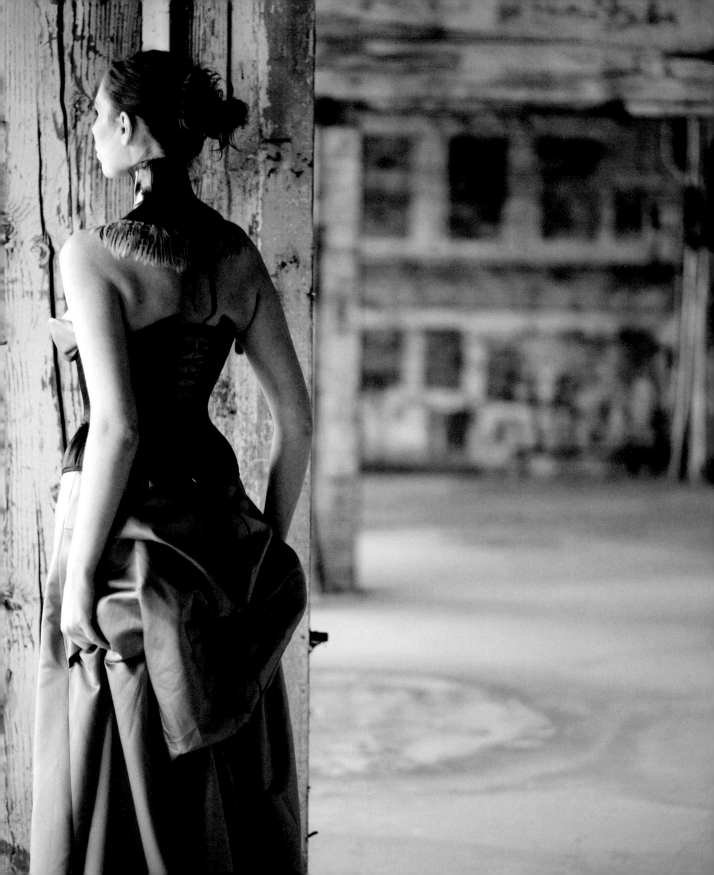

FASHION
AND NUDE
PHOTOGRAPHY

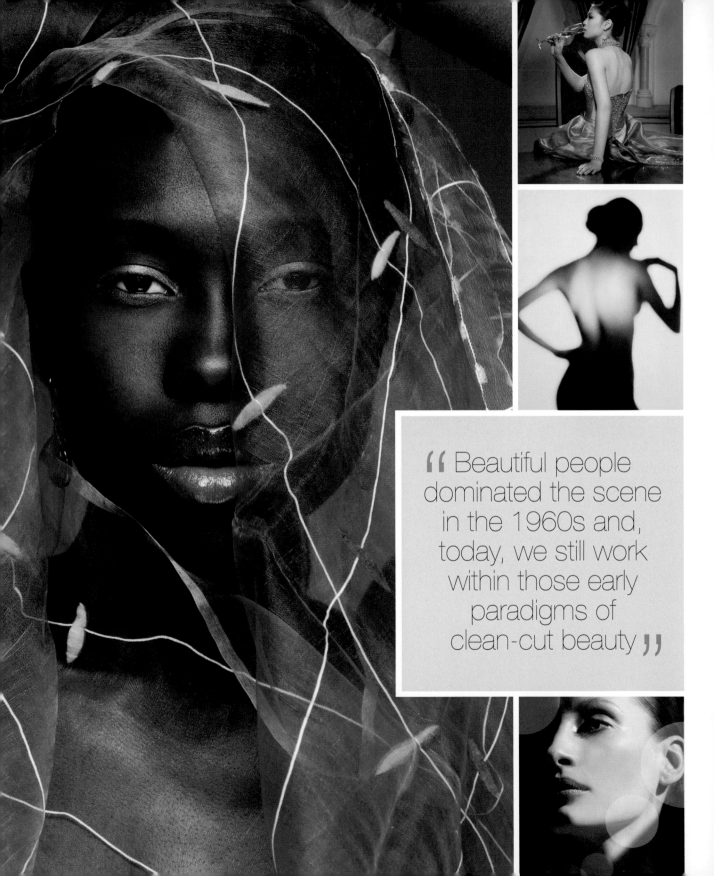

" Beautiful people dominated the scene in the 1960s and, today, we still work within those early paradigms of clean-cut beauty **"**

Fashion and nude photography celebrates the human form. Despite attempts to dismiss the artistic value of this genre, its images are almost always highly aesthetic. Regardless of location—a studio, a stately home, or a construction site—the fashion or nude photographer tends to deliver a beautiful image because he or she uses the most natural of subjects.

Photography's first love-affair was with beauty, particularly when expressed in the form of a human body—both female and male. Ensconced in their studios, photographers could explore the entire range of the subject safely and privately, from fully clothed to fully nude. Fashion photography therefore takes a natural place on a scale that is occupied at the other end by the nude.

Photographers' first explorations of beauty were expressed within a framework of conventions derived from fine art painting. This also suited the technical limitations of photography at the time: the need for long exposure times forced models to adopt static poses. At around the same time that moral limits were being relaxed, technical means improved that freed photographers from studios and allowed them to work outdoors, on location with their models. This naturally called for the old conventions to be thrown out of the window, and led to photography's divorce from the binds of painting conventions, which were themselves being torn apart by internal strife.

While great attention had always been given to the way a model was clothed, it was not until the rise of magazine photography (which developed alongside the growth of consumerism) that clothes themselves became a subject for photography. Fashion photography was a child of the magazine industry and was central to the peddling of consumerist lifestyles that were defined by exclusivity, privilege, and aspiration to wealth.

Beautiful people dominated the scene in the 1960s and, today, we still work within those early paradigms of clean-cut beauty—stunning models with perfect skin and slender figures. However, the range of acceptable approaches has also expanded. By the late-20th century, these could include anything from nostalgic images to violent, sexually-loaded, and deliberately ugly styles of fashion photography.

Today, we also have a creative explosion caused by there being more photographers and designers than ever, with fresh creations from outside the US- and Euro-centric mainstream demanding attention. The result is more competition than ever, with standards being edged ever higher.

In this chapter, we explore a range of approaches and styles to help you discover the ways of working that will best suit you by featuring inspirational work by many masters of their craft.

key moments

1853 Nudes studies account for 40 percent of all photographic production.

1911 The work of pioneering fashion photographer **Edward Steichen** appears in French magazine *Art et Decoration*.

1918 **Alfred Stieglitz** takes his first intimate portraits of artist Georgia O'Keefe.

1930s **Cecil Beaton** captures the style and glamour of the decade for *Vogue*.

1935 At *Harper's Bazaar*, **Norman Parkinson** revolutionizes fashion photography with shoots in natural outdoor settings.

1936 **Edward Weston** begins studies of nudes and sand dunes in Oceano, California.

1960s David Bailey and Terence Donovan capture **Swinging London** chic, becoming celebrities in their own right.

1975 Helmut Newton shows his huge, overtly sexual images of women, *Big Nudes*.

2000 **Nick Knight** launches the innovative website, SHOWstudio.com, the first to explore online fashion broadcasting.

tutorial: directing models

The first steps to becoming a movie director may start on a fashion or nude shoot, as the role requires similar decisionmaking. You can direct every pose and expression, giving precise instructions for each position, or you can set a mood and ask your models to move and pose as they wish.

two-way communication

A careful look at the work of the great photographers of fashion and beauty soon reveals that they use the same models over and over again. Such popularity in this competitive field comes not only from being extraordinarily beautiful, but being able to offer a quality that is even more prized: the ability to communicate and work with the photographer. This is the reason why top models are so highly sought after by many different photographers.

At the same time, fashion or nude photographers who can bring the best out of a model are themselves prized. The key ingredient to a successful shoot is teamwork: the photographer's ability to communicate what's wanted to the model and the aptitude of the model to interpret the directions are equally essential to getting great results.

directorial debut

If at all possible, it's worth paying for a professional model. Your shoot will be much more productive, especially if you have little experience. Professional models are better at adapting themselves to different styles and conditions than amateur models. If you're having to arrange locations, assistants, and so on, ensure that the most visible element—the model—isn't the weakest link.

When you first meet your model, do your utmost to make him or her feel part of the team. Make time for proper introductions to any other crew members, explaining their roles in the shoot. If you're working to sketches, or if you're trying for a certain effect, show the model the sketches and other material. Once they understand what you want to achieve, they may suggest ideas of their own.

Give directions clearly and steadily: if you bark out orders, your model is likely to feel uncomfortable—and possibly embarrassed and annoyed—resulting in awkward,

striking angles
Unusual or exaggerated angles and poses are effective when used sparingly for specific purposes, as their value depends on freshness and surprise.

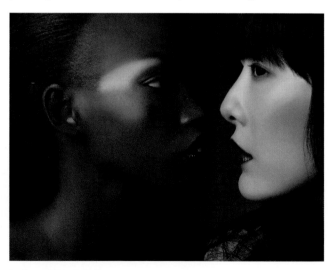

balancing detail
Formal, studied poses should be set up with great care, as the smallest error in positioning—not obvious in the viewfinder—can be glaringly obvious in the final image.

unnatural poses. Always ensure that your model is safe: you may be getting fabulous shots, but if you ask them to pose whilst standing in big waves, for example, ensure someone is on hand to help if they get into difficulty.

These concerns are central to your photography. A model exposes your talent, and if the model shines, so will your images. A happy, comfortable model will give his or her best, and that will show in your images.

style lines

In the theater, while the director has the final say on artistic matters, details of the set design and construction are often best left to a specialist. This is also the case with fashion photography. Decisions about the props to be used and the finer details about the shoot location are

changing expressions

Set up lights and camera, then keep shooting as the model poses. A good model may give you as many poses in a few minutes as you could plan in a whole day.

best handled by a stylist. He or she will also ensure that the model's clothes fit properly and as the designer intended, and will make any necessary adjustments before the shoot starts.

A good stylist will see the shoot as a whole, and will work to ensure that no element—even those not visible in the shot, such as background music—is jarring or inappropriate. Small easily missed details, such as a loose strand of hair, smudged mascara, or lipstick that is too glossy, can all work against delivering a first-class shot. The stylist takes responsibility for all these nuances.

mini theater

It is fun to set up a scene and ask the models to play out their roles, but you need to catch the action sharply, which calls for good light (**above**) or flash exposures (**right**).

tutorial: props and locations

Some fashion and nude photographers breathed a huge sigh of relief when they were able to break free of the constraints of the studio and work in a variety of locations. At last they could take their models and clothes to places that contrasted with, complemented, or augmented their images.

compare and contrast

Your choice of location might contrast with the clothed or nude model or be harmonious. A delicate waif, draped in silk, may be featured against a vast industrial backdrop that is dark with grime and pock-marked by rust. Or you could photograph in the ballroom of an elegant château, hung with tapestries and chandeliers. The model and clothes will be the same, but the impact of the two images will be entirely different.

When you unite two things that are never naturally found together, you are orchestrating a drama and creating a fantasy. (See, for example, Richard Avedon's famous image *Dovina with Elephants*, in which a model wearing a floor-length Christian Dior evening gown poses with circus elephants.) There is a risk that attention is distracted from the main subject—the dress or the model—by the theater that surrounds it. To avoid this, you need to ensure that it is strongly characterized and highly visible.

When you work in a location that supports and complements the clothes—for example, a bikini on a Caribbean beach—the result has no drama or implied narrative, lacks tension, and runs the risk of being too predictable. The shots droop to the level of a bland mail-order catalog. To avoid this, you need to inject an element of the unexpected.

highlight and surprise

Try to find a balance that's just right for your shoot. Seek locations that contrast with the subject while ensuring there are some familiar elements to soften the incongruity. For example, when shooting in a disused factory, use an elegant prop, such as a tapestry-covered chair, to add a touch of glamour to the industrial scene. If the location itself offers no surprises, introduce some of your own.

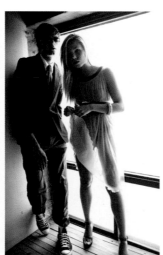

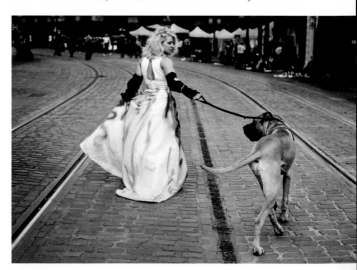

using the location
Working with the location means making the most of the light quality that is available and looking out for any textures that would make interesting backdrops.

statement prop
The contrast between the model and location may be a mild eccentricity, but adding an unexpected element, such as a large dog, animates the scene.

You can use startling props—animals are a favorite—or softer surprises, such as colored lighting or unusual flowers, to lift your image out of the ordinary.

The simplest surprise, and also perhaps the most cost-effective, is use of color. For an interior dominated by light green, try casting a red-haired model. If the range of clothes is bright red, look for white locations, such as minimalist interiors or offices.

Contrast in texture is another way of highlighting your model. The soft curves of the human body against craggy rocks or tree bark is popular to the point of cliché so, instead, try experimenting with both natural and man-made materials to provide the contrast.

location permits

So that your work is not impeded by bureaucracy, be sure to follow correct procedures and keep your paperwork up to date. Always get written permission to work in your chosen locations, and obtain property releases that allow the likeness of the interior design or architecture to be published freely both in print and on the internet. This is important even if the location is not recognizable. At the location, make an effort with the security guards and key personnel to ensure that they are a help rather than a hindrance.

injecting humor
Props have long been used to emphasize the body's desirability. The mirror is a favorite device, but here a teacup humorously reflects the tattoo.

telling a story
Images that work together to relate a simple story can be an effective way of presenting a range of outfits and of making full use of the location.

image analysis

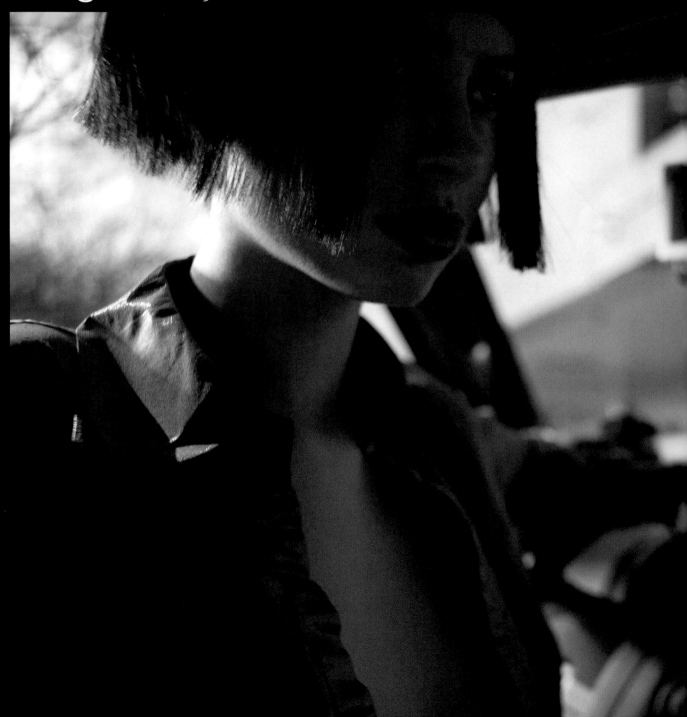

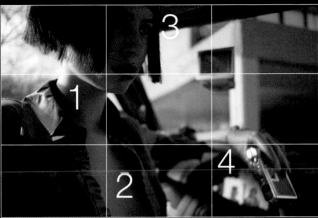

28MM ISO 200 1/250 SEC F/2

In the theater, you can rehearse every detail, but on the night, it is the little accidents that make the magic. Likewise, on a fashion shoot the small details can add up to brilliance, as seen in this image by Adrianna Williams.

1 light triangles
Back-lighting links the sky in the background to the model's neck, and a line of light continues along her chin to lead into the image. Thanks to an exposure expertly chosen to avoid a totally white, unattractive highlight, there is just a hint of tone on the brightest areas of the model's neck.

2 open suggestion
The falling lines from the light and the model's neck plunge to exposed areas of the model's skin, which hints at nudity and entices the eye to explore the image further.

3 eye line
Despite being located exceptionally high in the image, close to the top of the frame, the model's gaze leads to the geometrical lines that hold the composition together.

4 slim accidents
Thanks to being blocked by the car's steering wheel, the model's forearm appears to be unusually slim, which reinforces her doll-like appearance. A very shallow depth of field has blurred some of details, such as the gloved hand, that would otherwise be distracting highlights in the car.

assignment:
stage design

When you treat a fashion shoot as a theatrical event, its location turns into a stage set. The background you choose, and the way you style, dress, and light it all contribute to the image, complementing or contrasting with the clothes and the personality of the model. You can work in any environment, but beautiful or unusual ones are the most fun.

the brief

Work with a young fashion student (who is likely to be happy to collaborate with a photographer) to find interesting locations, from country houses to warehouses or ruined (but structurally safe) buildings. Negotiate with the owners to shoot at their property.

bear in mind that this exercise is as much about learning to work with a designer, models, and the owners of a location, with all the planning involved, as the photography itself.

try to capture the clothes and models in lighting styles and compositions that complement the chosen location, making full use of local lighting and features.

think about...

1 keeping it simple
Exploit minimal environments by mining all their possibilities, even a bare room has potential. Try different poses, lighting, and colored clothes.

2 snap decisions
Be prepared to make use of unplanned situations, such as a beam of sunlight entering the space. It won't last long, so shoot while you can.

3 shades of white
Allow different white balances to be present in your image—tungsten and daylight, for instance—to make the lighting and color as lively as possible.

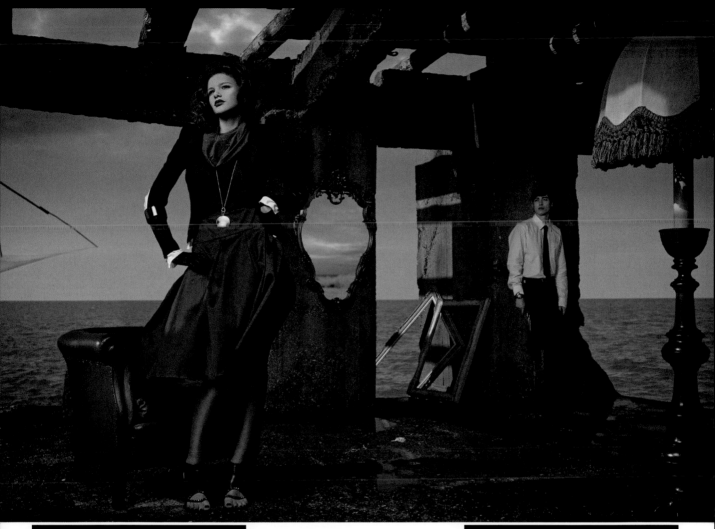

4 a blank canvas
Often, color palettes that blend in with the environment or offer limited contrasts make the best backdrops for showing off clothes.

5 lighting up
If you have to work in a small space or one that has distracting décor, try to focus the lighting on the model in order to throw the space into relative darkness.

6 tricks of the trade
Try manipulating the image to change the relationship of the model to the space for greater effect. You could even shoot each element separately.

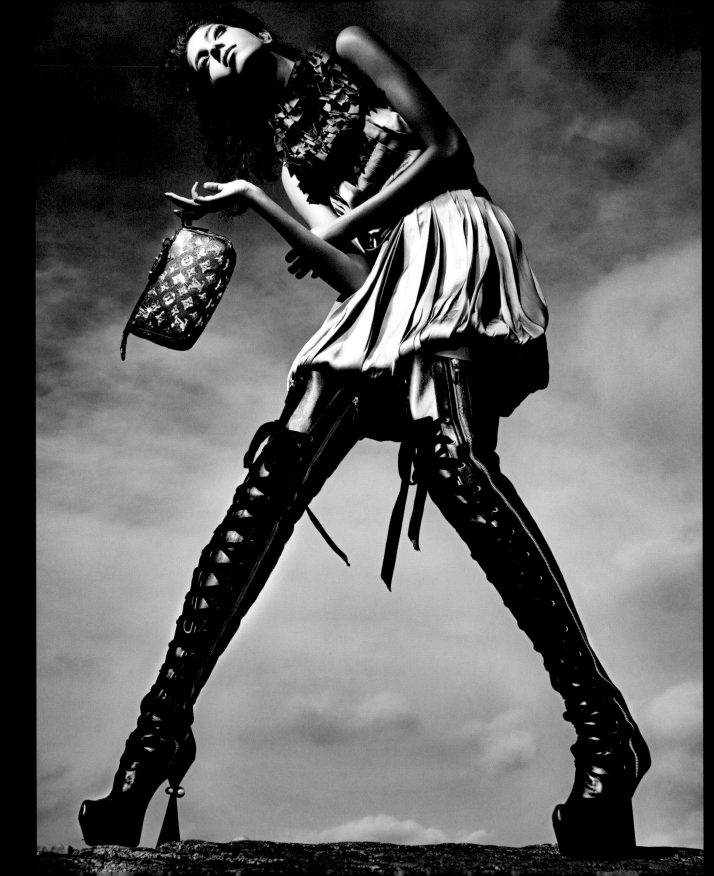

tarun khiwal

Tarun has photographed many stars of the Indian film and music worlds as well as working with big-name corporate clients such as Dior and Chanel. His many accolades include the Hasselblad Masters Award, the F Award, and the Asian Photography Award.

nationality
Indian

main working location
India

website
www.tarunkhiwal.com

◀ **for** this **shot**

camera and lens
Hasselblad 501CM with Phase One 25 digital back and 50mm lens

aperture and shutter setting
f/11.5 and 1/250 sec

sensor/film speed
ISO 100

for the story behind this shot see over …

in conversation…

What led you to specialize in fashion photography?
I started as a portrait photographer. Over time, I shot campaigns with fashion designers and eventually specialized in fashion.

Please describe your relationship with your favorite subject. Are you an expert on it?
I treat myself as a people photographer. Whether my subject is a nun in Kolkata, a holy man in Varanasi, or a model on the streets of Paris, it is fundamental for me to relate to them or else the portrayal is superficial. People have always been my favorite subject. I'm not an expert as the subject is vast and I'm still learning.

Do you feel you have succeeded in being innovative in your photography, or do you feel the shadows of past masters over you?
It's up to others to judge my work and decide whether it's innovative or not. I haven't been influenced by anyone or felt overshadowed; I enjoy myself and do what I want. I hope that at the age of 90 my answer to this will be the same.

How important do you feel it is to specialize in one area or genre of photography?
Commercially, it's important to specialize. It isn't possible for someone to master all genres; one has to decide based on what one likes. All the great masters of photography specialized in one area or another.

What distinguishes your work?
When I make images I try to do so honestly and follow my heart rather than the market. I don't believe that beautiful images can only be made by a set of rules. I don't hesitate to experiment or break the rules of framing or exposure.

As you have developed, how have you changed?
I get to travel a lot, meet people from all walks of life, and experience all that is beautiful. I have learned to see and appreciate what life has to give to us.

What has been the biggest influence on your development as a photographer?
The biggest influence on my development as a photographer has been my life and the universe that responds to me.

What would you like to be remembered for?

I would like to touch more lives through my work and share experiences and knowledge with those I work with.

Did you attend a course of study in photography?

I never received formal education in photography. I have worked with many people from photography schools in different parts of the world. Through my interaction with them I have noticed that the schools fail to teach students to experiment. I don't think many schools try to impart a vision that's open to learning or ready to question what is being taught. I believe that it's very important to see and experience how life pulsates in the universe before one can start making images.

How do you feel about the tremendous changes in photographic practice in the past 10 years? Have you benefited or suffered from the changes?

There have been great changes in the past 10 years and the shift from film to digital has been the greatest. The technological changes have only altered the means through which one's vision is realized. I follow my vision, so the changes haven't bothered me much.

Can photography make the world a better place? Is this something you personally work toward?

I believe photographers are making the world a better place. Photojournalists and war photographers show us atrocities. Documentary photographers and those at National Geographic make us more aware of our surroundings. Photography is one of the most powerful mediums of education, making the world more informed.

Describe your relationship with digital post-production.

I'm very positive about computers and in particular photography software because it has broadened our vision and allowed for immense creativity.

Could you work with any kind of camera?

At present I am using the Hasselbald 501CM and 503CW bodies with a Phase One digital back, and also the Canon 1Ds Mark III. I'm comfortable with any kind or make when it comes to cameras and equipment.

Finally, to end on a not too serious note, could you tell us what non-photographic item you find essential?

I always carry a book with me in my laptop bag to read during shoots.

behind the scenes

I wanted to shoot this Louis Vuitton travel story for Elle magazine in Hampi, in the Indian state of Karnataka. Encompassing the Vijaynagara Temple, it's a beautiful, very spiritual place, where one feels in sync with the surroundings.

07:30

07:45

07:30 After looking around the evening before I had decided I wanted morning light, so we arrived at the location early.

07:45 As it was an outdoor shoot in difficult terrain I took three assistants—all equipped with cell phones, which have revolutionized a photographer's life in such circumstances.

08:00

08:00 I wanted to create this story against a background of textured rocks, quite some way from our vehicles.

09:15 **After we set up the lighting,** I did a few test shots and made minor tweaks, using my assistant as a stand-in for my model, Smita Lasrado.

09:25 **I take any opportunity** I can to experiment, and here I considered using some colored gels.

09:45 **With Smita in place,** I tried three pale-colored gels that wouldn't affect the ambient lighting too much.

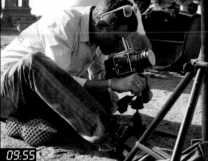

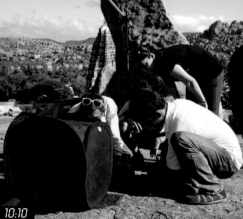

09.55 **I used a V system Hasselblad** with a Phase One digital back.

10:10 **The Lastolite Ezyview** tent enabled me to view the laptop screen shielded from the sun's glare.

10:15 **Malini Banerji, senior fashion stylist** from *Elle* magazine, helped Smita with her outfit.

10:25 **My assistant** held a card close to Smita's face to make focusing easier.

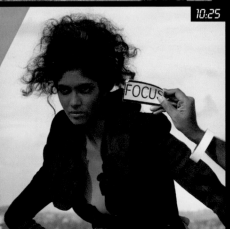

10:35 **Malini and Divya,** the make-up artist, checked the make-up, outfit, and hair to see if adjustments were needed.

10:45 **Deciding to abandon the gels** for another occasion, I started shooting in earnest. I had briefed Smita on the story I wanted and she took it from there.

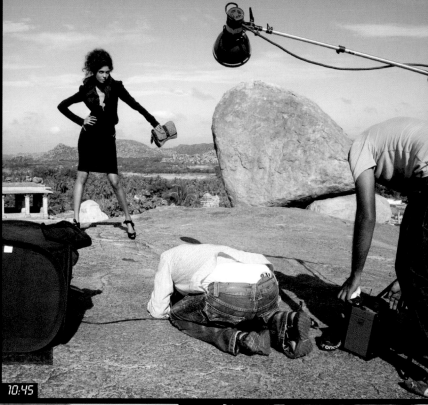

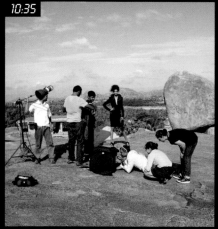

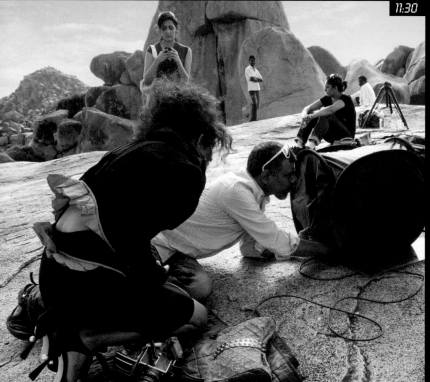

11:30 **I showed Smita the images** I had taken to help her improvise on her look and posture.

11:35 **I was happy with this shot**—the low viewpoint gave me plenty of sky and the pose was right.

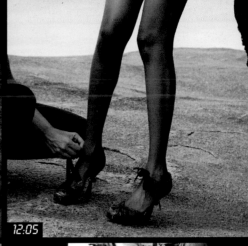

11:55 **For the next shot,** I wanted a natural surrounding that was minimalistic but dynamic, and this spot was ideal.

12:05 **Smita had changed into a different dress** and needed help with her shoes.

12:15 **I used a very low viewpoint** to make the most of the rocks and sky.

12:20 **A lamp fitted with a reflector** was angled toward Smita's face.

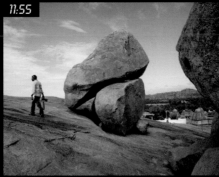

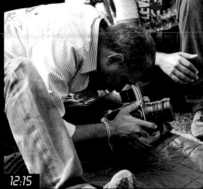

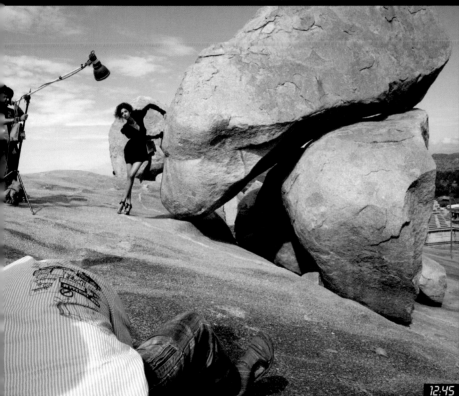

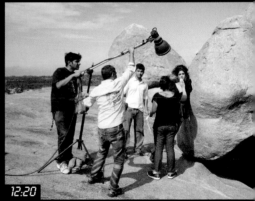

△ in **camera**

12:35 **I checked the direction** of the flash to make sure its light was falling on Smita in the way I wanted.

12:45 **For this shot,** I wanted Smita to strike a very graphic posture while taking minimum support from the rock. Once she understood the dynamism of her pose I left it to her to build upon it.

▶

07:30 **Next morning: I had explored some other locations** the previous evening but decided to return to the same place as it suited my intentions best.

07:50 **The crew gathered again** in the early-morning light, ready for another shoot—this time with Smita wearing even more dramatic footwear.

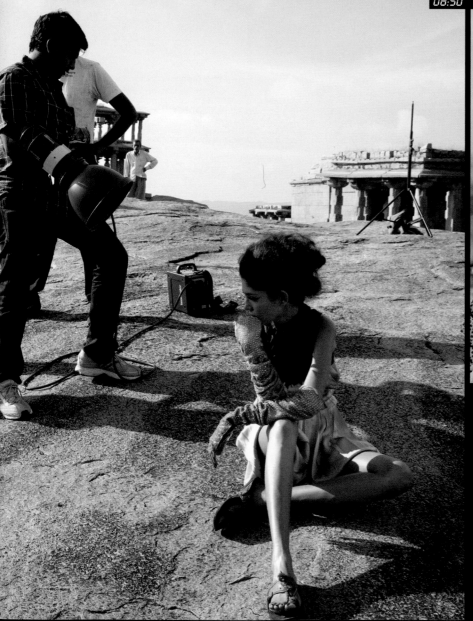

08:50 **Smita took the chance to relax** in comfy shoes while we were setting up the lights.

09:15 **Retouching the model's make-up** periodically is essential when shooting outdoors, especially in the heat.

09:50 **One of my assistants** took an incident light reading from Smita's face, using a Sekonic light meter.

10:35 **Given the rough terrain** and the height of Smita's heels, she needed some help to walk safely to a different spot.

11:35 **Using a low viewpoint again** to emphasize the length of the boots and set Smita against the sky, I shot a variety of poses.

09:50

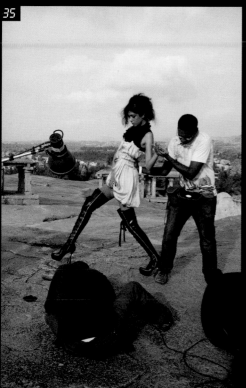

35

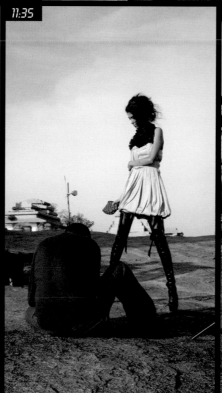

11:35

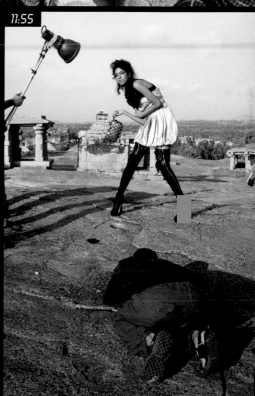

11:55

12:10

11:55 **Shooting stills is like capturing moments o**f a movie. As Smita continued to interact with the camera, I caught the mood and dynamic pose I wanted.

12:10 **Throughout the shoot** I used my 50mm lens on the Hasselblad.

△ in **camera**

portfolio

▷ **golden palace**

The location is the exotic Lake Palace in Udaipur, Rajasthan, India. I created this backlit image using only the available sunlight in one of the many beautiful verandas of the palace.

◁ **marching band**

This is from a story I did with *Vogue*, using the bandmen that are an integral part of an Indian wedding. They have a lot of character and charm. Everyone was lit with a single top light using a large Chimera softbox fitted with the Broncolor Pulso G lamp attached to the Broncolor Grafit A4 RFS power pack.

▷ **white silk and taffeta**

This image was created under mixed lighting conditions. The model was lit with both flash and continuous light. Shooting with a slow shutter speed as the model moved, the continuous light created the blur and the flash froze her movement.

tutorial: colorways

The fashion world did not take immediately to the introduction of color photography, since both the balance and accuracy of colors were unreliable. Paradoxically, now that we have access to highly accurate color, we distort it; and the impulse to turn color to black and white is never far away.

hymn to accuracy

Long before photographers discovered the necessity for color management, the clothing industry had fully mastered the art of controlling color with reliable accuracy. As a result, the fashion world was horrified by the poor reproduction of the colors of clothing in early color photographs. Color accuracy—ensuring that the hue and saturation seen in an image of a garment match that of the actual clothing—is an aspect of fashion photography often neglected by photographers. For magazine features, perfect color matching may not be vital, but for obvious reasons it is essential for catalogs and retail websites.

It therefore pays for a fashion photographer to attend to color on two levels. The first is the visually attractive, including factors such as whether the environment's colors conflict with or complement the clothing and model. The second relates to the technical accuracy of the color.

raw color

There are three elements to accurate color recording. The first is white balance—you should ensure that you take accurate white-balance readings from a well-made gray card. It also helps to take a sample shot of the card itself, or even a color target, in the lighting that you are using. Remember to reshoot the card if you change power settings on any continuous-output lighting. Accurate white balance gives you the best chance for simple color corrections.

The second is image data. Try to capture as much as possible by shooting in your camera's RAW format—in some cameras, color is captured at 12 or more bits per channel instead of the usual 8 bits. White balance is not fixed in RAW format, but shooting the gray card gives you an invaluable reference point for processing the RAW file.

over the top
Bright colors work best by themselves, so partner them with neutrals, like white. Here, fill-in flash has been used to remove shadows to reinforce the sun-filled, fun-filled look.

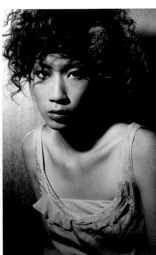

contrast and complement
Strongly colored backgrounds firmly set up a model, but may overpower the clothes. Pastel-shaded clothes call for soft colors, but may disappear into them.

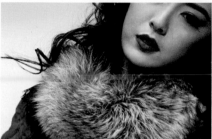

variations on one color

Red is a popular color for both backgrounds and clothes because the human eye and brain respond strongly to it. Notice how even a tiny area of red can help lift an image. Don't allow color saturation to be too vibrant, however. Red pixels have a tendency to spill over into adjacent pixels and cause an even wash of color that looks, and is, unnatural.

The third is an accurate profile for your camera, which helps extract an accurate processed image from the RAW files. This is obtained by shooting a test target, then analyzing the target to characterize your camera. From this a capture profile can be produced, using specialist software. It's not necessary to create a new camera profile for every change of lighting condition or lens; for all but the most critical work, a profile made in white light can be used widely.

let rip

With accurate color capture assured, you can concentrate freely on the usual flights of creative fancy. There is just one technical factor to observe: the color gamut of reproduction processes for print and online images is much less than that of clothing dyes, particularly for dark purples, blues, and bright yellows. Always try to shoot within the range of colors that can be reproduced accurately.

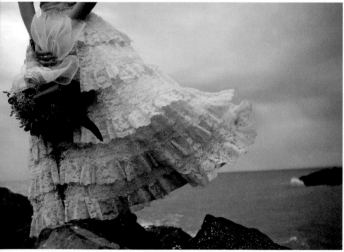

muted tones

The softest light of an overcast day is ideal for pastel shades, since everything is recorded in the mid-tones, which enables you to make fine adjustments of exposure.

color of black

For black clothes, strongly saturated flesh tones in hard lighting provide contrast while simultaneously showing off the color to perfection.

tutorial: light on the subject

Photographers are often glib about their craft being literally "writing with light." In practice, many fight with light, trying to force it to do their will, and never more so than when working with fashion and nudes. At its best, lighting is invisible: we see only the aesthetics of the shot, not noticing how it was achieved.

making light invisible

While photography begins with light, it does not end with it, but with the image. Great artistry is shown by creating images in which all of the elements meld together, function seamlessly, and—above all—do not call attention to themselves. Lighting effects can be exactly that: effects. Instead of revealing the contours or texture of a subject and its background, special lighting—such as rim lights on hair, or ring-lighting—produces a specific and recognizable visual signature. There is a place for them, but they are similar to filters in image manipulation: best when used very sparingly.

This is not a call to use only natural, sun-given lighting, but a warning that your images will benefit from lighting tailored to your subject and your visual intentions. If the setting is futuristic and glossily high-tech with muscular models, multiple spotlights with different colors will work well. While you could use the same lights on a pale, chiffon-draped waif if the art direction called for incongruous lighting (perhaps to suggest that the model had fallen into a strange world), it would nonetheless be a tough shot to make successful.

The issue is not about forcing conventions onto your practice, but recognizing that different modes of lighting carry emotional values. These arise from evolutionary processes—such as the survival value of recognizing dangers hidden in darkness—and a shared experience of light. For example, everyone associates light with warmth.

past associations

There is no right or wrong light, only lighting that does its job either quietly or with fanfare. To ensure your images are quietly lit, it's a good idea to start designing your shoot with no preconceptions. Until you have vast experience,

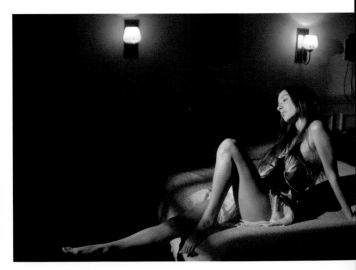

natural light
Sunlight is not only free, it is beautiful, but close attention to tiny details—such as the position of shadows falling over the model's face—is essential.

mixed lighting
Warm afternoon light from the windows may balance perfectly, in power and white balance, with room light, creating a warmly intimate atmosphere.

focus on technique: shaping with shadows

Large masses of shadow shape the features of a subject (**1**). Smaller shadows define textures: if they are tiny, the texture appears smooth, and as they become more visible, the texture is interpreted as being more rough. Shadows of this type are controlled by lighting, but there is another type—shadows that are cast on the subject by another object, such as netting or leaves, which delineate the shape of the subject (**2**). Keep the lighting diffused, or the objects some distance from the model to ensure you achieve sufficiently soft shadows.

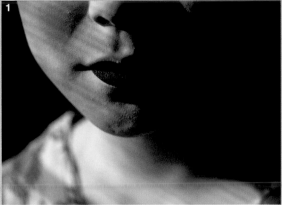

work with the simplest possible set-up: one lamp. You can vary its effect by attaching different light-shapers: obtain a hard, highly focused light by using a spotlight attachment, or use the soft, shadowless light from a large soft-box or light-diffusing tent. In between, large or small reflectors can be used to produce intermediate soft to hard light. Some photographers take an entire career to exhaust the possibilities of using a single light. And, of course, some achieve a great deal simply by making cunning use of only natural light. But there is also a secret weapon that makes the single light-source versatile: a reflector to fill in shadows.

reflecting glory

A reflector bounces light from the main source to divert light into shadow areas, bringing out hidden details. It's the single most cost-effective accessory. You can use a sheet of paper, a bedsheet, a piece of expanded polystyrene or other plastic sheet, or even your shirt. The more glossy or shiny the surface, the harder the quality of light that is reflected. If the surface is colored, it reflects a similarly tinted light. The more fully it is placed into the light-source, the more it reflects, and the closer the reflector is to the subject, the stronger the fill light (see also pp.118, 266–67).

one more light
The range of lighting effects available with one light (**above left**) is incredible, so adding another multiplies the possibilities to infinity (**above right**).

fun with multiplication
Multiple light sources bring multiple technical problems— such as white balance—that can be used to creative effect, but multiple shadows are usually best avoided.

image analysis

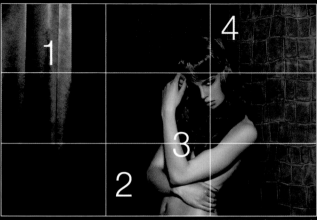

50mm ISO 200 1/60 SEC F/8

The maxim "less is more" is easy to say, but just as easy to forget. The natural urge to fill the frame with lots of interesting detail needs to be tempered with an awareness that space that looks empty can be full of suggestion.

1 active frame
The quietly repeated vertical folds of the curtain denote stability, suggesting columns holding up the space, while at the same time framing the rest of the image and offering textural contrast with the wall.

2 negative definitions
The large area of darkness—taking up almost one-third of the image—is not empty, but serves to define the shape of the model's body through contrasts of light with dark, and by setting texture against pearly smooth skin.

3 leading the eye
The model's arm—held in a natural gesture that leads the viewer's eye around the body to settle on the center of the image, the face—is also shaped like the corner of a frame, echoing the multiple squares on the textured wallpaper.

4 frames within a frame
The liveliest part of the image is the glossy hair that frames the face and upper part of the body. There are many layers of framing in this image, each leading inexorably to the model's face, lending coherency to an initially empty-looking composition.

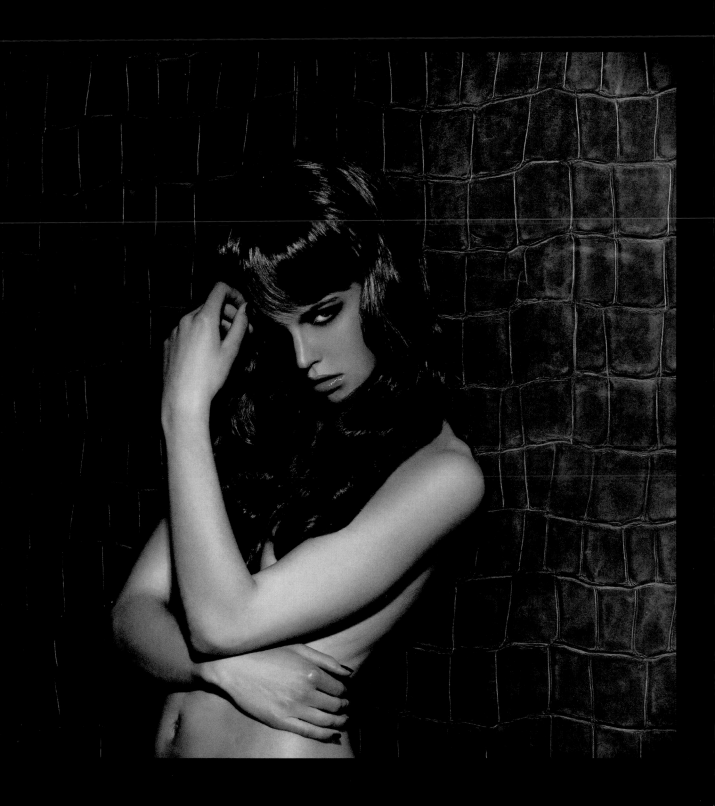

assignment:
gorgeous lighting

You could spend a lifetime discovering all the possibilities offered by a single subject lit by just one light source. You would essentially be exploring its intrinsic shadows—those cast by the subject on itself. But an even richer and more complex world opens with extrinsic shadows—those cast by other objects onto your subject.

the brief

Working with the human figure, and using a single light source (either natural or artificial), explores all lighting possibilities exhaustively. For variety, use objects, such as blinds, leaves, and paper cut-outs to cast shadows on the body.

bear in mind that the aim is to show the body to its best advantage: it doesn't have to be a standardly young, slim body, but can be of any age and any size or proportion.

try to capture individual beauty without turning it into a commodity that loses identity: choose lighting that makes the most of abstract qualities without hiding individual characteristics.

must-see master ▶

Lucien Clergue
France (1934–2014)

As a child Clergue witnessed his home town of Arles destroyed during World War II and his mother's death after a prolonged illness, so it's hardly surprising that his work is occupied with "death, life and a kind of no man's land in between." In 1953, he formed a life-long friendship with Pablo Picasso who, along with writer Jean Cocteau, encouraged the young photographer. Clergue is best known for his striking black-and-white nude studies.

career highlights

1957 Publishes *Corps Memorables,* his first book of nudes.

1969 Establishes *Recontres Internationales de la Photographie* at Arles, one of the world's most important art festivals.

2003 Receives Legion of Honor Award from the French government.

Nu zebra, 1997: Clergue returned again and again to images of the female nude. This shot, one of several with the same title, uses dramatic lighting to pattern the skin with zebra-like stripes.

think about...

1 sunlight and shadows
Leaves and sunlight make a versatile combination: use fill-in flash to avoid excessive contrast between highlights and dark areas.

2 halo effects
Similar to the reluctance to shoot into the sun, lighting from behind the subject is not popular, but it can give beautifully sculptural, filmic effects.

3 contrasts
Semi-hard lighting from a large reflector works well with dark skin as it enables glossy areas to shine against the deeply dark areas.

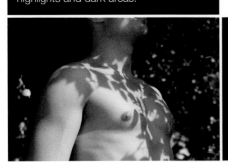

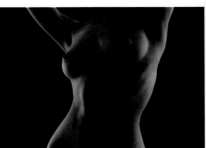

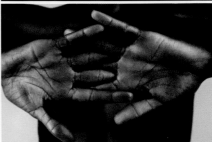

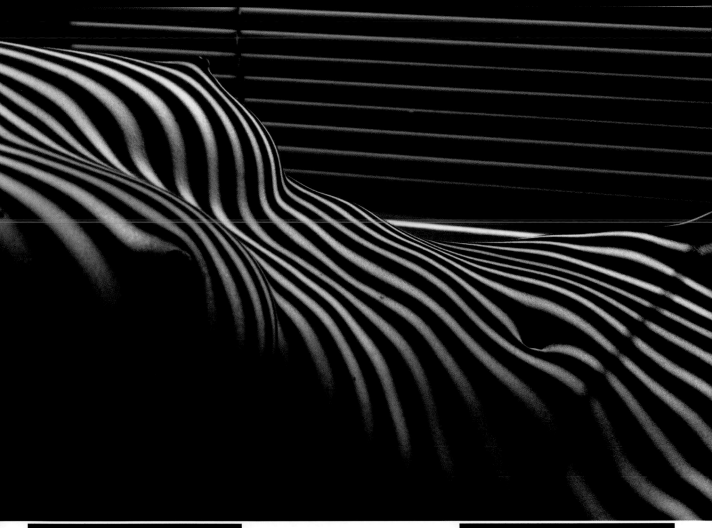

4 diffusion
Lighting and image details blend when both are diffused, hiding blemishes and smoothing tonal gradients—but this approach calls for well-defined shapes.

5 silhouettes
By reducing your subject to shadow, you work with its silhouette: try variations in focus and shooting through semi-transparent materials.

6 colored light
For color variation, place strongly colored gels over your lamp. Try only partially covering the lamps for two-color lighting effects.

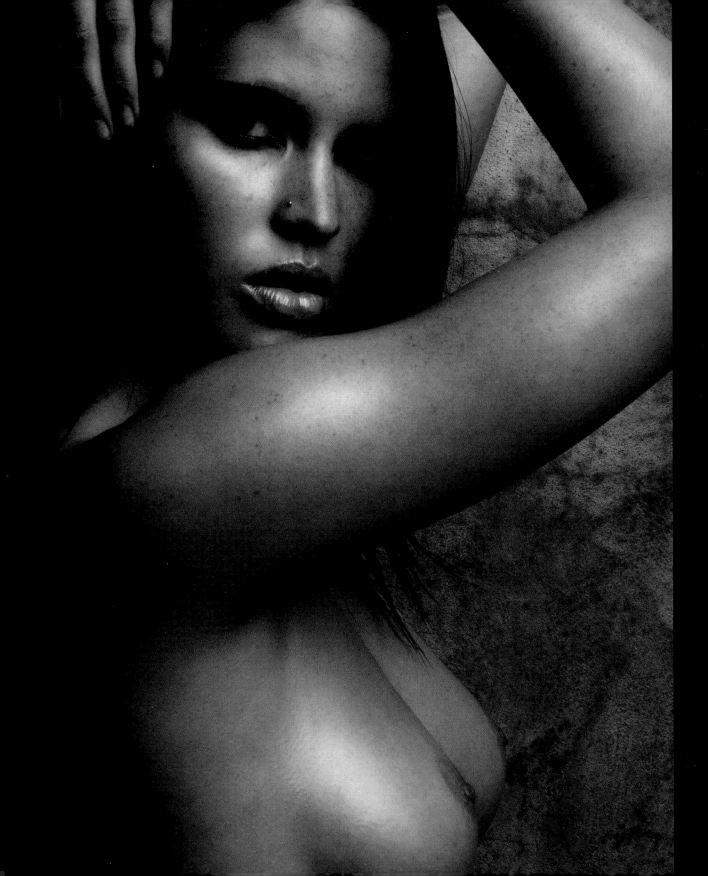

sylvie blum

Born in Austria, Sylvie was a model for 10 years before moving to the other side of the camera to become a photographer herself. She has had four books of her work published and her aesthetic style has been likened to that of Ansel Adams, Leni Riefenstahl, and Herb Ritts.

nationality
Austrian

main working location
Los Angeles

website
www.sylvie-blum.com

◄ **for** this **shot**

camera and lens
Nikon D2X and 80mm lens

aperture and shutter setting
f/22 and 1/250 sec

sensor/film speed
ISO 125

for the story behind this shot see over …

in conversation…

What led you to specialize in nude photography?
Before I started my career as a photographer I worked as a model with internationally known photographers. I always loved photography and it was natural to continue my passion for it behind the camera. To me, images of the nude body are timeless, and my goal is to create timeless art.

Please describe your relationship with your favorite subject. Are you an expert on it?
I like to play with female forms and as a woman myself I know the female body very well. I want to show it in a natural way with all its soft shapes, curves, and textures.

Do you feel you have succeeded in being innovative in your photography, or do you feel the shadows of past masters over you?
I have created my own style over the years—everyone who looks at my pictures will recognize it. However, I never stop learning new things to perfect it. I am influenced by many great artists and have had the opportunity to meet some incredible photographers.

How important do you feel it is to specialize in one area or genre of photography?
I focus on one genre at a time so that I can submerge myself in it until I am part of it; then I'm able to transform my vision into the desired image.

What distinguishes your work?
I think I have a gift for putting my vision, my style, and my inspiration into one image. It requires a lot of knowledge plus a sensitive eye to combine the light, the techniques, and the subject in a way that captures the moment perfectly.

As you have developed, how have you changed?
I gained a lot of experience and know how to use it.

What has been the biggest influence on your development as a photographer?
Living and working in Los Angeles. The city has its own tough heartbeat and is very challenging. It's great fun to be part of it by being successful.

What would you like to be remembered for?
As an attractive female photographer with a phenomenal body of work!

Did you attend a course of study in photography?

No. I was the muse and wife of the renowned photographer Günter Blum, from whom I learned all aspects of photography. After his death I organized exhibitions and publications of his work, so my life was steeped in photographic imagery. I also spent much time working in a laboratory learning darkroom techniques, which teaches you to look at your prints minutely for gradations of tone. You become very aware of the effect each of your lights is exerting in the image.

How do you feel about the tremendous changes in photographic practice in the past 10 years? Have you benefited or suffered from the changes?

I always enjoy new challenges—they open up great opportunities. I can't wait to embark on the next level of new technologies. However, the craftsmanship of the medium of photography never changes; you really have to know what you're doing and what result you want to get out of it. Technology only changes the path you travel to arrive at the desired goal.

Can photography make the world a better place? Is this something you personally work toward?

Absolutely—pictures are the visual ingredient in your life, just as music, wine, and food fulfill other needs.

Describe your relationship with digital post-production.

I have many computers and software applications. They belong to my studio, just as my traditional darkroom does. I regard them as my favorite toys and I can't live without them.

Could you work with any kind of camera?

I have my favorite equipment which is customized to my needs. Only the best is good enough.

Finally, to end on not too serious a note, could you tell us what non-photographic item you find essential?

My Dior lipstick.

behind the scenes

Ashley has modeled for me many times and is familiar with the way I work. I created a very flexible lighting set up because I wanted to focus on her movements rather than caging her in a fixed position.

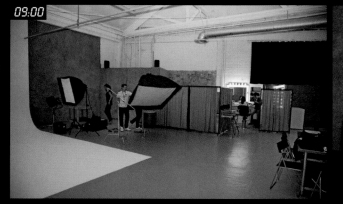

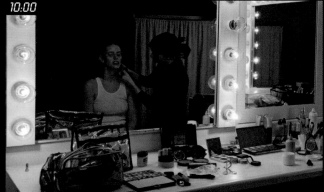

09:00 I decided to use a huge **softbox** for the main light, which could then be combined with a strip light, smaller softbox, or reflector.

10:00 Make-up artist Jennifer **Fiamengo** began preparing Ashley for the shoot.

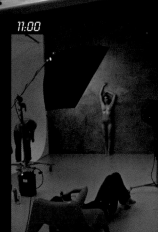

11:00 I started to explore angles from which to shoot some preparatory poses.

11:15 **Jennifer applied oil** to Ashley's body—I love to see the effect of light on oiled skin.

11:45 **When I saw Ashley** in the light I asked Jennifer to make a few small adjustments to her make-up.

12:00 **Ashley began adopting poses,** keeping close to the textured background.

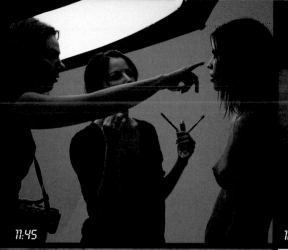

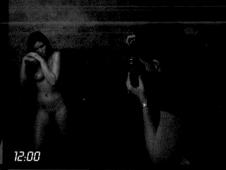

11:45

12:00

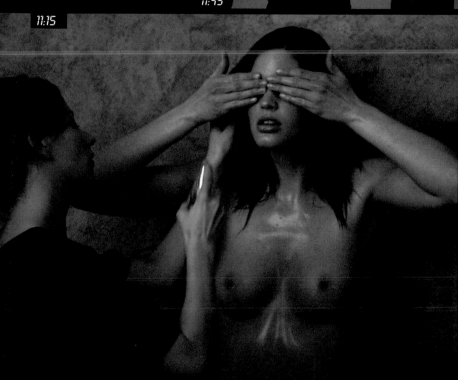

11:15

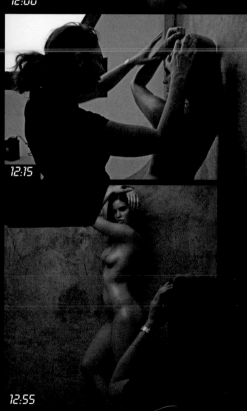

12:15

12:55

△ in **camera**

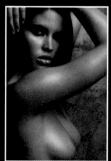

13:15

12:15 **I explained to Ashley** exactly how I wanted the pose to look.

12:55 **Ashley's raised and bent arms** give an angular geometry to the pose.

13:15 **I checked the pictures** on my camera screen to see if the poses worked well.

▶

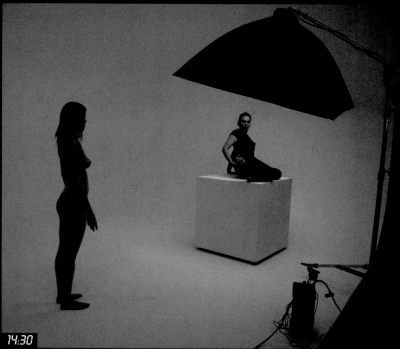

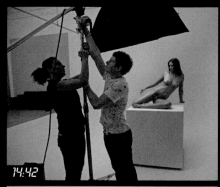

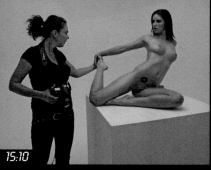

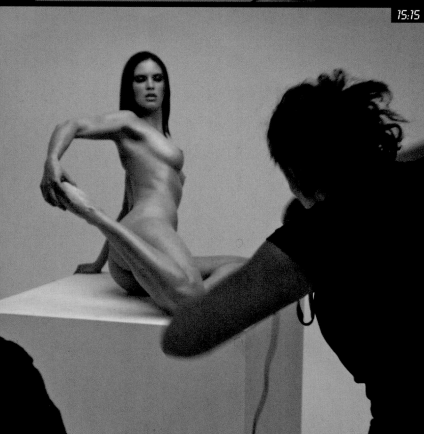

14:30 **As I used to be a model,** I often find it easiest to demonstrate the exact pose I want.

14:42 **With the help of an assistant,** I adjusted the position of the softbox.

15:10 **I showed Ashley** how I wanted her to position her hand on her foot.

15:15 **The pose was now composed** of extreme angles, making it very dynamic.

◁ in **camera**

15:55 **We started on a new pose,** with an assistant holding a reflector to bounce more light onto Ashley's body.

16:00 **A camera check** told me I had got the shot as I wanted it.

16:10 **Jennifer prepared Ashley's hair** for the final pose of the day.

16:00

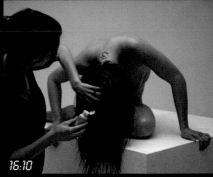

16:10

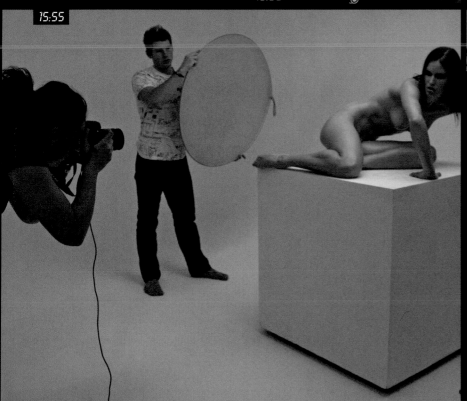

15:55

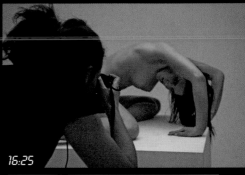

16:25

△ in **camera**

13:10

16:25 **This is a much more enclosed pose,** but it again has the angularity that I love.

17:30 **The shoot over,** I reviewed the day's images on the laptop to see what post-production work might be needed.

portfolio

▷ **Katja, 2008**
I wanted to do something different, so for this photograph I tried to find new angles, poses, or framings that would lift it above the ordinary nude study.

▽ **Sylvie's muses,**
Californian desert, 2008
This was one of the biggest shoots I've ever produced myself, so it wasn't just the big cats that made me nervous! I planned it for more than 4 years, traveling to South Africa to study big cats in the wild. It took me some time to find the right models, as the shoot was quite a challenge.

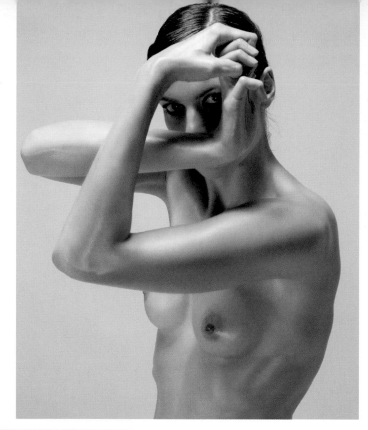

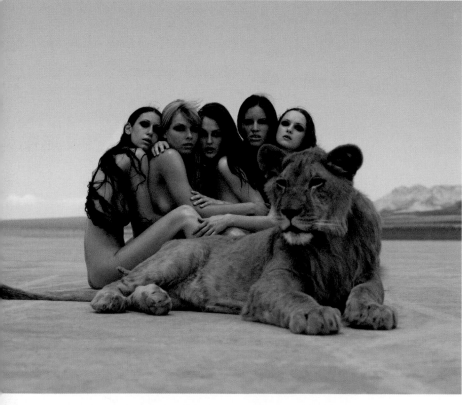

▷ **nude soup, 2006**
I wanted do a picture with big hair. I like this image because of the combination of forms and the unusual take on showing someone nude.

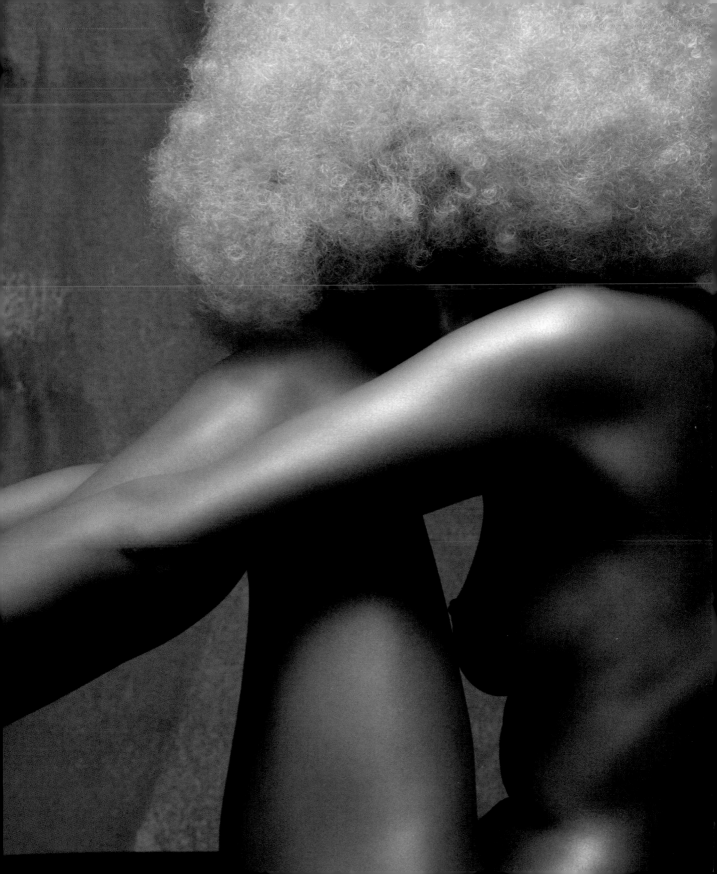

and
finally...

1 vivid vivacity
In the digital era, we can enjoy richer colors than ever before, so don't hold back—use color for its own sake.

2 whiter shades
You can turn images into subtly toned studies of form: reducing color strength increases textural richness, particularly when white garments are worn.

3 location light
Already operating in an unreal world, fashion and nude photography can exploit lighting to reinforce a sense of otherworldliness.

4 adventurous light
Defects in lighting, such as diffraction and flare, are usually avoided in other genres of photography, but can become striking effects in fashion shots.

5 simplicity
You don't need elaborate clothes, accessories, props, or sets to create a striking image—just a great model and a strong sense of style.

6 feel free
Anything in the armory of photographic effects can be exploited in fashion and nude photography if it adds to the glamour.

7 color process
Non-standard colors, or images that are processed to look like color film, create intriguing color worlds that imbue images with a touch of fantasy.

8 body contrast
The human form is extremely beautiful in itself, but can appear more so when contrasted with geometric forms.

WILDLIFE
AND NATURE
PHOTOGRAPHY

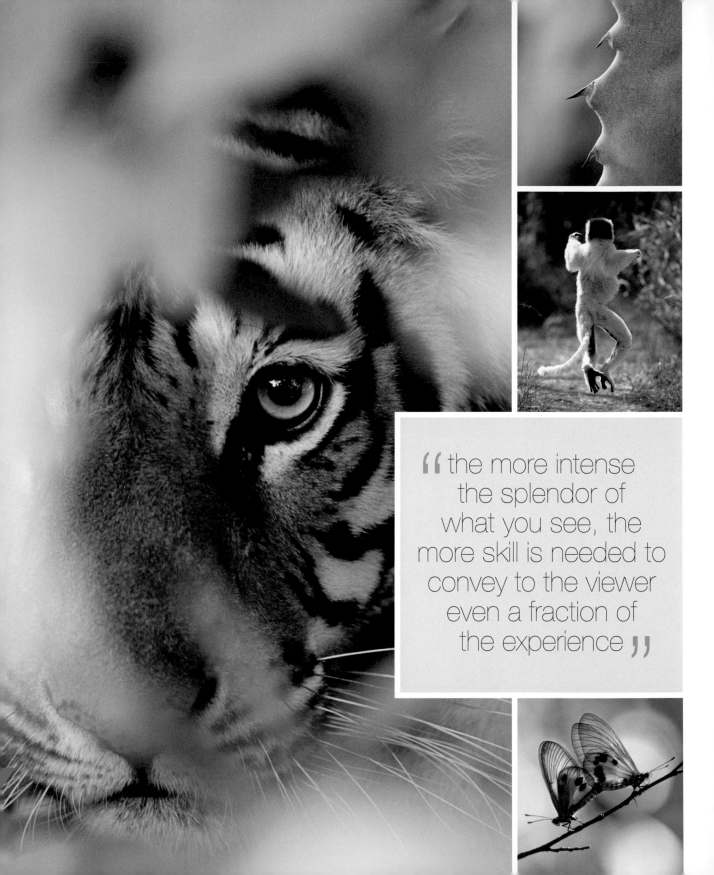

> **the more intense the splendor of what you see, the more skill is needed to convey to the viewer even a fraction of the experience**

Wildlife and nature photography has benefited from advances in modern technology, which have provided the means to produce the most stunning wildlife photographs ever captured. Tragically, the subjects for those images are dwindling, and wildlife photography is increasingly being used to highlight the plight of disappearing species.

Wildlife photography is at its zenith. Millions of photographers have discovered the joy of working in the wild, close to nature. And thanks to excellent modern equipment, many of them can produce images of a technical quality equal to the professional work of only a few years ago. More importantly, our exposure to nature via photography has generated a new level of awe and respect, and a sense of responsibility to the natural environment.

Approaches to photographing nature and wildlife tend to fall into two broad categories. You may take images in order to celebrate natural beauty or communicate the thrill of being close to wildlife. Or, you may engage with the issues around threats to the natural environment. Of course, the latter approach may produce images that look the same as those taken purely for their aesthetic qualities, but it can be far more rewarding to engage with the campaign for protection and conservation of the planet.

In this chapter we look at simple ways to make your images more striking and more effective at stirring the viewers' excitement with the beauty and diversity of life on Earth. It's easy to be so dazzled by the spectacle of animals fighting, or the gorgeous colors of a butterfly's wing, that you assume your image will capture it all. On the contrary, the more intense the splendor of what you see, the more skill is needed to convey to the viewer even a fraction of the experience.

One key element that can make a difference is the sense of scale. Many perfectly sharp and well-exposed images of animals and plants are little more than passport pictures, since we have no sense of size or distance. Failure to provide clues keeps the viewer on the outside of an image.

Another simple but extremely effective method of creating images with impact is by working with pattern. This applies to flowers, groups of animals, features in the landscape, and to movement. And while it's natural to concentrate on the subject itself, the astute photographer pays equal attention to the background: often it takes up the greater part of the image and it always creates the frame and context for the subject. Modern ultra-fast (large aperture) lenses have transformed our control of background while image manipulation can eradicate distracting highlights. Nonetheless, careful choice of background doesn't rely on mastery of equipment but on command of a few simple photographic techniques.

key moments

1840	**John Benjamin Dancer** photographs a flea using a gas-illuminated microscope.
1843	**Anna Atkins**' *Photographs of British Algae* is the first book to be illustrated with photographs.
1856	William Thompson takes the first **underwater photograph** of seaweed in the sea near Weymouth, England.
1872	*On the Expression of the Emotions in Man and Animals* by **Charles Darwin** features photographs by Oscar Rejlander.
1890	Étienne-Jules Marey's *Le Vol des Oiseaux* ("The Flight of Birds") records the first images of a **bird in flight**.
1906	George Shiras takes wildlife photos at night using **flash powder**.
1912	Arthur C. Pillsbury designs the first **time-lapse camera**.
1966	The prestigious **Wildlife Photographer of the Year** competition is launched.
1970	Stephen Dalton captures **insects in flight** for the first time.
1986	The first **weather-proof compact**, the Olympus Infinity, is launched.

tutorial: from scale to pattern

One of the miracles of nature is how it offers eye-catching visual banquets at every scale: from sub-microscopic insect parts, to millions of birds, or herds of wildebeest massing over hundreds of square miles. Capturing that sense of scale effectively can turn an average shot into something breathtaking.

amazing scale

Unlike the majority of other photographic subjects, our choice of viewpoint—and therefore our control of perspective—is limited with wildlife. For the most part, we are restricted to a flat projection because we have to photograph from a distance, either for our own safety or to avoid disturbing the subject. We can seldom get close enough to obtain intimate or dynamic perspectives.

What this means for our photography is that we need other ways to give variety to the depiction or articulation of space in our images. One approach is to work with scale. The fundamental ideas here are that an object overlapping another must be closer to us, and that if there are two objects of similar size, the one in the image that appears smaller must be further away. The overlapping "rule" enables us to show depth with small changes of scale while the larger variation in size helps the image to imply correspondingly larger spaces.

keeping your distance

By working with scale, you can overcome a common frustration in wildlife photography, which is not being able to get close enough. After all, it is only from a distance that you can show patterns of movement or groupings. And it only takes six flamingoes to form a line: all you have to do is wait for your subjects to get on with what they normally do. For example, flamingoes often feed in leisurely fashion several in a line: you can have a pretty good idea where they're going (and it's often the same route each day) and plan for when they will simply walk, on cue, into frame.

The further you are from your subject or the smaller it appears, the greater the number of animals you'll need for an effective pattern. That is why the reserves of the African

eye to eye
Close-ups of birds and smaller animals are obtained most easily with creatures in captivity. By filling the frame, the zoo environment becomes invisible.

blur and overlap
The three birds are the same size on the image, but their relative distances are obvious. Blur also carries distance information: the sharper parts usually look closer.

digital dark **room**: how far is too far?

Image manipulation ranges from bare-bones correction of exposure levels to the replacement of entire components of the image. For some genres of photography, such "improvements" are easy to accept: in commercial and advertising photography, for example. And in others, such as in news photography, "corrections" are tamperings with the truth. In nature and wildlife photography, purists condemn the removal of a twig from the scene. For others, pasting one animal into a scene it did not occupy is normal. This image of a leopard has been manipulated, and anyone who knows about leopards will be puzzled: normally it stalks through cover and does not give chase over open ground. In this image it is behaving like a cheetah. So if an image has been manipulated, at the very least, we should be told.

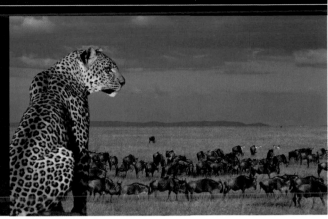

Rift Valley are so popular with photographers. The vast herds of animals on view offer a continuously shifting kaleidoscope of pattern. The key to an effective image of such subjects is patience. You will need to wait for the patterns to shift (sometimes watching through half-closed eyes helps reduce the visual overload) until visually it "clicks." This is usually when, momentarily, a symmetrical or regular pattern forms.

If the herd is large enough, you can capture effective images even with modest focal lengths. In fact, too much magnification only swaps detail for the sense of pattern.

monochrome work

The strongest way to convey the sense of a mass of animals and the patterns they create is by reducing elements of the image which do not contribute. Think of herds of zebra, or flocks of birds in flight or on a lake: you see a very limited range of hues. By working purposefully in monochrome or even in black and white you can improve the effectiveness of the image. The color dimension is reduced, which flattens the visual space and, in turn, brings out the pattern. Use your lens stopped down one or two stops for maximum sharpness and to

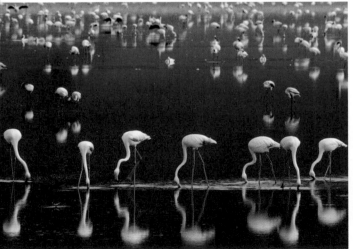

lined up
Careful observation of your subjects helps improve the chances of predicting their behavior so you can frame up and prepare for the shot.

massed groups
With an aerial view such as this, shoot many different scales to give yourself a wide choice later. It is difficult to be sure at the time which level of detail will work best.

give even illumination. Working in monochrome enables us to make use of abstract shapes and patterns. The abstraction can become an enjoyable visual puzzle, encouraging the viewer to study the image in order to make sense of it and identify the animal. In addition, abstraction allows the viewer to explore different aspects of the animal; if you don't show the usual identifiable features you offer something that is purely artistic.

Successful animal abstracts balance an absence of distractions with the presence of strong shapes or lively rhythmic patterns. The removal of distractions may stretch from working in black and white to obscuring unwanted details with mist, water-spray, or dust (see opposite). More subtle distractions include variations in sharpness, such as when the viewer sees blur where clarity is expected then the blur functions as a distraction. For example, if the stripes on a zebra appear soft—from falling out of depth of field or from movement—they interfere with the clarity of the pattern and distract the viewer. Highlights can be another source of distraction; that's why abstracts work best under flat or dull lighting conditions.

looking at the elements

One way to understand how to make successful images is to analyze the contribution of different elements in a picture. Each of the images of the wildebeest migration on the opposite page are all highly successful in their own way. All are shot from a distance, so perspective is flattened. One image (lower left) frames a long, winding line of animals in which the composition of repeated overlapping elements conveys a sense of depth and distance. But it suffers from stasis. In another image (opposite, lower right), depth is conveyed by varying clarity and color saturation: the image is almost entirely monochrome thanks to the dust, though it reveals just the key features—the outline of the animals. Again though, motion appears arrested.

The main image delivers a sweeping composition in the set of light-colored diagonal lines racing from the top to resolve into one strong line—full of movement—leading into the corner. Best of all, out of the half-concealing dust emerges one of the animals clear and sharp, contrasting beautifully with the rest of the pallid image.

natural patterns

As if made to order for black-and-white photography, zebras present a challenge to avoid the obvious. While the shot of a group of zebras lapping at a pool together (**above**) makes an attractive shot, the large image (**right**) needs more visual intelligence to understand. It is less obvious, and because we are sufficiently close to enjoy the subtleties of variation in shape and width of the stripes, it is more rewarding to view.

rhythm and motion

The dozens of wildebeest scrambling down a slope in these images create strong diagonal lines of movement while the dust simplifies shapes and colors. However, the single animal emerging on the left of the picture (**above**) is clearly a strong feature, while patterns can be used to mark out space in the winding line (**bottom left**). You can also make use of dust or mist to produce painterly effects by reducing image clarity (**bottom right**).

image analysis

16MM ISO 100 1/160 SEC F/6.3

This split-field technique works with the different refractive indexes of two disparate elements. Usually it is used to focus very near and distant objects. Here, Tim Calver brilliantly uses it to bring two worlds together.

1 bright skies

This image was taken while the photographer was free-diving off the island of Moorea (seen in the backgrond), near Tahiti. The subject is a juvenile humpback whale. The sky was burned-in a little to balance with the darker waters.

2 rays of light

A subtle but beautiful detail of this image is the fan of light rays, which appear to shine up from below. In fact, the rays of light are shining down into the water, and they are parallel but the projection of the wide-angle lens distorts them.

3 optimum distance

The whale is a juvenile who is at just the right distance from the camera to appear small against the islands. Whales of this age are usually very curious, so the problem is keeping them far enough away.

4 water flow

For this shot, the camera, equipped with a wide-angle lens, is held half out of the water. It's a matter of luck and skill that the water flow across the dome of the camera housing makes an attractive shape and doesn't obscure too much of the view.

assignment:
animal portrait

We know there is a big difference between recording the likeness of a person and capturing a quintessence of their character or personality. It's the same with animals: anyone can photograph the likeness of an animal, but to capture and convey a sense of its personality, its feelings, and its quality of life…that is a real challenge.

the brief

Carefully observe a wild animal in its surroundings in order to record a movement or a moment that shows its character, or capture something that comments on its environment.

bear in mind that, like human gestures, a revealing movement may be very small: a beak opening, a brief snarl, or a slight increase in tension in a tail or claw.

try to capture an emotion or a mood rather than a likeness. This usually means concentrating on essentials such as close crops with blurring of secondary information, or using space in your composition specifically to exaggerate proportions.

think about…

1 color and atmosphere
Cold colors convey a sense of the chilly world over which the owl presides. Use color and blur to set the mood even if it means loss of clarity.

2 less is more
The personality of a giant animal can be found in small but significant details, such as the eyes or mouth: search for key, telling features.

3 suggesting context
You do not need to show much of the animal's context but you need to convey some sense of the animal's mood, in this case its wariness.

must-see **master** ▶

Britta Jaschinski
Germany (1965–)

Britta Jaschinski was inspired to photograph animals in captivity when she discovered a zoo in Regent's Park, central London. Over three years she photographed animals in zoos using grainy black-and-white photography, which captured the discomfort visitors often feel when they see wild animals in artificial spaces. Along with her second book, *Wild Things,* Britta's raw, pared-down images portray the unhappiness of captive animals and her concern about the loss of their natural habitats.

career highlights

1990s Project documents the life of animals kept in captivity.

1996 *Zoo* published.

2003 *Wild Things* published.

2009 Wins Highly Commended in Wildlife Photographer of the Year.

Polar bear, 1993: This unhappy-looking animal was photographed in a zoo in Bremerhaven, Germany. The composition and absence of color add to the bleakness of the image.

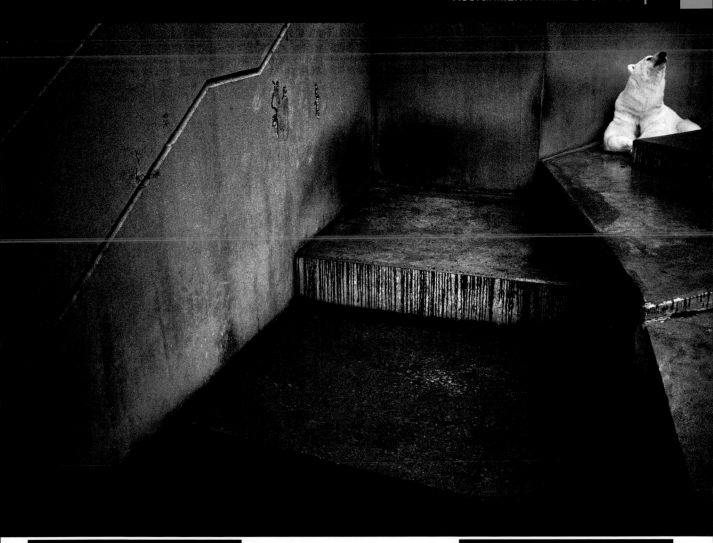

4 obstructed views
Make use of foreground foliage to give a sense of the animal's natural habitat. Use a long zoom and focus on the eyes.

5 captive subjects
You can photograph captive animals as if they are in the wild, or emphasize their caged state by focusing on details.

6 staying true
Beware of cliché. Big jaws or huge tusks can look terrifying even though they may belong to relatively docile animals, so how true is the portrait?

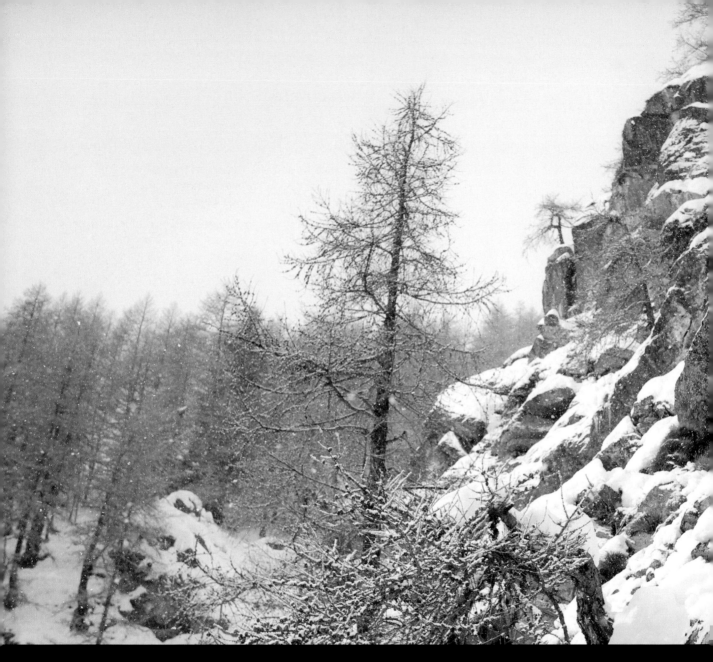

stefano unterthiner

Born in Italy in 1970, Stefano studied natural sciences followed by a doctorate in zoology before becoming a wildlife photographer and writer. His work appears in many magazines, including *National Geographic* and *BBC Wildlife*, and he is the author of five books

nationality
Italian

main working locations
worldwide

website
www.stefanounterthiner.com

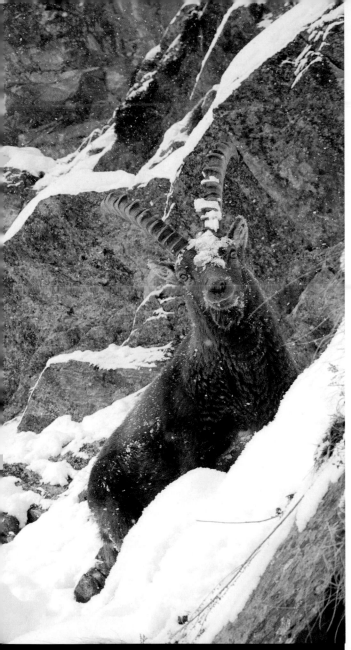

in conversation...

What led you to specialize in wildlife photography?
I started taking photographs locally in the Alps of the Valle d'Aosta when I was 17. My real passion was first for nature and photography followed. Photography was a means to spending time in contact with nature.

Please describe your relationship with your favorite subject. Are you an expert on it?
Before a project, I get as much information as possible. After months of work I develop an empathic relationship with the animals and I endeavor to respect them. The wellbeing of my animal "friends" always comes first.

Do you feel you have succeeded in being innovative in your photography, or do you feel the shadows of past masters over you?
It's important, if not essential, to know the history and work of past masters. However, I'd rather not reference their work because I must have my own style and path. I try to adapt my style to the subject in order to portray the link between the animal and its natural environment.

How important do you feel it is to specialize in one area or genre of photography?
It's essential: I admire others who can diversify, but rarely have I seen them produce good nature photographs. It's a specialized genre. You must be passionate about animals and nature and have an in-depth knowledge of the subject.

What distinguishes your work?
I enjoy capturing the relationship between a subject and its landscape, which helps to convey a conservation message. Sometimes we focus on protecting a species, but we forget that we need to protect its habitat, too. I also like to shoot behavior or action pictures with wide-angle lenses, because it gives the impression that you're right in the middle of things. The viewer enters the animal's world.

As you have developed, how have you changed?
I haven't changed a lot. When I was young I'd go into the mountains and dream of being a photographer. Today I do exactly what I love most. But with time my priorities have changed. Now I want not only good pictures but also ones that tell a story focused on ecological themes. I work on

▲ for this shot

camera and lens
Nikon D3 and 24–70mm lens

aperture and shutter setting
f/6.3 and 1/1600 sec

sensor/film speed
ISO 400

for the story behind this shot see over ...

conservation issues, denouncing abuses of nature and reporting on animals at risk of extinction. Conservation photography is the main focus of my work today.

What has been the biggest influence on your development as a photographer?

None in particular. Every day working on location and liaising with other photographers, I come across trends and developments. One should always endeavor to grow, improve, and experiment.

What would you like to be remembered for?

For my love and respect for nature and animals. These are the values that I have tried to communicate through my work. Nature is beautiful and I try to show it to others.

Did you attend a course of study in photography?

I am a self-taught photographer and learned through trial and error, but my doctorate in zoology helped me turn my passion into a profession. To be a nature photographer, you don't need a degree, but it's essential to have a good knowledge of the subject and of the biology of a species.

How do you feel about the tremendous changes in photographic practice in the past 10 years? Have you benefited or suffered from the changes?

I'm happy. Digital photography and new technology have given photographers fresh perspectives and new possibilities and this all helps with creativity and innovation.

Can photography make the world a better place? Is this something you personally work toward?

It may not change the world but it may change people's ideas. I hope my work helps humanity get closer to nature. With better understanding comes greater respect.

Describe your relationship with digital post-production.

Computer and software applications are part of my job. I try my best to work with them. They are, however, the most difficult and boring part of it.

Could you work with any kind of camera?

I could get good shots with a camera of any make. A photographer "sees" regardless of the equipment being used, but I've been working with a Nikon for more than 20 years and have developed a perfect relationship with it.

Finally, to end on not too serious a note, could you tell us what non-photographic item you find essential?

My travel alarm clock: it's indispensable when I want to get to work at dawn.

behind the scenes

Winter is the mating season for ibex so it's an ideal time to photograph them. I love working in these mountains when they're covered in snow. Packing the right equipment is essential, while taking care not to overload myself.

07.30

08.30

07.30 I considered taking my 600mm lens, but decided against it. Because the ibex are tame enough for a photographer to get quite close to them, it wasn't worth carrying the extra weight.

08.30 Italy's Gran Paradiso National Park is only an hour's drive from my home—a relatively short journey when it comes to wildlife photography.

10:40 Even with no wildlife in view, the valley and the light made a wonderful shot.

10:55 I climbed further up the mountain, heading for where I thought I might find ibex.

11:10 A good pair of binoculars is essential on a shoot such as this, where the animals are well camouflaged.

10:55

11:10

10:40

11:20

12:15

11:20 I walked with my camera at the ready—a wild animal won't wait while you put your bag down and get your lenses out!

12:15 My luck was in—I spotted an ibex and focused my 200–400 zoom lens, which was protected by a Tenba waterproof cover over a camouflage lens cover.

`12:20`

`14:08` **Eventually the ibex moved** into a better position and I swapped the long lens for a 24–70mm zoom.

`14:15` **I had the chance** for some extra shots before he moved away.

`14:25` **Now that I'd got the shot** I wanted I could stop for refreshments.

`14:08`

`12:30`

△ in **camera**

`12:20` **I hadn't taken a tripod,** trying to keep equipment to a minimum. My camera bag made a useful support instead.

`12:30` **I realized I needed to move closer,** but there was a dangerous slope to cross and the ibex retreated as he saw me trying to approach. It was hard to get a good angle and I wasn't happy with the shot that I got (left).

△ in **camera**

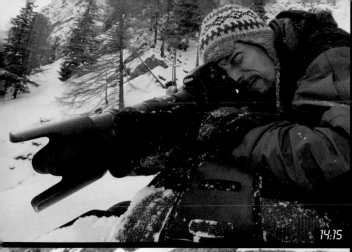

14:15

14:25

14:40

15:00

14:40 **A final review of my photographs** told me I could now pack up for the day.

15:00 **The long trudge back to the car** seemed shorter for knowing I hadn't had a wasted trip—you can't always rely on the animal you want turning up at all!

18:00 **Back in my studio,** I could begin on the post-production work.

18:00

portfolio

▽ **brown bear**
On a misty morning in August, a young brown bear walks in the Finnish taiga. I spent several months photographing the bears, trying to capture the beauty and mystery of these shy creatures.

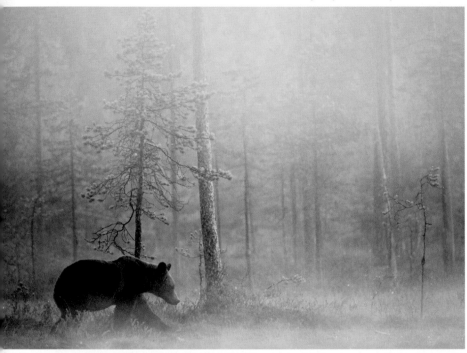

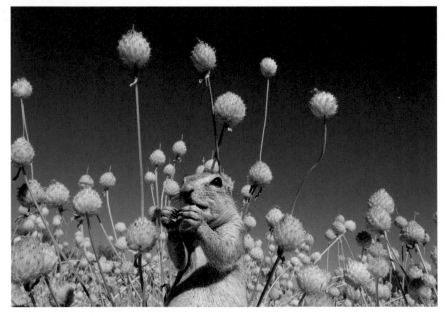

◁ **ground squirrel**
Working conditions were tough on this shoot in the Kalahari Desert in South Africa. During the day the temperature rose to 104°F (40°C) and at night it dropped to -14°F (10°C). But the main problem was the wind—sand was blown everywhere.

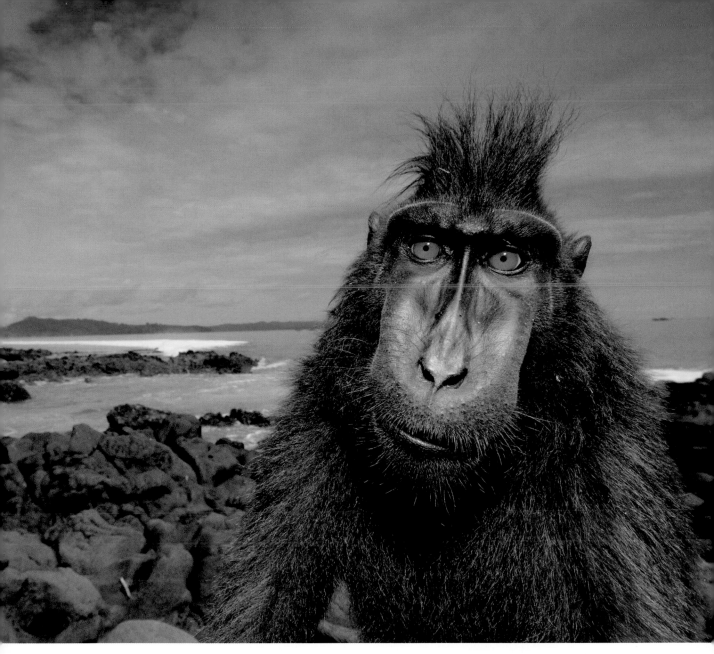

△ **troublemaker**
This black-crested macaque in Sulawesi is a young adult, and—like many young humans—he is up for troublemaking. To get this close-up shot I had to put up with him leaping around all over me.

tutorial: tuning the background

Think of a backing group for a singer or instrumentalist. They need to be in tune and in time, lively but not too prominent or they will take attention away from the soloist. The background in a wildlife or nature shot needs to work the same way, adding to, not detracting from, the subject.

tuning controls

In wildlife and nature photography, your skill with the background for your subject is of almost equal importance to your choice of subject itself. Indeed, a stunning background can turn an image of a common animal into a striking, prize-winning shot.

Your control extends over three dimensions of the image. First, of course, is your choice of background: you can choose to show that the animal is in a zoo or try to be ambiguous about the context. There may be some obvious limits—a picture of elephants against the sky calls for you to be at their feet—but that unusual angle is exactly where the prize-winning picture will come from. In general, busy, or active backgrounds can only work if their details are not too clear.

The second dimension follows from this: you can control depth of field. This is a function of three inter-related factors: your choice of focal length, your working distance and, of course, the working lens aperture.

perspectives

While lenses such as the 400mm f/2.8 or 600mm f/4 give you a combination of high magnification and minimal depth of field, they are bulky and expensive. If your long lens is not fast, you can obtain a narrower depth of field by getting as close as possible to your subject. If your lens is not at its sharpest at full aperture, it's worth shooting at full aperture with a view to sharpening in post-processing—it's easier than trying to blur a background that's too sharp.

third dimension

The third dimension of control is easy to use and very powerful—you simply vary the exposure. This controls the brightness of the background relative to the subject, which

black is beautiful

For close-ups of small animals, a black background—usually as a result of using flash to expose only the foreground—shows the subject off to perfection.

maximum for minimum

When you set maximum aperture, not only does the background blur nicely, you can set a very brief exposure time. Here, it's needed to catch sharp images of the water spray.

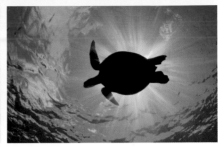

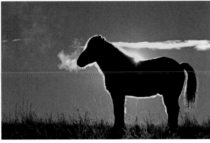

backlighting

A simple rule for exposing plain backgrounds such as mist or sky is whether there is some color: if there is no color or it is very pale, your exposure is too high. It is better to err on the side of too little exposure. Reduce exposure with shorter exposure times: if you stop down the aperture, depth of field may increase too rapidly. Shorter exposures also have the benefit of freezing action effectively.

in turn affects the way you shoot and time your shot. The easiest strategy is to set a strong under-exposure: this can create silhouettes even when your subject is not lit from behind, particularly if it's against the sky or another plain background.

By the same token, deliberately over-exposing allows the background to burn out to a featureless white. This can deliver detail even in back-lit subjects. It is

in effect the technique used to create studio portraits: the backgrounds are strongly lit so that they are over-exposed when the subject is correctly exposed.

If you're not sure which exposure is best, shoot the subject in RAW format, which allows the most scope for working in post-processing. Of course, it's worth bearing in mind that the correct exposure is the one that you don't have to adjust at all later.

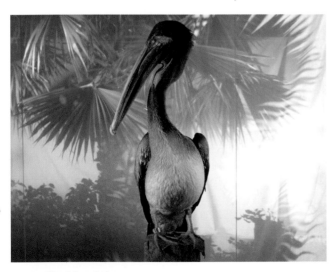

controlled backdrop

Studio-based portraits needn't be against plain backgrounds. Here, a gauzy screen softens what would otherwise be obtrusive detail competing with the pelican.

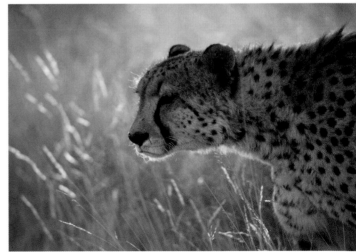

blur the highlights

The brightly-lit grasses in the background could have been very distracting, but their impact has been reduced by the strong blurring from reduced depth of field.

tutorial: miniature worlds

Nature offers glorious riches at every scale. Even the tiniest plants and animals can lead us into fascinating new worlds. And, as the smallest scale is outside the scope of everyday experience, it appears new and intriguing, though it lies at our feet, unnoticed when we pass it everyday.

appeal of the ordinary

Many of us dream of a wildlife safari unaware that rewarding nature photography can be found nearer to home. An overgrown suburban back yard may lack the glamour of exotic lands, but getting close to the subject means that the rest of the environment doesn't matter, for what is out of shot is out of sight.

Much of this miniature world lies at ground level. A camera with a tilting screen, so that you can hold it low down but still look at the LCD screen, makes this type of photography more comfortable. Set the mid-range of focal lengths to provide the working distance you need; the longest focal lengths hamper close-up focusing.

the gift of light

There is less wind low to the ground so your subject is unlikely to be blown around. You can stop movement in the subject by using flash. This also takes out more of the

moving magic
Motion blur is best shot against a dark background, which brings out even pale colors, and it is most effective when accompanied by some strong shapes.

background by throwing it into darkness. For the best results, use a flash-unit that can be set to one side of the subject, or placed very close to the lens. Specialized macro-photography flash-units allow you to vary the position of the units and balance their effects.

If you don't have flash, you must wait for the light to come to you. On a morning after a night of light drizzle the uncut grass will glisten with hundreds of beads of light. A morning light often illuminates a spider's web to perfection: move around it to find the right angle. Experiment with different focal lengths from the same

focus on technique: photomicrography

The ultimate miniature subject may measure only a fraction of a millimeter and be visible only under a microscope. Thanks to the inexpensive optics now available, the microscopic world is open to amateur photographers and naturalists. If you want to make a different kind of image from the billions that populate photo-sharing sites, purchase a microscope with an adaptor for your camera. Suitable subjects are no further away than your nearest pond, or park. Many specimens (**1**) don't need preparation though they will need to be killed if active, or you can work with still objects such as microscopic plant life or spores. Remember to light your subject too. For views that look through the specimen (**2**) a little simple laboratory preparation by setting the subject onto a glass slide, will make it translucent.

viewpoint: narrower views—from longer focal length settings—tend to concentrate on the lighting effect but the depth of field will also be narrow.

It's worth trying out widely varying exposures in these situations because very often a greatly over-exposed image can be as effective as an under-exposed one. As you frame your subject, try to imagine what it would look like if all the shadow areas were mid-tone or higher. Or imagine it with only highlights visible.

To train yourself, use bracketing exposures. A good range to set uses two-stop steps: one is over-exposed two stops, the next is normal, and the next is under-exposed two stops.

apertures and highlights

A crucial aspect of working in miniature is your handling of highlights (see p.36). When highlights are out-of-focus, they form blur spots whose shape depends on the physical

art in miniature

Your subjects might be in your nearest potted plant. Watch the light at different times of the day and in different seasons, experiment with fine sprays of water—the closer you look, the more you will find.

shape of the aperture in your lens. In many lenses, it will be a rounded pentagon, or hexagon, or an irregular shape. The best shape is perfectly round, obtained only at full aperture or, when stopped down, only in the costliest of lenses. Examine any highlights in your image with as much care as the main subject, as misplaced highlights are extremely distracting. If using a dSLR and not working at full aperture, study the stopped-down image with the preview button to see what the highlights will look like.

The quality of the out-of-focus blur can be important. For the best results, aim for any blurs in the image to be smoothly graduated. Some of the smoothest blurs come from macro lenses, which are ideal for this type of work.

image analysis

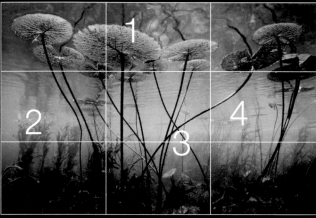

24MM ISO 200 1/30 SEC F/16

Eerily otherworldly yet beautifully poised, this image by Frans Lanting brings together the best that nature photography can offer. It opens our eyes to the unseen with a breathtaking ballet of light and lean forms.

1 back-lit details
Bright light from overhead penetrates the leaves to bring out both their color and structure. Thanks to reflections from the under-surface of the water, there is also color in the background, contradicting our usual experience of back-lighting and heightening the ethereal atmosphere.

2 distance perspective
The soft outlines and contrast of plants that are actually not very far away give the sense of greater distances, and disturb our sense of the proper scale of the image. Are these gigantic leaves or only hand-sized?

3 calligraphic lines
The clean lines of the stems, all equally sharp, are graceful and rhythmic, articulating the space into neat portions like irregular frames. And, of course, they contrast with the softness in the rest of the image.

4 graduated tones
The background is a perfect gradation from blue-green at the top through yellow to dark greens at the bottom, setting off bright leaves to dreamlike perfection.

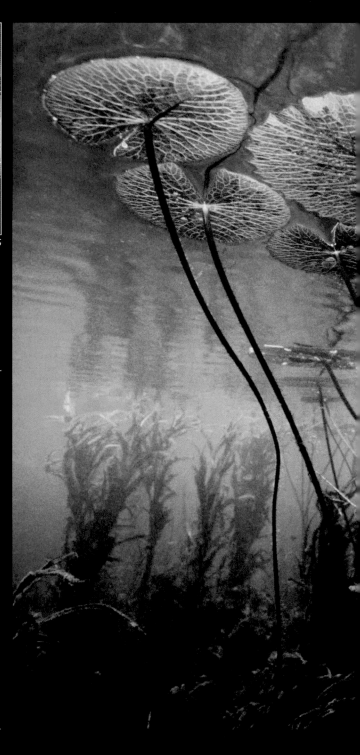

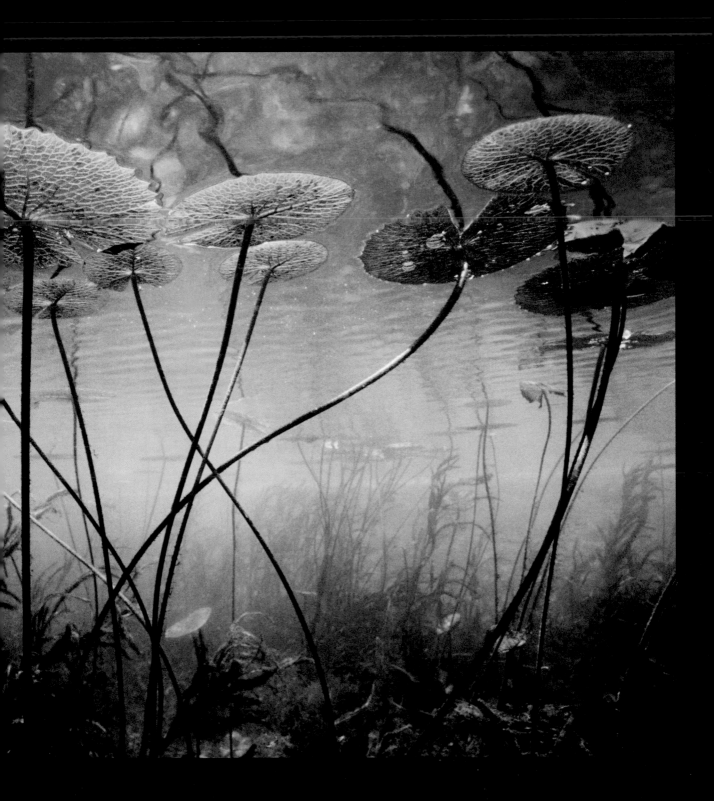

assignment:
dramatic close-up

Not long ago, getting close enough to an insect or plant to fill the frame was a technical triumph. Now that is commonplace, so your challenge is to capture more than the subject and convey more than the appearance. The more background you know—biology, behavior, threats to environment—the more you can put into the picture.

the brief

Capture a close-up view (half life-size or larger) that shows the beauty and intrigue of wildlife and nature on a small scale. Try to convey drama though light and composition and, if possible, an element of the struggle between life and death.

bear in mind a long focal length lens (100mm or greater) makes it easier to magnify the image while giving enough working distance to avoid disturbing the plant or animal. Use flash, preferably from the side or in a ring around the lens, for the sharpest image.

try to capture striking lighting effects such as glistening surfaces and contrasts of dark and light—these help to enrich colors.

think about...

1 a bug's life
Battles for survival and life and death scenarios are played out in miniature all around us all the time—you don't need to go on safari to observe nature in the raw.

2 tricks of light
Strong lighting effects such as bright colors against dark backgrounds are the best ways to show off the rhythm and patterns of natural forms.

3 water colors
Close up, water droplets become objects of beauty in their own right. Try under-exposing to improve contrast and to deepen colors.

4 distant context
Backgrounds not only help to place the subject, they provide effective visual contrast. For a wide-angle view, the lens must be almost on top of the subject.

5 micro view
The closer you approach your subject, the greater the abstraction of the image. Try techniques such as side-lighting to create more unusual images.

6 plain view
If you choose to show your viewer everything, the image may be useful for identification, but there's no mystery to reveal or tension to resolve.

thomas marent

Born in Switzerland in 1966, Thomas began his photographic exploration of the world's rain forests in 1990. The first of his books, *Rainforest*, was published in 2006 and has since been translated into 13 languages in 25 countries.

nationality
Swiss

main working locations
worldwide

website
www.thomasmarent.com

▲ for this shot

camera and lens
Nikon D3 and 105mm lens

aperture and shutter setting
f/19 and 1/90 sec

sensor/film speed
ISO 500

for the story behind this shot see over …

in conversation…

What led you to specialize in wildlife photography?
Since childhood I've been fascinated by wildlife. I started to observe the birds, amphibians, and insects around my village. I was always different from my schoolmates, who were more interested in sports, cars, and girls.

Please describe your relationship with your favorite subject. Are you an expert on it?
I have many favorite subjects, such as the rain forest. I'm always thrilled by the endless beauty you can find there. If I focus on a subject intensively I forget everything around me and merge with the theme I am working on. I am not an expert on one specific subject, but as a wildlife photographer you have to know about the habitat, behavior, and biology of every subject you photograph.

Do you feel you have succeeded in being innovative in your photography, or do you feel the shadows of past masters over you?
It was never my purpose to be innovative, but I feel I've succeeded in the way I wanted to succeed. I'm grateful to have been able to take so many beautiful pictures that have touched people.

How important do you feel it is to specialize in one area or genre of photography?
Nature photography has always been my favorite genre. As long as you photograph your genre with all your passion it doesn't matter if you specialize in one or more areas.

What distinguishes your work?
Compared to most other wildlife photographers, who go for the big and most popular animals, I also like to show people the smaller animals, very often including unknown species. I try to focus on details.

As you have developed, how have you changed?
The difference is that now I have to make a living as a photographer, while before it was my hobby. I believe that nature photography is the most difficult genre from which to earn a living.

What has been the biggest influence on your development as a photographer?
The time I have spent immersed in nature.

What would you like to be remembered for?
I'd like to be remembered as a photographer who created images that inspired people to develop a love and appreciation of nature.

Did you attend a course of study in photography?
No, I am a self-taught photographer.

How do you feel about the tremendous changes in photographic practice in the past 10 years? Have you benefited or suffered from the changes?
The change to digital photography was very significant. For wildlife photographers especially it has brought benefits, but disadvantages too. In my opinion, the benefits are that it's still possible to shoot with natural light in very low light conditions, yet now you can shoot as many images as you want and see the results immediately. You don't have to send the original transparencies to publishers any more because there is an easily duplicated digital file of every image. The disadvantages are that since digital photography has been introduced almost anyone can take correctly exposed pictures without a knowledge of photography and without much effort. Because of this there are now countless images available to buy online, which makes it more difficult for professionals to sell their images. And with the possibilities available today to digitally manipulate a photograph, you can't be sure any more if an image has been faked or not.

Can photography make the world a better place? Is this something you personally work toward?
With my images I want to remind people of the beauty of nature.

Describe your relationship with digital post-production.
It's just a necessary tool. I prefer to work outside in the field but I also enjoy looking at the image on the screen at home.

Could you work with any kind of camera?
I work with a Nikon camera but I could equally well work with a Canon.

Finally, to end on a not too serious note, could you tell us what non-photographic item you find essential?
Mosquito repellent!

behind the scenes

In a rain forest I'm confident there'll be plenty of small creatures to photograph, and this area of Cambodia, about two hours' drive from Phnom Penh, didn't disappoint. It was a bright, sunny day, and very hot and humid.

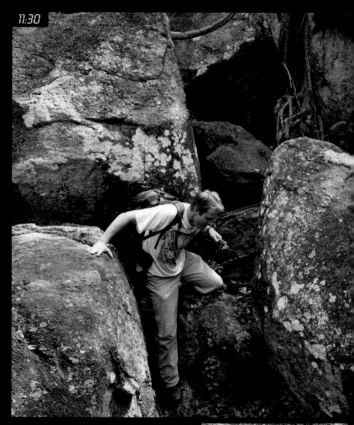

11:30

11:40

11.30 **I had to scramble** over some difficult terrain to get deeper into the rain forest.

11.40 **Even as I climbed I kept an eye out** for any rock-dwelling creatures.

`12:00` `12:20`

`12:45`

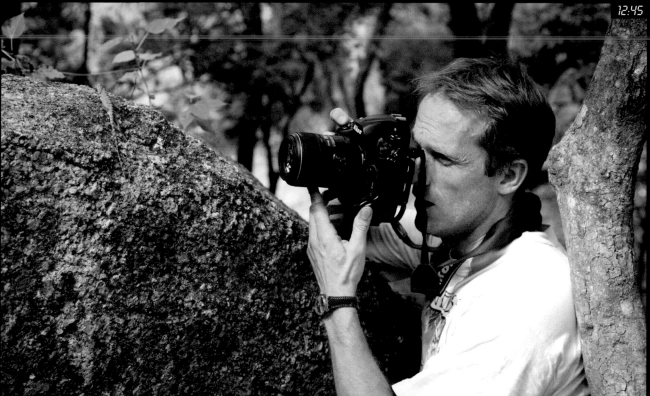

`13:00`

△ in **camera**

`12:00` **Deeper in the forest,** I found interesting vegetation that would harbor small creatures.

`12:20` **I set down my gear** and got ready to begin shooting.

`12:45` **I had to wedge myself** between the rocks to shoot a lizard I had spotted.

`13:00` **Checking the camera,** I could see I had a shot I was happy with.

▶

13:30 **Finding two attractive red beetles,** I asked my assistant to hold the reflector to shield them from direct sun.

13:40 **The beetles moved** into an area of dark shade, so I fitted softboxes to two flashguns to introduce diffuse artificial lighting.

14:00 **I was now equipped** to shoot in even the darkest conditions.

▷ in **camera**

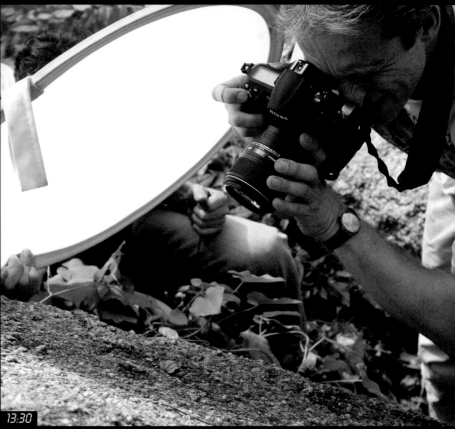

13:30

13:40

14:00

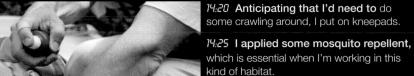

14:20 Anticipating that I'd need to do some crawling around, I put on kneepads.

14:25 I applied some mosquito repellent, which is essential when I'm working in this kind of habitat.

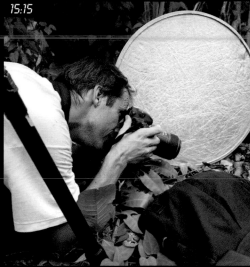

△ in **camera**

15:00 I spotted a frog on some vegetation and tried several angles, but I had to move the frog to ground level to get a decent shot.

15:15 A silver reflector helped to light up the darker conditions on the forest floor.

portfolio

▽ **leaf-tailed gecko**
The fantastic leaf-tailed gecko is almost invisible among the leaf litter on the forest floor of its native Madagascar. As you might imagine, it took me a long time to find this one.

▷ mushroom parasols
The natural design of some fungi can be astonishing, especially when backlit like this. I photographed these mushrooms in Manu National Park, Peru.

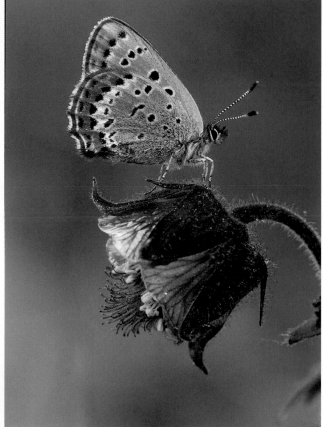

△ butterfly wings
Perched on a water avens, this violet copper butterfly sits with its wings closed—typical of a butterfly at rest. I used a very shallow depth of field and a wide aperture to pick out the butterfly and flower without a distracting background.

and
finally...

1 up- and down-scale
Work at every scale available to you. The patterns created by massed animals are as beautiful and intriguing as an individual portrait or detail.

2 know your subject
Learn as much as possible about your subject and observe it closely in the field: the more you know, the better you can predict behavior.

3 close in
Get close and closer still to explore, and then capture, the beauty of abstract patterns and colors.

4 whites
Experiment with different exposures such as nearly white: not every subject is best represented at normal exposure levels.

5 gorgeous grays
By converting your image to black and white, you will often reveal details in texture that were lost in the color original.

6 avoid the bait
The temptation to put out bait to attract animals is strong, but it distorts natural behavior and may cause them to become dangerously unpredictable.

7 long distance
When you're working in challenging conditions, shoot at full aperture with long lenses to allow you to select the most effective planes of focus.

8 emotional impact
Don't be afraid to portray animal expressions and gestures to evoke sympathy for their plight.

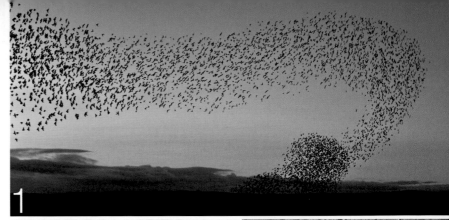

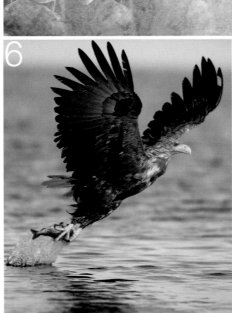

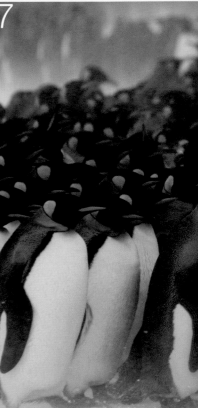

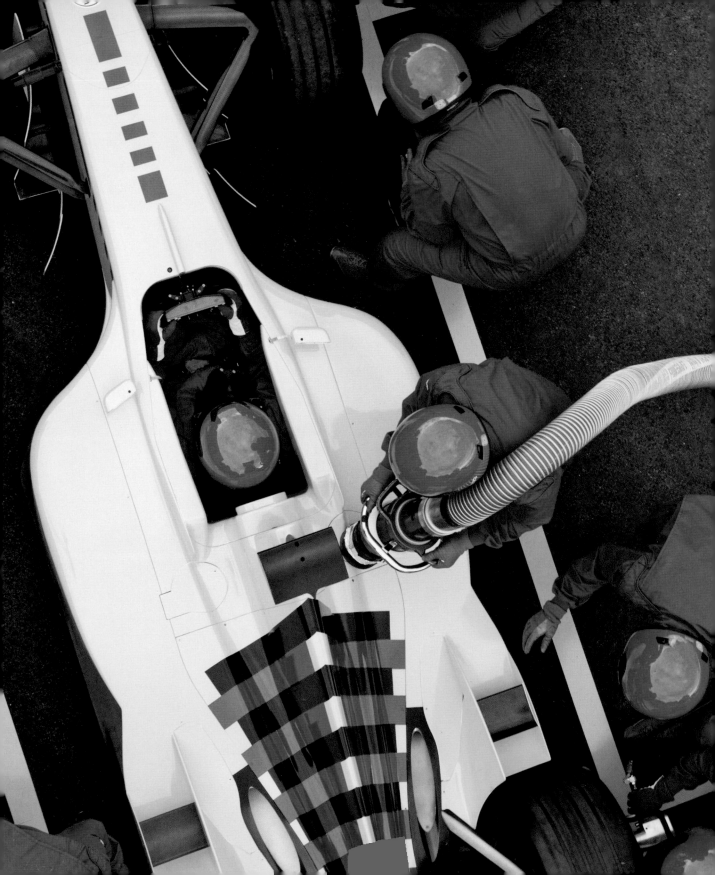

SPORTS
PHOTOGRAPHY

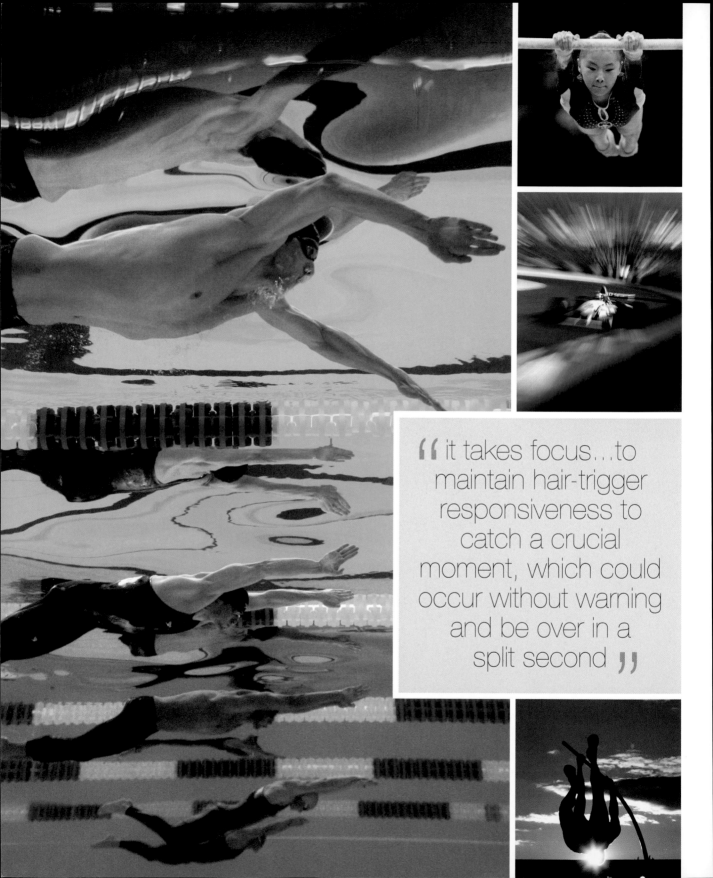

"it takes focus...to maintain hair-trigger responsiveness to catch a crucial moment, which could occur without warning and be over in a split second"

Sports photography has now leaped over almost every technical hurdle. Split-second and complicated action can be frozen in time and each moment analyzed in minute detail. Distant parts of the playing field are within reach of long focal-length lenses. And low light holds no terrors for modern sensors. Today's challenge is how to astonish.

The general public is used to stunning views of sportsmen and -women thanks to television broadcasts, which use cameras with enormously long focal length lenses and remote-controlled robotic video. One great advantage still photography has over television, however, is that we can admire a gymnast's perfect balance or marvel at the musculature of an athlete in detail and at leisure.

These expectations—that an image will provide both an exciting viewpoint and offer revealing detail—create a double challenge. As with other genres of photography, such as wildlife, a genuine love of the subject as well as some expert knowledge is a great advantage. Much of what happens in sports is thoroughly regulated and bound by rules that make it less likely that you will be exposed to completely unpredictable behavior. Needless to say, however, as a photographer you must always be prepared for the unexpected such as a fall on the running track, a last-second win, or a gust of wind that tears a sail. This is when you can capture the passion of sports, the moments of intense concentration, incredible exertion, utter devastation, and total elation. Sports are, after all, an overwhelmingly human endeavor.

key moments

1851	William Fox Talbot uses an exposure of 1/1000 of a second to demonstrate high-speed photography.
1878	First action photos taken as Eadweard Muybridge captures a horse in motion.
1894	Jules Beau starts to document swimmers, athletes, boxers, and cyclists in action.
1900	The first sports journals appear.
1912	Jacques-Henri Lartigue photographs the French Grand Prix.
1930s	Athletes are caught in faster motion as improved shutters and lenses allow ever-shorter exposure times.
1936	Leni Riefenstahl films the 1936 Olympics in Berlin, showing athletes in motion by using tracking shots.
1937	Gjon Mili and Harold Edgerton pioneer stroboscopic photography.
1954	Sports Illustrated launches in the US.
1983	Nikon NT1000 picture transmitter allows images to be sent quickly around the world.
1990	Kodak's DCS-100, the first digital SLR, is launched.

In addition, the sports photographer needs stamina. It can be hot and tiring work waiting for a sports event to start and following it—sometimes for hours—until its conclusion. And it takes focus and concentration to maintain hair-trigger responsiveness to catch a crucial moment, which could occur without warning and be over in a split second.

It helps to be strong too, because modern super-telephoto lenses with their cameras are extremely heavy. Carrying them from parking lot to stadium is the easy part. You have to make micro-adjustments in the aim of long lenses, which means handling over 14lb (6kg) with the delicacy of a paintbrush. That takes strength and practiced technique.

But, if you are a sports fan, the rewards seem amazing: you get to spend your working day in an environment you love, and, with sports photography becoming ever more popular, you are in an enviable position.

In this chapter we will analyze images that impress with their style and insight and we will encounter practitioners with innovative techniques that reveal the action in stunning detail or breathtaking blur. And we will learn how simple strategies are the basis for winning sports images.

tutorial: fresh views

The photographer's most powerful tool is a restless vision, and the more restless, the better. Photographers need to constantly search for a new angle or viewpoint, and to be on the look-out for unusual perspectives. By being imaginative with viewpoint, you can create more striking and intriguing images.

the best views

There are several aspects to the task of finding your viewpoint and they depend to some extent on the sport you are shooting. Some sports, such as gymnastics or tennis, take place in confined spaces. In such cases you need to work out where to stand for the best views of high leaps or serves, as well as where the sun will be in relation to the players. Other sports, such as bicycle races or marathon runs, range over much greater distances. You may be restricted in where you can stand, and you have to wait for the action to come to you. You will want to place yourself so that you can see the athletes' faces at

the key moment of an action, or be able to photograph a movement or body shape cleanly against a clear, uncluttered background such as the sky.

In between are sports such as athletics, football, and rugby, where the space is confined but too large for you to cover it all and impossible for you to predict exactly where the action is going to be. You have to concentrate and follow the action, or wait for those specific moments like goals, penalty kicks, or the breaking finish-line ribbon.

One more factor to keep in mind is the amount of sharpness or blur you want in the image. Action that's directed straight toward or away from you is easier to capture sharply than movement that runs across your field of vision (see also pp.190–91).

The movement of the sun is also a consideration—remember to plan for the changing direction of light as it crosses the sky. This is particularly important if you're attending an all-day event: a position in the morning in which your subjects are beautifully lit may mean that everything takes place in shadow later in the day. Even a few hours may be sufficient to alter the lighting, however, as shadows move surprisingly rapidly at high latitudes.

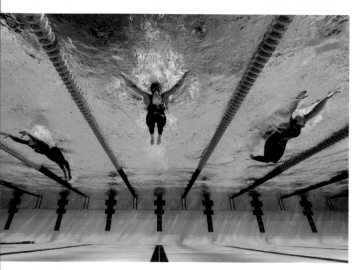

low level
Thanks to pools with glass walls, underwater views of swimmers are becoming commonplace, but good timing for composition is still essential.

oblique views
If you never take your eye off the ball you may miss the incidentals: athletes adjusting their clothes, hand gestures, shadows. Sometimes small things make the best shots.

focus on technique: ultra wide-angle and fish-eye lenses

Ultra wide-angle lenses (those with fields of view greater than about 90 degrees) are synonymous with dramatic perspectives. They exaggerate the differences in size between near and distant objects. But for the most dramatic effects, the lens must be close to the action. (**1**) shows a normal or rectilinear wide-angle shot—the lines are straight—that shows a lot of the action while being inside it. (**2**) shows a fish-eye shot—lines are bent around the center—that optically pulls the context and the action into one seamless whole.

using the foreground

Frequently the most powerful and effective techniques are absolutely free. Foregrounding is one such technique: that is, photographing a scene in such a way that the lower half of the image competes with the main subject. Concentrate on making the foreground strong, energetic, and appealing. The main subject, whether it's a yacht or a climber, is almost left to make its own way visually. This technique exploits the fact that the foreground is often used as visual padding. By ensuring it makes a vigorous contribution to the image, you create a stronger image as a whole.

Essential here is a narrow depth of field, because foregrounds that are too clear tend to dominate. Limited depth of field is easiest with a long lens, especially with a foreground close to the camera. For wide-angle views try an ultra-fast lens at its full aperture for the best results. In bright conditions set the lowest ISO; you may also need a ND (neutral density) filter to reduce the light entering the lens. Another technique is to use reverse lens tilt (see p.75). Mount a tilt and shift lens and set the lens to tilt backward, so that it points upward by a few degrees. When the lens is aimed at the subject, depth of field is dramatically reduced.

bringing out the foreground

Backgrounds can be in the foreground. By filling the frame with more of the context of the sport, you can bring out your subject using contrasts in shape, tone, or color.

point of view

A wide-angle view focused close up makes the climber's hand appear the same size as his torso while the defocus blur forces our attention onto the tense fingers.

tutorial: in the action

Securing a good position is one of the most important factors for sports photography. The closer to the action the better: the test is whether you can see the athletes' eyes.

long reach

Your choice of position is the only way to control the perspective of your images. This means that giving the impression that you are right inside the action is possible only if you and the camera are truly inside the action. This is possible with many water-based sports such as sailing, surfing, and swimming, as well as sports not limited to a field or track, such as rock-climbing, skateboarding, and skiing. This calls on you to be fairly competent at the sport.

In these situations you can strap a compact camera onto a chest harness or a vented helmet so that it doesn't interfere with your movements. If you use a wireless release strapped to your wrist or chest, you don't even need to touch the camera. There are also very compact housings that can be used underwater, and which add little bulk to the camera.

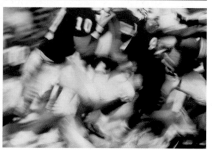

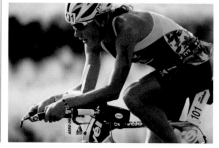

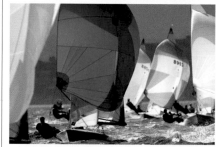
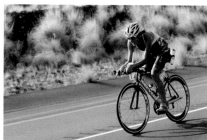

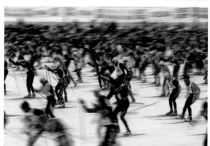
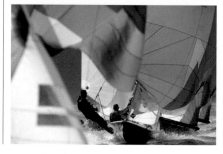
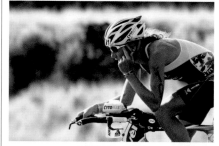

flurry of action
Variations in sharpness help to separate out different participants in a scene: expose at, for example, 1/30 sec for variations in blur.

zooming in
If you can't get close to the action, the only recourse is to zoom in as far as possible, but use nearer objects to frame the shot.

track events
Set the auto-focus to follow or continuous focus and fire off a series of shots to track the action; choose the best shot later.

Where it's impossible to join in the game—for example, photographers are not allowed on football or cricket fields, and we don't want to be in a boxing ring either—we must rely on long focal-length lenses. Early long lenses were relatively slow—f/8 was considered fast for a 500mm lens—causing too much clarity in the background. This gave the impression of viewing the scene from far away. Conversely, shallow depth of field mimics our natural experience that the closer we get to a subject, the more it is out of focus. The introduction of fast and very long lenses, such as 400mm with f/2.8 maximum aperture, meant that by always using the widest aperture for minimum depth of field photographers could be far away from the action yet give the impression of being close.

in the frame

Once you've secured a good position, the next challenge is to frame and compose the shot. You don't always have to catch a magic moment to make a great picture. Your most effective strategy is to fill the frame from corner to corner with action. Aim to simulate the sense of taking part: the fun and excitement of sports is often in the frenetic swirl of activity—flailing arms, splashing water, or spraying snow. A composition with a strong diagonal structure works well to emphasize this feeling of action. Rapid movement close to the camera is almost impossible to capture sharply, but the contrast of movement blur close to a sharper subject helps to draw the viewer into the action (see also pp.190–91, 288).

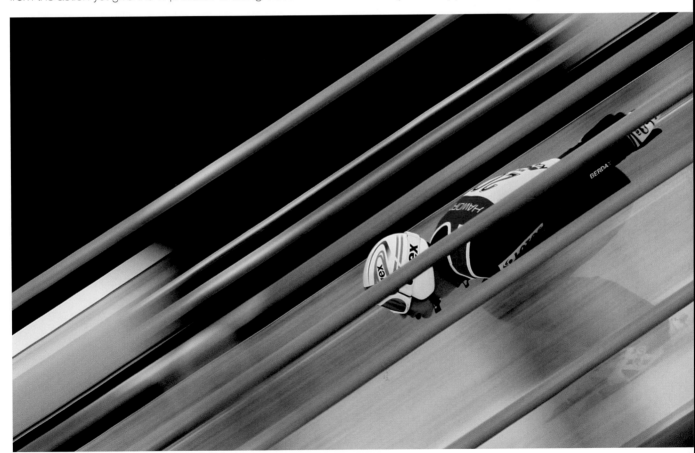

strong diagonals
A panning movement following the action means that, if the motion is diagonally downward, that is the direction you need to move the camera. Here color contrasts help pull the viewer into the action.

image analysis

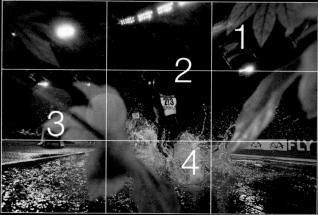

21MM ISO 800 1/350 SEC F/5.6

It's a rare image that combines elements of landscape with sports action and architecture. Ryan Pierse took many photographic risks to capture the Womens' 3000m steeplechase event at the IAAF Golden League to create an eye-catching shot.

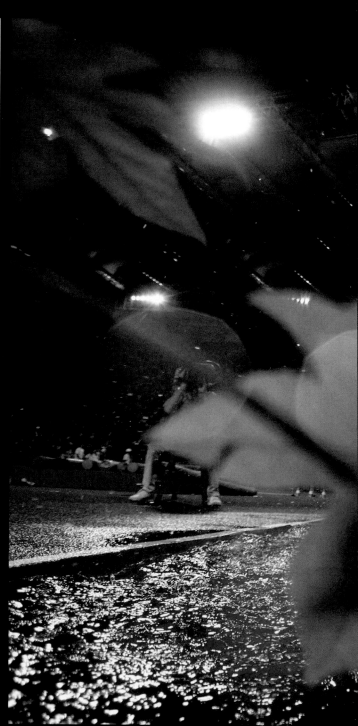

1 inventive framing
By choosing to frame the shot with the leaves decorating the water-jump, the photographer filled in the empty spaces covered by his wide-angle lens. But he also limited the area in which he could catch the athletes to a small central window.

2 highlighting the skin
The athlete could have been hard to make out against the dark stadium, but by skillful timing and fortuitous positioning the athlete has caught the light so her outline shows up well.

3 hiding distractions
Another advantage of framing a shot with objects close to the lens is to disguise or conceal distractions. Here, for example, the leaves hide a television cameraman who is filming the event.

4 perfect blur
With expert timing and the choice of a relatively short exposure time, the water spray has just the right quality of sharpness and blur to convey powerfully the sense of movement—and almost the sound of the splash and dash.

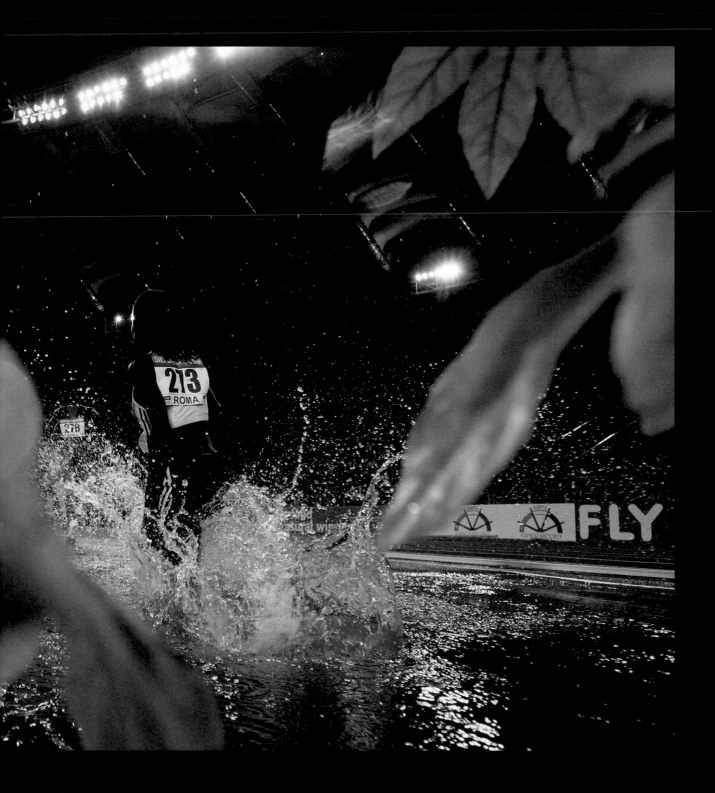

assignment:
close and closer

Unlike photographing animals in the wild or people in conflict zones, it can be relatively easy to get close to your subject in sports photography. Apart from sports officials, the main difficulty is being unintentionally involved in the action—getting spattered by mud or covered in water. If you prepare for these risks, the results are well worth the effort.

the brief

Obtain a shot of any sports action that's different from the normal view: usually you stand with other photographers and your pictures will look similar. Be different by getting closer than anyone else.

bear in mind that using a telephoto lens for close-up shots may not be enough—the perspective will be different. Sometimes getting closer means being physically nearer. To keep safe, for example, when shooting motor sports, try using wireless remote control.

try to capture a sense of being right inside the action, as if you're a participant rather than observer. Use flash, if possible, to freeze fast action or, alternatively, allow some motion blur.

must-see master ▶

Quinn Rooney
Australia (1976–)

Pick up a sports publication anywhere in the world and the chances are you'll find an image by the multi-award winning Quinn Rooney. He has worked for a variety of sports magazines, covering everything from the Olympics, the Australian Open, and the Swimming World Championships, to Formula 1 racing, World Rally championships, and the football World Cup. His work presents beautiful imagery by stopping time on scenes that the naked eye could never hope to capture.

career highlights

2002 Begins working for Getty Images.

2008 His images first appear in *Sports Illustrated* Pictures of the Year.

2009 Wins the National Press Photographers Association Sports Photojournalist of the Year.

Shane Perkins, Melbourne, 2008: To create the unusual lighting for this dramatic shot of the Australian cyclist, an off-camera flash with a homemade snout was mounted on the outside of the track.

think about...

1 pre-event action
Preparations for an event can be highly photogenic, particularly in close-up. Observe the activities and rituals carefully—they build up atmosphere.

2 focusing on the eyes
You can't capture a more intimate expression of the emotional and personal impact of an event than by focusing in on the eyes of an athlete.

3 filling the frame
If you can't get into the action, focus a telephoto lens on your subject. Blurs of other athletes frame the subject and give the impression of immediacy.

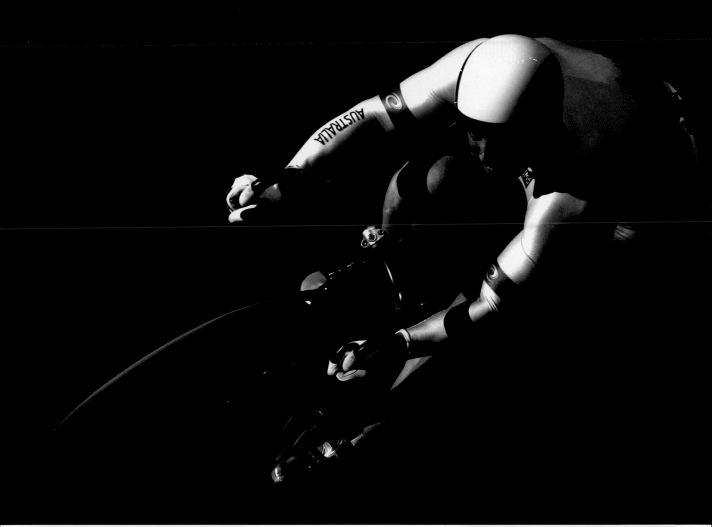

4 crossing boundaries
Getting drenched is all part of the fun, so water on the lens crosses the boundary between your camera and the event to become part of the image.

5 key moments
It is easy to miss the micro-moments that have significance. Keep an eye out for the minutiae of the sport as well as observing the main action.

6 graphic outlines
A fear of under-exposure leads many photographers to miss the power of silhouettes: try exposing for highlights and frame for graphic effect.

tim clayton

Born in England in 1960, Tim moved to Australia in 1990 to take up the post of sports photographer at the *Sydney Morning Herald*. His assignments have included six Olympic Games and he has won eight World Press Awards. He now works as a freelance.

nationality
British

main working location
Australia

website
www.timclaytonphoto.com

in conversation…

What led you to specialize in sports photography?
It's a combination of passions. I love photography and I love sports. The chance to specialize means you can do a better job than when you're shooting something you have no particular feeling for.

Please describe your relationship with your favorite subject. Are you an expert on it?
I think photography is a "failing forward" process—those who fail but learn from their mistakes ultimately become the better photographers. As you learn about each sport you become experienced at it, your understanding grows and so you give yourself every chance to get good pictures.

Do you feel you have succeeded in being innovative in your photography, or do you feel the shadows of past masters over you?
That's a tough question and one that others need to judge. Every photographer is influenced to a degree by their heroes and idols. As we learn we aspire to be like them, but then we have to break those mental shackles and go beyond. It is an inward thing I'm constantly striving for.

How important do you feel it is to specialize in one area or genre of photography?
If you can combine your passions you will do a better job, but it doesn't mean you are going to be bad at other things. If you have a good eye you can shoot anything well.

What distinguishes your work?
My attitude is that you're evolving all the time and you have to keep pushing yourself to attain the next level. With that attitude and work ethic I've created some special work which has helped me to be recognized. I'm not as good as I want to be yet. I'm still working on constructing and telling stories better, for instance.

As you have developed, how have you changed?
I used to be really hard on myself if I missed a good picture. Now I am able to rationalize and analyze my mistakes, so I smile and learn and enjoy rather than beating myself up.

What has been the biggest influence on your development as a photographer?
My thirst to acquire knowledge about photography and

▲ for this shot

camera and lens
Canon EOS 5D Mark II and 35mm lens

aperture and shutter setting
f/7.1 and 1/1600 sec

sensor/film speed
ISO 320

for the story behind this shot see over …

also simply my maturing as a person through life's experiences. It all leads to where you are now and the photographic direction you are going in.

What would you like to be remembered for?
I wish I had scored the winning goal for Leeds United to win the European Cup Final, but as that didn't happen I will have to say I hope I have helped to make sports photography respected by photojournalists of all genres.

Did you attend a course of study in photography?
I passed my NCTJ (National Council for the Training of Journalists) in the UK. I have mixed feelings about photographic education; sometimes it can do more harm than good. Of course education is important, but ours is a "doing" profession. Keep educating yourself by shooting, because there's no substitute for your own experiences.

How do you feel about the tremendous changes in photographic practice in the past 10 years? Have you benefited or suffered from the changes?
I think some of the changes have been fantastic. We can now upload and send at the click of a button from pretty much anywhere in the world. It's amazing—but I do miss film.

Can photography make the world a better place? Is this something you personally work toward?
I take my hat off to the hundreds of photographers who are shooting the reality of the world, many because they believe in telling the truth and bringing attention to the issues that society neglects and the media turns a blind eye to. They make us see what we don't want to see.

Describe your relationship with digital post-production.
Well, I proposed to my Mac some time ago—I love it that much. Today, the computing and software possibilities are awesome.

Could you work with any kind of camera?
I shoot Canon 35mm for most of my sports, but despise the format. I pick up my Hasselblad for panoramic views and have a Mamiya 6x7 for black-and-white portraits.

Finally, to end on a not too serious note, could you tell us what non-photographic item you find essential?
A bottle of red wine, a corkscrew, and a wine glass. You have to reward yourself at the end of the day. At least it makes me go to sleep with a grin on my face!

behind the scenes

This race track is a journey of about 30 minutes from Sydney's central business district and I visit it two or three times a year, equipped with the necessary press pass to access the course itself.

17:10

18:45

17:10 **My first step** was to phone the media officer to confirm that I could set up my remote controls on the far side of the track.

18:45 **In the weighing room,** I used a 35mm lens to photograph the jockeys.

in camera ▷

18:50 **Jockeys are accustomed** to the presence of photographers, but I made myself unobtrusive.

18:55 **I checked my pictures** before heading for the stables.

19:00 **The contrast of highlight** and shadow I found at the stables is something I particularly love.

19:05 **One horse's head** and the dark shadows around it made a strong image.

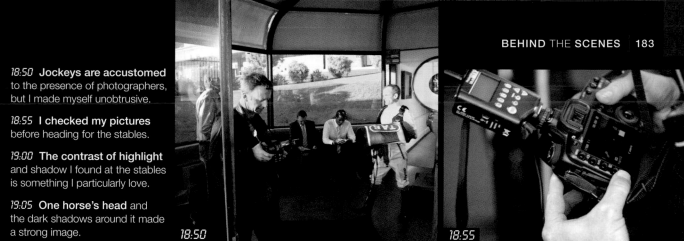

18:50

18:55

19:00

19:05

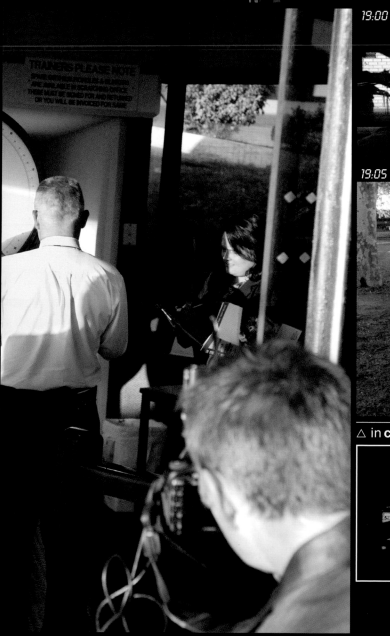

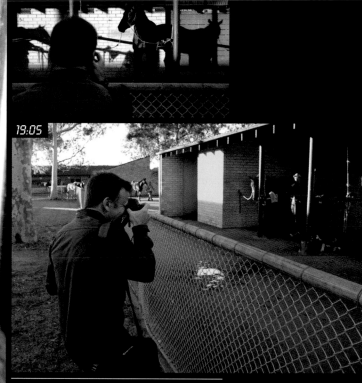

△ in **camera**

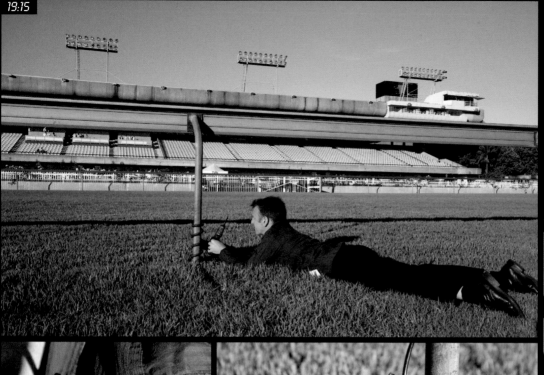

19:15

19:18

19:20

19:15 **I tied a camera** to one of the racetrack posts—perhaps surprisingly, I've only had two cameras broken so far!

19:18 **I use a remote control** that allows me to fire a camera from a second one a short distance away.

19:20 **I set a shutter speed of 1/2000 sec** and an aperture of f/9 on the 35mm lens.

△ in **camera**

19:35 **To get an overhead view** of the track, I climbed the observation tower.

19:38 **As the sun was low,** I tried to shield my lens to prevent flare.

19:40 **I got myself into position,** ready for the horses to hurtle around the bend of the track.

19:42 **Placing the horses** at the top of the frame allowed for long, dramatic shadows.

△ in **camera**

20:00

20:05

20:00 **As darkness fell,** I looked for some atmospheric shots of the horses in the parade ring.

20:05 **A faint glow of sunset** still lingered against the darkening sky, giving me some color to work with.

20:10 **Kneeling down,** I pointed the camera upward to silhouette the horses and riders against the sky.

20:10

in **camera** ▷

20:41 **For my last shot of the day,** I took up a position next to the racetrack and got ready as the horses approached.

20:42 **Swinging my camera to my eye,** I poised my finger on the shutter release.

20:41

20:42

20:42

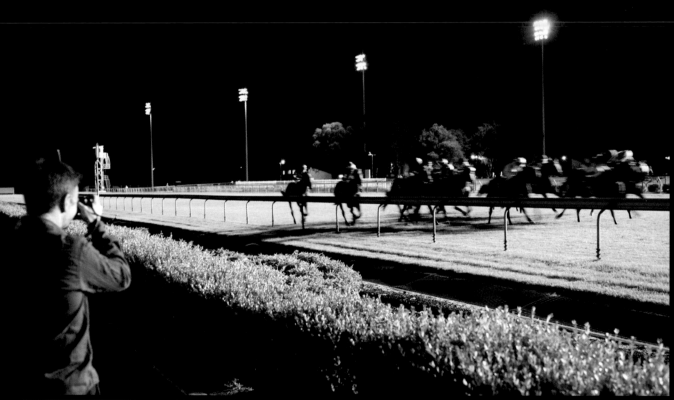

20:45

△ in **camera**

20:42 **Seconds later I took the shot** as the horses streaked past, using an aperture of f/9 and shutter setting of 1/4 sec to blur the movement and capture a sense of speed.

20:45 **Reviewing my shots,** I was satisfied that I could pack up for the day.

portfolio

▽ **World Paragliding Championships, Australia, 2007**
Dozens of brightly colored paragliders fill the sky at Mount Borah, Australia.

◁ **Sydney, Australia, 1994**
The water tension is stretched to the limit a split second before Australian swimmer Matt Dunn breaks the surface during training.

△ **New South Wales Surf Life Saving Championships, 1995**
The Avoca Beach female surf boat crew are sent airborne after crashing into a wave at South Maroubra Beach, Sydney, Australia.

tutorial: sharpness and blur

Every sport involves movement, and every movement can be captured anywhere from tack-sharp to blurred. It depends simply on your choice of shutter setting in relation to the movement. This deceptively simple selection generates a surprisingly wide range of effects.

freezing and blurring

Sports photographers could be said to lead shutter-priority lives. They decide only on the shutter setting and nearly everything else flows from it. The exposure time given by the shutter determines how much time the image spends on the sensor: if it is very brief, the image of the moving subject won't have traveled far on the sensor: and the blur is minuscule so the image looks sharp. If the exposure time is longer, the image smears across the sensor to a visible extent and the impression is of unsharpness.

Having fixed the shutter setting, adjust the lens aperture to ensure you obtain the brightness you want—for a given sensitivity or ISO setting, and for the lighting conditions.

It is possible to alter the ISO setting itself, so that you obtain the right combination of shutter and aperture setting. This is a facility particular to digital photography, and it is one of the great advances that technology has brought to the sports photographer. It has never before been possible to set ISO to ensure that the same, winning combination of very short exposure time with maximum aperture can be used across a variety of lighting conditions. Choosing exactly which shutter setting is best to capture movement in a particular situation depends on your evaluation of the speed and direction of the action (its velocity).

separation and speed

Choice of exposure time also depends on the distance you are from the movement. You'll need the shortest exposure times when the movement crosses your field of vision at right angles, as well as when it is close to you. Longer exposures—and consequently greater depth of field—are possible when the movement is directed straight toward or away from you, and this also applies when it is further away.

freeze-frame
Short exposure time coupled with excellent timing, with the action caught at the instant the player is in the air, ensures a sharp image of the central players.

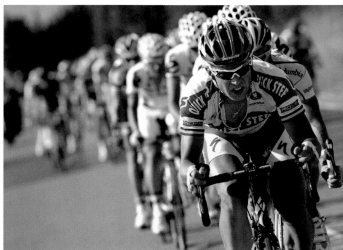

depth of field
Setting the shortest exposure time to catch the action forces the use of a wide aperture, so it's best to frame to make the most of the resulting narrow depth of field.

focus on technique: multiple exposures

A multiple exposure that breaks up rapid movement into discrete steps was first attempted by Eadweard Muybridge in 1877. Then Harold Edgerton in the 1930s showed how to combine the images into one shot. With the rise of digital cameras, the technique fell out of favour, but some modern cameras will make multiple exposures on the same image file. It's best to use flash-units offering a repeating flash or multi-flash mode. You need to set the number of flashes per second.

It's always a good idea to make a few tests before shooting anything critical. Try out different shutter settings on a movement that is similar to what you want to capture. Then magnify the image to the maximum on your camera's screen to evaluate the results.

movement blur

When you experiment with movement blur (see p.288), start with shorter exposure times, such as 1/60 sec. Then set progressively longer times. The most effective use of blur is to contrast it with relatively sharp areas in the image: the eye is naturally drawn to these focused parts of the shot, so, for example, you need to ensure the sharpest part of a race car is around the driver or another important detail, while the rest of the image is blurred.

The technique for acheiving this is panning, so during exposure you move the camera in the same direction as the subject is traveling. Set the auto-focus to tracking or continuous. Keep both eyes open during exposure so that you can keep track of the movement, and fire off as many shots with different settings as you can, as soon as you have the opportunity.

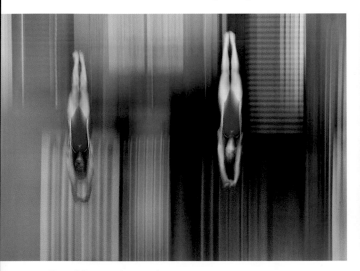

motion blur and panning
Shots that follow the action are usually effective, but this image is particularly striking as the softer outlines of the bodies contrast with the abstract lines of the background.

zoom burst
A short twist of the zoom control during exposure, plus some extraneous movements, produces a dynamic shot, although this technique should not be over-used.

tutorial: capturing the spirit

Of all subjects, sports is perhaps the easiest for capturing raw, genuine emotion. Often giving their utmost, athletes—as well as people concentrating on the game—conceal nothing. In catching a sense of the painful struggle, the joy of winning, or the despair of losing, you also capture the spirit of the sport.

essential knowledge

The changing expressions on an athlete's face may appear with little or no notice and be fleeting, lasting only a fraction of a second. As well as locating yourself in just the right position to catch the moment, you also need to find a spot where no one blocks your view and where the athlete's face is visible at crucial moments.

To have a better chance of catching these moments it is obviously better if you know a sport. That knowledge should extend to knowing how the sports appear to spectators. For example, you should know that rowers grimace most when they pull on the oars and that then they are still for a moment. At the same time they lean

focus on **technique**: the "documentary" look

The documentary-style photograph unpeels the glamour of sports to reveal the human drama. Often shot in black and white, it affords a more leisurely approach, one that often concentrates on training and practice using shallow depth of field. Gymnastic events on bar or beam and boxing are the most popular subjects, almost to the point of cliché. However, there's plenty of scope for work in other areas of sport.

back, which could block the faces of the rowers behind. With this intimate understanding you will know that you must position yourself so that you can see everyone, even when they lean backward, or you must focus on the nearest rower.

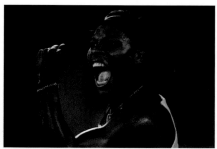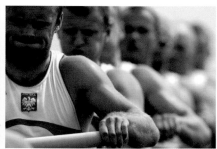

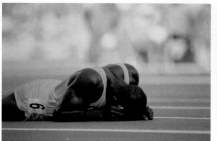

exertion and emotion

Each sport has its key moments—whether it's at home plate or the finish line—but you can capture its spirit at any time. It's not just about peaks of exertion. It can be the exultation of hitting a home run or settling in on the track for the long haul. The spirit is visible after the climax, too: be ready to record the joy of winning or the despair of losing.

focus and stamina

Physical stamina is also key, as your attention to the sport must be almost as intense as that of the athletes. To maintain concentration it helps to have your camera supported. The minimum support is a monopod. Use one that's sturdy enough to take your equipment plus your weight when you lean on it. Set it up with the eyepiece at exactly the right height so you don't have to bend down.

For greater stability, use a tripod. On the majority of monopod or tripod heads, when you change your camera's orientation, the position of the eyepiece changes so you have to adjust the height of the column. To avoid this, you can use special brackets that rotate the camera around the lens axis, which minimizes changes in the position of the eyepiece.

When using very heavy lenses, the normal heads such as ball-and-socket or 3D are not adequate. Gimball mounts, in which the camera/lens combination rotates

signs and symbols

Using symbolism is a potent way to create arresting images. Here, there are obvious symbols such as arrows pointing in confusing ways, but loneliness is also implied, as well as oppressiveness suggested by the massive iron girder.

and swivels around its center of gravity, allow you to alter the aim of even the heaviest lenses using only the pressure of your fingertips.

in transit gloria

As most athletes are on the move and moving quickly, for some sports the best—if not the only—way to follow the action is by using appropriate transport: a chaser boat or motorcycle, for example. If you can't arrange this, position yourself at the finish line or where action tends to slow a little—such as on sharp corners, chicanes, or at fences. There, pre-set focus or focus manually, and set exposure manually to optimize your camera's reaction time.

image *analysis*

300mm ISO 200 1/250 SEC F/4.5

Here we see only the backs of people; the action is moving away, and empty space dominates a scene drained of color. Paul Gilham's image breaks every "rule" with a quiet confidence that succeeds brilliantly.

1 leader lines
Long, uninterrupted lines cross the image in parallel groups that fade and break up toward the bottom of the image. The overall effect is of a tranquil, calm landscape of shifting tones and repeated shapes.

2 bustling contrast
The numerous bug-like shapes ranged right across the horizon are small, irregular and clearly on the move. They contrast sharply with the peaceful landscape that they traverse; it's a visual stampede on placid ground.

3 aerial perspective
Despite the lack of visual pointers, the sense of depth in the scene is strong. Contrast is lowered with the increasing distance due, here, to a combination of dust and spray. Subtle changes in the size of the sportsmen also convey depth.

4 foregrounding
Spectacular pinpoint reflections of light sources lend sparkle and liveliness to the foreground. These echo the busy elements in the image and contrast with the darker figures at the top of the picture.

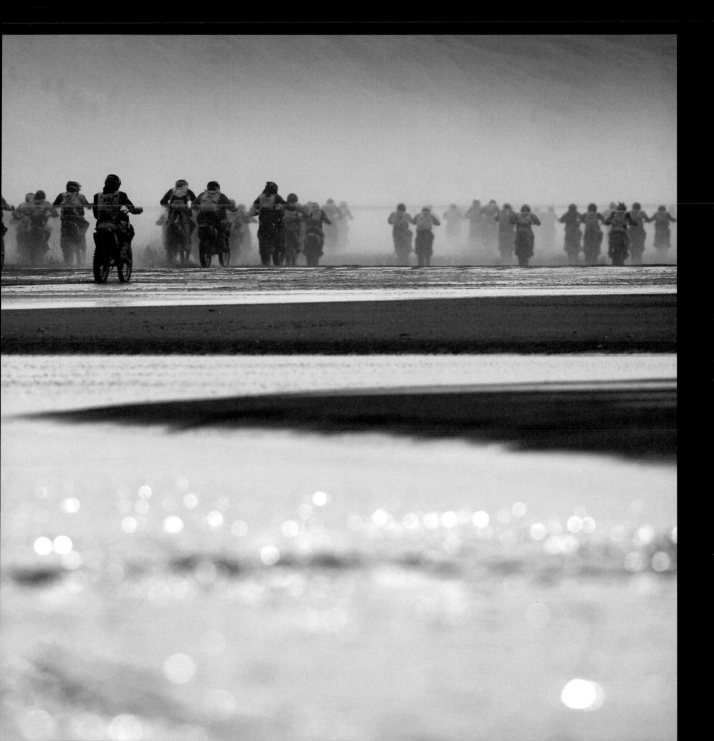

assignment:
action and reaction

The beautifully skilled athlete is without doubt the "hero" of the occasion, but there are no heroes without an adoring crowd. And it is usually with a cheering audience that sportsmen and women achieve their superhuman best. It may be hard, but it can be rewarding to shift your attention from the hero's exertions and watch their audience.

the brief
Convey the relationship between the participants of a sport and their spectators in a single shot. Include athletes and fans in the image, and try to express the nature of the interaction.

bear in mind the photography of relationships often depends on facial expressions or reactions which are very fleeting, even though the relationship may be long-lasting. Set your lens to manual focus for the most rapid response from your camera.

try to capture an elegant image. This is one that shows you knew what you wanted and simply waited for the right moment. It demonstrates your empathy with the participants.

must-see master ▶

Elizabeth Kreutz
American (c. 1973–)

Born in Austin, Texas, Elizabeth Kreutz has captured some remarkable moments in sports. Making the most of her outgoing personality and her love of sports, independent photojournalist Kreutz has photographed sportsmen and women in diverse sports including swimming, gymnastics, and cycling. She has also photographed Lance Armstrong and the Discovery Channel Cycling team. She has traveled all over the world and her photographs have appeared in *Australian Bicycling*, *USA Today*, *Newsweek*, and other publications.

career highlights

2006 Photographed the Winter Olympics in Torino.

2007 Photographed the Tour de France.

2008 Photographed the Winter Olympics in Beijing.

Ice-skater: By giving herself plenty of room—using a shorter focal length than usual for skating—Kreutz was able to catch the skater's slip and the expressions of the audience in the frame.

think about...

1 predictability
Watch for moments that are regularly repeated: focus manually and make settings ahead, then wait for the action to take place in the viewfinder.

2 the coach's agony
Don't forget that coaches and managers often have the most emotional investment in the result. Position yourself so that you can see their responses.

3 blur and confusion
Choose apertures with care when blurring out the background. Contrasts in light and shade can reduce the effect of blur and confuse with the main subject.

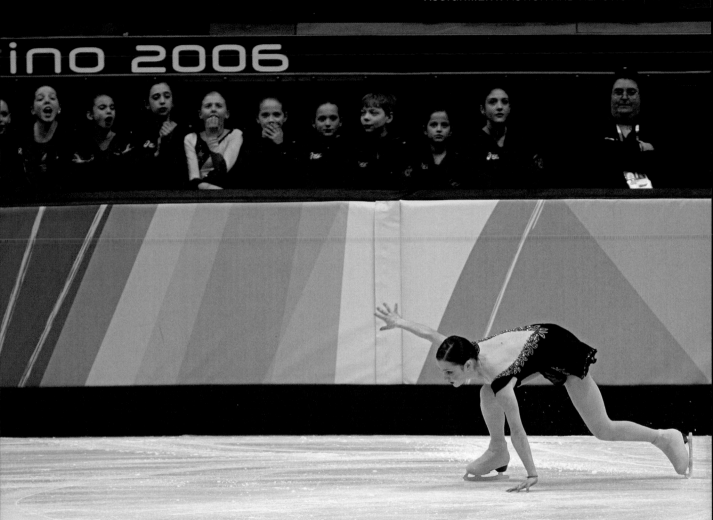

4 exposure indication

Use the fact that the relative brightness of a subject in your image carries a subtext: darker areas tend to be of less importance than brighter ones.

5 heroes

Use viewpoints to convey meaning: a low camera position looking up suggests the subject is strong and powerful in relation to the viewers.

6 framing

Use spectators to frame the game: this is a metaphor for the relationship of athletes to fans. But choose an expressive moment—winning or losing.

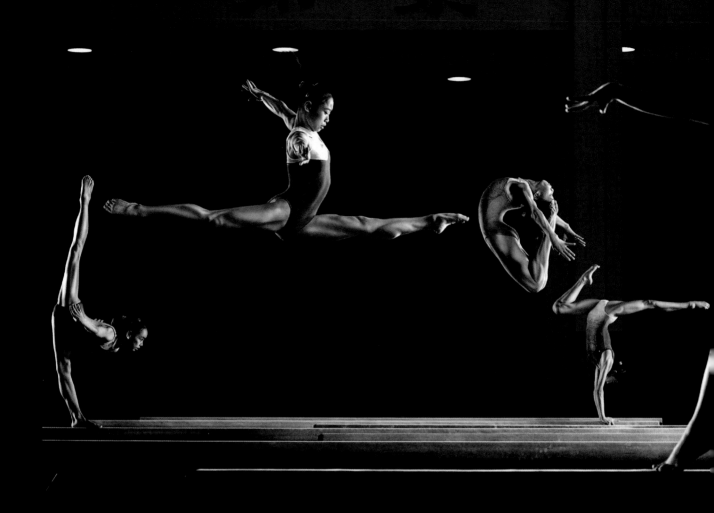

adam pretty

Adam's career began in 1997 as a news photographer at the *Sydney Morning Herald*. In 1998 he moved to Getty Images to pursue his interest in sports photography; since then he has photographed five Olympic Games and won several major awards.

nationality
Australian

main working locations
China, Australia, and the USA

website
www.adampretty.com

▲ for this shot

camera and lens
Sinar Hy6 with eMotion 75 digital back
and 110mm lens

aperture and shutter setting
f/8 and 1/60 sec

sensor/film speed
ISO 100

for the story behind this shot see over …

in conversation…

What led you to specialize in sports photography?
I loved water sports when I was at school and I fell in love with photography as well, so it was a great match.

Please describe your relationship with your favorite subject. Are you an expert on it?
I don't really have a favorite—my work's so unpredictable. Maybe any subject in great light with water involved.

Do you feel you have succeeded in being innovative in your photography, or do you feel the shadows of past masters over you?
I hope I have. I've always tried to create my own look and not follow the crowd. You realize most things have already been done and it's your own interpretation that makes it yours. I really respect the past photographers whose work I have drawn inspiration from and have learnt from. I'm pretty happy about where my photography is, but I'm never totally satisfied, which keeps me looking for new ideas.

How important do you feel it is to specialize in one area or genre of photography?
It's important when you're starting so that you can build a name, but if I want to do something different, I will. Saying that, specializing in sport has given me all my opportunities, but I never considered myself a "sports photographer."

What distinguishes your work from others?
It's a culmination of my experiences, and it's my eye, so hopefully that makes it unique.

As you have developed, how have you changed?
My back has got worse! These days, I try to work smarter, not harder, as I tend to try to do everything at a million miles an hour. I pace myself a little and remember I can't do everything, even though I still try sometimes.

What has been the biggest influence on your development as a photographer?
My wife, and before that always my colleagues. I was surrounded by people I could talk to and ask questions of.

What would you like to be remembered for?
Passing on the knowledge I was given by photographers around me when I was learning (I still am!); sharing my experience and always being happy to answer a question.

Did you attend a course of study in photography?

No. I needed practical experience. I think sometimes a photographic education can trap you a little and make you think in a certain way, which isn't particularly helpful when you are trying to develop your individual style.

How do you feel about the tremendous changes in photographic practice in the past 10 years? Have you benefited or suffered from the changes?

I think it's fantastic how fast the changes have occurred. The competition has really got better, which means you have to push yourself harder and harder to try to keep producing fresh work. It was just fortunate that I was starting out a bit before everything went digital. I really appreciate having an analog background and having worked in a wet darkroom. It was a great experience that has helped me appreciate where we are now.

Can photography make the world a better place? Is this something you personally work toward?

Yes. It's a sharing of ideas and cultures in a language that everyone understands. Photography is hugely popular, which means you meet people from all over the world and you can share and learn from one another. I hope I can help other photographers and people in general with my experiences and I expect the same from them.

Describe your relationship with digital post-production.

I think I'm pretty solid on the computer—but they can frustrate you in numerous ways! But it's another whole world where you need experience too and, unfortunately for my computing and software career, I spent too much time behind the camera. However, it's never too late to learn more and that's my goal over the next few years.

Could you work with any kind of camera?

I have my favorites; I've used stacks of different gear and some of it I wouldn't touch ever again, so I think I can work better with some cameras than others. For achieving certain results I'm after, only specific gear will do. But if I had no choice, I think I could work with pretty much anything as long as I could keep making pictures.

Finally, to end on not too serious a note, could you tell us what non-photographic item you find essential?

Ear plugs! I need my sleep.

behind the scenes

I've done shoots at this Beijing gym before and have a good relationship with the head coach. I love photographing gymnasts—I have huge respect for the sacrifices they make and their almost superhuman physical capabilities.

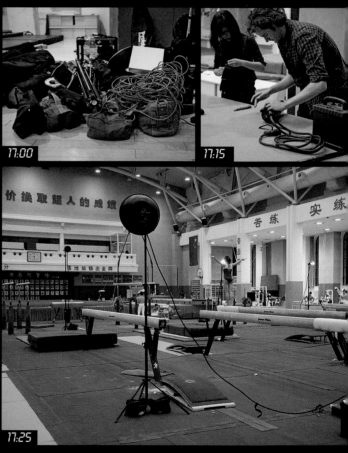

17:00 As I was planning a complicated shot, I had to bring a large amount of gear with me, mainly lighting equipment.

17:15 Dan, one of my assistants, got busy taping on a red gel for the background lighting.

17:25 For direct lighting I decided to use a softlight reflector, known as a "beauty dish."

17:30 I drew a lighting diagram for my assistants, showing the balance beam positions and the lights in relation to them.

17:55 I lit the background first then worked forward. Checking on screen, I saw that the gels on the lights were giving the slight red background glow I wanted.

18:30 I showed the gymnasts the poses I had in mind and asked which pose they would each like to do.

18:45 With my eye to the camera, I positioned the gymnasts.

19:00 After seeing test shots I started tweaking some poses.

19:05 Exact positioning was crucial to the success of the final shot.

▶

19:25 **Finally, I could start shooting** in earnest. Everything was carefully planned and the gymnasts performed in unison.

19:40 **The gymnasts gathered around** so that we could discuss the test shots together.

19:10 **I gave the gymnasts pose references** to help them understand exactly what I wanted.

19:15 **The gymnasts started getting** into place for the whole composition.

19:20 **I set up my camera** and used a level to ensure that it was square to the floor.

19:40

19:45

19:55

19:45 One gymnast had been a bit late in her jump, and I also thought I should swap her position for a better composition.

19:55 The gymnasts each had their own take-off signal, and with the new positioning and a perfectly timed jump I had the shot I wanted.

◁ in **camera**

portfolio

▽ **Shanghai Moto GP, 2007**
Valentino Rossi was so far ahead of the pack when I took this shot that I was able to isolate him against the lines of the empty grandstand.

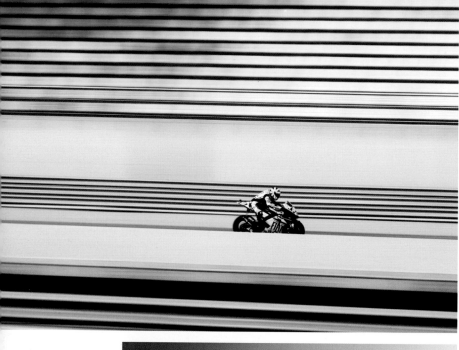

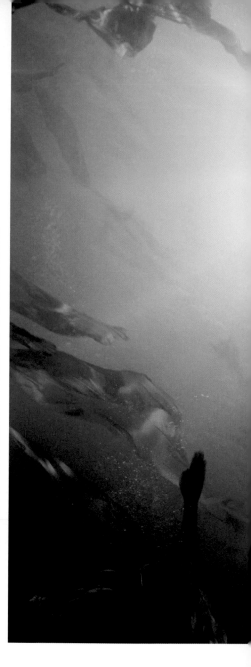

◁ **the diver**
This is Matt Mitcham of Australia, who achieved the highest ever dive score in Olympic history, in Beijing 2008. He wasn't diving in this shot, but was on a trampoline.

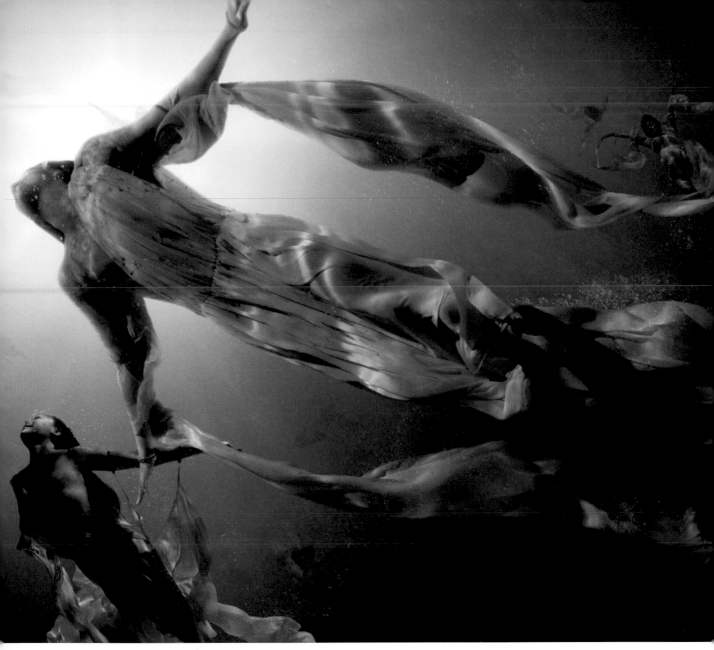

△ **mermaids**
This shot was part of a personal project that I undertook before the Beijing Olympics, for which I photographed 10 Chinese teams. I worked with a local designer to create these costumes, worn by the National Synchronized Swimming team. The final image was created by the talented retoucher, Ferdy Harmsen.

and
finally...

1 master your equipment
Know your equipment so you can react as rapidly as a athlete—instinctively and without hesitation—and without having to take your eye away from the viewfinder.

2 high ISO
Setting high ISO is not just for dark conditions: use high ISO, such as ISO 1000, so you can freeze action with ultra-short exposure times, for example 1/8000 sec.

3 back story
Behind-the-scenes shots can provide fascinating and unusual angles on a sport: start with minor-league games where it will be easier to obtain access.

4 know your sport
For the most involving, emotional images get inside the minds of the athletes and right into action of the sport—but take steps to avoid endangering yourself or others.

5 convey energy
When you freeze very rapid motion such as a car speeding around a track, you need to return a sense of motion: try using sweeping lines.

6 unusual angles
Always be on the look-out for new viewpoints for photography: exploit today's many remote-control options.

7 timelessness
Working in black and white can give a sense of the timeless, universal qualities of sports—the emotion and physical exertion.

8 super-charging
Using hyper-real colors and contrast to depict modern sports imparts a "life-style" feel and emphasizes their youth appeal.

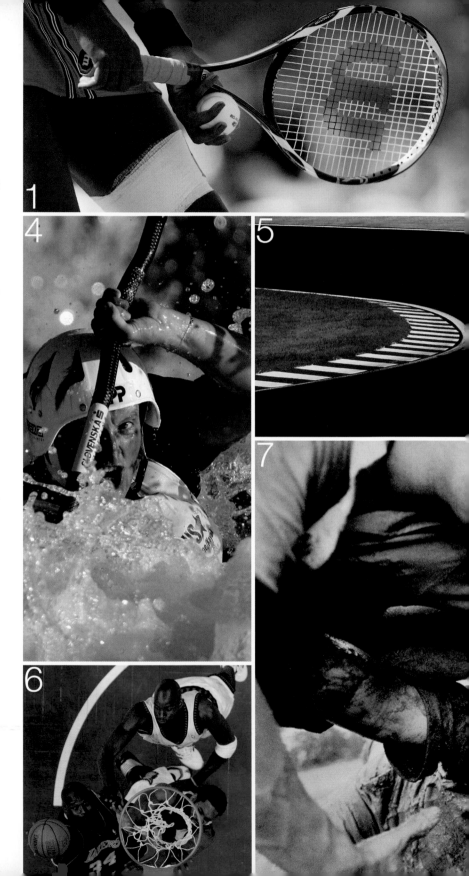

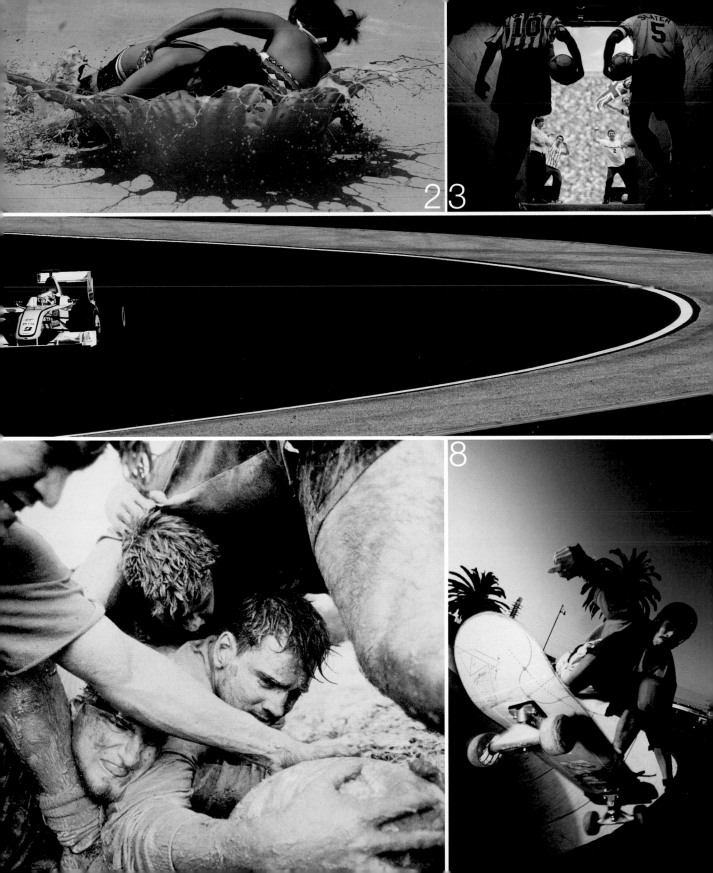

DOCUMENTARY PHOTOGRAPHY

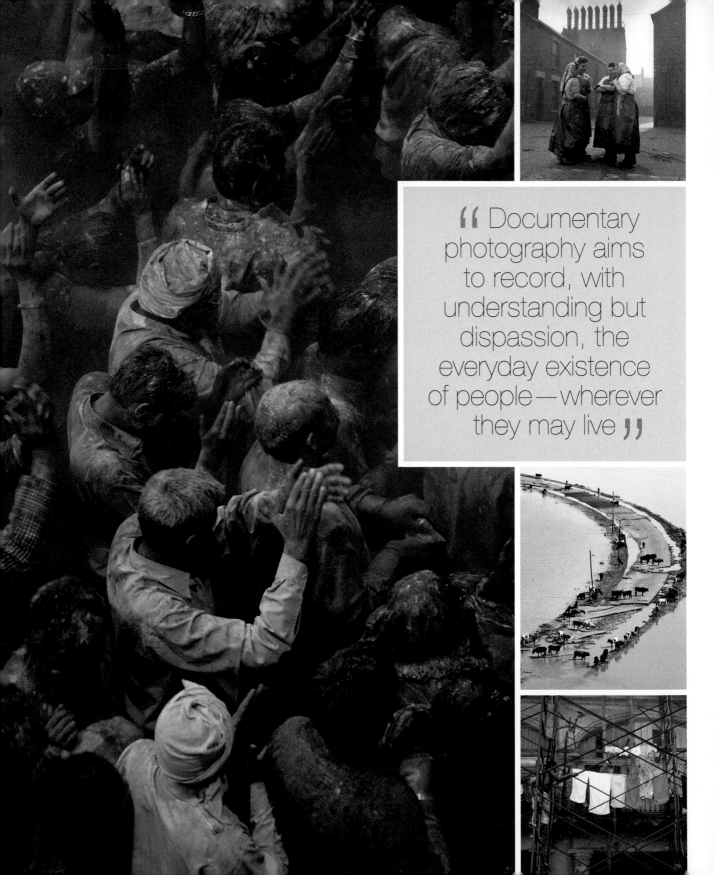

" Documentary photography aims to record, with understanding but dispassion, the everyday existence of people—wherever they may live **"**

Documentary photography has made a great contribution to world affairs, from political coups to environmental change. It acts as a bastion of civil society, a proven defense against corrupt governments and greedy corporations: its unflinching eye revealing unpalatable truths, and recording for posterity those events that some would prefer forgotten.

Thanks to a renewed recognition of their crucial role in today's society, we are now enjoying a resurgence of enthusiasm for documentary photography and photojournalism. That said, the distinction between the two categories is blurred. Documentary photography aims to record, with understanding but dispassion, the everyday existence of people— wherever they may live—to reveal the true nature of human society. Its approach may be the "soft" story, such as family life or the celebration of milestones—birthdays and weddings, for example—that can sometimes be hard to distinguish from other genres of photography. At the other extreme is the "hard" story, such as coverage of gang warfare or animal trafficking. Implicit in the hard story is the need for investigative, long-term, and possibly undercover methods, and the high risk to the photographer of personal injury.

Along the continuum from hard to soft lie photographic stories dealing with universal themes, such as the struggles to feed one's family or a particular community's relationship with the land. These blend with the coverage of current affairs, or the placing of timeless themes within contemporary contexts, such as bringing up children in an area of chronic conflict. Stories of this type lead us to photojournalism. Here the thematic emphasis is on current affairs, usually built around a continuing news story: photojournalism may be defined as providing the back-story to news. For example, the impact of floods on village life, the delivery of aid to victims of famine, or the treatment of the wounded in war zones are stories initiated by newsworthy events, but that illustrate the aftermath of the event rather than the news itself.

Irrespective of where you locate your documentary photography, there are now more people keen to view it than ever before. This type of photography was once consumed largely by northern hemisphere cultures with the wealth to publish glossy magazines. Now, however, it's available to people worldwide. This is arguably a golden age of documentary photography, with people all over the globe taking up their cameras to record both the everyday stories and those that highlight the plight of the disadvantaged on their own turf.

In this chapter you'll find an inspiring range of images, along with well-tested techniques with which you can improve the effectiveness of your own work in the genre.

key moments

1847	**Charles J. Betts** takes the first war photographs during the Mexican-American War.
1855	Photographers document the **Crimean War** for the British Government.
1861	Mathew Brady's team begins to document the **American Civil War**.
1877	The first photographically **illustrated pamphlet** is published, which shows the conditions of the London poor.
1880	The first **half-tone photograph** appears in *The New York Graphic*.
1903	**Lewis Hine** pioneers the use of photography for social reform.
1920s	Bell Labs develops a **teleostereograph** to wire pictures between locations.
1935	The **AP WirePhoto** network is launched.
1936	The first all-photographic US news magazine *LIFE* is published.
1947	**Magnum Agency**, a photographic cooperative owned by photographer members, is founded.
1955	Inauguration of the annual **World Press Photo** awards.
2000s	**Citizen journalism** becomes a widespread method of reporting news.

tutorial: true stories

Building a narrative from a sequence of images is to turn a deficiency—the inability of a single image to tell the whole story—into a virtue. A documentary account told with powerful images has the power to stay in the mind's eye, and to stir a complex of emotions that is unique among all the communication arts.

truth is fundamental

The power of any recounting or retelling of events must be founded on truth. If we don't trust the teller, at best the account is entertaining, at worst it's misleading.

This doesn't mean, however, that documentary photography can be totally objective. All kinds of emotional, cultural, and instinctive factors within you as well as exterior factors outside your control combine to determine the exact framing and timing of each image you record.

What matters most is the spirit and quality of your intentions. Imagine a violent slum area: one photographer may bring back dark images of death on the streets and people living in constant fear. Another photographer working in the same area may find hope in, for example, the dignity of mothers doing their best to bring up their children. Both documents are equally valid, but neither will be entirely objective.

answering questions

Whatever the editorial direction you take—whether attempting to be balanced, to document hope in the struggle, or to expose the despair of the dispossessed—there are simple fundamental elements that make your account coherent. Ensure your photographs answer the key questions—who? what? why? where? when? how?—and you have completed at least half the job.

Who are the main characters in your story? Be aware that for the most part you will have access only to one side: the addicts, but not the drug barons. It's almost always the case that you can photograph only with the full cooperation of the characters you depict. This alone undermines any claim to total objectivity of coverage, but it will allow you more access than if you don't gain the trust of your subjects.

who?
Portraits of the main characters in your story should convey their character through gesture or expression, and also show their environment.

what?
Show elements of people's lives that help to define them—what they eat, their clothes, or their homes. Even better if you can show people working with these elements.

the first casualty

These pictures of war dead during the American Civil War were made in 1863 by Alexander Gardner. But it was not until nearly a century later that scholars noticed that the soldier in the well-known image (**right**) was the same as that in a less well-known image (**far right**). The captions also contradicted each other, claiming that the soldier was from different sides. In fact, the corpse had been moved and the rifle is a prop that reappears in other images.

What is going on? You need to show what the story is about, and thus explain why you are photographing it: portraits alone or beautiful landscapes will not do. And, of course, you will need to show where your story takes place as well as conveying some sense of the time, season, and duration over which the story stretches.

angles to cover

In the process of looking for photographs that answer the key questions, it's helpful to shoot with a view to ticking off a tried-and-tested checklist of shots. The general view sets the scene: it answers the question "where are we?" and gives a sense of the stage for all the action. This will usually be a wide-angle view but could be a long shot from a distance, or an aerial view taken from the top of a building, for example. The aim is not only to show the setting—the surrounding countryside, the state of the buildings—but also to set the mood. Choose this with care, as the general view is often the first image a reader sees.

Portraits show us the people involved, answering the "who?" question. You can get close to people to convey their character strongly, or you may choose to show them

where?

A general view sets the scene by catching interest, encouraging the viewer to enter the scene to learn more, so a clean, clear composition is ideal.

why?

The most emotional images often give answers to the "why" question: because children are most vulnerable, because poverty leads to poor health, and so on.

a day in the life

The best training for more sophisticated picture stories is the day-in-the-life structure. Each image represents a moment in a person's life: here the gauchos of Argentina prepare themselves before work, round up their horses during the day, and rest in the evening after a hard day's work. Aim to take images with a lively variety in tone, color, perspective, and composition.

in their own environment (see pp.34–37) to give a sense of the kind of life they lead, or their relationship to material possessions.

Close-ups take us deeper into the story: we see the significant small possessions, such as a broken lock that indicates the subject's vulnerability and their inability to pay for a repair. You can afford to be artistic and create somewhat abstract images. Shoot with both normal and wide-angle lenses, the latter giving you the opportunity to depict the context of the detail you're examining.

Action is an essential component for giving life to the story: people interacting with each other, children playing in the street, someone preparing a meal. The image need not be very dramatic, but the skill of the documentary photographer is fully tested here. The most effective images are always those that demonstrate total trust between photographer and subject, which is essential in order for the photographer to catch what may be the briefest, most subtle shifts of mood or minuscule action:

the tightened fist around a stone, the brief droop of a head, the tender look between lovers. These shots answer the "how?" and "what?" questions.

Finally, remember to make point-of-view shots—taken over someone's shoulder to show what a scene or action looks like from their perspective.

model releases

A model release is a contract between the subject of a photograph (or their parent) and the photographer that allows the photographer free use of the images. Ideally, model releases are obtained for everyone photographed, but this is practically impossible. If the photograph is used only to report news or current affairs, a model release is, in general, not required. It's always wise to ensure that captions are accurate and unbiased, and the context of use is not derogatory to the subjects. In practice, the further the location of photography is from its use, the more relaxed you can be about lack of model releases.

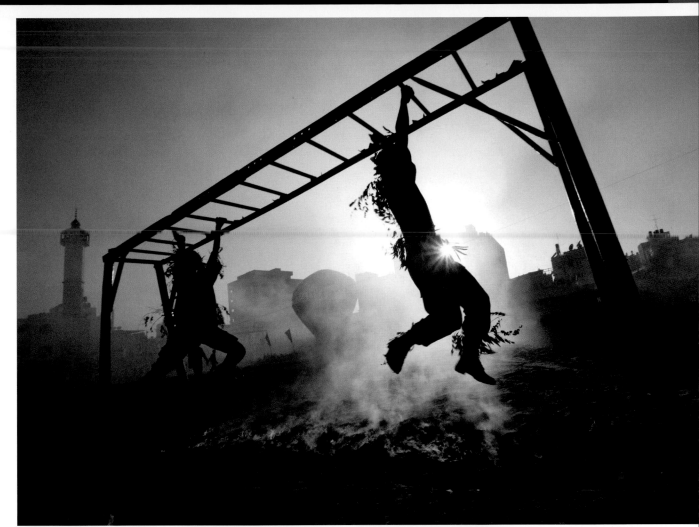

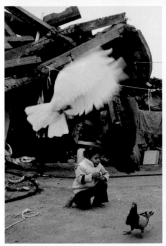

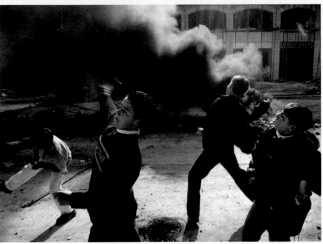

piecing it together

Picture stories don't have to show everything. The power of a sequence may arise from making viewers figure it out for themselves; the process of understanding forms part of the communication. Often a textual clue enables the viewer to piece together the story. Here, the white dove (symbolic of peace but here rather blurred), the stone-throwing schoolboys, and the assault-course training are all clues that the images are from Palestine. The result is a complex of thoughts relating to intractable unrest.

image analysis

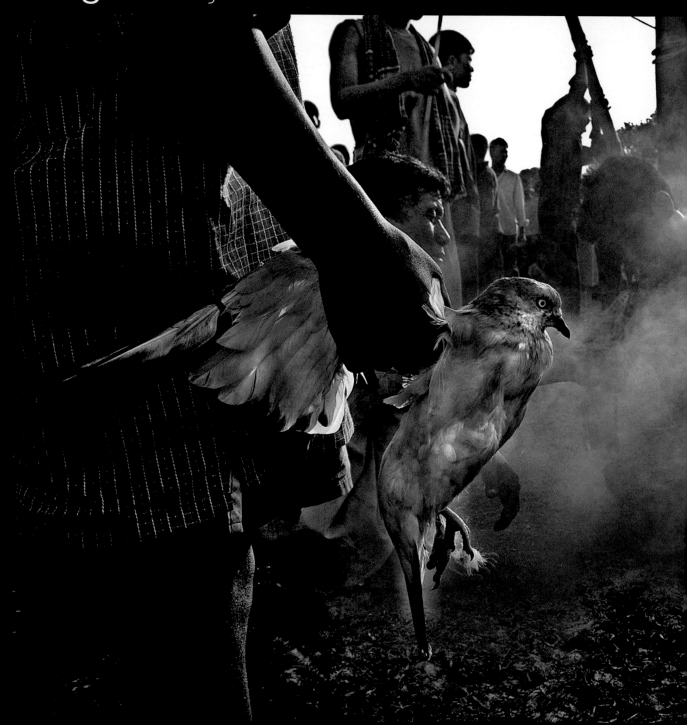

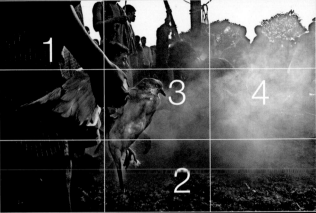

24MM ISO 400 1/200 SEC F/9

It's not sufficiently recognized that the art of finding order in chaos is not only about the decisive moment, but also about the crucial position. For this shot, Munem Wasif was in exactly the right place at the right time.

1 enter frame
The figure entering from stage-left leads with his hand into the frame (resonant for cultures that read left to right). At the same time, the fine pattern on the man's shirt enlivens the framing effect to focus the composition toward the center of the image.

2 setting the stage
The rough ground strewn with debris forms the bottom layer for the rest of the image, contrasting with the relatively textureless smoke that takes up the central third of the image, leading to the blank sky in the top third.

3 victim viewpoint
The crux of the image is in the bathetic detail of the bird's eye: by choosing to shoot from a low position, Wasif is able to catch the whole sacrificial event from the level of the victim, with heart-stoppingly sharp focus.

4 fog of war
While at first glance the smoke seems to mask completely the activity in the background, it does focus attention on the bird. After a while, however, more details emerge as you look more closely at the image.

assignment:
gaining access

In our search for the genuine record—one that's as faithful as possible to the facts as we know them—it's essential to enter into people's personal space. Whether it's to be allowed physically close, into a private space, or permitted to watch sacred or even intimate interaction, the key is to earn trust from those you photograph.

the brief

Record a day in the life of a person or group of people. Choose, if possible, to work with people who don't know you—a large element of your work is to gain trust to obtain access.

bear in mind that people will need to get used to you. It may take days, even weeks or months, before you are trusted sufficiently to be ignored, which is when your subjects will behave most naturally.

try to capture the movement, flow, and rhythm of their life to convey its essential character or quality: a single shot may sum up a whole day, or you may need a narrative sequence that tells the story from dawn to dusk.

must-see master ▶

Katharina Hesse
Germany (birth date unknown)

Hesse studied Chinese and Japanese in Paris and took a short apprenticeship under the renowned photojournalist Peter Turnley (see pp.234–35). She initially worked for a German TV station, before becoming a freelance photojournalist. She has been based in Beijing since the mid-1990s and is one of a few foreign photographers accredited by the Chinese Ministry of Foreign Affairs. Her work has featured in numerous magazines and has appeared in exhibitions around the world.

career highlights

1996 Begins working for *Newsweek*, gaining her first cover in 1999.

2003 Works in China for *Getty News*.

2009 Wins National Press Photographers Association award for *Human Negotiations*, a project looking at the lives of prostitutes in Bangkok.

Ballet school: These girls are being tutored by dancers from La Scala, one of the world's most famous ballet schools. They are oblivious to the photographer—a sign that Katharina is doing her job well.

think about...

1 making the approach
Avoid sneak shots by asking permission and inviting participation. After a short time you'll be ignored, while your subject gets on with their business.

2 eye contact
Signifying the subject's awareness of the camera, eye contact draws the viewer's attention. It can sometimes distract from the rest of the image.

3 intimate actions
Artists and performers are used to being on stage, but backstage access calls for sensitive coverage and full cooperation from the subjects.

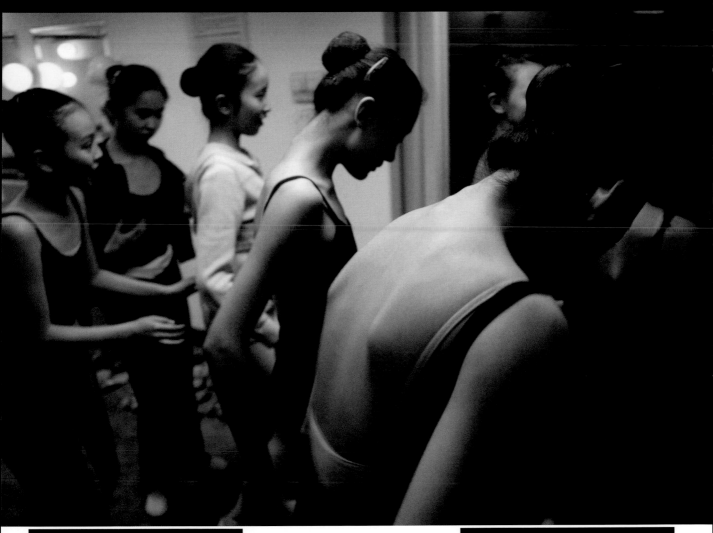

4 where to stand
Getting close enough to the action for effective shots often runs the risk of getting in people's way: watch first, then you will know where to stand.

5 sharing hardship
An effective, but tough, way to gain trust is to share hardships such as storms or cold weather—the most intimate of shots may be your reward.

6 safety first
If you choose to work in conflict zones, stay out of trouble as you could endanger others. When danger levels are high, shoot from a relatively safe position.

natalie behring

Natalie has worked as a freelance photographer
for 10 years, covering stories in Asia, Africa, and
the Middle East for the world's leading publications,
including *The New York Times*, the *Chicago Tribune*,
and *Newsweek*. She lives in Beijing, China.

nationality
American

main working locations
Asia, Middle East, Africa

website
www.nataliebehring.com

in conversation…

What led you to specialize in documentary photography?

I enjoy the whole process of telling stories through photos. My first job at a newswire required me to take mostly single photos that illustrated a concept. As my career developed, however, I began working on longer-term projects that I genuinely cared about.

Please describe your relationship with your favorite subject. Are you an expert on it?

I don't really have a favorite subject, but I love taking portraits. When I first started I was often intimidated by the subjects. As I gained experience and confidence, I was able to overcome the nerves. These days, I always try to have a light-hearted chat before we start shooting and take the pictures in a place they feel comfortable.

Do you feel you have succeeded in being innovative in your photography, or do you feel the shadows of past masters over you?

I'm constantly inspired by other photographers, though not necessarily past masters. I browse through photos on Flickr and am endlessly fascinated by the photos that amateurs and professionals alike are taking all over the world.

How important do you feel it is to specialize in one area or genre of photography?

Not at all. I am so curious about all genres of photography. Whenever I have the chance to learn something new I try to take it, whether it be experimenting with architectural lenses or taking the odd food assignment. I hope everything I learn helps me become more well-rounded.

What distinguishes your work?

It's difficult to say. Occasionally a friend will look at my work and identify it as mine before seeing my name. I couldn't say that my images have a style that can be translated into words, but I hope to be known for working very hard. There are hundreds of talented workaholic photographers out there, though, so it's very tough to get noticed.

As you have developed, how have you changed?

The most noticeable development is that I feel calmer and more confident. When I began, I often felt nervous or worried that I wouldn't be able to produce good pictures.

▲ for this shot

camera and lens
Canon EOS 5D Mark II and 16–35mm lens

aperture and shutter setting
f/2.8 and 1/60 sec

sensor/film speed
ISO 640

for the story behind this shot see over …

Sometimes when I was shooting a portrait I'd feel intimidated by the subject—for example, the CEO of a big company who could only give me two minutes—and my trepidation showed up in the pictures.

What has been the biggest influence on your development as a photographer?

In 2000 I moved to Jerusalem to work for Reuters with Jim Hollander, a Middle East expert. I learned so much from working with him, not just about improving my photography, but how to be a better journalist.

What would you like to be remembered for?

I don't think I've shot whatever it is yet!

Did you attend a course of study in photography?

I studied history in college rather than photography and regret that I never had any formal training. There is a huge benefit to be had from it, not just from the instruction but the support system around it.

How do you feel about the tremendous changes in photographic practice in the past 10 years? Have you benefited or suffered from the changes?

It's wonderful, but it's also frustrating trying get work at newspapers, which are laying off staff, or hearing about images stolen off the internet and used without permission.

Can photography make the world a better place? Is this something you personally work toward?

Photographs transcend language, and images instantly communicate complex ideas, as well as just being a pleasure to look at. I do try to contribute to society and to be a useful human being through my work.

Describe your relationship with digital post-production.

Every time my system is perfected some new upgrade messes everything up. It's wonderful that the quality of digital imaging is improving, but keeping up is costly.

Could you work with any kind of camera?

These days I take many photos with my iPhone! But when it comes to assignments, I've been shooting with Canon cameras for my whole career.

Finally, to end on a not too serious note, could you tell us what non-photographic item you find essential?

My camera bag is hugely important. It's useful to have one that opens at the top, so lenses can be easily changed. I often spend a whole day shooting and need extra pockets for my sunglasses, wallet, and energy snacks too.

behind the scenes

In Manhattan, the recession has led to many storefronts amid the famous buildings being boarded up. I decided to explore this and then move on to Chinatown, where I knew I would find plenty of busy small traders.

09:00

09:15

△ in **camera**

09:00 **I found this empty building** right away and liked its big windows and repeating verticals.

09:15 **In this glass and concrete jungle**, I'm always looking for a way to use reflections imaginatively.

09:40 Even though I'm not a generally gregarious person, I often chat with people along the way to get them involved.

09:50 I liked the light coming through the window, and the missing lettering on the wall fitted well with my theme.

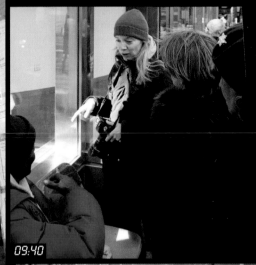

09:40

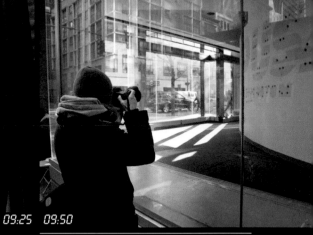

09:25 09:50

09:25 The Empire State Building has been photographed so often it's hard to get an image that's different. I squeezed myself against a storefront to try to shoot its reflection.

09:26 I was pleased with the results, which made a change from the usual direct view.

09:26

△ in **camera**

10:05 **I changed to my 70–200mm zoom** lens to take some shots across the street.

10:10 **The longer lens** gave a very different perspective to the scene.

10:15 **Taking a view upward** often pays off, as there may be interesting displays on the first floor of a building.

10:40 **I had to wait patiently** for a lull in the traffic before I could shoot this shopfront.

10:45 **Changing back to my 16–35mm** lens, I reviewed my shots quickly—it's easy to get so engrossed in what you've just done that you miss great shots meanwhile!

10:55

11:00

10:55 It wasn't long before I found another empty building.

11:00 Inside, the décor had deteriorated badly—all that remained of a formerly successful business.

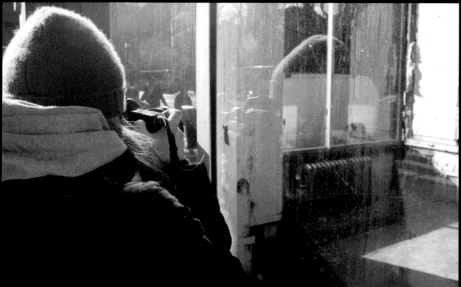

11:10

11:20

◁ in **camera**

11:10 I shot looking in through a window and caught the reflections of the passersby. The bright sunshine created drama with strong tonal contrasts, producing an almost painterly effect.

11:20 I found an empty shopfront in which some of the city's iconic buildings were reflected—symbols of optimism and economic boom set against a more uncertain present.

▷ in **camera**

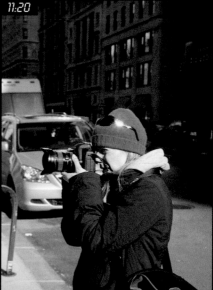

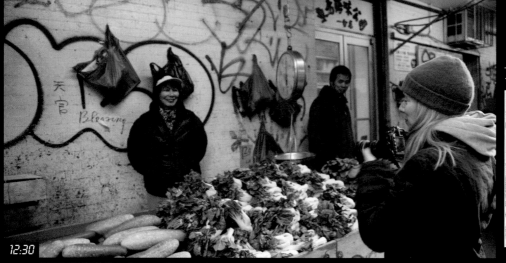

12:30

12:40

12:55

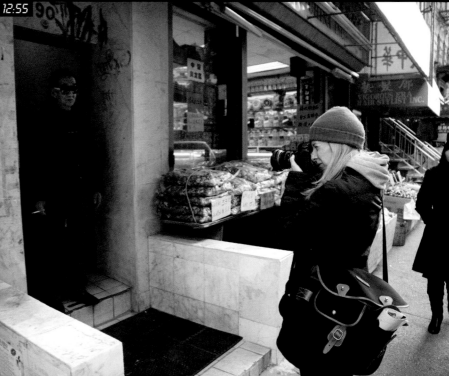

12:30 **Now in Chinatown,** I found a lively, busy scene—a contrast to the empty shops.

12:40 **These two men** sitting outside their restaurant made a nice portrait.

12:55 **This characterful man** allowed me to photograph him—just a friendly smile gains unspoken permission from most people.

12:56 **I checked to make sure** I had the right exposure—the area in the center of the image was dark but the walls were whitish, so they could easily be over-exposed.

12:56

13:15 There are so many interesting buildings in Chinatown. I took my time composing a shot of an arcade.

13:18 Inside, the arcade was a chaotic mix of images, calligraphy, and reflections.

14:00 I walked across the Manhattan Bridge, which has great views of the city, and took a photograph through the mesh.

14:05 These rooftops in Chinatown are particularly popular with graffiti artists.

▽ in **camera**

13:15

13:18

14:00

14:05

△ in **camera**

portfolio

▽ **Ulan Bator, Mongolia, 2003**
I loved how the pigeons looked in this square at the Ganden Monastery in the Mongolian capital. I experimented with some slow shutter speeds to see what kind of effects I could come up with. I was really just playing and got lucky!

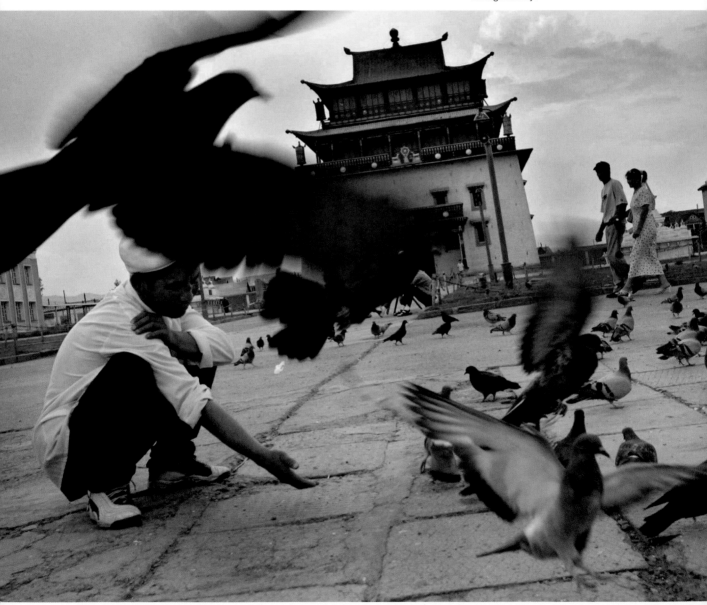

◁ **beneath the veil, Kabul, 2002**
Although I didn't ask permission for the photograph, this Afghan woman and I were looking at each other for some time and she gazed right into my lens. I think we were both fascinated by one another.

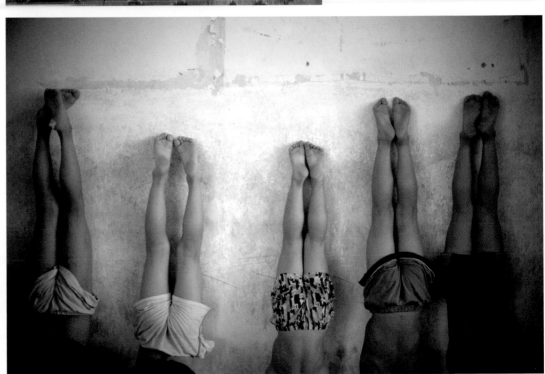

△ **young gymnasts, China, 2008**
I shot this image in the lead up to the Beijing Olympics while on an assignment exploring how Chinese gymnasts work their way up to the national team. It was taken at a sports school in a relatively poor province. As part of their warm-up, the kids were asked to stand on their hands for 5 minutes at a time.

tutorial: composition on the fly

More than any other genre, documentary photography and photojournalism calls for constant readiness, very sharp reflexes, and a consummate mastery of camera technique. The key skill to develop is an intuitive, reflexive ability to compose a picture on the fly and in an instant.

speeding up response

Even if you have no skill in composition, you can greatly improve your photography by cutting out processes that take up time but do not contribute to better photography. This frees you up to concentrate on composition—the one element of technique that even smart cameras have not yet mastered.

A central skill to acquire is knowing what your camera sees before you hold it up to your eye. This can take a lifetime to accomplish, since there are so many subtleties involved. But it is the reason for the old advice to use only a standard lens: because its field of view is close to that of a single human eye, a standard lens needs the least adjustment or exercise of imagination (although it helps if you shut one eye). What you see is what you will get in the frame.

It follows that to be able to compose quickly, you need total familiarity with the world as seen through your lens. (This is much more difficult with a zoom lens, as it has a varying field of view.) As you become more confident, you'll begin to recognize what the camera will capture even before you put it to your eye. In time you will be able to point the camera and shoot, without needing to frame up. Obviously, where you have the time and opportunity you'll frame as carefully as you can.

learn to not zoom

If you use a zoom lens, try shooting without adjusting the zoom setting. Choose a setting, and even tape it down so you're not tempted to change it. You'll find that, contrary to what you might expect, you'll shoot more quickly than usual. You don't have to waste time adjusting the zoom to fit the scene or composition, you simply lift the camera up to your eye, focus, and shoot. The reason why adjusting

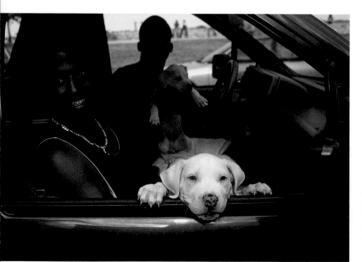

instant frame
Framing devices such as doorways, arches, or car windows instantly organize the image for you, but remember to expose for the nearest subject.

off-center
Compositions with the main subject close to the picture frame tend to look more dynamic than if centered, even if the subject is static, but beware of cropping the subject.

compare and contrast: front and back

Both these images offer radically different views. In part, the lighting in (**1**) is soft and overcast while in (**2**) it is stark and brilliant. But while both images use the metaphor of blurred, indeterminate shapes to signify an uncaring attitude, by facing the subject in (**1**) we have a better sense of his dignity compared to (**2**).

zoom takes time is that each different zoom setting calls for a slightly different composition, so you may simply confuse yourself by fiddling with settings.

As your use of a zoom becomes more disciplined, practice setting the zoom before lifting the camera to your eye, then make the shot without touching the zoom control. This advice is particularly valuable if you use a camera with zoom controlled by a switch or dial on the camera.

keep your distance

As part of the discipline of working quickly, you'll find that in fast-moving situations—and in photojournalism a sleepy afternoon can turn into fast-paced pandemonium in an

instant—manual focusing is faster than auto-focus. The reason is that no focusing at all is the fastest, and if you are using normal to wide-angle lenses stopped down to f/5.6 or f/8, the majority of subjects will fall into adequately sharp focus without the need for adjustment on your part.

Modern cameras react very swiftly to changing light conditions, and by shooting in RAW format (see p.112), you'll have much greater room for adjustment if you or the camera make a mistake. In this circumstance there's not so much to be gained from setting the exposure control to manual: it is better to capture a slightly inaccurate exposure of the right moment than to miss the moment altogether while trying to adjust the exposure.

perspective contrasts
Shots at street-level are more intimate and involving than those taken from further away or high up, but both are useful for setting the scene and capturing atmosphere.

association test
You need to look out not only for compositions, but also for associations, such as these street dogs with the forlorn shop sign "Veterinaria" in the rubbish-strewn background.

tutorial: recording a moment

Documentary photography can be like a time machine that transports the viewer into the past. Not only do visual documents recreate a sense of a historic moment, they can help you experience a sense of a way of life, open your eyes to fashions and culture, and perhaps even invoke sentimental yearnings for the past.

start now

The past starts right now, so the time to start documenting is right now. A part of your neighborhood is about to be flattened to make way for a new big-box store. Old folk gather by the seaside to gossip. Teenagers share headphones to listen to an MP3 player. You can record any scene around you—the very ordinary of today can tomorrow become the nostalgic documents of a heyday we didn't appreciate until it was past.

This is not, however, a call for the unbridled recording of every moment of your life. As an accomplished photographer you want your images to be those that rise to the surface to be seen and valued, while the billions of ordinary images—which are nonetheless documents of a life—sink without trace. Your aim is to capture images with universality of meaning and appeal.

convey a message

In documentary photography, the moment that matters is not necessarily the decisive one, but it must nevertheless have significance. You must aim beyond capturing a composition that brings the elements of a scene into a balanced and dynamic whole—aim for an image that also carries information.

For instance, when documenting a neighborhood about to be pulled down, one moment you could record easily is a composition with people in the street. You could include ordinary passers-by but the document will take on greater significance if it features workers with clipboards and hard hats. In short, aim to pack as much information into your image as possible. This approach will also reduce your reliance on textual information to support your images.

With modern cameras, a great deal of useful information is recorded at the time of image capture. Make the best use of this feature by setting the time and date correctly on your camera. When you travel into different time zones, you'll need to reset the time—but remember to change the time back on your return.

Another important datum is your location. This can be semi-automatically linked to your pictures using a GPS (Global Positioning System) receiver, which tracks your movements. After you download your images, you'll need to synchronize the GPS data with your images.

focus on technique: citizen reporting

With well over a billion camera phones in use around the world, the likelihood is that there will be a camera near dramatic events, such as a local fire, bombing, or accident. Increasingly, news is being recorded by ordinary people. It's important that amateurs understand their ethical responsibility for accurate reporting, and do not alter or manipulate their images. Nor should the desire for fame or notoriety encourage reenactments to "make better shots" or, worse, to be entirely set up. Use camera phones in preference to digital cameras if you need to transmit your images to a picture desk or website. Choose your moment to shoot carefully if your camera phone is slow to save images ready for the next shot. Hold the camera phone with both hands to steady it for sharp images.

intimate observations

Scenes from everyday life may have seemed trivial and not worth recording at the time, but now give us a flavor of a particular era. By using compositional techniques to enhance their visual quality, these images transcend their ordinariness to evoke both a timelessness and a specific period in history.

news records

Documents can not only record important events, such as the launch of a ship or the building of a tower, but can also depict a time past by showing the style of clothing or machinery in use. Again, applied photographic skill is the best way to ensure that your records will be valued in the future.

image analysis

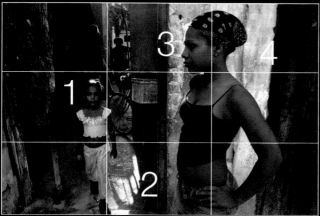

28MM ISO 200 1/125 SEC F/5.6

The ideal street photograph encapsulates a human moment that is a snapshot of social history, within a composition created with visual and photographic skill, such as this striking image by Peter Turnley.

1 spot light

The light—almost a halo over the young girl's head—highlights her and helps carry the viewer's eye into the depths of the picture, ensuring that we see the traffic coming through this bustling alleyway to the buildings at the far end.

2 leading shadows

Bright areas near the center of an image usually attract attention to themselves, but in this photograph the shadows cast by the spokes of the bicycle wheel help to take us deeper into the scene.

3 two in one

The wall on the center-line divides the image into two distinct halves, each almost independent of the other, but tied by color and tone. The wall provides an ideal background for the main figure's sassily beautiful profile.

4 structural supports

The busy image, with its moving and still elements, clearly defined spaces, and contrasts of texture, such as the girl's smooth skin and the dilapidated walls, is held together by pairs of solid vertical lines on both sides of the composition.

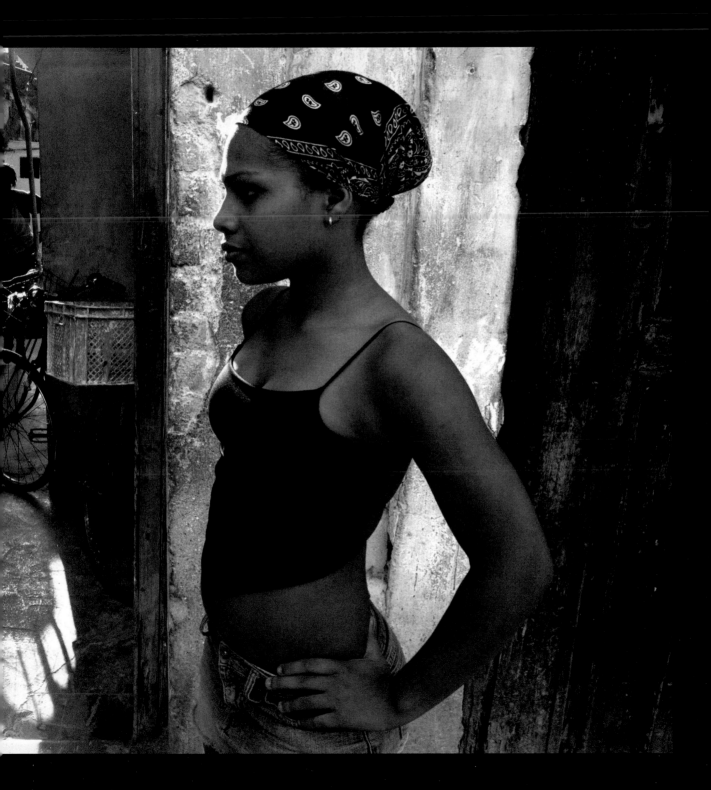

assignment:
record of a walk

As photographers, it is our delightful duty to walk around in a high state of visual attentiveness, readiness to photograph, and constant awareness of developing situations. You should be as alert and as visually aware when you are walking down your home street as when you are exploring a village or byway in some far-off holiday destination.

the brief

Rediscover and re-envision a street that's familiar to you by photographing what you see during a walk along its length. You may choose a busy street full of shops, traffic, and people, or one that is quieter—but aim always for a striking image.

bear in mind that this is a good opportunity to practice very fast-response methods: use manual focus, don't touch the zoom control, and keep your camera and your attention switched on.

try to capture clear, simple compositions that sum up the character of the street or situation in a visually arresting way that effectively exploits light and color.

think about...

must-see master

Ekaterina Nosenko
Russia (1973–)

Also known as Che-burashka, Nosenko took up a compact camera while traveling extensively on business as a certified accountant. Her work took her to London in 2000, where she began to use photography to counter her feelings of alienation in a different culture. As she captured spontaneous moments of urban life, she began to fall for her new home. Nosenko's evocative images are full of reflections, light and dark, people and buildings. They highlight the fleeting moments when beauty emerges from the most mundane environments.

career highlights

2000 Moves to London.

2009 Becomes official contributor to Getty Images Flickr collection.

2009 Self-publishes her first book, *Urban Lyric*.

Dance in the Rain, London, 2008: This image captures a magical moment when a couple, oblivious to the world, spontaneously break into a dance while the light reflects off the wet sidewalk.

1 conflicting elements
Use limited depth of field to organize and separate the many conflicting elements found in the typical urban environment.

2 low options
Shoot from low positions to set people and action against the sky or buildings, working with wide apertures to provide cleaner backgrounds.

3 animal subjects
If you're uncomfortable about candid photography of strangers, try featuring pets and other animals to bring the street scenes to life.

4 regular statements
Look for juxtapositions of subject-matter that tell a story, or make a statement about contemporary life and relationships with the environment.

5 looking down
High vantage points provide scope for creating interesting images, but you may need to wait patiently for attractive compositions to arise suddenly.

6 decisive moments
Aim for shots that don't look like a chaotic melée even though, a split second later, the scene may instantly dissolve back into a random pattern.

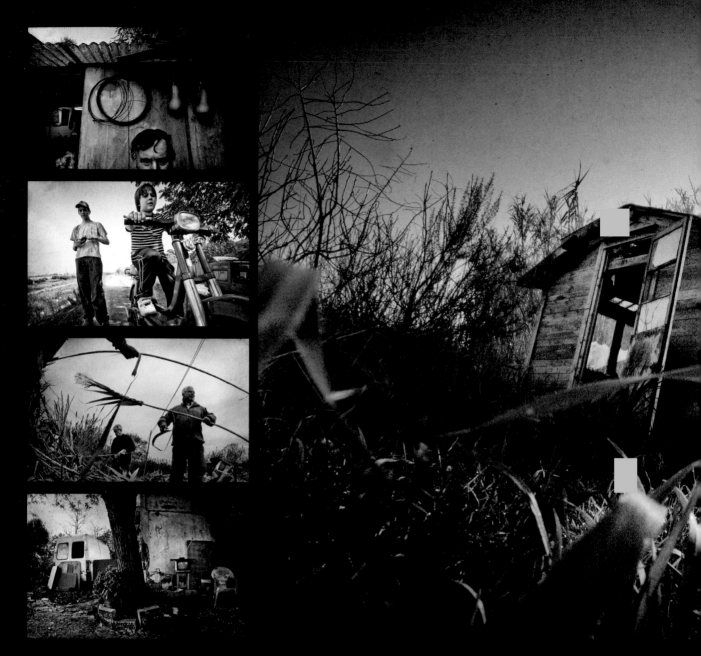

salvi danés vernedas

Salvi's work is published in numerous magazines and he won second prize in the Photojournalism and Documentary Sport category of the Sony World Photography Awards 2009. He holds photography workshops in his home town of Barcelona.

nationality
Spanish

main working location
Spain

website
www.salvidanes.com

in conversation...

What led you to specialize in documentary photography?

There are a number of things that drew me to documentary photography, but mainly the fact that it deals with real life.

Please describe your relationship with your favorite subject. Are you an expert on it?

I think we are always learning and we should approach our profession with humility. This helps us to gain knowledge from everybody. In my view this is one of the things that defines documentary photography—it's a learning tool for both the photographer and the viewer.

Do you feel you have succeeded in being innovative in your photography, or do you feel the shadows of past masters over you?

It's always difficult to innovate because photography has its limitations, but I think I'm not the best person to answer this question. In any case, as well as making a contribution in the field of photography I would also like to contribute to the world in general.

How important do you feel it is to specialize in one area or genre of photography?

I think any photographic discipline requires a knowledge and understanding of it for success. Concentrating one's own efforts in a particular field combined with drawing on the experience of other photographers will always bring new ideas to the genre.

What distinguishes your work from others?

It's difficult to say when there's still so much to cover and so much more to learn. In my case, I emphasize aesthetics in order not to produce a mere record of information.

As you have developed, how have you changed?

My way of looking at the world, and at the beauty and fragility of everything around us, has changed.

What has been the biggest influence on your development as a photographer?

Putting myself in the shoes of the person being photographed; understanding and above all respecting someone who rewards me with a moment of his or her life.

▲ for this shot

camera and lens
Nikon D300 and 14–24mm lens

aperture and shutter setting
f/14 and 1/800 sec

sensor/film speed
ISO 200

for the story behind this shot see over ...

What would you like to be remembered for?

I would like to be remembered for my empathy for the people whose photographs I take.

Did you attend a course of study in photography?

I started in the field of general photography. Later, I wanted to specialize in documentary photography so I studied different courses at IEFC (Institute of Photographic Studies of Catalonia) in Barcelona. I think all training is beneficial but it must always be combined with a willingness to teach yourself.

How do you feel about the tremendous changes in photographic practice in the past 10 years? Have you benefited or suffered from the changes?

It's been just a few years since I started in the world of photography, so I haven't suffered from the changes as directly as some others. I understand there's a sense of loss of prestige because digital cameras are easier for amateurs to use effectively and there is less mystique about technique. Perhaps, in some cases, this is based mainly on misunderstanding.

Can photography make the world a better place? Is this something you personally work toward?

We can't deny that the visual power of an image makes an audience think. Documentary photography is not only a way of expression but of denunciation and social conscience: these two functions must be kept in balance. The problem is that the sheer amount of information we get from the media spoils the informative value that photography has, or pushes it into a mere photographic complement at the expense of its own power.

Describe your relationship with digital post-production.

I started photography as the digital technology age got under way. Although I think there are losses as a result of this revolution, everyone should be able to use the necessary tools to create their own photographic language, but above all maintain their ethics.

Could you work with any kind of camera?

To achieve a good work pace you need a training period with a camera. Everyone should consider their own needs and then choose the equipment accordingly.

Finally, to end on a not too serious note, could you tell us what non-photographic item you find essential?

Comfortable boots.

behind the scenes

My visits to this location in the suburbs of Barcelona are ongoing, two or three times a week. Over the course of six months the people here have accepted my presence, though it was a matter of gaining their trust.

13.20 **As the location was familiar,** I knew the lens I would need—a 12–24mm f/2.8 zoom.

13.40 **It takes only 20 minutes by car** to reach the location, which makes frequent visits easy.

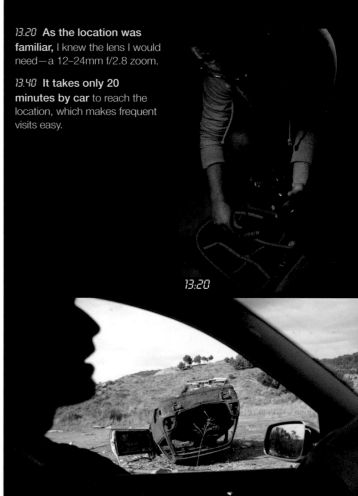

13:20

13:40

14:00 **A steep climb** from where I parked the car took me from modern Barcelona into a different world.

14:45 **My laptop was useful** not only to look at pictures but also to take down notes on the location.

△ in **camera**

16:40 **Late afternoon shadows were** lengthening, creating interesting light on the rickety angles of the shacks.

18:50 **As light levels fell toward evening** it was possible to find new perspectives on the scene.

20:30 **Back in my studio,** I began work to achieve the final effect I wanted.

portfolio

▽ **camper van, 2009**
This photograph was taken on a spring morning at a campsite in the Camargue, southern France, when all was still quiet and the sun was not too hot. I created the "aged" effect on the computer.

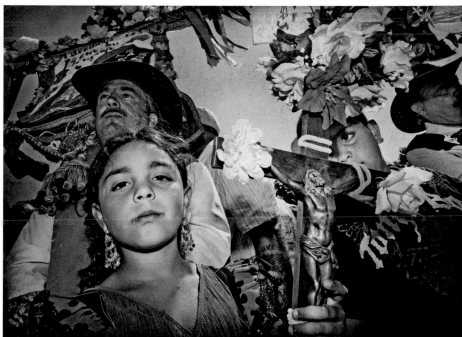

▷ Roma festival, 2009

Thousands of Roma gypsies gather each spring in Saintes-Maries-de-la-Mer, southern France, for a festival in honor of Saint Sarah. This picture captures the serious expressions of pilgrims, both young and old, who are lost in moments of spirituality.

△ Sunday morning sports on Barceloneta beach, 2008

This elderly athlete is doing his daily morning exercises. It is a clear demonstration of the battle of strong will against age.

and
finally...

1 set the stage
Look for vantage points that offer not only a scene-setting general view but compositions that are eye-catching in their own right.

2 telling contrasts
Combining contrasting elements—war/peace, love/hate, light/dark—is a most effective way to tell a story with a single shot that does not need text for support.

3 monoculture
The traditional medium of documentary was the black-and-white photograph, and it remains capable of emotion and powerful abstraction.

4 in the wings
Ensure that you cover the back-story: the origins of the event, the lives of its actors—these elements give depth and longevity to documentary photographs.

5 sparing technique
Traditionally, documentary photographers avoided camera effects, but some, such as motion blur, are acceptable provided they don't distort reality.

6 in the thick
The old adage "If it's no good, you're not close enough" is as true as ever: the best working distance is touching distance.

7 location with a view
Take the time and effort to plan a shoot to ensure that you're in the best location to record the action in a dynamic way.

8 in trust
To gain trust, you must deserve it: take your time, be honest and pleasant, then people will open up to you, and let you into their lives.

EVENT AND MILESTONE
PHOTOGRAPHY

> **In the early days, photography was not sufficiently agile to follow events—even stately processions—so it enforced a regime of static and formal poses**

Event and milestone photography is almost as indispensable as the rites and rituals it documents, so terrified are we that the important moments will have only our fragile memories as their record. In the early days, photography was not sufficiently agile to follow events—even stately processions—so it enforced a regime of static and formal poses.

It took many years after its invention before photography could master the recording of events and celebrations. Yet today, we take it for granted that photography is the ideal medium. In the early days, every aspect of photographic practice mitigated against speedy response: sensitive materials had to be coated individually, response times were slow—which called for bright sunlight—and lenses were also slow. In addition, to make the photograph you had first to focus the camera, stop down the lens and close the shutter, then load the film before making the exposure. In that time interval—at least three seconds, even for the most practiced operator—the subject had to keep very still.

In order to make a virtue of necessity, the strategy of the carefully staged pose was invented. Unable to keep up with a rapid flow of events, photographers simply stopped the action to suit their purposes. The "important" people were gathered and photographed in groups as though they were taking part in the event.

Today, photographing formal groups is a practice that we still see—at weddings, formal dinners, and awards ceremonies—but its function is mainly to prove the presence of the subjects. However, photography has also

key moments

1843	A patent is approved for a **swing-lens** panoramic camera used to photograph large groups.
1864	**Flash powder** is used for illumination.
1888	**Kodak No.1 camera** combines a pre-loaded camera and printing service.
1893	The **first flash bulb** filled with magnesium-coated metal ribbon is ignited electrically.
1900	Kodak launch the **Box Brownie**, making photography accessible to the masses.
1947	The first commercial **instant camera**, Polaroid's Land Camera, is launched.
1950s	**Wedding photography** moves out of photo studios to record the event on location.
1980	Former sports photographer Denis Reggie coins the phrase "**wedding photojournalism**".
1988	FUJI DS-1P, the first consumer **digital camera**, is launched.
2000	The world's first **camera phone** is introduced in Japan.
2005	The **Flickr website** is launched.

become more nimble on its feet and it's possible to work in any conditions—even in the dark—so we can now report on the event itself. Generally, the emphasis has shifted away from recording the presence of certain people to capturing a sense of the occasion. Photographers can show people enjoying themselves and record significant moments as they occur, without interrupting or interfering with the proceedings. Taken to its extreme, you can now aim for fly-on-the-wall documentation of proceedings.

Of course, some people might not want everything to be recorded. In the early years of photography, it was considered impolite to photograph anyone while they were eating and dignitaries were never shown drinking. Now, it's hard to determine what's acceptable to photograph and publish on global social networking sites. You can take formal, posed images, record events as they occur, or operate like a documentarist for whom all and anything can be recorded. Or you can be more selective, to avoid embarrassing any parties or to give an editorial slant to your coverage, perhaps by emphasizing the joy and happiness of the event, or recording the splendid costumes or the fireworks.

tutorial: instinct, luck, and planning

The old news photographer's advice "f/8 and be there" is as sound as ever. Nowadays we may not need to worry so much about camera settings, but the burning question is where exactly you should be to get the shots. The answer relies on one part instinct, one part luck, and one part planning.

instinct

In photographic terms, instinct is what makes you first set out with your camera. It drives you to make the effort to reach some destination and trudge around for hours, carrying all your equipment, fueled only by the feeling that today you will capture a great image. Beyond the urge to take photographs, instinct is what prompts you to walk that bit further than you intended, or to look up or around the corner. It tells you to wait on a street corner until something you did not know would happen does happen: you had only to be patient and hold the camera ready for the image to walk right in.

While you can't change the capacity for instinct you were born with, you can change how much attention you pay to it. A large part of the fun of photography is that listening to instinct is so often and quickly rewarded. The vital element is taking the extra step or time needed.

luck

Following your instinct is part of the process of being so prepared that luck favors you. Why might you feel like turning the camera on and lifting it up to your eye when there is nothing to photograph? Don't question it, just do it; when two people walk into shot and kiss passionately but briefly, you have your picture, not only because you were lucky but also because you were prepared. If you had seen their kiss and grabbed your camera you might have drawn attention to yourself as a voyeur and you would still have missed the moment.

planning

There are practical steps you can take to help both your instinct and your luck, of which planning is the most important. The first step is to log the dates of key events in

get in early
Careful groundwork not only wins you trust but also special access: work softly and quietly to capture the preparatory moments before a performance.

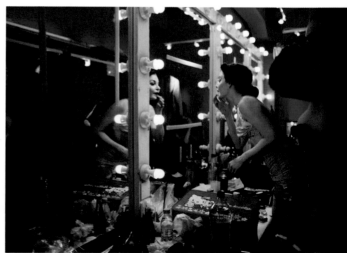

the professional approach
Professional performers are usually well used to being photographed, but to be sure of obtaining permission approach the management as early as possible.

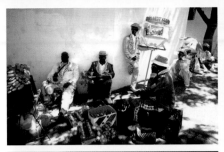

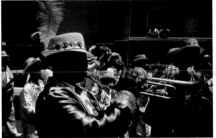

parading views

A colorful parade under clear skies is a dream job for the photographer: from beginning to end, and from every angle, color and activity will pass non-stop in front of your lens. Ensure you do the parade justice by covering it from start to finish and from high, low, far, and near. Along the way, exceptional images such as the clean silhouette of the man shown here will present themselves.

your planner, especially if events are close together but geographically distant, requiring traveling time and accommodation. Before an event, try to scout the location to discover where best to position yourself. Bear in mind that this will usually be where every other photographer will want to stand, so explore other options if you don't want to be with the crowd. You can also contact the event organizers to see if you can obtain permits for favorable access.

If you will be working outdoors, check the path of the sun so that you can try to avoid shooting into the shadow side of an event. Talk to local people—bartenders, newspaper vendors, and street stall-holders—to learn about the event and to make yourself known. If people like and trust you they may help you get in front of other spectators or even offer their balcony to shoot from. Local help is always gratifying to win and can prove invaluable.

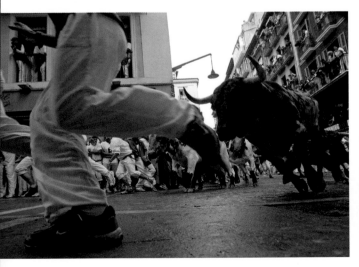
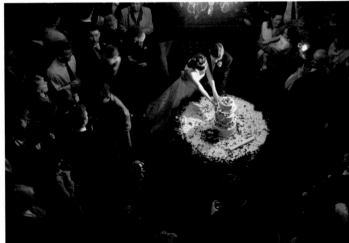

get down

Shooting from low down has many benefits: from behind crowd control barriers it enables you to avoid signs of metalwork while also providing a dynamic viewpoint.

bird's eye view

For a clear view of key ceremonial moments, try to reconnoiter some unusual vantage points such as an overlooking balcony.

tutorial: oblique views

An effective way to add an unexpected twist or an element of surprise to images of familiar events is by showing an unusual or partial view of the proceedings.

creative approach

As photography offered ever-improved technical means to keep pace with events as they unfold, photographers could develop more informal styles for their coverage of life's milestones. The formally composed set-pieces—stiff and dignified—were replaced by gaiety and backslapping, which were much more fun. The most recent development has come from the fact that now absolutely everyone brings out their cameras at every event, from a military parade to a wedding. This has put professional photographers on their mettle. They must search for angles and interpretations that, as well as being creative and inventive, raise their images above the ordinary. The result is a trend toward approaches inspired by photojournalism. At the same time, we now expect to see the small details that can define the event.

all hands on deck
Since we do so much with them, details of hands are always informative, and their inherent beauty makes them ideal subjects.

incidentals
Record everything you see during the event, especially incidental details, since they help to build a rounded picture of the occasion.

dress sense
Celebrations bring out all the best costumes and color, so let your camera roam over the details and record them in their own right.

small but perfectly formed

Should you be the "official" photographer at an event, your task is two-fold. Primarily, of course, you must make a record of all the key moments using your skills to ensure that the images are not only sharp and well-exposed (the guests' cameras can manage that much), but are also well-composed, catch the moment perfectly, and are distinguished from the amateur snapshot in some way. Limited depth of field obtained by using a large aperture is the easiest way. Superior image quality is another.

The other part of your task is to record the aspects of the event that guests may not think of recording, but which nonetheless contribute to a rounded record of the event. Guests may not have access to the dressing-rooms for

the bride or groom, or carnival performers, for example, but often the most charming and amusing moments occur in the run-up to the main event. It takes a professional to be able to capture such fleeting moments in the midst of frenetic activity, while keeping out of the way.

Then you can amuse yourself with all the peripheral details: the rows of champagne glasses, the street decorations, the details of the costumes. Don't forget signposting, such as street signs or the nameplate of the hotel hosting the event. Treat each shot as a mini-exercise in still life, shooting with a variety of settings. For example, shoot a row of glasses from a steep angle and from above; with a small and large aperture; with long focal-length from a distance; and with a short focal-length.

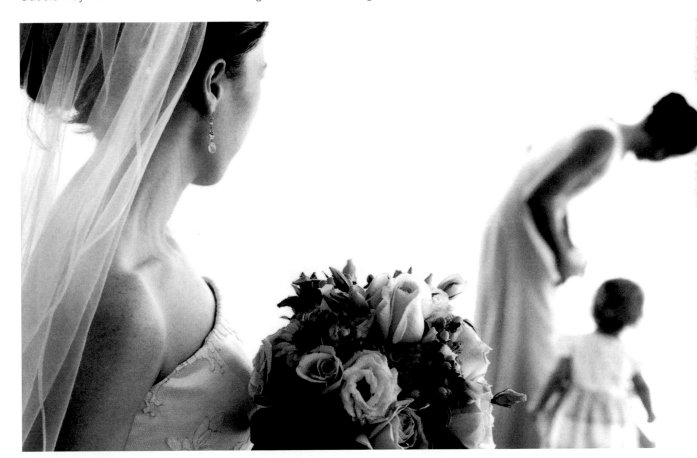

visual ambiguity
The framing of this shot points to the action to the right, but the focus draws attention back to the bride and flowers, with the net result of visual tension that confers a quiet drama to the image.

image analysis

28MM ISO 100 1/15 SEC F/16

It's a mistake to regard sharpness as essential; in fact, too much may spoil the mood. In the right circumstances a lack of sharpness is a highly expressive gesture, as Peter Adams demonstrates in this photograph.

1 leading the eye

High-contrast lines look sharper than they are in reality. These trombone tubes are crucial to the image as they catch the eye and take the attention straight into the procession, which is so gloriously busy you can almost hear the band.

2 false sharpness

Patterns in movement that are caught with relatively long exposures such as in this image can appear to be sharper than they are when different parts are superimposed on one another. This reinforces edges, making them look relatively sharp.

3 unifying elements

The bells of the four brass instruments in this image are vital for holding the composition together. They give the eye easily identifiable elements from which to explore the more blurred parts of the image.

4 eye contact

The eye contact in this image is indistinct and fleeting; arguably that is appropriate, given the subject. Nonetheless it is important, as looking at a face provides a brief respite for the viewer's exploration of the image, and a point of human contact.

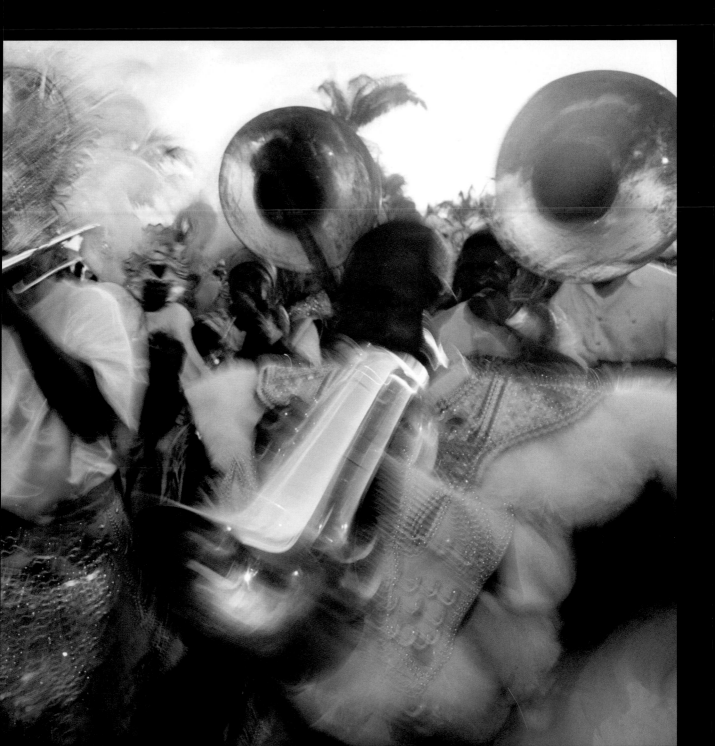

assignment:
one-shot summary

A picture can be worth far more than a thousand words. Some photographers have created single images that have encapsulated the very essence of a person's life or a turning point in history. Successful pictures that sum up an event or milestone work at a symbolic or iconic level, using visual universals understood by all.

the brief

Capture a powerful image of any event that you cover. Aim for a crucial moment in the event that allows you to combine energy and intensity of emotion, while creating a strong composition.

bear in mind that this moment within the main event may be quite small and transient, but if you capture a strong image it can stand for the whole. A visually gripping image with convincing composition is essential, preferably with strong colors or lighting.

try to capture the mood of the event—whether a child's birthday or a dramatic festival—in visually appropriate ways. These could be humorous, sad, gentle, or violent.

must-see master ▶

Cristina García Rodero
Spain (1949–)

Rodero studied painting at the School of Fine Arts in Madrid, before taking up photography. Many of her studies focus on traditional Spanish festivals. She tries to photograph "the mysterious, true, and magical soul of popular Spain in all its passion, love, humot, tenderness, rage, pain—in all its truth." In the late-1990s, she began to travel widely in search of the traditions of other cultures, and visited Haiti many times to record the extraordinary voodoo rituals.

career highlights

1989 *España Oculta* ("Hidden Spain") wins Book of the Year at Arles Festival of Photography.

1996 Receives Premio Nacional de Fotografía award in Spain.

2009 Becomes the first Spanish full member of Magnum agency.

La Cremá, *Las Fallas*, Valencia, 1991: The spectacular culmination of *Las Fallas* ("The Fires") festival, sees the burning of hundreds of huge cardboard, wood, papier-mâché, and plaster sculptures.

think about...

1 universal themes
There's nothing wrong with featuring the same moment as a million others have, so long as your image genuinely and concisely captures the event.

2 abstracting the image
With intrinsically graphic subjects, such as military parades, you can work with abstract imagery that emphasizes patterns and colors.

3 contextual framing
With good planning you can use a personal moment to frame the bigger view. In this image the foreground provides a sense of scale too.

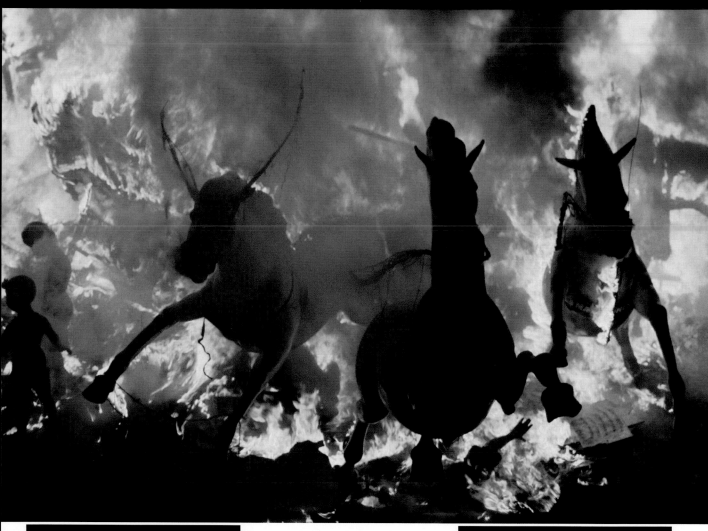

4 simple overviews
Some events have so much going on that almost any shot will capture a great deal. The myriad details you sweep up will encapsulate the event.

5 humorous asides
Every big event has its little heroes who are as much part of its spirit and energy as the big players. Rely on the little ones to provide gentler moments.

6 being in the thick of it
At some events the only way to capture the best shots is to get yourself right in to the activities. But never forget to take care of your camera!

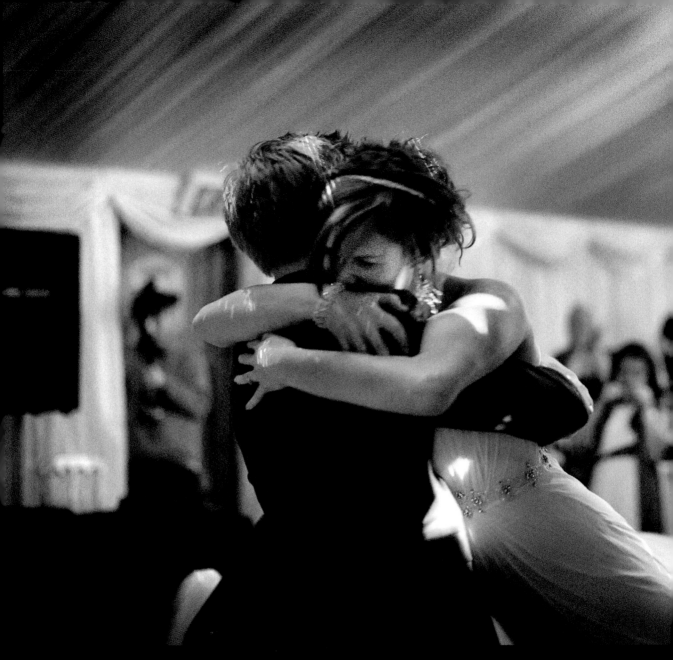

jeff ascough

Based in the north of England, Jeff has exhibited all over Europe and has seen his work published in magazines worldwide. He holds masterclasses in wedding photography and is an international ambassador for Canon cameras.

nationality
British

main working location
UK

website
www.jeffascough.com

in conversation...

What led you to specialize in wedding photography?
I began my career working for my parents' business, shooting studio portraits. When I left to start on my own in 1991, I didn't have a studio. Weddings were really the only thing I could do without having studio space.

Please describe your relationship with your favorite subject. Are you an expert on it?
I am an expert in my chosen field of photography. I have 20 years' experience and have covered well over 1000 assignments. My favorite aspect of wedding shoots is definitely low-light winter photography.

Do you feel you have succeeded in being innovative in your photography, or do you feel the shadows of past masters over you?
I would like to think that my work has been innovative. As far as I know I was the first wedding photographer to really use the documentary style in the wedding environment.

How important do you feel it is to specialize in one area or genre of photography?
It's absolutely essential. If you concentrate all your time and effort on your chosen genre you will master it. Photographic genres are so different from one another, even though we all use largely the same equipment.

What distinguishes your work?
I would think that possibly the truthfulness within my images and the idea that my work has an honesty about it, along with a high level of technical proficiency in terms of light and composition, are what makes it unique.

As you have developed, how have you changed?
Elements such as composition, light, and storytelling have grown more important to me. I often look for light and composition and then wait for the decisive moment to happen within that picture. Early in my career I would just snap away blindly, hoping to achieve a good picture.

What has been the biggest influence on your development as a photographer?
The work of Cartier-Bresson. I study it passionately and as I've grown older and my work has matured I still see things in his work that push me to improve my own photography.

▲ for this shot

camera and lens
Canon EOS 5D Mark II and 50mm lens

aperture and shutter setting
f/1.6 and 1/160 sec

sensor/film speed
ISO 6400

for the story behind this shot see over ...

What would you like to be remembered for?
I would like to be remembered for changing the public's idea of what a wedding photograph should look like.

Did you attend a course of study in photography?
I started a part-time City and Guilds course in the late 1980s but quickly outgrew it. Photographic education has a value, but people should use it as a starting point and not allow it to stifle their creativity.

How do you feel about the tremendous changes in photographic practice in the past 10 years? Have you benefited or suffered from changes?
It's been great. I've adapted really well. Photography has become a very important part of people's lives because it's so accessible now. The downside is that there are more photographers in the marketplace, but the upside is that the general public has a much greater understanding of what makes a great picture.

Can photography make the world a better place? Is this something you personally work toward?
It can bring our attention to different events and situations in the world. James Nachtwey springs to mind as a great photographer who really pricks the conscience of the viewer. But whether photography is strong enough to make the world a better place, I'm not so sure. I would be surprised if photography has the power to change things. I also think people are suspicious of photography, especially with the prevalence of photo manipulation.

Describe your relationship with digital post-production.
The computer has allowed me to take my pictures and produce what I envisaged at the moment I pressed the shutter. It has allowed me to give my images a signature, and to improve the quality of my work. I much prefer working with a computer than in a smelly darkroom.

Could you work with any kind of camera?
I've used several cameras throughout my career—rangefinders, SLRs, twin-lens reflexes. You name it, I've used it. Currently, I use Canon professional dSLRs for all my work. I love their skin tones even at a high ISO, and the cameras have always appealed to me ergonomically.

Finally, to end on a not too serious note, could you tell us what non-photographic item you find essential?
My iPhone.

behind the scenes

This wedding took place in the countryside, and I had to travel there through a blizzard. No matter what the weather conditions may be, a wedding photographer has to be prepared to deal with them and turn up on time.

12:00 Arriving at the venue, I unpacked the equipment I needed. I always carry a spare camera body and lenses.

12:10 I was pleased to see that the light conditions in the tent were fine for my purposes.

12:15 Before starting to shoot I explored the whole venue to investigate its possibilities.

12:25 **Having reached the room** where the bride was preparing, I took a shot through the open door.

12:30 **I used a 70–200mm lens** to isolate certain moments amid the chaos of the crowded room.

12:35 **Changing to a 16–35mm lens,** I photographed the bride having her make-up applied.

▽ in **camera**

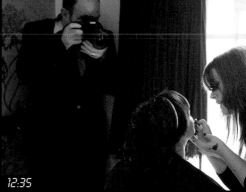

12:50 **A lot of time and care** goes into organizing a wedding, and it's my job to make sure that the photographs include the small details that are part of the day.

13:50 **The main illumination** as the bride hugged her father came from a window to the left. The wall light gave only a little background illumination.

◁ in **camera**

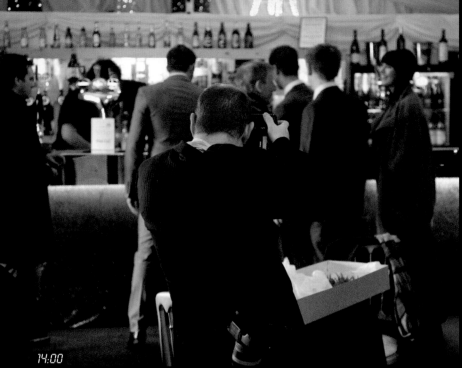

14:00

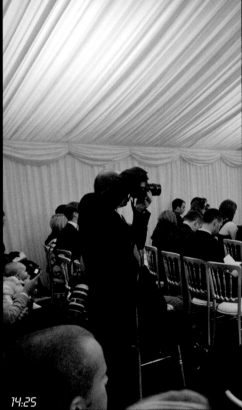

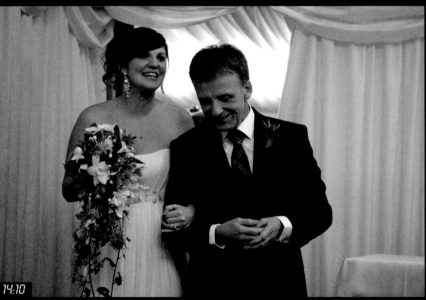

14:10

14:25

15:15

14:00 In the bar area, I used a 50mm f/1.2 lens at f/3.5 to give sufficient depth of field for the people to be captured clearly.

14:10 For the bride's entrance, I stood to the side of the aisle so that I could photograph her and her father head-on without getting in their way.

14:15 I checked the LCD periodically to make sure the camera was functioning properly and the exposure was fine.

14:15

14:25 **Once the bride and groom** were in place at the ceremony, I could move to the center of the aisle.

15:15 **I consulted the bride** to check that we were covering all the formal shots she had asked for.

15:25 **It took no longer than 10 minutes** to do half a dozen formal shots—couples prefer my documentary style, but there's always a requirement for some family shots, too.

16:20

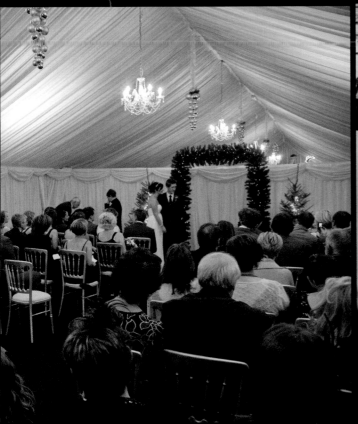

15:25

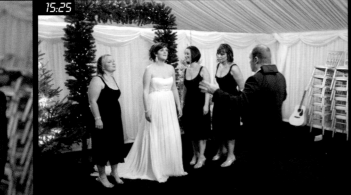

17:00

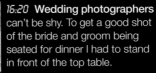

16:20 **Wedding photographers** can't be shy. To get a good shot of the bride and groom being seated for dinner I had to stand in front of the top table.

17:00 **This shot, full of emotion and spontaneity,** was exactly what I wanted before taking general shots of the partying.

△ in **camera**

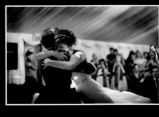

portfolio

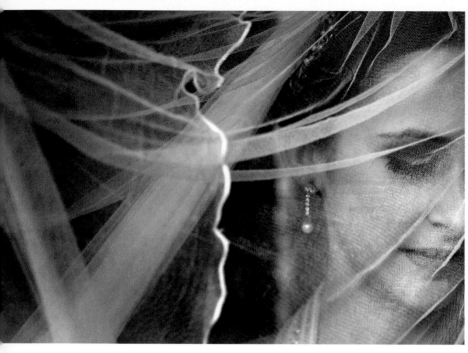

△ **beneath the veil**
As the bride entered the porch of the church,
the light was fading. Fortunately, I managed to
catch a lovely moment as she had her veil adjusted,
even though she was surrounded by two ushers,
six bridesmaids, her hairdresser, and the minister.

◁ **the wedding morning**
The bridesmaid's dress is creased,
Mom still has curlers in her hair, and
the ring bearer is eating snacks. For me
this picture portrays perfectly what the
wedding morning is all about.

△ an intimate moment

I like this image because all around the couple the party is in full swing, yet they are isolated in this beautiful moment. I used a high ISO so that I could shoot unobtrusively without resorting to flash.

tutorial: light and dark

Lighting conditions at events or celebrations appear beyond your control; when it's dark, you may feel the need for your flash. Another approach is to make the best of any light condition, however poor it may seem to be. If you can appreciate its qualities, you can make any light work for you.

stay in the dark

Exposure control systems work in a way similar to the eye in attempting under all circumstances to render mid-tones correctly. This ensures that flesh tones keep their natural color and that other colors remain as true as possible. This similarity holds good in bright to medium-bright light (such as in the shade on a partially cloudy day) but as light levels fall, the two systems diverge.

Photographic exposure controls can continue to increase exposure to compensate for low light, but the eye cannot. This leads to a common error: when it's dark, photographers try to record images as if the light levels were brighter, resulting in images that are too light. If you choose instead an exposure that allows the image to be as dark as experienced, the biggest problem with working in low light is instantly reduced.

the key exposure

One way of expressing this solution is to "under-expose," but that suggests you apply the "wrong" exposure. In fact, you simply proceed as normal: expose to ensure that the key tone—light on a face or catchlight in the eye—looks as we would see it in reality. This forces shadows to be completely black and your camera meter will complain of under-exposure. However, a dark image will be sharper and have better color than one that is too light.

With this simple strategy, dark conditions that once seemed challenging will become inviting. If you're limited to lenses with a relatively small maximum aperture or with low maximum sensitivity, concentrate your attention where there is light such as rim-light or highlights and use them to define and shape the shadows. If you have to work with automatic exposure, try setting override or compensation to between −1 and −2 stops, or even greater.

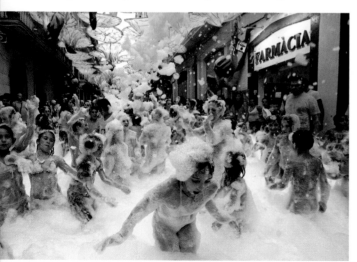

daylight brilliance
Fast and furious action is ideally caught in bright light. Working on a sunny day out of direct sun is best as you can catch action without excessive contrast.

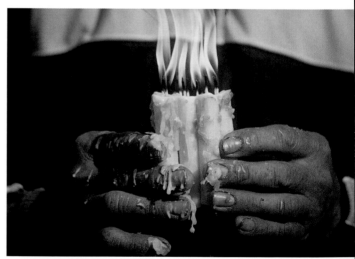

candle lighting
A balance between small light sources such as candles and the ambient light is ideal: both highlights and shadow areas can hold detail and color.

compare and contrast: sharp or soft

Working with light and shade also applies within the image. Very bright and dark areas in the same image (**1**) appear full of light, giving sharp contrasts that are perhaps too harsh for a newborn. Where there is a dearth of bright white and black but a lot of mid-tones (**2**), the effect is soft and mellifluous—very suitable for a newborn.

turn out the light

One of photography's proudest moments was when it could claim "If you can see it, you can photograph it." Obviously, development of sensitive materials—when ISO film speeds pushed through to four figures—and the maximum apertures of lenses had to progress together. Lenses with apertures of a maximum of f/1 or even f/0.7 promised light-gathering power superior to that of the human eye. Combined with film speeds of ISO 1000 or better, candlelit scenes could be photographed.

The last frontier was to be able to photograph even when you cannot see. Electronic flash was half the answer, but focusing in total darkness was not possible until auto-focus systems aided by infrared light became available. However, relying entirely on electronic flash for light is seldom a photographically attractive option.

super sensitivity

Today's photographer can benefit from advances in sensor technology that have propelled ISO well into the once-fabled five-digit figures: ISO settings of 25,600 or greater are now available. Supplemented by modern algorithms for reducing chroma (color) and fixed pattern (sensor-based) noise, it's possible to process amazingly clear images from light conditions that are all but too dim to see by. The reduction of noise offers another advantage:

the dark side

Working with silhouettes has the advantage of simplifying and abstracting very busy events and also allows relatively low ISO sensitivities to be used.

after the event

Auditoria emptied of their crowds tell their own story and having all stage- and house lights turned on provides yet another angle on the event.

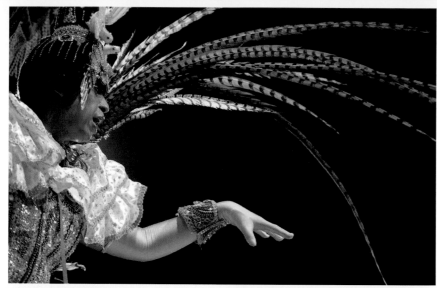

live performances

The combination of low light, fast action, limited access, and having to work discreetly and silently makes live-performance photography one of the toughest genres. You master low light and fast action with technology: cameras with high ISO and low noise capabilities, plus fast lenses. For improved access you wage a long-term campaign to raise your profile and reputation so that managers want you to photograph their performers. Part of your reputation will be built on your ability to work unobtrusively: change position only between numbers, move lightly and smoothly, and don't fire the shutter in the silence at the end of a number.

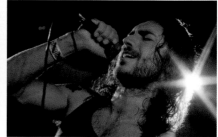

it allows tonal manipulations that reveal more details in shadows. As these are the noisiest part of the image, attempts to extract shadow detail used to result in simply showing up a lot of noise. However, although this has been solved, the color quality in shadows remains poor. This is acceptable only while shadows remain dark, thus setting a limit to how much you can extract shadow detail.

choice lenses

For the best results in low-light conditions where light sources may be point sources that cause veiling flare in the lens, you need to use prime—fixed focal-length – lenses. These have fewer elements than zoom lenses and are generally superior at suppressing flare. In addition they offer larger maximum apertures, and their full aperture performance is also superior to that of zoom lenses.

A relatively inexpensive but very useful lens is the 50mm f/1.4, while 85mm f/2 lenses offer a little more reach. These lenses are excellent for full- or half-length shots of performers at intimate events such as jazz clubs and revues. At larger events, 50mm may be useful for shots of the audience or the entire stage, but you really need longer lenses. The shortest useful lens is 135mm, but for head-and-shoulders shots you'll find you need focal lengths of 200mm or greater. Fast optics of this focal length are not only costly but heavy and prone to camera shake, so image stabilization—built either into the lens or camera body—is essential.

In addition, a monopod is useful for steadying the camera. To avoid aching muscles over the period of long performances, make sure you set the monopod height so the eyepiece is at eye-level—you might not notice at first if it is a little lower, but you certainly will later. If you swap horizontal and vertical views frequently, consider obtaining a L-shaped bracket that enables the camera to be set so that the eyepiece is always at the same height. An added advantage is that when it is set to vertical format the camera's weight is centerd over the supporting column.

light in darkness

The essence of succeeding with images shot in the dark is that this should be evident. The test is that light sources should show their color rather than being bleached white. Don't rely on the appearance of the images if you review them—check the histogram display. The peaks should cluster to the left, in the mid-tone to shadow region. Use maximum aperture for circular highlights and try focusing manually if your auto-focus has problems in dark conditions.

image analysis

60mm ISO 200 1/350 SEC F/11

It takes courage to condense the annual Reed Dance for thousands of Zulu maidens into an image showing just half a dozen of them. But what Pers-Anders Petterson's image loses in comprehensiveness, it gains in involvement.

1 in deep
The dark shadow, probably that of the photographer, contains no detail at all. This results from the exposure being strongly reduced to retain the dark skin tones, which also suppresses highlight reflections on the girls' skin.

2 identity loss
Deep shadow also causes the main subject's face to become anonymous. The lack of eye contact renders the shot impersonal and abstract but, at the same time, the photographer has taken us right inside the group.

3 honesty and sensitivity
Photographers need to be sensitive, not only toward their subjects, but also to the potential market for the images. For some, the nudity of these girls may be unacceptable, and

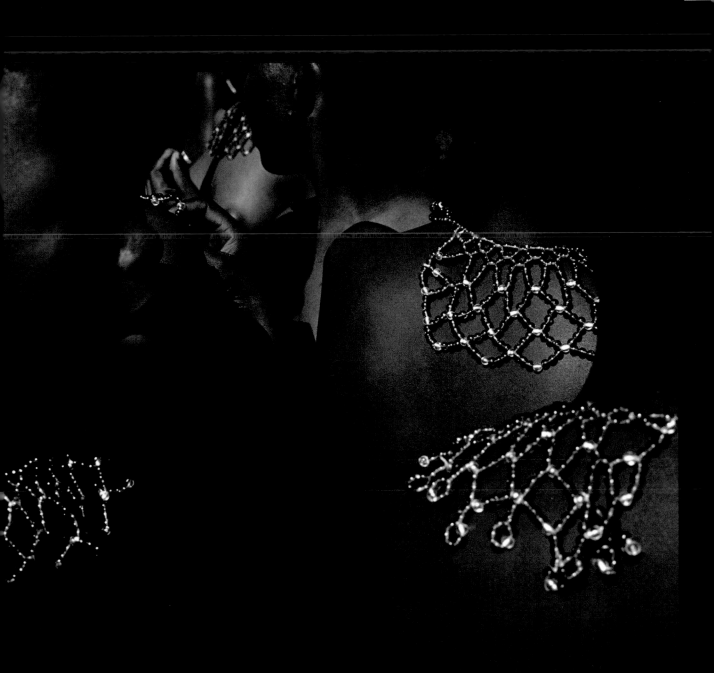

assignment:
clarity from chaos

Photography is a great simplifier; it can cut through chaotic events involving thousands of people, and offer a clean, clear-cut composition. The resulting image may not be one that sums up or even fully represents the event or celebration. However, what's important is that you captured a moment at the event—thus marking one of its heartbeats.

the brief

Attend any event and immerse yourself in the crowd in order to capture a moment in which participants and your surroundings produce an image with strong shapes and clean composition.

bear in mind that you can work in color or shoot with the intention to convert to black and white as the final product. Work efficiently by using single focal length, set exposure time to 1/125sec or shorter on shutter priority, and focus manually only to touch up fine focus.

try to capture in your image only those elements that are essential for the composition to work, cutting out unnecessary or distracting details as much as possible.

think about...

must-see master ▶

Caroline Bennett
USA (1983-)

With degrees in Documenting International Culture and Society and in Political Science, Bennett has worked as a magazine picture editor, freelance photographer, and multimedia journalist. Based in Quito, Ecuador, her work captures the human side of political and social events throughout Latin and North America. From the Obama election campaign to Mexican farmers' naked protests over land rights, her portfolio is full of warm, often moving, imagery.

career highlights

2006 Graduates Colorado College, Eddie Adams Workshop alumna.

2008 Receives Foundry Photojournalism Workshop scholarship.

2009 Runner-up in Picture Story category in the Best of Photojournalism awards.

Inauguration of Barack Obama, 2009: Photojournalists live for days like this. Bennett captures history being made among 1.8 million people who saw the USA's first black president sworn in.

1 aerial views
Looking down on a mass of people from a high viewpoint, it's possible to find order because the figures are reduced to a similar size and shape.

2 the individual
A simple, effective strategy is to concentrate on the individual: search out people in isolation or who are framed by the events around them.

3 the abstract
You can seek abstract compositions that don't even have to include people, but remember that hands on their own can convey a great deal.

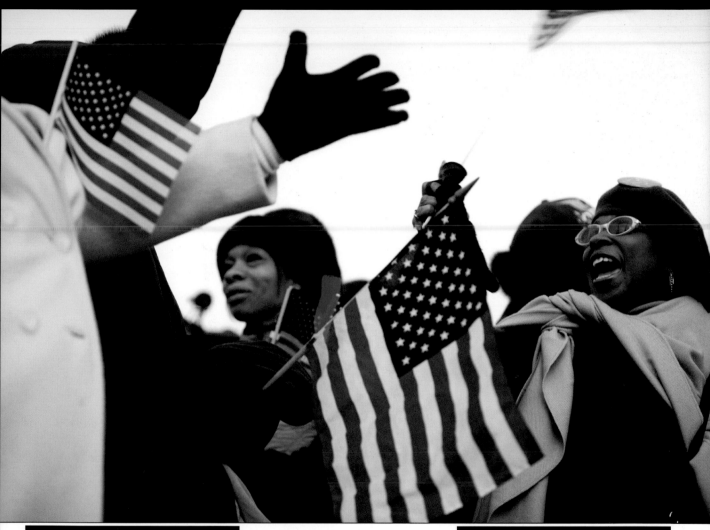

4 motion blur
Any blur simplifies details through the merging of elements, but motion blur retains a sense of activity. Try to keep some elements sharp for contrast.

5 long views
Choose your position carefully when covering massed parades: too distant loses tension and sense of space, but too close loses the sense of numbers.

6 silhouettes
Underexposure offers a quick way to eliminate confusing detail, but ensure that dark shapes are graphically strong and contribute to the composition.

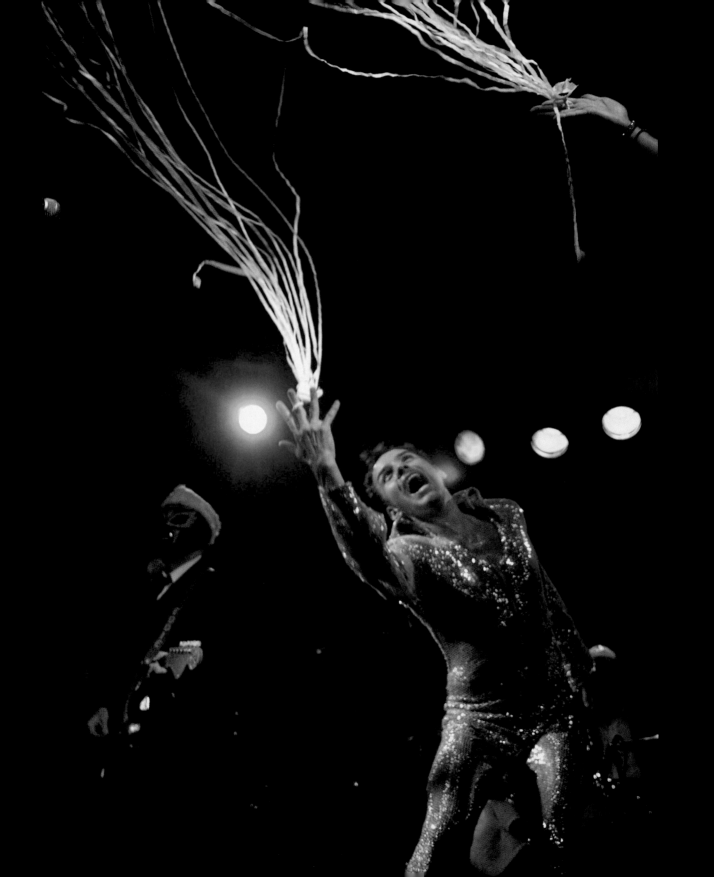

carrie musgrave

Born in London, Ontario, Carrie now lives in Toronto, where she has established a career as a music photographer. She has worked with over 1,000 musicians, including Oasis, Madonna, AC/DC, and Leonard Cohen. Her clients include music magazines and websites, and record labels.

nationality
Canadian

main working location
Toronto

website
www.livebabylive.com

◀ for this shot

camera and lens
Canon EOS-30D and 18–50 mm lens

aperture and shutter setting
f/2.8 and 1/100 sec

sensor/film speed
ISO 1600

for the story behind this shot see over …

in conversation…

What led you to specialize in live-music photography?
I've attended concerts, camera in hand, since I was a kid. I started posting band photos to my website just as a fan and an art director asked me to shoot for his magazine. So I fell into it, mostly. Luckily, I seem to have an eye for capturing the right moments, so I pursued my passion, and began shooting for more publications. Who wouldn't want to stand almost within touching distance of their favorite rock star and photograph them?

Please describe your relationship with your favorite subject. Are you an expert on it?
My favorite subject would be any musician who gives it their all on stage. I live for capturing the pure energy of the performance, whether it's a local band or the biggest band in the world. I also appreciate those split-second moments when the musician connects directly with my camera.

Do you feel you have succeeded in being innovative in your photography, or do you feel the shadows of past masters over you?
I try not to judge my work based on past masters. I try to simply document the musicians to make them look their best, in as creative a way possible. If you spend too much time thinking about how another photographer would shoot, you'll miss the moment.

How important do you feel it is to specialize in one area or genre of photography?
Photographers should specialize in what they excel at. If that happens to be more than one genre, then go for it.

What distinguishes your work?
It's difficult to be unique shooting concert photography, but I've been told I have an innate ability to capture the height of action and reveal a musician's soul.

As you have developed, how have you changed?
I'm more confident in almost any shooting situation. I've learned to do my homework so I know what type of lighting to expect and how active a band will be, for example.

What has been the biggest influence on your development and maturing as a photographer?
Learning how to deal with the business side of photography.

What would you like to be remembered for?

At least one truly iconic image, such as Jimi Hendrix's burning guitar from the Monterey Pop Festival, or The Clash's *London Calling* cover with Paul Simonon smashing his bass on stage. It's getting tougher to create this type of image because most newer bands don't have the staying power of the bands in the past.

Did you attend a course of study in photography?

No, I'm self-taught. Other than learning the basics of exposure and understanding how your camera works, concert photography is more of a hands-on learning experience. The conditions are changing constantly from minute to minute and show to show, so the only way to learn how to adjust is to practice. It's also important to study the bands and learn their visual cues, such as when a band member is about to jump, and to be able to see what's happening on the entire stage.

How do you feel about the tremendous changes in photographic practice in the past 10 years? Have you benefited or suffered from the changes?

I wasn't involved in music photography professionally 10 years ago, so I can only comment secondhand. There have been many changes over the years in terms of accessing bands—this is much more limited now, with photographers typically getting only three songs to shoot.

Can photography make the world a better place? Is this something you personally work toward?

Absolutely. Photos are cherished moments in time. I love receiving messages from music fans who have attended a show I've photographed and told me their personal experiences about it. It's nice to know that you've helped to preserve a memory for someone.

Describe your relationship with digital post-production.

I'm very comfortable using editing software. I shoot in RAW so it's a necessary step in processing my images. Sometimes I love post-processing, sometimes I hate it.

Could you work with any kind of camera?

I could work equally well with any equipment that has low noise at high ISO and a fast lens (typically f/2.8 or faster).

Finally, to end on a not too serious note, could you tell us what non-photographic item you find essential?

My iPhone. I feel lost without it.

behind the scenes

This gig was at a club in downtown Toronto. I don't scout out venues in advance, as I know all of those in Toronto so well. Bringing two cameras—Canon's 5D and 30D—meant that I didn't have to waste time changing lenses.

21:10

21:15

21.10 The club has no pit, so I arrived early to ensure I had a clear shooting spot.

21.15 Before the band started, I put in my ear plugs—I don't want to lose my hearing.

21:20 **When the band came on**, I took a few shots and double-checked my camera settings.

21:30 **I'm always aware** of not only what's happening on stage, but also what the crowd is doing, in order to avoid being jostled or getting in a fan's way.

21:40 **I almost always** use spot metering. Lighting can change every few seconds, so this is the most accurate setting for proper exposure.

23:50 **Down at the front** of the stage, I found the perfect spot and got some great close-ups.

21:20

21:30 *21:40*

23:50

◁ in **camera**

portfolio

▽ **Mastodon, 2008**
Covering a music festival is all about
capturing the raw energy of the performers.
For this shot of heavy-metal band Mastadon
at the Bonnaroo Music Festival in Tennessee,
USA, I was shooting from the pit with my
telephoto lens.

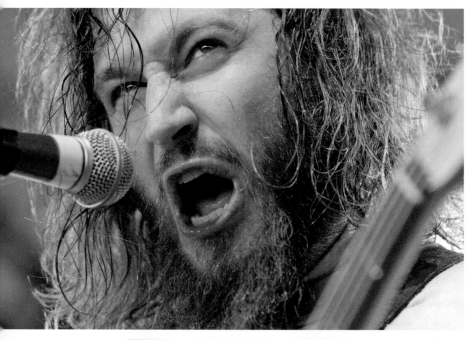

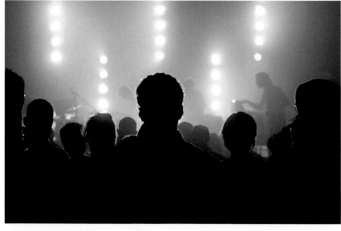

◁ **mod club, 2006**
This image was taken at a Soulwax gig in
Toronto, Canada. The photographers weren't
restricted, so I explored the venue and took
this shot from the back. I like to shoot as many
elements as possible to help tell the story.

△ **reverb, 2007**
To capture the streaks of light, I used a slow sync second curtain flash, which is basically a long exposure with the flash firing just as the shutter closes. At this particular show, there was a very intense crowd, so I shot on the side of the stage to avoid any injuries to myself or my equipment.

and
finally ...

1 keep it simple
Images with large numbers of people easily become cluttered and disorganized—keep the composition simple and clear.

2 look out for little ones
Children may not play a big part at an event or celebration but they are often in the thick of things, and provide an excellent counterpoint to grown-up activities.

3 it ends when you leave
By being the last to leave you can capture the aftermath of the event, and the clean-up and any other activity, which provide a new angle on the event.

4 backstage
With a little planning, and by arriving early and working discreetly, you can catch the intimate human moments leading up to the main event.

5 short cuts
Avoid photographing players or actors full-length as that gives the image a formal appearance: cropped images tend to look more active and energetic.

6 bit players
Keep your peripheral vision tuned to the side-events and sub-plots, since they often yield the most amusing or unusual images.

7 mono clarity
Shoot in color, then convert images to black-and-white in post-processing both to remove the distraction of too much color and to evoke a photojournalistic feel.

8 tell-tale signs
The time to record small, telling details is when you first notice them. It's also a good way to occupy time while waiting for the main event to take place.

TRAVEL
PHOTOGRAPHY

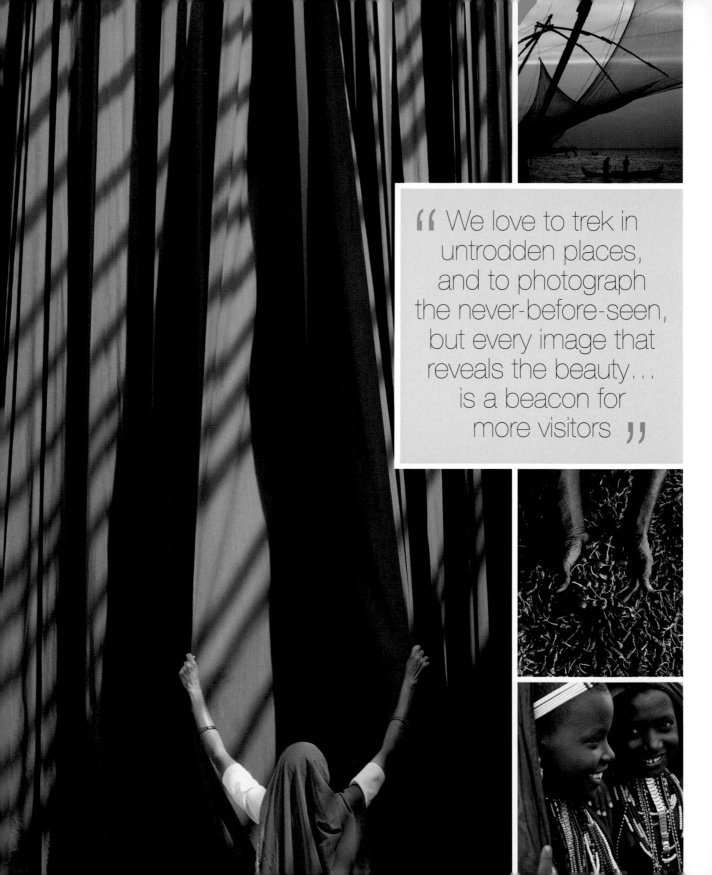

“ We love to trek in untrodden places, and to photograph the never-before-seen, but every image that reveals the beauty… is a beacon for more visitors ”

Travel photography is the best way to enjoy foreign travel, but it's also the greatest danger to the subjects it celebrates. Photographers are the vanguard for modernizing changes and tourism. We love to trek in untrodden places, and to photograph the never-before-seen, but every image that reveals the beauty of a far-off land is a beacon for more visitors.

Even in the days of film, travel was the one area of professional photography in which amateurs contributed the bulk of published pictures. Now that many more travelers possess very high-grade digital cameras, they are producing even more professional-grade images. And, to judge from images on the Internet, travel is everyone's favorite subject. One result of its popularity is that you may feel the cloak of cliché hangs heavy on travel photography; that it is near-impossible to make a fresh, new visual statement.

Far from it. There are still enormous opportunities for anyone who takes the trouble to learn, to listen, and to look below the surface of their destination. The key is to let your subject lead you. And there are hugely rewarding projects for those who make a small effort to involve themselves with their host communities to create sustainable and mutually beneficial relationships. Intrinsically, travel photography offers the greatest variety and richness of subject-matter. There are many opportunities to tell a story by putting together a narrative of the experiences of people you meet or of the everyday life of the place, and by doing so convey something of the atmosphere of a new location.

key moments

1836	Organized tours by Thomas Cook see the start of **mass tourism**.
1840	**Stereoscopic images** of foreign lands become popular.
1841	William Fox Talbot's **calotype process** makes photography more portable.
1851	**Maxime Du Camp**'s book *Le Nil, Egypte et Nubie* is published. It's one of first titles illustrated with photographs.
1852	**Roger Fenton** travels to Russia and takes the first photographs of the Kremlin.
1854	Felice de Beato and James Robertson start to lead **photographic expeditions** to Malta, Greece and Jerusalem.
1888	The first issue of *National Geographic* is published.
1911	Herbert Ponting covers Scott's ill-fated **South Pole expedition**.
1922	The Earl of Carnarvon photographs the tomb of **King Tutankhamen** in Egypt.
1969	**Neil Armstrong** takes the first pictures on the moon, using a Hasselblad EDC.
1987	*Condé Nast Traveler* magazine is launched in the US.

A consequence of the democratization of technology is that the space for visual innovation has expanded, and more varieties of expression are possible. The dramatically ultra-wide-angle view, the motion-blurred abstract, and the barely discernible outline in the dark would, in the past, have been rejected out of hand. Today, we welcome these visual offerings as refreshing and creative.

There is also space for brilliant work that straightforwardly captures a scene—giving objectivity, sharpness, and true color. At the other end of the scale, there is plenty of room for the emotional, interpretative approach: one that expresses a scene in a personal way, using a specific choice of lens, a personally developed technique, or a particular method of post-processing.

What's new for our generation of travel photography is that the image is no longer detached from its subject, but retains a strong, living link to it. Travel photographs carry new sensibilities, in particular, a feeling of responsibility for the fate of people and the environment they live in. Travel photography is thereby wonderfully enriched with new dimensions. This chapter explores all these aspects of this most popular form of photography.

tutorial: elusive atmosphere

We strive for clarity in our images much of the time: we aim to make details clear and sharply defined, and to include the full range of tones and colors. However, you will often find that as the clarity and sharpness of an image decreases the sense of atmosphere or mood of the place increases.

foggy opportunities

An effective—and freely available—way to reduce image clarity is to photograph in foggy or misty conditions. Reduced clarity increases the emotional charge of an image, and consequently its ability to convey atmosphere. By eliminating distracting details the viewer concentrates on the bare essentials. This is a reason why many people are drawn to black-and-white photographs.

The usual response to a misty, rainy day is to give it up as hopeless for photography. But what an opportunity you'll miss if you do. When there is fog and mist the air is full of suspended water particles, which rub out details but in the process extract the essentials of a scene. You can work with simplified shapes and outlines, which become graphic elements in a rhythmic composition. At the same time colors are subdued, to become water-infused washes of tint. Cloudy or misty conditions in the morning tend to give cool tones, that is, the color temperature for white balance is high, evoking a sense of chill. The same conditions in the evening create yellow-red tints, giving a warmer atmosphere. This is due to the low color temperature caused by light scattering (see also p.289).

misty distortions

Atmospheric effects that reduce the clarity of the air also transform the way space is depicted, with the shifting densities of mist often providing misleading spatial cues. The resulting confusion causes buildings or trees that are actually close together to appear further apart, or buildings that are relatively distant from one another to appear on top of each other. In short, mists can distort our sense of perspective, appearing to compress it. This tension between what we expect to see and what we actually see is a cornerstone of effective photography.

atmospheric transformations
Fog and mist reduce details and colors to transform the ordinary into the painterly. A long telephoto view compresses distances to emphasize contrasts in shape.

gradient filters
Filters set in front of the lens—here a tobacco gradient filter—puts color into an otherwise colorless sky and complements the fog-bound mood.

A distinct effect is that filigree details, such as tree branches that would usually be lost against busy backgrounds, can emerge strongly against the pallid, even tones. At the same time, shadows that would normally appear dark are lightened, transforming normal tonal values and providing another source of visual tension.

filter effects

You can try using fog or diffusion filters on your lenses— either screwed in directly to the lens or slid into plastic holders—if you don't want to wait for fog to appear. The effects of these physical filters—particularly the smearing of color and highlights—can't easily be replicated by image manipulation filters. They don't fully replicate real mist either. Diffusing, or mist, filters attempt to simulate the effect of real mist or fog, but the effect may look artificial. This is because the filter affects all incoming light equally, so it blurs all details to the same even extent, instead of the subtle variations and unevenness of real life.

It's best to familiarize yourself with these filters before using them on a live project. This will help you visualize their effects. It also helps you avoid spending too much time evaluating the review images on the back of your camera: the small screen and low resolution are especially misleading when displaying blurred or soft images.

compare and contrast: haze and flare

Textbook rules work well in textbooks where sharp details, full tonal range, and accurate colors are required. But you often find the only way to truly record what you see is to ignore the rules. And the results can be highly rewarding. (**1**) shows a textbook-correct image: sharp throughout, with rich color, accurately exposed for a full tonal range from deep shadows to highlights. And how dull it is! In contrast, (**2**) is a textbook example of an image spoilt by a combination of flare – the degradation of shadows due to internal reflections—and haze, which has washed out colors and details. Yet it is an atmospheric image that is true to the spirit of the experience.

bright darkness
Reflections of city lights appear best against the night sky, especially after rain, which turns the streets into acres of mirrors—another reason to work in wet conditions.

raindrops on glass
The best filters are actually part of the scene, such as windows and car windscreens. Shoot through them, and set different apertures to experiment with varying blur.

focus on technique: using blur

Motion and focus blur are always-available ways of reducing image clarity. Use a relatively long exposure time on moving subjects and pan—move with the subject— (**1**) or focus on the foreground with a large aperture set (**2**). If your camera or lens offers image stabilization, experiment with it turned on and off. Try zooming during a long exposure (**3**).

low light, high emotion

High clarity is naturally associated with bright lighting. So working in low light is another way to reduce clarity. In these conditions shadows tend to be filled, bright areas are minimized and, above all, the lack of light forces you to make technical adjustments such as using wide apertures, long exposure times, and high sensitivity settings. The dim light of early mornings or evenings—as opposed to the blackness of the night—tends to soften colors and flatten contrasts. Allow your images to be softer than usual—the loss of sharpness and detail encourages an emotional response.

qualities of blur

Some photographers will debate long and hard over the relative sharpness of different lenses. Considering, however, that the majority of images of three-dimensional objects are for the most part not sharp—a result of insufficient depth of field—you would think that more discussions would center on the quality of the blur. As it happens, the best lenses do offer the best quality of blur; that is, the fall-off of sharpness is smooth and not ridged or stepped. We also want to reproduce the tonal gradations that are smooth in real life—particularly around highlights—equally smoothly in the image. Nonetheless some extremely good lenses produce poor blurs: each needs to be tested and judged individually.

The quality of blur (also known as "bokeh," from the Japanese word "boke" meaning blur or haze) is most important when you work with shallow depth of field or at extreme close distances. Poor lens design can lead to aberrations in the image as well as to curvature of the field. This, alongside apertures with irregular shapes, all contribute to poor bokeh.

If you're working with a shallow depth of field by setting a large aperture or focusing on one part of the image and deliberately leaving large parts blurred, try the following strategies to get the best results. First, use full aperture only; don't stop down at all. Then, use prime lenses; that is, those of fixed focal length (note that in general, longer focal lengths give the best results). The 135mm f/2.8 STF (smooth transition focus) lens for Sony Alpha is specially designed to control transitions into blur as smoothly as possible.

compare and contrast: balancing whites

White balance aims to ensure accurate colors. But that could spoil the mood of dawn (**1**), whose cool tint would be neutralized. The warm colors of late afternoon (**2**) are usually outside the range of white balance controls, but applying white balance can reduce the atmosphere.

time of day

It's a fact of life that some of the best times to photograph are when other (sensible) people are either still in bed or eating their dinner. Indeed, one of the advantages of working at dawn is that there are fewer people around. Of course, it's really the quality of light that gets us out of bed at this time. At sunrise, the rays of the sun hit the atmosphere at a tangent so they must find their way through a much thicker layer of atmosphere than later in the day. The long light-path of dawn has three important consequences for us. First, the scattering by atmospheric and water particles softens the light and shifts its white balance toward reds and yellows. Second, there are contrasts because the sky is darker than usual, while subjects in the path of the sun are brightly lit. Finally, there is the effect of a low angle of light that makes shadows long and dramatic.

The light of sunset is in many ways similar to that of dawn, and at times you can tell the difference only if you know the location and the points of the compass. Many photographers prefer to work at sunset simply because it doesn't require an early start.

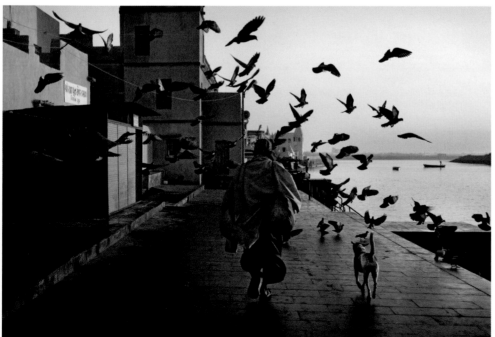

soft hour

When you shoot during the golden hours of dawn or dusk you can really create magically evocative images such as this morning scene on the banks of the Ganges River. A key element in conveying the gentle mood of the scene is visible in the feet of the man and dog: both are in mid-stride, which gives an impression of fleeting lightness and transition.

image analysis

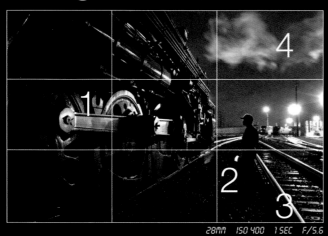

28MM ISO 400 1 SEC F/5.6

Without artifice or gimmickry, using straightforward techniques with a moderate wide-angle lens, Steve Crise has created an eye-catching image that is impressive for its atmosphere and stunning composition.

1 counterweight
The bright, highly saturated colors reflected in the gleaming metalwork are positioned exactly to balance the figure. This sets up an interesting counterbalance between the abstract and mechanical and the human.

2 key lights
The figure is shot against the light, but what is visible is perfectly judged. From the rim-light around the head to the lamp in his hand, we can work out something about the figure without actually being able to see very much.

3 leading lines
Strong, straight lines with highlight tones, alongside the rhythmic elements of the sleepers, lead the eye from the corners of the image into the heart of it—the figure—and then beyond, deeper into the picture.

4 motion blur
The movement in the clouds or smoke fill an otherwise quiet part of the image. Their blur suggests a long exposure, which implies that the shot was posed with the railroad worker standing still for just a few seconds.

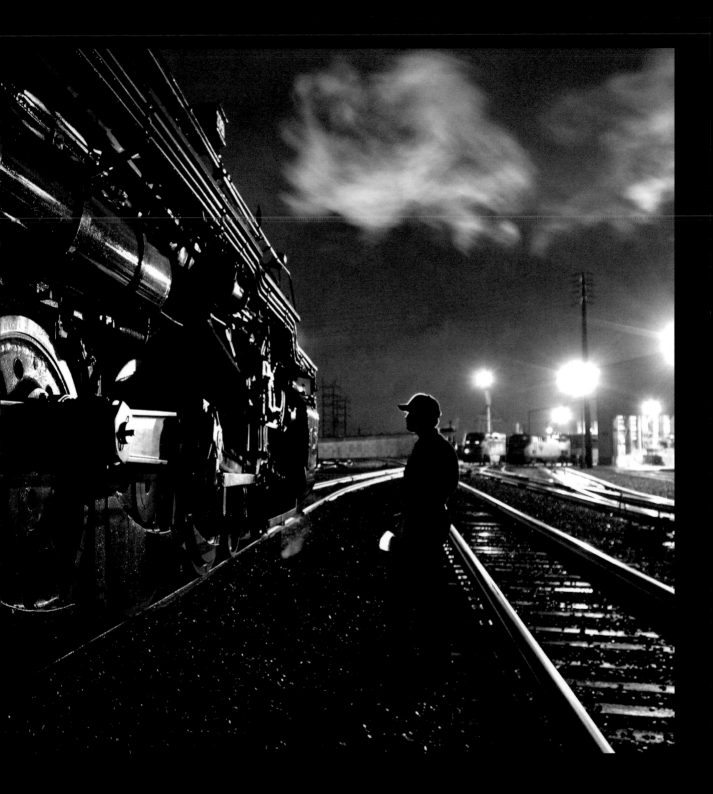

assignment:
transformations

Anyone can take a presentable shot of a famous landmark or tourist destination, but can you transform the ordinary into a magical location? You may need simply to be there in gorgeous light, or you may need a combination of factors—time of day, weather conditions, light—to work together.

the brief
Make at least two images, one recording the scene as it normally appears, the other showing the same scene—not necessarily taken from the exact same spot—touched with magic and almost unrecognizable as the same location.

bear in mind that exposure—either in fog and mist or with steeply angled light—is likely to be tricky. Bracket your exposures, shoot in RAW mode, and make final decisions about image brightness at leisure, not on location.

try to capture stunning cloud formations, or perhaps low, raking light that is strongly tinted. Wait for autumnal or spring weather that brings down a shroud of thick fog, usually in the early hours.

must-see master ▶
Ernst Haas
Austria (1921–1986)

A pioneer of color photography and a giant of photojournalism, Haas originally studied medicine in Austria but was prevented from his degree because of his Jewish ancestry. He moved to New York in 1950 and traveled extensively as a photojournalist for magazines, such as *Life*. Both creative and commercial, Haas worked for Marlboro, Chrysler, and Volkswagen, as well as with Marilyn Monroe on a film set. He is renowned for deliberately out of focus, deeply saturated color motion images.

career highlights

1949 Prisoners-of-war pictures for *Heute* magazine attract global attention.

1958 Publishes his first color photographs showing motion.

1964 Directs creation scenes for John Huston's epic movie *The Bible*.

Western Skies, 1978: With a cloudy night sky over the Western Skies Motor Motel in Colorado, Haas makes the ordinary look extraordinary. His work is often described as painting with the camera.

think about...

1 clear shapes
In low-clarity situations, work with clean outlines for the strongest composition as these give shape to the flat areas of tone and color.

2 scale
Use objects or figures to offer the viewer clues to the scale in your image. The more abstract the image, the more help you need to give.

3 color schemes
Low light, mist, and falling snow are ideal conditions for working with low-saturation, pastel shades. They act as a relief from a diet of bright, gaudy colors.

4 noise
You can further reduce image clarity by working at very high sensitivities (high ISO settings). The resulting noise blurs image details and can add to the mood.

5 focal length
Moving figures gain extra impact when seen in a broad, uncluttered area of tone. Wide to normal focal lengths are the easiest to work with in this situation.

6 viewpoint
Experiment with high and low positions. Discovering an unusual viewpoint can make your image fresh and surprising.

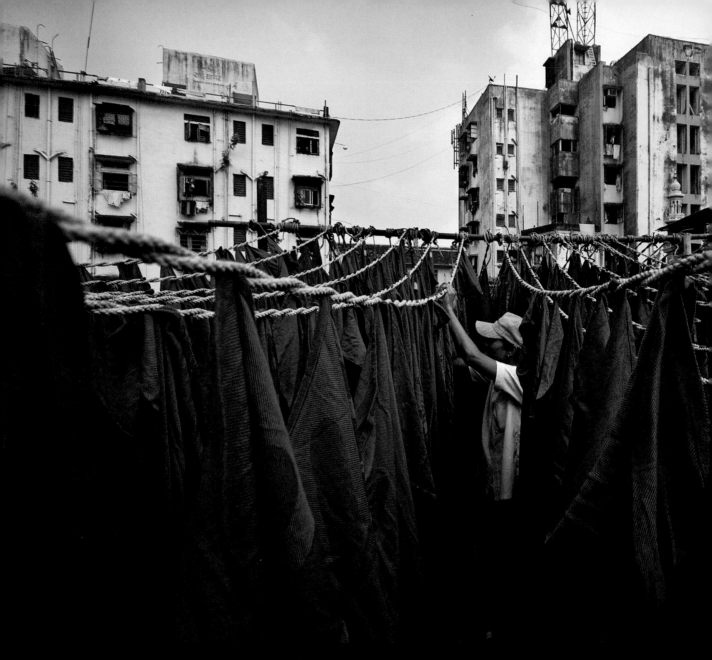

dhiraj singh

Dhiraj's work has appeared in publications such as *Newsweek*, *Vanity Fair*, and the *Wall Street Journal*. He was awarded third place in the War and Disaster category at CHIPP 2009 and third place in Spot News category at IFRA's Publish Asia 2008.

nationality
Indian

main working location
India

website
www.dhirajsingh.com

in conversation...

What led you to specialize in travel photography?

I'm not really into travel for its own sake; my specialization just happened by chance. I will go wherever the story and my interests take me.

Please describe your relationship with your favorite subject. Are you an expert on it?

My favorite subject is life on the street. Through my photography I can explore people's lives, whether they are rich or poor, and the world around me. But in no way am I an expert on the subject; far from it.

Do you feel you have succeeded in being innovative in your photography, or do you feel the shadows of past masters over you?

No one can altogether avoid the influence of past masters, but I think all photographers want to add something new of their own. I hope I do, or will.

How important do you feel it is to specialize in one area or genre of photography?

I don't think it's important to specialize. A good photograph is more important than any category you can put it into.

What distinguishes your work?

Nothing specific, I don't think. I shoot what interests me and what I can feel a connection with. I guess that's the same with all photographers.

As you have developed, how have you changed?

As a graphic designer I used to be stuck in a room in front of a computer. The world outside was strange and intimidating. The camera gave me the courage and the determination to examine the "out there." I'm no longer as shy as I was before. I can now walk up to complete strangers, strike up a conversation and leave having made a new friend. It's a change in my personality that I could never have imagined.

What has been the biggest influence on your development as a photographer?

I remember first seeing Raghu Rai's book *Taj Mahal*. I had never experienced photographic language as a means of communication, but those photographs spoke to me. Then I saw the book *Mother Theresa*, also by Rai, which affected

▲ for this shot

camera and lens
Canon EOS 400D and 10–20mm lens

aperture and shutter setting
f/4 and 1/750 sec

sensor/film speed
ISO 200

for the story behind this shot see over ...

me the same way. That has been the biggest influence. A photograph may not have drama or glamour, but as long as it speaks to me, it's a good picture.

What would you like to be remembered for?
For being a good photographer.

Did you attend a course of study in photography?
I haven't attended a course in photography and don't believe a formal education is necessary. Passion is necessary—if you have that you will learn regardless.

How do you feel about the tremendous changes in photographic practice in the last 10 years? Have you benefited or suffered from the changes?
I'm a fairly new entrant in this field. I was a graphic designer and I only picked up the camera very recently. Hence I kind of skipped most of the transitional period when film was losing out to memory cards. I've only ever known digital and I'm comfortable with it because it's a gentle teacher. You can afford to take a few bad pictures on an 8GB card, which you would be hard pressed to do on a roll of 36 exposures.

Can photography make the world a better place? Is this something you personally work toward?
No. A photograph can never change the world or make it a better place. It can help, but a photograph alone cannot bring about change, especially not in today's television-saturated world.

Describe your relationship with digital post-production.
It's a necessary evil as far as I'm concerned. I've noticed that increasingly I'm spending more time with my computer than with my camera.

Could you work with any kind of camera?
I'm one of those photographers who can only work with digital. The older cameras are a challenge I'm not up to.

Finally, to end on a not too serious note, could you tell us what non-photographic item you find essential?
Movies. I usually travel with a whole stack of DVDs in my backpack when I'm on a long shoot.

behind the scenes

In Mumbai, modern skyscrapers overlook timeless scenes such as laundries and potteries where all the labor is still done by hand. It's these areas, teeming with humanity, that are of most interest to me.

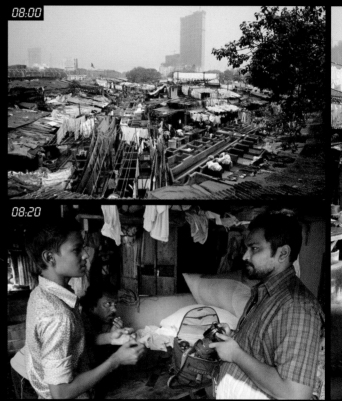

08:00 It's possible to get a view of the laundry from above, so I was already familiar with its layout.

08:20 The first step was to start making friends. Showing people my camera equipment is always a good way to establish a rapport.

08:30 I took two Canon bodies (a 400D and a 1DS Mark II) so that I could have a lens ready on each of them to catch fleeting moments.

08:45 Looking around, I could see great potential in the contrasts of hard geometrical patterns and the jumble of fabrics.

08:55 As I anticipated taking a lot of pictures, I took along a hip pouch full of memory cards.

09:00 In constricted circumstances where I couldn't stand back from my subjects, my 28mm lens was ideal.

08:55

09:00

08:45

09:30

09:30 Spotting the daughter of one of the laundry workers playing among the clothes, I clambered across the troughs to get a good angle.

09:35 She obligingly posed for me. I always try to show photographs of children to their parents and check that they are happy for me to use them.

▷ in **camera**

09:35

09:45 **Using my 50mm lens,** I took a few shots of some of the laundry workers relaxing in the boiler rooms.

09:50 **The shoot was going well**—the workers seemed to be enjoying it as much as I was, and that's the best way to get a good story, with plenty of communication.

09:45

09:50 10:00

10:00 **The light slanting in** through the partially open roof gave atmospheric effects to a cloud of cigarette smoke

10:15 **If people are camera shy,** I often allow them to handle the camera and look through it. This makes them feel more like a participant rather than someone being observed at the photographer's whim.

10:15

△ in **camera**

10:35 **I found a high viewpoint,** which always presents a completely new perspective on a scene.

10:45 **The brilliant red** of the drying laundry gave me all sorts of opportunities for photographing interesting patterns of color.

11:15 [clam]**bering down** from the rather haphazard structures, I had to keep my equipment to the front of my body where I could see it wasn't at risk of damage.

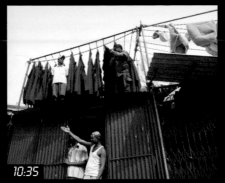

◁ in **camera**

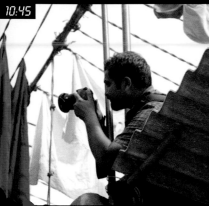

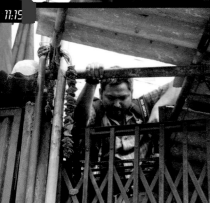

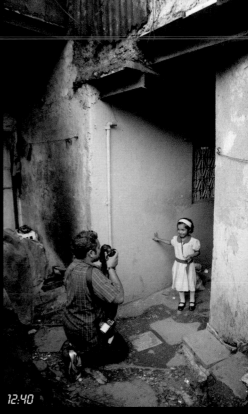

11:45 **After a break I set off** to a second location across town—a pottery located in Dharavi, one of Asia's largest slums.

12:40 **There I found this little girl** setting off to school, immaculate in freshly laundered white clothes—a comment on the dignity of Dharavi's inhabitants.

12:50 **I photographed two more children** who were eager to pose for the camera.

13:10

13:30

13:50

△ in **camera**

14:15

13:50 **This family lives** in Dharavi, which provides homes as well as work. The grandfather was happy for me to photograph him resting in his chair.

14:15 **The pots standing on top** of the huge old kiln interested me—repeating patterns work well in a photograph.

13:10 **Pottery-making is a traditional** industry in Dharavi, and except for a few small details of clothing and a plastic container or two the photographs I shot here could have been taken a century ago.

13:30 **Using the wide-angle lens** to emphasize the foreground, I photographed the pots being heaped into the kiln.

▽ in **camera**

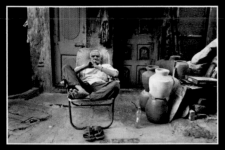

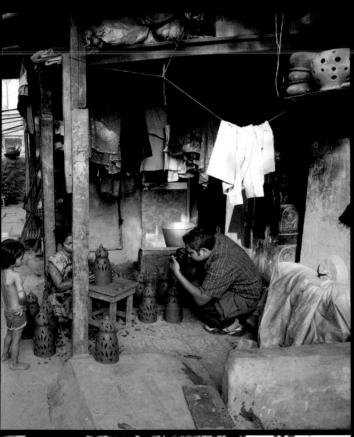

△ in **camera**

14:25 **Among the roots of a tree,** I found a shrine—another aspect of life in Dharavi.

14:40 **Out in the street,** a barber was attending to a customer. I photographed the tools of his trade, neatly laid out.

portfolio

▽ **Pushkar camel fair, India**
The woman in this picture seems oblivious to the beautifully painted screen. Was she deliberately choosing not to glance at it? The photographer Raghu Rai had it made especially for a project and I was admiring his work when she passed by.

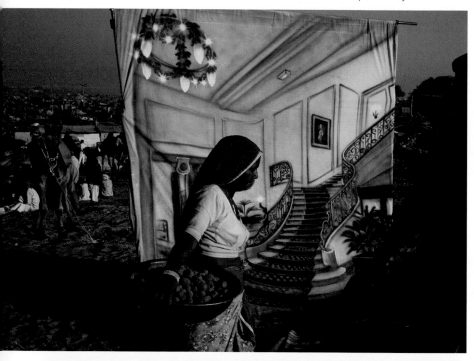

◁ **Kumbha Mela, India**
This festival is the largest gathering of people for a religious purpose in the world. What strikes me about this picture is that the two naked sadhus (Hindu holy men) look as if they are preparing to fly.

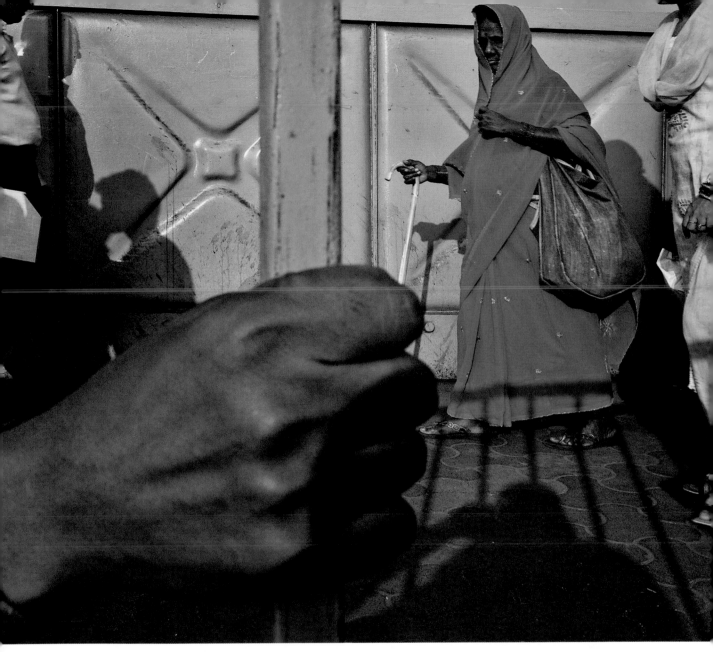

△ **street scene in Mumbai, India**
I had seen this blind woman before, selling
lottery tickets at Mumbai train station. On this
occasion, she was returning from work when
I saw the man with the file approaching. I like
the composition because the yellow bar
divides the image in two, and the color of the
wristband matches the woman's sari.

tutorial: keeping it real

The revolution in photography has coincided with a huge growth in international travel. As a result, there are few places on earth that haven't been photographed, and most have been photographed from just about every angle. So these days we have a much more honest and real-life view of the exotic.

green message

We know that the reality of many an idyllic white-sand beach or remote mountain viewpoint is that piles of trash lurk just out of the frame. Indeed, these days, to cut out the hotel, or telephone pole, or shantytown from an otherwise glorious view may invite cynicism at best, or worse, derision. While the travel photograph was once akin to advertising in the way it emphasized the allure of a destination and ignored the less attractive elements, it's now frequently an altogether more honest process, and also, by consciously allowing unslightly elements into your image you hand to the end user of your picture the choice and responsibility of deciding whether to crop them out.

There are positive reasons for the honest view, one of which is to convey a message about the impact of human activity on the environment. Too many tourists in fragile habitats trample vegetation and cause erosion; too many hotels ruin lagoons and shorelines. Today, these facts are as much part of travel photography as the picture-perfect destinations that fill travel brochures.

Unlikely as it may seem, your home town could be someone else's destination. What appears run-of-the-mill to you may prove fascinating to someone who's unfamiliar with your area. And when you're traveling you may be inspired by things that locals walk past everyday.

romance of the old

From the earliest days of photography, it was recognized that the photograph had a knack for turning the old and broken into things of beauty. The romance of the old remains, and it's not just Roman ruins or ancient temples emerging out of the jungle. Rusting chains at a fishing port, weather-worn doors, or peeling posters always look better in photographs than in real life.

Frame up square to doors and walls to avoid any distortions that don't contribute anything to the image. Ensure a good depth of field by using small apertures

focus on technique: depth of field

Use wide-angle lenses at small apertures to provide extensive depth of field and to pull in foreground details against the background. Take care when using ultra wide-angles because, with only a small increase in distance, the background quickly becomes too small to recognize. If skies are very bright, graduated filters placed in front of the lens pull in highlight details, and make post-processing much easier.

diagonal framing
Explore different ways to split the image frame. Here a strong diagonal divides the warm colors and activity of the stevedores from the dark, static hulk of the ship.

such as f/8 to f/11. It is probably best to avoid the smallest apertures as the increase in the depth of field is gained at the cost of reducing overall sharpness. This loss of sharpness is caused by diffraction. A little darkening in the corners, which is typical of the small-diameter zoom lenses used in compact cameras, helps "hold in" the edges of the image, and concentrate attention on the center. You can exaggerate the effect, which may be useful for tidying up areas that are either too empty or too cluttered, during your post-processing.

high dynamic restraint

Where the range of brightness is too great for a sensor to capture fully, you can use in-camera processing or image manipulation techniques such as shadow/highlight controls or high dynamic range (HDR, see p.325). Whether you choose to make adjustments or not depends on what you wish to show or say with your image. HDR and tone

portraying the everyday
Including less attractive areas in your images can bring a rich source of inspiration, and often all within a small area. The more slowly you walk, the more you will see. Approach formally: square-on and flat, and simply framed with a normal to moderate wide-angle lens works best. Strongly angled upward or downward views can be more dynamic.

mapping can make images look painterly—all mid-tones suit a super-real style. But strongly applied HDR isn't advised if you wish to present a landscape that looks naturalistic. To have sufficient scope in post-processing, shoot in RAW format (see p.112). Additionally, bracket your exposures with wide steps, such as 1.5 or even 2 stops.

Of course, the alternative would be to ignore any part of the extreme range altogether. Try working with, instead of fighting against, the light. Burned-out highlights and black shadows can become expressive tools when they are used in partnership with the composition.

tutorial: connecting with people

The single most rewarding and richest subject for travel photography is people. A photograph of someone you meet on a trip is much more than a likeness, it is a record of your encounter and all that this means— the meeting of two different worlds.

recording relationships

Your travel pictures will improve significantly if you bear in mind that your photograph of a person captures something of the quality of your relationship with that person.

Many travel photographers work with their zoom lenses at the longest setting to photograph people. This enables them to work discreetly, but still obtain a head-and-shoulders shot that fills the frame. However, it can also deliver a picture that can feel voyeuristic and somewhat unconnected to the subject.

Contrast that with pictures taken with the full and willing consent of a subject, shot nearby, that is within the subject's personal space, which feel personal and relaxed.

This very different approach will be immediately obvious from the person's more comfortable pose, their relaxed body language, and friendly smile.

A very useful rule to impose on yourself is to set the zoom at no longer than 90mm. Then you will move, physically, toward your subject to fill the frame. You will find it hard to approach someone if you have not first created a relationship with them—even if it is a fleeting and shallow one. But if you have taken the trouble to build a rapport—all it takes is eye contact and a smile— it's actually more comfortable to photograph from close up than from far away.

the eyes have it

The most eloquent component of an image—what we instinctively look at first—is a person's eyes. We learn to interpret moods and intentions by looking into the eyes, and likewise with photographs we obtain instant information about the person from their eyes. If there is warmth and friendliness we will be drawn to the image, it will make us smile. If there is suspicion and fear, we are fascinated (see Steve McCurry's famous portrait of the

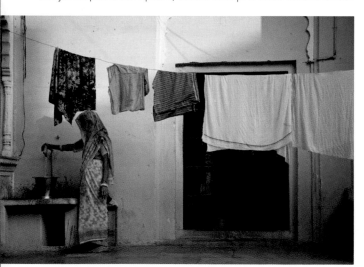

form and balance
If you are photographing a person from either middle or far distance, it's often more successful to treat them simply as an element of the overall composition.

surging masses
By using a long exposure you get a combination of sharpness and blur, which conveys a sense of the frenetic activity and the moments of stillness amid the bustle.

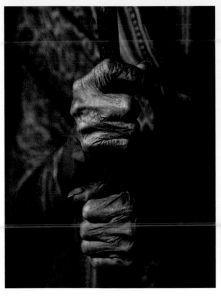

focusing on details
Details such as hands at work, tools in use, or personal jewelry can be more telling than a full-face image. It's best to photograph close-up, which means you need to form enough of a relationship with your subject to enter that person's space. If their movements are too rapid for auto-focus, use manual focus: track along with the action or wait for the detail to come into focus.

Afghan girl staring into the camera). The expression in your subject's eyes conveys powerfully the nature of your relationship. It is brutally honest and revealing. Hands, too, can be incredibly expressive. At rest, at play, or working— a person's hands can reveal a lifetime of experience.

When you see someone you want to photograph, get your equipment ready. Set the aperture depending on whether you want minimum depth of field or to include more of the background. If they are dark-skinned, set any exposure over-ride to under-expose. Anticipate the best angle—bearing in mind the direction of ambient lighting and the background, as well as what the subject is doing. If you consider these matters in advance you will be able to work quickly once you have permission to photograph. The rest involves simple life skills: approach openly, make eye contact, and say "Hello!" in the local language.

eye contact
The eyes account for a minuscule proportion of this image, but they are central to it; the raised arms draw you down to the face, and the eyes hold the image together.

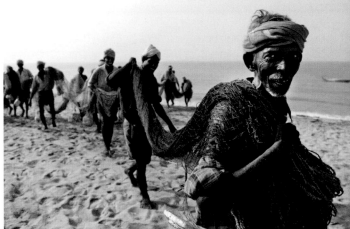

active lines
A strong line leads from soft focus into the sharp details of the face. Well-crafted in its limited depth of field, this image works as an environmental record and a portrait.

image *analysis*

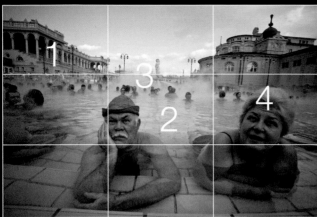

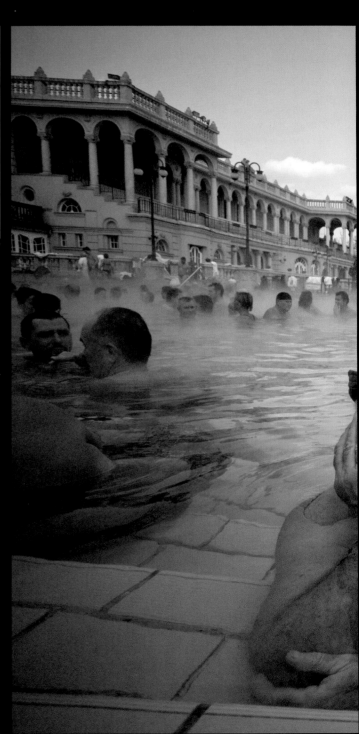

24MM ISO 200 1/60 SEC F/8

The quintessential quality of the perfect travel photograph is to evoke a desire to be there. Ami Vitale's image of these baths in Budapest, Hungary, is warm, gently humorous, and, above all, inviting.

1 correct verticals
The image gently slopes, which has the effect of straightening the important parallel lines of the columns on the building on the left. It is less crucial that the verticals of the building on the right are straight, as these are not part of such a rhythmic structure.

2 wash of color
The aquamarine colors typical of mineral-rich waters provide a soft, enclosing world for the image. It contrasts with—and therefore brings out—the skin tones as well as the yellow stonework of the surrounding buildings.

3 central focus
The radiating lines of the fountain lying at the center of the image provide a focus that is almost subliminally subtle. Like the spokes of a wheel, the whole image revolves around this understated hub.

4 relaxation mode
We encounter the bathers at close quarters, but there is no tension evident. This suggests the people are perfectly relaxed about being photographed and, because they are at ease, we feel free to explore the rest of the image.

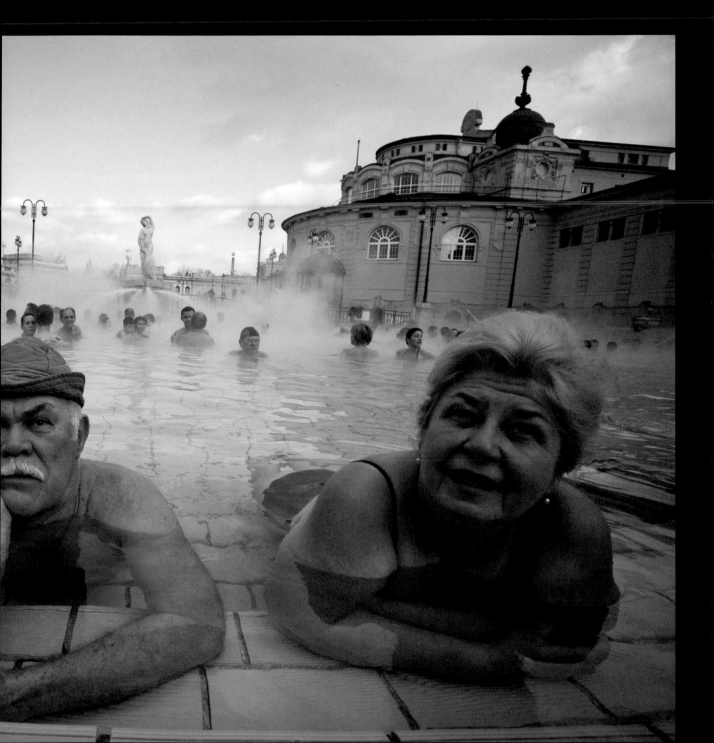

assignment:
heart of the country

If it's difficult to portray the character of a single person in a photograph, then it is almost impossible to capture the essence of a whole country. The secret is to think of your photography as a form of poetry: narrow down what you want to say to the bare essentials, then express it concisely and beautifully.

the brief

Imagine that a travel magazine or the tourist board of a country you are visiting has commissioned you to find a shot that captures the soul of the country.

bear in mind that there are different ways to characterize a country, and different views of what constitutes its heart. Think about activities surrounding food, music, ceremonies, and religion, and avoid static subjects such as landscapes and buildings.

try to capture human activity in an arresting way, with its context in evidence so that the location is easily identifiable, and when national—rather than international—dress is worn.

must-see master ▶

Tewfic El-Sawy
Egypt (1948–)

El-Sawy's interest in photography began while traveling extensively as an international banker. His works, which merge photographs with sound recordings, aim to capture traditional ways of life across the world, in particular cultural ceremonies and tribal rituals. He organizes and leads exclusive photographic tours, often to places seldom visited by western tourists.

career highlights

1980 Moves from Egypt to work for Citibank in Houston, Texas.

1997 Begins to take photographs as he travels as an international banker.

1999 Leads first photo-expedition to the Himalayan Kingdoms.

2001 Photographs Maha Kumbh Mela, an Indian religious festival attended by millions of pilgrims.

La Guelaguetza, Mexico, February 2008: A sense of movement is captured perfectly by the blurred dress of a dancer at *La Guelaguetza,* an ancient religious ceremony in Mexico.

think about...

1 universal faces
Close-ups of faces may say much about a country and its life, but it may make it look as if the story is about an individual rather than the whole country.

2 mass identity
Crowd scenes can be colorful and rich, carrying lots of information as in this view of a market, but there is a lack of personal contact with the camera.

3 group shots
A group of people posing for the camera can be effective for conveying different personalities, dress, or tribal decorations in one image.

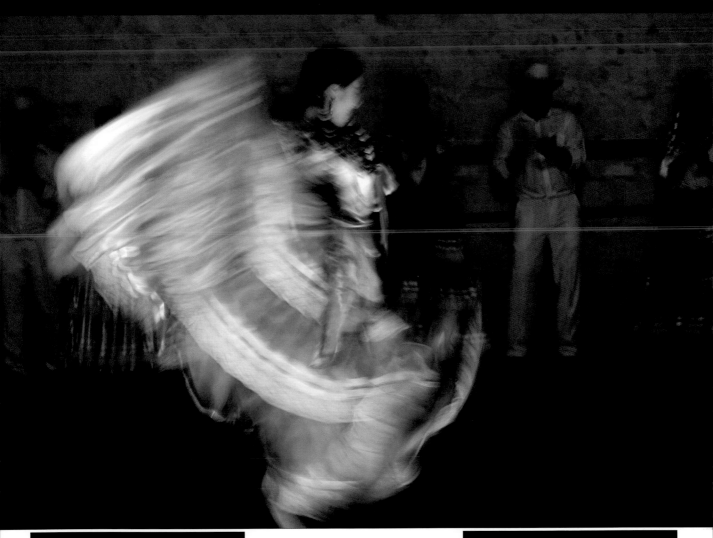

4 colorful religion
Religious events or ceremonies are important to the life of many countries and are often very attractive. But avoid becoming too abstract.

5 black is the new color
Working in black and white can be easier than working in color, as there are fewer things to think about so you can concentrate on the central action.

6 way of life
The country's way of life may be the best representation of its character: your image does not have to hide the facts but you can choose lovely light.

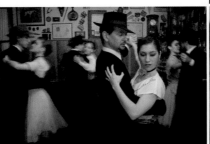

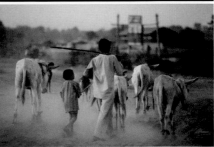

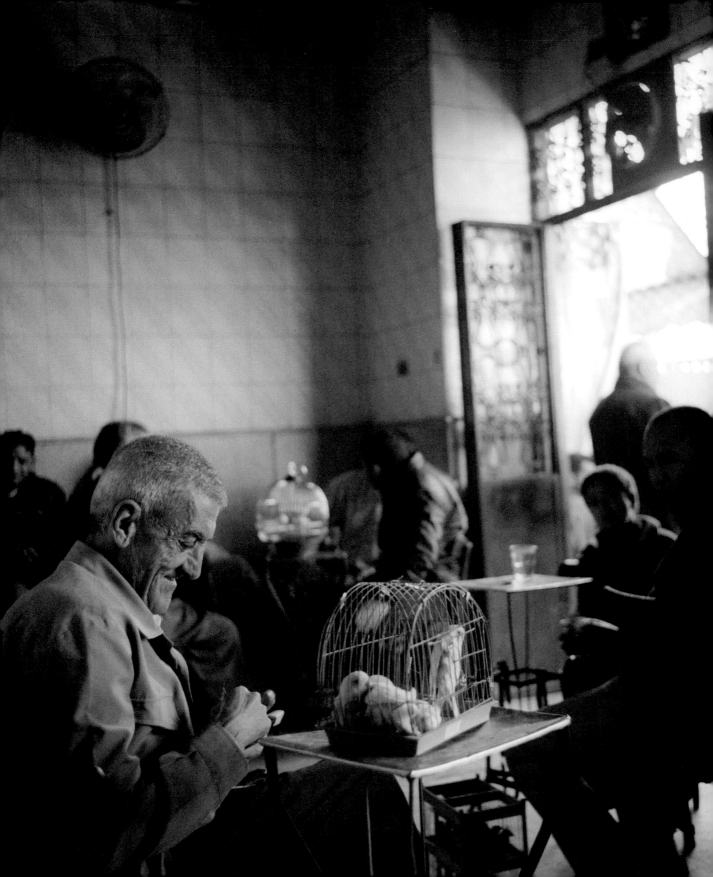

denis dailleux

Denis was born in Angers, France, in 1958. He now lives in Cairo, where he spends much of his time creating a unique photographic portrait of Egypt's capital city. His subtle, thoughtful studies of anonymous subjects who live in the city's slums convey his passion for the country and its people.

nationality
French

main working location
Cairo

website
www.denisdailleux.com

◀ **for** this **shot**

camera and lens
Mamiya C330 and 65mm lens

aperture and shutter setting
f/8 and 1/60 sec

sensor/film speed
ISO 400

for the story behind this shot see over …

in conversation…

What led you to specialize in travel photography?
I didn't set out to become a travel photographer—in fact I had never traveled at all before I visited Egypt for the first time in 1992. I went to Cairo to see an Egyptian friend I had met in Paris and fell in love with the country.

Please describe your relationship with your favorite subject. Are you an expert on it?
My favorite subjects are ordinary people, as I am myself an ordinary person. I have a lot of empathy with them. I identify more with losers than winners. Some of this comes from my childhood, as my grandparents and my great uncles and aunts were almost all *métayers*—sharecroppers.

Do you feel you have succeeded in being innovative in your photography, or do you feel the shadows of past masters over you?
I started taking photographs because I admired those of Avedon, Irving Penn, Diane Arbus, and Paul Strand.

How important do you feel it is to specialize in one area or genre of photography?
It seems to me that it is important to dig one furrow. Very few photographers are capable of handling all genres.

What distinguishes your work?
I think it's the proximity to and empathy I have with the people I photograph that makes this subject my speciality. I have been told that my photos are often pictorial; I am unconsciously influenced by Caravaggio, Watteau, and El Greco, I think. I spend a lot of time observing the light before taking photographs. I don't take pictures when I don't like the light—I never use artificial lighting.

As you have developed, how have you changed?
I don't know if I have changed, but I'm probably more confident now.

What has been the biggest influence on your development and maturing as a photographer?
The beautiful black-and-white work of my friend Bernard Guillot in Egypt has influenced me. I like the mystery and the spirituality that radiates from his pictures. And, of course, the opinion of my friends and other photographers has influenced my work.

What would you like to be remembered for?
I sincerely don't know if I would want anyone to remember me for anything in particular.

Did you attend a course of study in photography?
I spent a year studying in a private photography school. However, I believe that there are no rules. A lot of good photographers are self-taught.

How do you feel about the tremendous changes in photographic practice in the past 10 years? Have you benefited or suffered from the changes?
I'm resisting the changes that have taken place over the past 10 years and continue to work with film as I love using my camera and only that particular camera. Moving to digital would mean that I would have to get the Hasselblad to achieve comparable quality, and I don't like it. I'm very sad to witness the decline of the film-processing labs in Paris caused by the switch to digital. The person who used to develop my pictures has just been laid off.

Can photography make the world a better place? Is this something you personally work toward?
I don't practice social documentary photography, but if my work makes people dream the way music transports me then yes, perhaps it can make the world a better place. But it isn't really for me to say.

Describe your relationship with digital post-production.
My relationship with computers is practically nonexistent. I can't even scan a negative. However, I do like using the scans that are sent to me when I have my films developed. They help me to select my pictures and it is a pleasure to send them to my friends.

Could you work with any kind of camera?
I would find it impossible to work with just any camera as I don't care for equipment much in general. I can only use my Mamiya. There's nothing special about it. I've had it for 25 years and it has only two lenses.

Finally, to end on a not too serious note, could you tell us what non-photographic item you find essential?
My iPod and Radiohead.

behind the scenes

For a successful image, it's important to have a strong relationship with the subjects of the photograph. I like to walk through the streets of Cairo with my Mamiya, observing people and waiting for an inspirational moment.

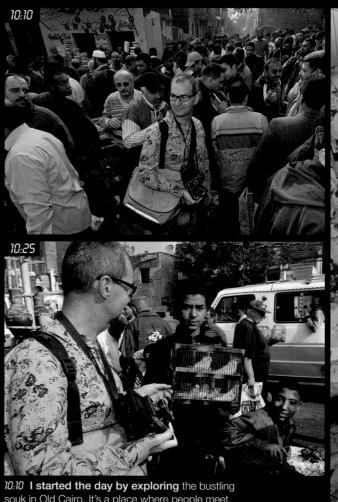

10:10 I started the day by exploring the bustling souk in Old Cairo. It's a place where people meet every Friday and is very lively. There were so many interesting subjects here—I was spoiled for choice!

10:25 A young trader tried hard to sell me some budgerigars. I asked if I could photograph him, but he declined.

11:15 **This café made a great subject**. Before I took any pictures, I joined some men for tea and asked permission to shoot.

11:20 **I changed to a 65mm lens**.

11:22 **There was natural light in the café**, but it was quite dark so I took a light meter reading.

11:25 **It helps to let people** be part of the moment, so I showed these men how I had lined up the shot.

11:35 **Finally, I started photographing** and got some great images.

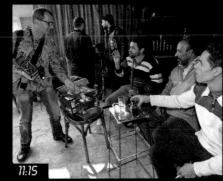

11:15

11:20

11:22

11:25

◁ in **camera**

11:35

portfolio

▷ **an Egyptian boy, 1998**
The bright colors of the boy's coat and the patchwork of cloth behind caught my eye. I took this picture in a village near Cairo at night using only ambient light.

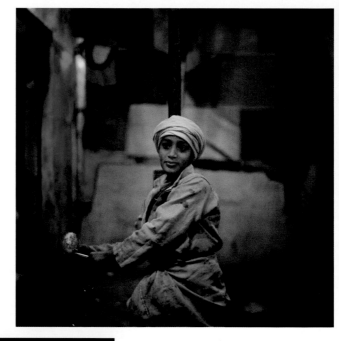

▽ **Alexandria railway station, 2005**
Egypt is commonly seen as a bustling place, but I wanted to show the other side of its character. This photograph taken at the railway station in Alexandria captures a tranquil moment.

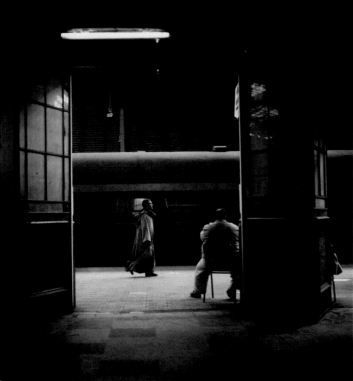

▷ **café in Cairo, 2000**
This image of a coffee shop in Bab Zuweila—Cairo's Islamic quarter—was taken at dawn with a long exposure. For me, it really captures the spirit of Egypt.

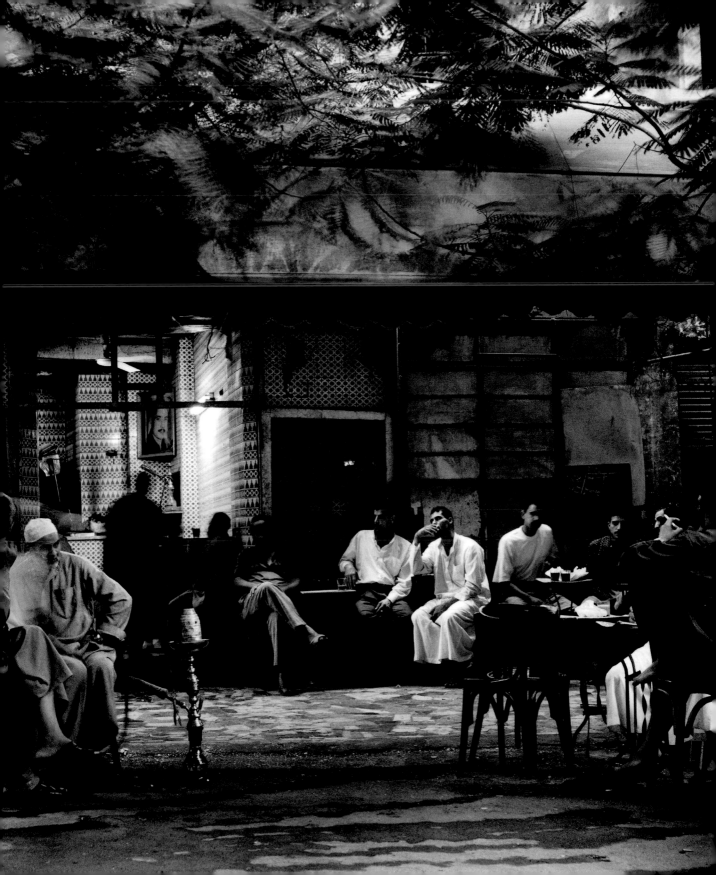

and
finally...

1 make your returns
Go back to your top-choice locations at different times of the day and try out different shooting positions—for example, look for high vantage points.

2 get up early; miss dinner
For the best light, catch the golden hours—the half hours before and after sunrise and sunset.

3 get wet
You'll distinguish yourself from other photographers simply by going out in the rain. The pay-off for your discomfort is finding shots rich in atmosphere.

4 mono simplicity
Don't forget that black-and-white images sweep away distractions and present the scene in its clearest form.

5 capturing place
Use every tool available, including panoramic views made both horizontally and vertically, to capture the location in a range of visual styles.

6 varied views
When presented with a wonderful view, shoot it many different ways: try landscape and portrait formats, using deliberate slants, or varying distances and zoom settings.

7 take more not less
Shoot more in your frame to allow for cropping and to show the context—for example, include dark shadows to frame the action.

8 bracketing insurance
To make sure you have a good choice of pictures, bracket your exposures. This will also allow you to create HDR images if the lighting is tricky.

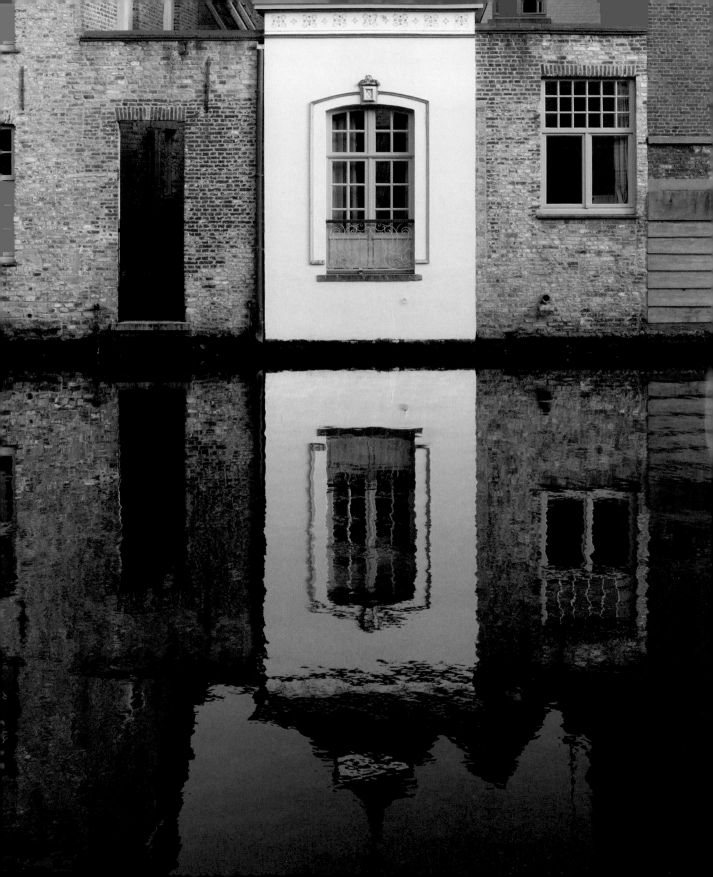

ARCHITECTURE
PHOTOGRAPHY

> **"** Much like the glamorous sitter of a portrait, many buildings are created to be attractive to the eye and appear to be loved by the camera **"**

Architecture photography tends to rank the photographer in inverse proportion to the importance and magnificence of the subject. Buildings that are themselves a form of high art need no creative enhancement. The grander the edifice, the less personal interpretation comes into play. Therefore, modest buildings can often make more rewarding subjects.

Faced with a modernist masterpiece, a looming castle, or ornate madrassah, the photographer's task is less one of exercising individual creativity, but of finding an interpretation of the building subservient to the architect's vision. However, given an abandoned farmhouse or a disused factory, the photographer is the hero: it is their vision, craft, and skill at image processing that brings the subject to life.

This tension is not unique to architecture, but it is trickier with buildings because they are unresponsive. On the other hand, they give you all the time in the world to photograph them—the only time pressure comes from changing light or sky conditions, or the movements and demands of people.

Much like the glamorous sitter of a portrait, many buildings are created to be attractive to the eye and appear to be loved by the camera: every angle is a winner. But such is photography's catholicism of taste that even the ugliest building in the most dilapidated condition can make a striking picture.

With the expansion of the built environment, subjects for architectural photography have multiplied enormously—and digital techniques make it easier than ever to create stunning images. For example, the problems caused by a scene's dynamic range exceeding the capacity of the camera's sensor have now been largely overcome. In the past, we had to wait for the right balance of brightness, but today we can work with a wider range of lighting options, confident that image manipulation with tone-mapping software can blend different exposures into one dynamically compressed image.

Similarly, provided you use high-quality lenses that draw images with the minimum of distortion, small errors of aim that cause parallels or verticals to converge, or verticals that are not quite true, can be easily corrected in post-processing. Furthermore, problems of color balance that used to plague film-based architectural photography are wholly a thing of the past: even without working in RAW format, digital images have a wide tolerance to white-balance variations and adjustments.

In this chapter we explore the art of working with any type of building, whether photographing a World War II bunker or a Moorish masterpiece, by working with the powers of position and light.

key moments

	
1839	The **first architectural photographs** are taken—buildings were a popular subject because of long exposure times.
1855	**Philip Henry Delamotte** publishes *Photographic Views of the Progress of the Crystal Palace, Sydenham*.
1878	French architectural photographer **Albert Levy** starts to manufacture gelatin dry plates.
1897	**Eugene Atget** begins documenting the architecture of Paris, taking more than 10,000 images over the next 30 years.
1903	Frederick Henry Evans takes a series of photographs of **Wells Cathedral**, most notably *The Sea of Steps*.
1922	Josef Sudek records the reconstruction of **St. Vitus Cathederal**, Prague.
1929	Berenice Abbot begins an extensive photographic study of **New York City**.
1930	Lewis Hine is commissioned to document the construction of the **Empire State Building**.
1961	Nikon's 35mm PC lens with built-in **tilt and shift** allows in-camera control of focus and shift.
2009	**Julius Shulman**, US architectural photographer, dies aged 98.

tutorial: forming with light

Photographers of architecture have an ideal partner in architects. The latter's planning and design—the architectonic—ensures that half the work is done for the photographer. The relationships in the building between form and light, context and mass, and texture and line have all been carefully arranged.

finding your own way

A good architect will have worked out all the sightlines in advance so that you view the structure and space in the best way possible. The orientation of the building and the size and shape of the windows will all have been planned to make the best use of light—to maximize it, to create attractive forms, or to cast intriguing shadows.

This offers the sensitive photographer a dilemma: whether to be guided by the architect or to try to find a personal interpretation that may or may not be equally valid. This dilemma is one reason why it's hard to find an architectural photographer whose work shows a strong

personal signature. If you specialize in buildings you also specialize in understanding how architects think, and how to show their work in the best light. Consequently, personal vision becomes subordinate to the architectonic.

looking the other way

If you're free to approach a building in your own way, without having an architect to please, one way to be innovative is to look the other way—meaning that you try to find unconventional viewpoints. The majority of people look toward centerpieces put there in order to attract attention. Try to look elsewhere: look up, down, through holes and small gaps, from floor level or from ceiling height, in order to find a good angle from which to present the building in a unique way.

light tools

The technical advantages of digital photography have made more of an impact in architectural imaging than in perhaps any other form of photography. This is because, more than any other genre, architectural images must constantly confront the problem of excessive dynamic

flat light
The lighting conditions in all three images are identical—flat, overcast daylight. Yet different building spaces mould the light to produce widely varying effects.

focus on technique: high dynamic range (HDR)

Once an advanced technique for handling high dynamic range, HDR quickly became a popular, even a preferred, technique for some. Faced with a scene with large differences in light and dark, you need to make a minimum of three exposures in register for good results. One is exposed for highlights (it looks very dark), one for shadows (it appears too light) and one in-between (it appears normal). HDR software overlaps and

blends the three images so that highlights are exposed as they appear in the dark image, and shadows as they look in the light image. The light and dark tones are compressed to near mid-tones. You can tune results so they handle just the dynamic range or make it look painterly with all tones close to mid-tone. HDR images work well with art-material effects, as in this image combining HDR with Watercolor and Find Edges filters.

range. Dynamic range, for our purposes, is the ratio between the power of the brightest part of the scene that is to be recorded with some detail, and that of the darkest part that has to hold some detail.

This ratio was always beyond the capacity of film to record because capturing the detail in the darker parts of the interior would mean that the brightest parts would appear burned out with no detail. Modern sensors are little better, but image processing has made all the difference. In-camera processing can detect where an image is threatening to become too bright and responds by tailing

off the tone curve that translates the sensor's signal into an image, so that some details are retained in the highlights. Similarly, the processing can hold shadow detail by slightly boosting the tone curve at the "toe" or shadow end of the sensor's response.

In addition, there are two post-processing (short for "post-capture processing") methods for dealing with high dynamic range. One is to make HDR composites (see box above). The other applies algorithms that analyse the image to boost shadows and darken highlights—the Shadow/Highlight control. Note that these controls work

follow the shadow
Lanterns placed in interior spaces can magically transform the area by throwing long shadows. Using a tripod allows exposures to last as long as needed.

rhythm of the day
Large structures will cast shadows during any sunny day, but it's worth finding out what is the best time of the year, and of the day, for the most attractive pattern of shadows.

with JPEG or TIFF images; you don't have to use RAW format, although by working with RAW you will give your software the most data to work with, and the best chance of artifact-free results (i. e. with no visible defects). These measures mean that architectural photography is easier than ever before. Young photographers who point their digital cameras boldly toward the sun from the interior of buildings have no idea how lucky they are.

colored lights

HDR methods are not only for truly high-dynamic range situations. A positive side-effect is that we can now see far more intense hues in images that feature light sources. In the days of color film, light sources would simply look more or less white. The greater visibility of color in bright light is a product of image processing, for our normal view of light sources is that they appear mainly white.

Actually what we are describing is a significant visual artifact, created by the photographer for greater artistic effect. However, we don't use that derogatory label because, on the whole, we like the effect. It makes images of interior lights and illuminated buildings at night look full of color. The effect doesn't have to be permanent, though. If you want to remove the color, you can increase image contrast using a Curves control.

Another advantage of digital technology is flexibility with white balance. Where incandescent lights dominate we can choose to leave our image warm or fully correct for a cooler effect. This also applies to shots taken at dawn or sunset, where the color temperature is very low and there are mainly red-yellow hues.

However, if fluorescent lights are prominent, it's usually best to remove their greenish cast, although greenish whites in a scene with other lights can be attractive. This brings us to the problem of including several different types of light source within the same image. The fact is, we like the variety: a scene with different colored lights, if fully corrected, might as well be in black and white.

saturation control

The man-made colors in buildings are characteristically rich: their high saturation produces lively areas. But that holds dangers for the photographer. A small patch of over-saturated color easily disrupts a composition by visually dominating the image. And overall high saturation tends to make all images look very similar. Consequently, a simple strategy to offer something different is to lower saturation, preferably to a selective range of colors, using a Replace Color or Vibrance control (see p.57).

sunny days
Bright sunny days may be difficult for many types of photography, but they are excellent for architecture. The sharp shadows and deep contrasts are ideal for showing up form, bringing out texture, and giving strong color. Use a polarizing filter to intensify colors. The evening of a sunny day is equally dramatic: don't be afraid to have totally black shadows.

mixed lighting

Embrace the mixed white balance of different colored lights. The contrast of incandescent lights with the evening sky is particularly attractive and there's no technical reason why you shouldn't attempt to make an "accurate" image of both light sources at once. You can use a Replace Color or Vibrance control to knock back reds and yellows that are too strong. The greens from fluorescent lamps can have a strongly dampening effect on reds and magentas: correcting green tints can be very effective.

image analysis

10MM ISO 100 306 SEC F/4

It's liberating to learn that the most prosaic of subjects can make a great photograph. Here, Andrew Whyte's skillfully applied vision has turned this ugly war remnant into the centerpiece of an intriguing image.

1 star tracks
With an exposure lasting around five minutes, the rotation of the earth is sufficient to blur pinpoints of starlight into blurred streaks—an extreme form of motion blur. If the exposure lasted all night, the blur streaks would describe circular paths.

2 string of light
An aircraft flight path determined the viewpoint and framing of the image: as planes flew overhead, their navigation lights "painted" a track across the sensor, and their pulsing lights created regularly spaced spots of light along the tracks.

3 eerie glow
A green filter set over a lantern casts a green light, which the photographer used to light up the interior of the pillbox (gun emplacement).

4 angled illumination
With the green gel removed, the lantern was used to "paint" the exterior of the building. It takes experience to know how much light to give a subject. Note that the lighting was applied from an angle to bring out the texture of the building. The photographer does not appear, because he moves through the exposure.

assignment:
playing with light

Light can be the photographer's accomplice in upstaging the architect. However skilled, no architect has perfect control over the effect of light on a building. The photographer, on the other hand, can illuminate interiors or use natural light to make full use of the structure's features—he or she can, quite literally, put them in a new light.

the brief

Transform the normal view of a building through the use of light. Fill a dark interior with light, or shoot a part of the building that's usually in shadow and hidden from view.

bear in mind that you can make a scene brighter in two simple ways: either by adding extra illumination or by giving the shot extra exposure. Remember that you'll need to get permission before undertaking the shoot.

try to capture details that are not normally visible, or bring out interesting aspects of architectural or surface features—for example, by lighting them from an unusual angle. Use a tripod for precise framing.

think about...

must-see master ▶

Edwin Smith
United Kingdom (1912–71)

A trained draftsman, Smith saw himself as a painter rather than a photographer. At the age of 15, he saved up coupons from cornflakes packets to buy a Box Brownie, but soon upgraded to the 1904 Ruby plate camera that he used throughout his career. During the mid-1930s, he worked briefly as a fashion photographer for *Vogue* magazine, but found his niche realizing architectural, landscape, and garden scenes. In the 1950s, he created a series of respected photographic books depicting English life in collaboration with his wife, Olive Cook.

career highlights

1935 His work first appears in *Vogue*.

1939 Publishes his first two books in a series of photographic manuals.

1952 Publishes first in a series of three books on British building types.

Westminster Abbey, London, 1958: In Smith's charming black-and-white image of Westminster Abbey, the vaults are carefully lit to expose the magnificent architecture in all its glory.

1 leading shadows
Ambient light is the most effective form of illumination, but it depends on the time of day. Ask someone with local knowledge when the best light will be.

2 using flare with flair
Flare is too often treated as an optical mishap, but it can be used effectively to create an appearance of brilliant, blinding light.

3 high dynamic range
HDR or tone-mapped images can alter the apparent lighting of a scene, as well as pump up the colors and contrast for effect.

4 light painting
If there's poor light, or if a building demands drama, an effective technique is to paint with colored lights in total darkness, using a flash or flashlight.

5 infra red
You can use infrared techniques to vary lighting, because they turn the dark tones of greens to light values and the bright tones of skies to dark values.

6 flooding with light
On overcast days, which may seem unpromising, generous over-exposure can fill a space with light. Avoid burning out any sunlit areas.

jean-claude berens

Born in Paris in 1970, Jean-Claude has lived in
Luxembourg since he was a child. His interest in
abandoned iron ore mines led him to experiment
with lighting and digital techniques to produce
moving studies of architectural decay.

nationality
Luxembourgish

main working location
Belgium

website
www.urbanvisions.lu

in conversation...

What led you to specialize in architectural photography?

I find buildings fascinating because they tell a story about the people who designed them and those who lived and worked inside them.

Please describe your relationship with your favorite subject. Are you an expert on it?

I don't have to be an expert on a building but I have to get a feeling for the place. The more I feel its history, the deeper my relationship with it is. I look for revealing details so that my pictures become more than simple "photocopies."

Do you feel you have succeeded in being innovative in your photography, or do you feel the shadows of past masters over you?

It's sometimes difficult to make a shot of an architectural object that has not already been shot before. I always want to create something new so I am innovative, even though I use standard techniques.

How important do you feel it is to specialize in one area or genre of photography?

Through specializing, I have learnt how to represent a subject as I perceive it. I then found a way to create a real dialog that transmits my message in a simple and subtle manner to the person reading my photograph.

What distinguishes your work?

It's difficult for me to say. However, I think the subject matter, the use of a wide-angle lens, desaturated colors, processing, and composition give a recognizable quality to my work that people refer to as my "typical touch."

As you have developed, how have you changed?

I have become more sensitive to the characteristics of the image before my eyes, even if I don't have my camera with me. My sense of observation has been sharpened.

What has been the biggest influence on your development as a photographer?

I grew up in a town that was heavily industrialized and was inspired by its abandoned mines and buildings. My main influence has been Buddhism, which has taught me that impermanence is an important and beautiful part of life.

▲ for this shot

camera and lens
Canon EOS 5D and 15mm f/2.8 fisheye lens

aperture and shutter setting
f/8 and multiple exposures for HDR

sensor/film speed
ISO 100

for the story behind this shot see over ...

What would you like to be remembered for?

There is a clear emphasis on decay and abandonment in my work. It's in our nature to fear age and death, so it's very rare that we give time a chance to show us the beauty of decay. I want my photography to show the inherent beauty of age, death, and decay, so I would be happy to be remembered as a photographer who unveiled that.

Did you attend a course of study in photography?

I didn't, but I read a lot of books about theory and practice. However, photographic education is very important if you want to continue to develop your skill.

How do you feel about the tremendous changes in photographic practice in the past 10 years? Have you benefited or suffered from changes?

I have benefited quite a lot. New techniques in photographic practice, such as HDR, allow the camera to capture the full dynamic range, even going beyond the capacities of our eyes. Many of my pictures would not have been possible without multiple exposure and tone mapping, because the contrast range of the subject would have exceeded the capabilities of the sensor.

Can photography make the world a better place? Is this something you personally work toward?

Photography has a big influence in good and bad ways. I use it to convey my personal message to people contemplating the decay in the subjects I depict, encouraging them to see its beauty. This doesn't change the world, but even a small spark can light a big fire.

Describe your relationship with digital post-production.

I use a dSLR camera and therefore my darkroom is called "Photoshop" and my relationship is positive.

Could you work with any kind of camera?

I feel comfortable with any equipment as long as it's digital. I'm very experienced in digital post-processing and I don't have enough practice in traditional film photography and darkroom work. I use a full-frame dSLR.

Finally, to end on a not too serious note, could you tell us what non-photographic item you find essential?

I always wear a black SWAT suit during my photo sessions because the places I depict are sometimes very dirty. I can lie down in the dirt and the dust without worrying about my clothing.

behind the scenes

The Centrale Thermique is located in my home town. Its function was to convert toxic gas from furnaces to electricity, but it's been falling into dereliction since its closure in 1997. I have photographed its interior many times.

13.00 **From outside, the building gives** no clue to the breathtaking symmetries within it.

13.15 **Whichever angle I looked at it from,** the building just seemed ugly in the dull light.

13:00

13:15

13:45

13:45 In the dim interior slow shutter speeds were needed, and therefore a tripod.

14:35 This building has extremes of contrast between windows and shadowed areas, so I used multiple exposures for HDR.

15:10 By now I was in full protective gear of overalls and a hard hat for safety.

16:15 Spotting the most interesting shot, I looked for the best angle and shot six exposures from 1/8 sec to 120 sec.

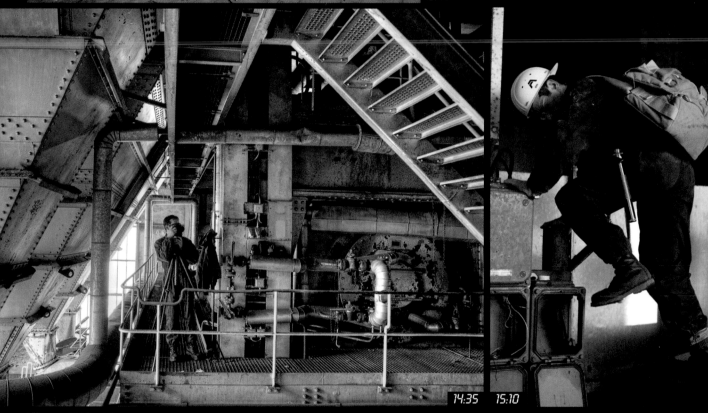

14:35 15:10

16:15

◁ in **camera**

portfolio

▷ **Château de la Source, 2009**
This staircase is in a small abandoned castle in the eastern part of Luxembourg. I used a fish-eye lens to help accentuate the beautiful curves of the architecture.

▽ **chaos, 2008**
After almost 90 years of industry, the last coal-mining cart ascended the pits of Beringen, Belgium, on 18 October 1989. In this photograph, I wanted to capture the decay and impermanence of this lost underground world.

▷ **sun and dust, 2008**
The furnaces at the iron-ore silos in Esch-sur-Alzette, Luxembourg, operated from 1872 until they closed in 1977. In this photograph, I made the most of the available light to highlight the cathedral-like grandeur of this abandoned space.

tutorial: drawing lines

The technical term for how a photographic lens projects an image is "drawing." Although it sounds quaint in a technical context, it's perfectly accurate: lenses each have their own individual way of "drawing" the lines in a scene onto the photographic image. When they get it wrong, we call it "distortion."

straight lines

The vast majority of photographic lenses are designed to be rectilinear—they draw straight lines in the subject space so that the sides of buildings appear as upright lines in the image. This is the result when the magnification of the lens is precisely even, or the same across the image field—from center to edge. Small variations in magnification makes lines appear curved. Fish-eye lenses (see box opposite) are designed with constantly varying magnification, giving the characteristically barrel-shaped distortion. We tolerate small curvature in the majority of

images, but of course architecture offers lots of straight lines, so any curvature is more easily visible. This means that architectural photography (as well as special areas such as document copying) demands higher standards of freedom from distortion than normal photography.

The lenses that deliver the least distortion are single focal-length designs with normal fields of view and are usually of symmetrical design, meaning that the shape of the component lenses are similar on either side of the aperture. Zoom lenses tend to offer poor correction for distortion and are best avoided for architectural work. If you do use a zoom, try setting it to the middle of the zoom range to give the least distortion.

projection distortion

Another type of distortion is not caused by the lens but by viewing the photograph from an incorrect distance. In order to see what the photographer saw through the lens when he or she took the picture, you should regard the image from a distance determined by the enlargement and focal length of the image. With wide-angle views reproduced at normal page size, you should view the photograph with your nose almost touching the paper. If you view it from further away, nearby objects appear larger than expected, giving the dramatic effects typical of ultra wide-angle views.

bold curves
Use bold framing and cropping to turn a dramatic design into a dramatic composition. Set a small aperture for maximum sharpness and depth of field.

focus on technique: fish-eye lens

Fish-eye lenses were originally designed to take lighting measurements. To ensure even coverage, magnification varies across the image, giving the distinctive barrel-shaped curvature. The most useful type is the full-frame (**1**), which projects an image that covers the whole format, with a field of view of 180 degrees from corner to corner. The circular lens (**2**) projects its image uncropped and centered on the sensor.

converging ideas

It's well known that pointing a camera upward to frame the top of a building makes it appear to lean back. This is not a true distortion, but it could be said to be a projection error. The leaning-back effect is also caused by magnification variation across the image field. When the camera back is tilted, the distance from the top of the building to the sensor is much greater than that between the bottom of the building and the sensor. The top of the building therefore appears much smaller. This variation in magnification changes the shape of the building in the

exploiting projection

Strongly converging lines suggest a rapidly receding space that pulls us in. However, the viewpoint keeps us outside the space and this visual tension drives the image.

image space so that vertical lines appear to converge toward the top. Instead of treating these effects as technical errors to avoid you can actually exploit them, so that your images then become more subjective and interpretative (but beware—architects usually loathe them). It's important to use the effect strongly, to ensure that your gesture is seen to be deliberate. For example, a slight upward tilt to frame the top of a building often looks like poor technique. In contrast, pointing upward at a near-vertical angle, while standing close to the building, with or without a strongly inclined horizon, makes a bold statement.

Finally, remember that photographing a building from one side, instead of head-on, gives the horizontal equivalent of converging verticals, offering another way to treat buildings expressively.

tutorial: visceral spaces

All the vital functions of a building take place within its interior—whether we use it for entertainment, worship, manufacture, or trade. Here, architectural character derives as much from the contributions of the interior designer and the activities within as from the architect: that is what we need to convey.

in the corner

Faced with an unfamiliar interior, the natural tendency for the photographer is to shoot from one corner and aim toward the opposite corner. This gives the widest view of a room, maximizing its apparent size and spaciousness. This is a look often called for by interiors magazines or by agents promoting a property to potential clients. But this approach leads to a repetitiveness in feel and composition that may mask or miss the true character of a space.

The elevation of the camera introduces another variation. You can photograph from higher or lower than usual—the standard eye-line height is not a rule you have to follow, it's merely the most convenient. Try shooting from the top of a ladder or low down for a child's eye view. Where permitted, move the furniture around if you think it will improve the shot: an arrangement suitable for living is not necessarily the best for a photograph.

balancing act

Another consideration is the balance between the brightness of the exterior and that of the interior. A good strategy is to work at dawn or dusk, at which times the interior and external light levels are commensurate. You may still have to juggle with white balance, but even that is likely to be less of a problem than in the middle of the day, since the light conditions at dawn and dusk tend to have a color temperature not far from that of incandescent lights.

If you have to work while the outside light overcomes interior light, you need to supplement the light inside by using flash or other sources balanced to daylight. Bounce the light or flash against walls that are out of shot in order to soften the illumination. Cover the walls with white paper if they are strongly colored.

light-filled
A space illuminated by daylight is a dream to photograph. Here, skillful use has been made of reflections in the table to provide fill-light and color contrasts.

color values
Warm colors evoke intimacy, even in public spaces, while neutral or cool shades are more usually associated with modern style and space.

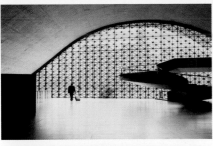

walking and seeing

Whatever the scale of the space, the first thing you should do is walk around it; very slowly. Each step you take will give you a new view: some viewpoints will emphasize the spread of lines, while others will show features compressed. In any well-designed space, each and any position will offer a picture that reveals something different.

mood shots

A space that, in use, will be filled with many fascinating clues that reveal everything from the prosperity of the owners to their visual preferences may also reveal their ethnic origins and even how obsessive they may be. The visible items are a signature of use. That is why "dressing" a room prior to photography is almost an art in itself—a good stylist can make or break an interior photograph.

There was a time when the over-dressed room was the norm, but we now prefer to see one that makes minimal use of props—that looks natural. So the huge bunch of flowers is out, as are the meaningful pile of books and champagne bottle. In are the smartphones, laptops, and executive toys. Remember that people may be treated as props, too: a figure in the background—perhaps just a blurred streak—provides scale and enlivens the space.

simplicity

Remember that transit areas, such as corridors and stairs, are functional spaces too—sometimes the busiest, yet bare. Their simplicity offers contrast with other spaces.

image analysis

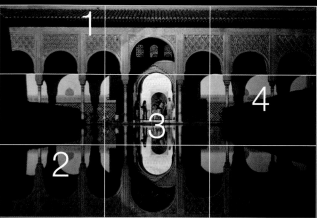

135MM ISO 250 1/250 SEC F/8

The Alhambra Palace in Spain is renowned for its undeniable beauty. Here, however, Jose Luis Roca's ingenious use of light brings out serendipities of shadow and color that even the architect might not have fully predicted.

1 straight lines
An image free of distortion is essential for formal views of archtecture. For example, it would be unacceptable for the line of the roof to be visibly curved. Being so close to the image border, small, visible, variations from straight would destroy the symmetry.

2 stately reflections
Reflections create a powerful sense of grandeur and expanded space. By using the water's reflection in the image, the photographer creates symmetry and opens up the sense of space.

3 pointed color
The flash of red caught by the sun, seen here toward the middle of the photograph, catches a viewer's attention. By drawing the eye to the center, the symmetry and rhythmic pulse of the composition are emphasized and reinforced. Warm colors from the sun relatively low in the sky unify the rich variety of patterns.

4 rest in the dark
The areas in darkness may not have been welcome when this photograph was taken. However, the shadow provides welcome areas for the eyes to "rest," away from the intricate mosaics and stonework and the highly detailed columns and arches.

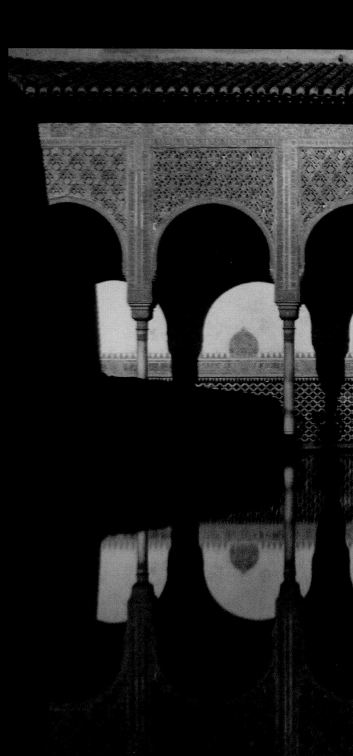

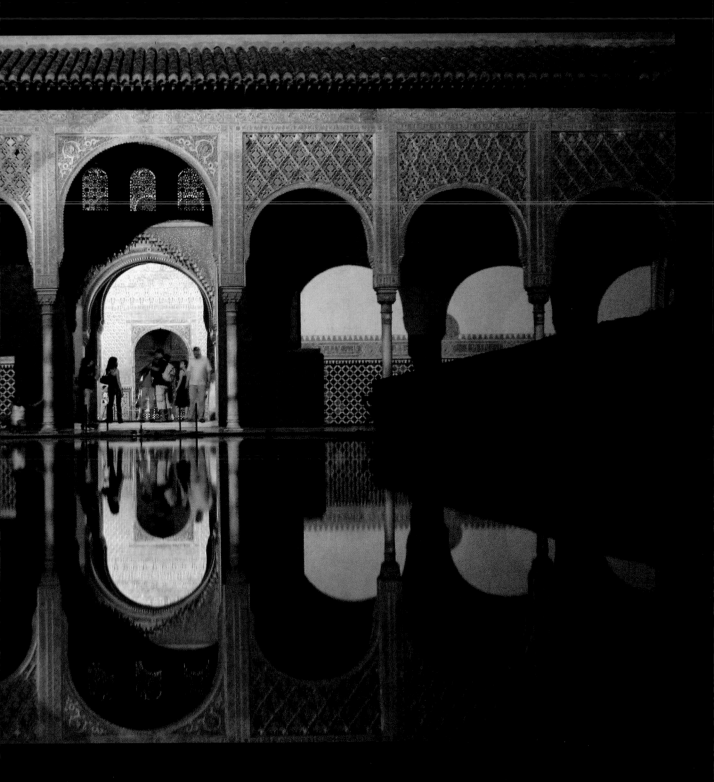

assignment:
ultimate quality

In architectural photography it's taken for granted that your images must be of the highest technical standard. However, the search for ultimate quality can sometimes lead to images that lack character. You need a special element: a surprise, an incongruous object, or a homage to a master, to raise your image above the ordinary.

the brief

Capture the character and quality of a building using the best technical means available to you. At the same time, try to incorporate an element that animates the scene.

bear in mind that the animating factor could be simply a person or pet walking across the floor, or something humorous or surprising but appropriate: the owner cleaning a window for example, or someone in the background playing to the camera.

try to capture the image perfectly in-camera, pre-empting the need for post-processing by recording at the highest resolution, with the lens at its optimum setting, and shooting from a tripod.

must-see master ▶

Juergen Nogai
Germany (1953–)

With a raft of art, media, and teaching qualifications under his belt, Nogai began a successful career as a commercial, fine art, and architectural photographer. In 2000, he met revered architectural photographer Julius Shulman (1910–2009), who came out of retirement to work with him on a number of assignments. Nogai often uses large-format cameras, which produce images that require little or no retouching.

career highlights

1982 Publishes an architectural guide to the Free Hanseatic City of Bremen, Germany.

2000 Moves to Los Angeles.

2002 His work appears in *The Case Study Houses*, which captures modern homes built by key US architects between 1945 and 1966.

Kaufman House, Palm Springs, 2007: This image replicates Julius Shulman's original photograph from 1947. By placing Shulman in the shot, Nogai brings some emotion to the piece.

think about...

1 perfect parallels
A *sine qua non* of a high-quality shot is that straight features are perfectly aligned with the picture frame. Deviate from this only for very good reasons.

2 noisome noise
Long exposures—even at low ISO settings—may be noisy, detracting from the quality of detail and tone. Reduce noise in post-processing.

3 lighting up
Even illumination across the entire image field is an important element of quality: use post-processing to lighten corners if light fall-off or vignetting occur.

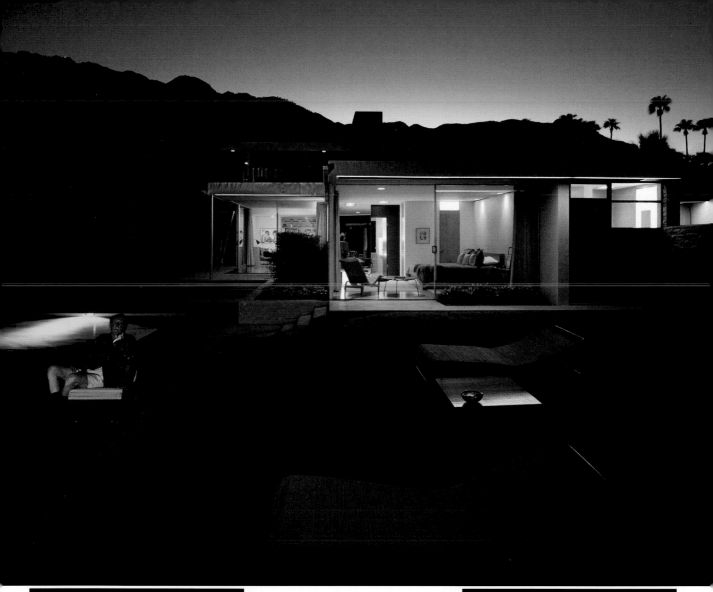

4 animal magic
The presence of a person or pet in an image can add character and lend a lived-in feel to even the most pristine domestic interior.

5 human traffic
Blurs of people in transit help to give life and energy to what could otherwise be empty, static spaces. Movement is accentuated by the still backdrop.

6 gorgeous light
A favorite time to shoot is dusk, the magic hour when sky and foreground lighting are in balance. Try to catch stunning natural light whenever it occurs.

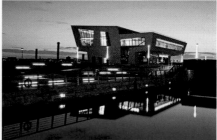

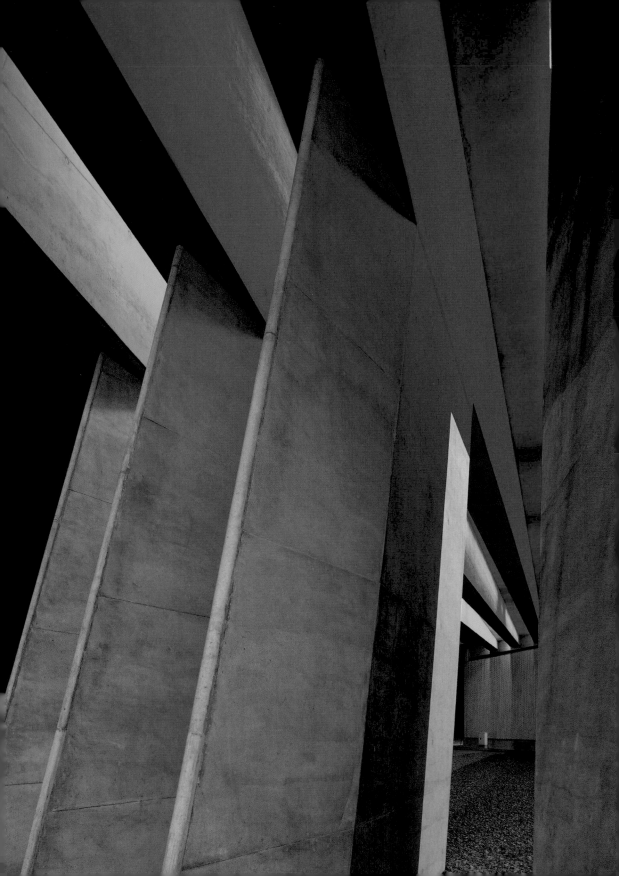

ales jungmann

Born in Czechoslovakia in 1971, Ales studied photography at the Film and TV School of the Academy of Performing Arts, Prague. He is a member of the Association of Professional Photographers Czech Republic (AF). Ales specializes in clean, sharp shots of architecture and interiors.

nationality
Czech

main working location
Czech Republic

website
www.alesjungmann.com

◄ for this shot

camera and lens
Canon EOS-1Ds Mark III and TS-E 24mm lens

aperture and shutter setting
f/10 and 30 sec

sensor/film speed
ISO 100

for the story behind this shot see over …

in conversation…

What led you to specialize in architectural photography?
As a student I was given the task of photographing an outstanding building, Prague's Trade Fair Palace, built in 1928. I was overwhelmed by its architecture and realized that this type of photography might be a field I could explore for a long time and even make a living from.

Please describe your relationship with your favorite subject. Are you an expert on it?
My photography is a service for architects, so I must portray responsibly and with humility a picture of the place for a person who may never visit it. But it is up to me to interpret the picture. I choose the visual means to do this—I always try to express the nature of the building, whether in an overall picture or an abstract detail.

Do you feel you have succeeded in being innovative in your photography, or do you feel the shadows of past masters over you?
I don't know. I haven't thought of it this way. Of course, I have admired photographs made by other architectural photographers, such as Pavel Štecha and Ezra Stoller.

How important do you feel it is to specialize in one area or genre of photography?
There's no real reason why a photographer shouldn't become outstanding in all genres—but I can't recall anyone who has done it.

What distinguishes your work?
I feel this is up to others to decide. I just try to do my best.

As you have developed, how have you changed?
I have become more self-confident in my work and clear in my mind about what I don't want to do.

What has been the biggest influence on your development as a photographer?
My own mistakes and my college professors.

What would you like to be remembered for?
I would be pleased if people looking at my photographs see that the architecture is good and then say, "That's a good photograph. Who took it?" And I would like my clients to regard me as a reliable professional.

Did you attend a course of study in photography?

I majored in photography at the Film and TV School of the Academy of Performing Arts (FAMU). This education was essential for me. You can possibly become a successful commercial photographer even faster through self-study or working as an assistant. But thanks to this art school, I think I have developed a more complex personality than I would have done if I had started to work in the commercial field and specialized from the very beginning.

How do you feel about the tremendous changes in photographic practice in the past 10 years? Have you benefited or suffered from the changes?

The past 10 years have really been revolutionary. High-quality digital photography became available almost overnight, so everybody became a photographer, which must have been frustrating for the professionals. On the other hand, I am able to sell more photographs and I am better off. But I feel nostalgic about the old days when, working with a large format 4x5 camera and cloth over my head, I felt like a magician.

Can photography make the world a better place? Is this something you personally work toward?

Nowadays, when TV is so ubiquitous, perhaps not. Even the documentary photography after World War II did not bring about change, although photography as a medium had much more impact back then than it does now. However, a good photograph pleases people.

Describe your relationship with digital post-production.

I made friends with my first Mac in 1992. I can't imagine my work without it, though I try to do most of the work during the process of taking the picture.

Could you work with any kind of camera?

With architecture I need special equipment to correct converging parallels. I used the Sinar F 4x5 camera long after digital photography arrived. However, after I bought a new Canon EOS-1Ds Mark III and then Canon's new series of 24mm and 17mm tilt and shift lenses arrived I made the switch to digital.

Finally, to end on a not too serious note, could you tell us what non-photographic item you find essential?

I love driving, so I choose big, playful cars with a large trunk for my equipment. But equipment is getting smaller and smaller, so I am considering buying a Mini Cooper!

behind the scenes

The BMW plant in Leipzig, Germany, is an amazing building by Zaha Hadid. As the shoot was in December when daylight hours are short, I decided to start in the afternoon and do the main shots I wanted at dusk.

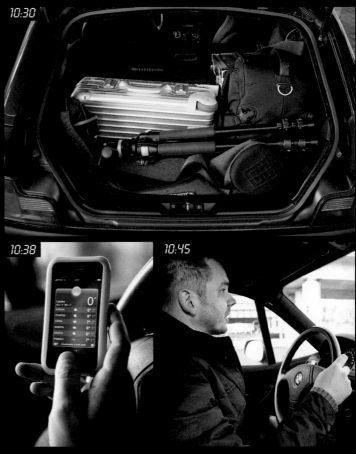

10.30 I packed a basic set of equipment, though I did take along my Sinar F view camera as well as all the digital gear so that I could take one "old-fashioned" picture.

10.38 Checking the weather in Leipzig, I saw that a sunny afternoon was still promised.

10.45 I set off, allowing plenty of time to be sure of arriving while the sun was still up.

15:20 **When I arrived** I found the weather overcast, so I didn't get the sunlight I wanted to show up the plasticity of the building.

15:40 **I set up my Canon 1Ds** with the 24mm TS-E tilt and shift lens, set to maximum shift.

16:00 **The hard case for my Sinar camera** stands in for a stepladder when I need one— I was able to use a height of about 7ft (2.1m) on my Manfrotto tripod.

16:05 **I concentrated on interior shots first** as the light levels would fall more quickly inside than outside.

◁ in **camera**

16:15 **I moved outside** at the time I planned but, on checking a test shot (below right), I realized I needed the light levels to fall a little further for the intensity of the colored light to strengthen.

16:30 **I took a shot with the Sinar view camera** first as it takes a while to set up. I used a single 1200Ws flash lamp to bring out details in the shadows.

16:50 **Changing back to the Canon,** I took a digital photograph, again using the lamp and flashing about four times during the 25-second exposure.

▽ in **camera** ▷ in **camera**

16:15

16:30 16:50

17:05

17:10

◁ in **camera**

17:05 Perched on an uneven surface, I used a self-timer to reduce the vibrations.

17:10 The colors were now strong, but I had to be quick as the sky was getting dark.

17:45 I quickly reviewed the shots I had taken on the camera screen.

18:15 It was now too late to repeat anything, but I checked my shots carefully on the laptop to give me peace of mind on the way home.

17:45

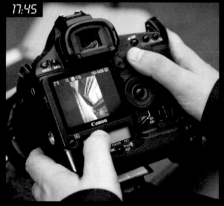

18:15

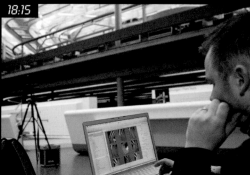

portfolio

▽ **detail of a ceiling at Village Cinemas, Prague, Czech Republic**
This was the very first picture I took of a movie theater, but I have since photographed more than 20 new multiplexes. I used no additional lighting.

△ **interior of the PVR Cinema, Juhu Mumbai, India**
I have photographed theaters in cities all over India, including Delhi, Indore, and Hyderabad. When I'm on a shoot, I like to catch a movie at the theater too, so when I was working in India I became a big fan of Indian films! I used a 2500w Hedler tungsten light with a softbox.

◁ **Andel's Hotel, Lodz, Poland**
When I was on this shoot I had bad luck
with the light—it was either overcast or
raining heavily. This picture was the last
shot taken on the last day. Just as I was
loading my equipment into the car, there
was a moment of bright sunlight. I quickly
grabbed the camera without the tripod
and pressed the button.

and
finally...

1 strong convergence
For special effects, converging parallels are acceptable: exaggerate them strongly to show that you know what you're doing.

2 action stations
Architecture photography need not be entirely static: action that complements the structure such as traffic—human or otherwise—enlivens the image.

3 symmetrical heaven
If in doubt, compose the image with a mirror symmetry—preferably centered on the middle of the image and maintaining the verticals: it never fails to impress.

4 home straight
Distortion of either straight lines or shapes is the Number One enemy of architectural photography: use low-distortion lenses and frame carefully.

5 color restraint
Limited color palettes are most effective at delineating form, as the lack of variety brings out shapes and lines while a little splash of color catches the eye.

6 highly dynamic
Use HDR and tone-mapping techniques to solve lighting problems, rather than to provide unreal effects that distort tonal values.

7 look up
The feature most often neglected by photographers is the ceiling: it pays to look up from the center of the space and capture its expanse with an ultra-wide angle lens.

8 twilight zone
The best way to balance indoor and outdoor lighting is to wait for the brightness of the day to diminish toward evening.

FINE ART
PHOTOGRAPHY

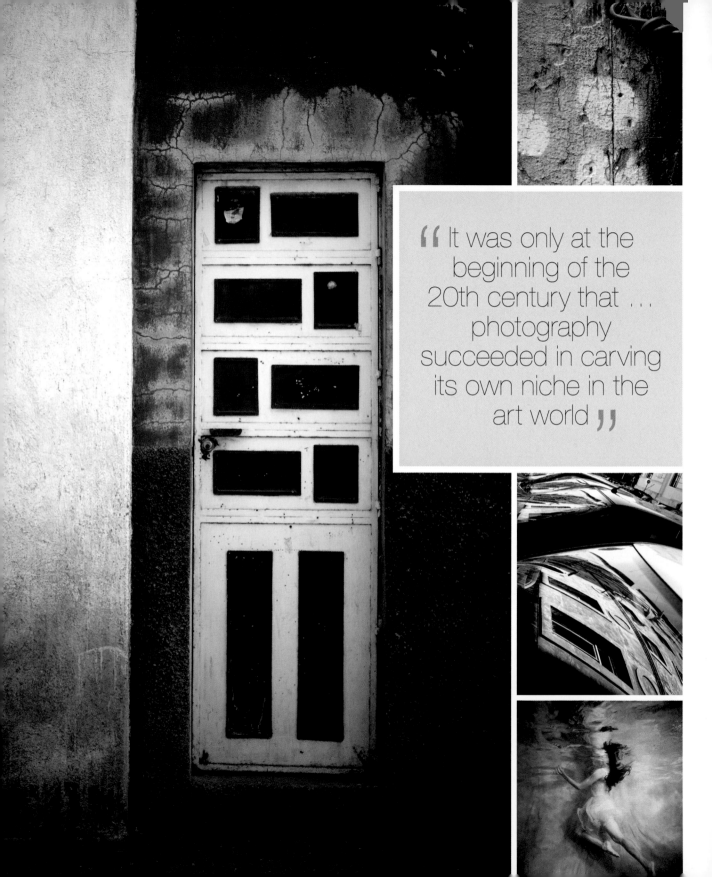

> "It was only at the beginning of the 20th century that ... photography succeeded in carving its own niche in the art world"

Fine art photography was long regarded as an oxymoron: for many, photography was the very opposite of fine art. Indeed, for much of its history, intellectual property legislation classified photography as simply a mechanical process. Now, the shoe is on the other foot and there is hardly any area of fine art left untouched by photography.

Photography's early attempts to create works that would be taken seriously by the art world were greeted with the sneering question: "But is it Art?". In response, photographers borrowed heavily from the conventions of oil paintings, some using elaborate stage sets combined with multiple printing—an early example of image manipulation—in order to imitate compositions with multiple models. It was only at the beginning of the 20th century that the debate between art and photography was accepted as trivial. This was the point at which photography succeeded in carving its own niche in the art world, proud to use its own visual vocabulary, and owing no debts to painting.

At the same time, fine art shook itself free from the requirement to be representational and turned its aesthetic notions upside-down. It began borrowing from any source including, ironically, photography. Today, photography is incorporated into so many artworks that we may be moved to ask "But is it Photography?".

The melée resulting from the tumultuous union of art and photography means there are many different forms of fine-art photography. For some, the photograph as

key moments

1845	John Edwin Mayall illustrates The Lord's Prayer with 10 **allegorical photographs**.
1892	**Linked Ring** is formed—a UK collective for the furthering of art photography.
1901	Historian and critic **Charles Caffin** publishes *Photography as a Fine Art*.
1902	The **Photo-Secessionist** movement is founded in the US to promote fine-art photography and image manipulation.
1916	Paul Strand creates Cubist-influenced **abstract studies** featuring cups, bowls, and fruit.
1917	Elsie Wright and Frances Griffiths create fake **"fairy" photographs**.
1921	**Man Ray** places objects directly onto photographic paper to create **photograms**.
1923	László Moholy-Nagy introduces photography at the **Bauhaus** school.
1978	**Robert Mapplethorpe** courts controversy with his *X Portfolio*, which features explicit sexual images.
1990	The first version of **Adobe Photoshop** is released.

object is paramount: created on the basis of silver-gelatin processes, the print is the created work—precisely exposed and beautifully crafted. The subject on the piece of paper may be anything from an historical news event to an egg on a table.

Others define fine-art photography in terms of the approach. One is conceptual—work that's based on critical or theoretical notions of fine art, which are usually intellectually engaging but not always visually captivating. In fact, if the concept is to question normative values, the resulting images may deliberately be made repellent. Some conceptually driven work also pays close attention to creating a context for the image, making art installations that isolate the image from the real world.

Another way cleaves more closely to 18th-century aesthetics, which emphasized form, balance, beauty, and elegance as ideals. This is the broad thrust of what we cover in this chapter. There is a return to these roots, in part as reaction to the anti-aesthetics of modern art, and in part as a wish to reconnect with nature and its inherent beauty. The 21st-century approach adds sophistication and delicacy, which is applied through the use of image manipulation.

tutorial: still alive

Still life and photography are a match made in heaven. Indeed, photography could well have been named "still life," as it freezes motion into stasis. But that doesn't mean the still-life image should be lifeless: the challenge is how to permeate the photograph with implied movement and transience.

observing life

We are surrounded by many examples of still life: the arrangements of objects—some accidental, some carefully placed—that we set up in our living spaces and then forget until we need to dust or clean up. Still-life photography can be as passive as simply the observation of these details. The light and events that surround a still life can alter its appearance profoundly. This is particularly true of objects placed near a window. As the light changes from hour to hour and the seasons create ever-shifting activity in the world outside, the still-life becomes the axis around which the activity revolves.

active still life

You can create a still-life arrangement using absolutely anything that comes to hand. It helps to decide in your mind whether you intend to create a world within a world or whether you will take things largely as you find them, making only small adjustments to position, and refining or supplementing the available lighting.

In fact, there is a vast range of possibilities for your composition, running from the wholly constructed at one extreme to the wholly found at the other. The wholly constructed still life uses items selected specifically for the shoot that are arranged on a table against a designed background and lit with studio lighting. With the wholly found arrangement, nothing is touched or adjusted.

In between these two extremes there are many ways of constructing a still life. One approach is to give careful consideration to the feelings you want your viewer to experience. Do you wish to convey a sense of nostalgia redolent with warm memories or longings for a lost childhood? Or do you wish to impress the viewer with your visual virtuosity by seeming to create images out of almost nothing?

compare and contrast: varied settings

It's only a slight exaggeration to claim that it could take you a lifetime to exhaust the possibilities of an arrangement of pears on a table. You can vary the size and shape of the container that holds the pears (**1**). You can shoot the image in either color, toned or untoned black and white, or from different angles. Or you can work in a more graphic way, exploring the compositional properties of the pear's shape, together with other objects (**2**). Both of these approaches reference the concerns of painters, which you may eschew by investigating the articulation of space using scale and depth of field (**3**).

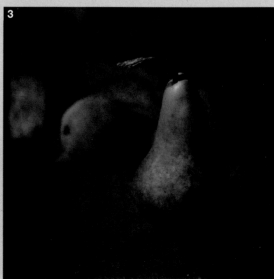

wealth in the mundane

One of photography's unique qualities is the way it can be used to turn the ordinary into something extraordinary. Plain objects, such as these simple pieces of paper, can yield images of purity and elegance—and even convey a sense of movement—when a soft, oblique light is used to illuminate them (**top row**). Simple kaleidoscopic filter effects are then applied to create other-worldly symmetries (**bottom row**).

control, control

Still life seems easy to master because the subject is static, but technical demands arise whenever you get close to a subject. Depth of field drops rapidly, and perspective can create illusions regarding the object's size. Work with portrait lenses (70mm–120mm focal length) for three-dimensional subjects with depth. Use standard lenses (about 50mm) for flat objects, such as maps and documents.

The way you light still life calls for subtlety. Even the softest lighting can cast shadows on a small scale, so you need to ensure that shadows don't conceal too much detail. Try to avoid specular highlights (i.e. reflections of light sources) as these are relatively large when seen close up and can detract from the mood. Generally speaking, it's best to start with the softest lighting possible, then increase contrast as needed.

beauty found

Ordinary households abound with still-life arrangements. These accidental juxtapositions come to life with a certain play of light. Look out for landscapes in the home.

still poses

A whole school of still-life photography has been created using toys, which are often posed in elaborate tableaux. However, simple arrangements can work just as well.

tutorial: extracting the extraordinary

Photography is essentially a means of abstracting and extracting elements from the world around you. It does this by simplifying a scene and capturing only as much as the camera can record. The image frame also crops out all unwanted information that would complicate the image.

flattened dimension

The urban environment offers innumerable flat surfaces that are as irresistible to photographers as cave walls were to cavemen. The random wearing away of paint, the tearing of posters, and the interaction of paint with rough surfaces all provide infinite resources for experimenting with abstract compositions.

The key notion is that of surface. When we record patterns and textures, it's important to ensure that the subject surface is transferred onto the image surface. This means, in practice, that when you take a photograph, you need to ensure that there is no variation in sharpness across the image. In addition, if you are shooting the surface at an angle, there should be no clues to that effect. Usually, you will find it easiest to photograph from a position square on to the surface.

reducing clues

The purpose of this approach is to ensure that you record your subject with the greatest clarity, by reducing distractions and clearing away clues about size and angle of view, lighting, and how you framed the shot. Paradoxically, this makes abstract photography among the most objective of all genres: you are recording the image with the minimum of artifacts (i.e., visible defects) introduced by the process of photography.

Flat lighting is the native environment for extracting abstract images from the world. Colors are generally at their most intense because they are not diluted by reflections. However, overcast light is often deficient in reds and yellows, which means that warm colors may not have their full color values. If you try to boost reds and yellows, you may introduce color artifacts. If in doubt, record in RAW format to allow a good range of enhancements.

light textures
Fine art abstracts do not have to be of urban decay, but they do call for an observant eye. Be alert and carry your camera everywhere with you.

 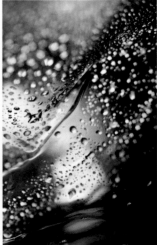

on reflection
Water is a magic potion, instantly transforming objects into mirrors and lenses. Use depth-of-field effects to vary the sizes and shapes of its highlights.

When post-processing the image, you may be tempted to boost colors by increasing saturation or vividness: if you do, you'll start on a slippery slope that leads to increasingly unnatural colors. Better to analyze the image to single out the color that seems to be the weakest, then improve its saturation selectively.

Old paint and torn paper will appear soft in the image. Any attempt to make them sharper will cause the finer details, such as the grain of concrete or brick, to appear unnaturally sharp. The best tactic for sharp images is to capture sharp: use the best lens that you have, set to its optically optimum aperture.

randomization

The usual advice for framing abstract compositions is to frame with care so that you extract the best combination of colors and obtain a balanced photograph. When you follow such advice (and the dreaded Rule of Thirds),

street observatory
A short walk through any inner-city environment in the world will yield many rewarding subjects (if it doesn't, you should try walking more slowly). Look up, look down, look behind you.

the resulting images will all tend to look rather alike. Adhering to this kind of strict rule will mask your unique identity as photographer.

Fortunately, there are some strategies that can help you to break out of the straitjacket. For example, be extremely selective about the kind of image you create, perhaps choosing only to work with reflections or with effects caused by glass. Alternatively, you can simply concentrate on minimal markings, such as a single, calligraphic stroke of paint. Another effective strategy is not to frame at all. After all, any number of different framings can work, so just point the camera at the subject and let it do the work.

image analysis

35MM ISO 160 1/13 SEC F/14

Artistically, the only clue that this abstract image by Jean Macalpine is photographic is the fiercely enforced border: objects are cut off abruptly by the frame. This is germane given the random size and position of the elements.

1 blue ground
In painting this might be called the blue ground, on which the other colors are applied. As in painting, photographs of abstract objects are easier to construct when you have a strongly characterized background.

2 half time
The half-way points of images are important for maintaining structure and coherence. A clear line demarcating differences in textures is placed exactly at the mid-point of the width, where it quietly anchors the whole image.

3 golden section
A fascinatingly colored and textured surface alone is not enough to make a successful image. This photograph demonstrates another carefully applied compositional feature: the strong band of pale colors straddles the Golden Section, dividing the image into two perfectly balanced halves.

4 flat focus
Another successful element in this image is that its flat focus hides one of photography's characteristic signs: depth of field. There is no variation in sharpness, so the image looks painterly.

assignment:
ordinarily extraordinary

Given that one of the very first photographs ever made was of a broomstick leaning against a doorway, the path of photographing the ordinary subject is very well trodden. Yet there is still room to surprise—the trick is to enter into the heart of the subject and forget about photography. When you gain the spirit of the object, the image emerges.

the brief

Explore ordinary objects to create an extraordinary image. Choose objects that mean something special to you, and find a way to present them that brings out that special meaning.

bear in mind that the objects needn't be static, or left where they are found. They could be held by someone (you perhaps) or framed and placed against artwork or photographs. One or two objects strongly presented is preferable to a variety of objects in one image.

try to capture contrasts of scale or texture, or juxtapositions between animate and inanimate. Aim for a sense of stasis or frozen time, with styling that is also timeless.

think about...

1 depth and angles
Photograph from an oblique angle to compress shapes and emphasize repetitive patterns. Exploit blur gradients from depth-of-field effects.

2 contrasts
Letter forms or numerals offer a contrast against the random patterns of peeling paint or rust, and also offer a sense—sometimes misleading—of scale.

3 square-framing
Objects with rectangular shapes should be shot precisely square-on or strongly at an angle. Framing that is in between the two looks poorly controlled.

4 clean colors
If you photograph neutral colors, such as grays, white balance should be accurate to ensure that both mid-tone grays and highlights are truly neutral.

5 transformations
Zooming in unnaturally close to ordinary objects can be astonishingly transformative—just let the camera and optics do the work for you.

6 unusual views
Exploit shadows and reflections to create an entirely abstracted view of an object or objects. Here, light is refracted through a glass of water.

ciro totku

Born and brought up in Moscow in the 1960s, Ciro now lives and works in Cambodia. He uses minimal equipment and relies on waiting for the weather conditions to provide the right light rather than using artificial means to create his striking images.

nationality
Russian

main working location
Cambodia

website
www.totku.com

in conversation...

What led you to specialize in fine art photography?
Fine art photography is a very enjoyable occupation and an easy, pleasant business. When I was a child, my father, a professional architect, introduced me to the world of visual arts.

Please describe your relationship with your favorite subject. Are you an expert on it?
Unexpected objects can initiate a lot of creativity. If you work with photography you have to be ready to encounter surprises and never ignore bizarre ideas. Fine art is alive as long as artists worldwide continue to experiment. I like to make images of water, darkness, and detritus of any kind.

Do you feel you have succeeded in being innovative in your photography, or do you feel the shadows of past masters over you?
I love the work of advertising designers, industrial designers, and logo creators the most. I'm always looking out for good works in these areas—but I never remember the artists' names, nor those of past masters!

How important do you feel it is to specialize in one area or genre of photography?
It is crucial for an artist who works in fine art. Each real masterwork has to introduce a new style or new graphic idea. But it requires effort. If you make a good picture, even by chance, you shouldn't try to repeat the same idea.

What distinguishes your work from others?
I guess that you can see things in my photographs other than what was there in reality. And such photographs can be made instantly—the only thing you need is sufficient light. Most of my photographs were taken in a small area in the slums of Phnom Penh or around my house.

As you have developed, how have you changed?
I have realized more and more that beautiful abstract images can come from an inexpensive, uncomplicated camera and an unpromising location.

What has been the biggest influence on your development as a photographer?
The invention of digital cameras helped me a lot because it made art photography much less expensive.

▲ for this shot

camera and lens
Samsung 585 and 16.4mm lens

aperture and shutter setting
f/3.5 and 1/180 sec

sensor/film speed
ISO 50

for the story behind this shot see over ...

What would you like to be remembered for?
I don't want people to remember me or my works. I think the best path for any artwork is to be sold for a movie DVD cover page or to a rich dude to be used for interior decoration, and to be forgotten thereafter. I don't even wish to elaborate on the content of my images – they are what they are. This is why you won't find any captions on my portfolio shots.

Did you attend a course of study in photography?
I don't think regular study is very useful. My father taught me the technical aspects of photography, but now the basics of digital photography can be explained in a couple of hours.

How do you feel about the tremendous changes in photographic practice in the past 10 years? Have you benefited or suffered from the changes?
In recent years digital photography became a favorite, light, portable hobby for millions of people, who produce terabytes of images daily. And this is a very good thing because it opens the gates of human creativity.

Can photography make the world a better place? Is this something you personally work toward?
Of course! Pictures on walls make a room look better. Glossy magazines would disappear without photographs and the internet wouldn't be so popular. Imagine how empty this world would be without photographs!

Describe your relationship with digital post-production.
Photo-editing software is a useful thing, but any good image is like a gift of God, and you can't generate this miracle by performing software tricks; you can't change the core of the image you made.

Could you work with any kind of camera?
I prefer to use compact cameras—you can take them everywhere. I tried dSLR cameras but discovered that I lost many fantastic images because I didn't want to take a huge camera bag to the market or to visit friends.

Finally, to end on a not too serious note, could you tell us what non-photographic item you find essential?
Rubbish! Any random objects that are left around can be useful for my photography: empty beer cans, broken bottles, cigarette packs, plastic bags, chopsticks, or even dead insects.

behind the scenes

Although most of my work is done in a small area of Phnom Penh, what I find there changes every day. Detritus left by wind, water, or people, washing lines with colorful clothes—there is always something new to shoot.

08:30

08:45

09:00

08.30 **The water's edge** in the early morning light often yields intriguing shapes and patterns.

08.45 **Squatting down for a low viewpoint,** I took some shots of the boats.

09.00 **Balancing on a plank** above the water was precarious, but worth it.

△ in **camera**

09:15 Moving just a short distance away gave me fresh views of possible subjects.

09:35 I always look at anything that has caught my eye from all angles to make sure I'm not missing a better shot.

09:15

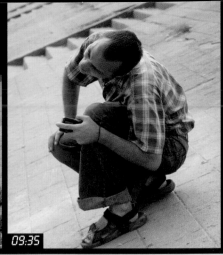

09:35

09:50 10:05

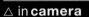

10:30

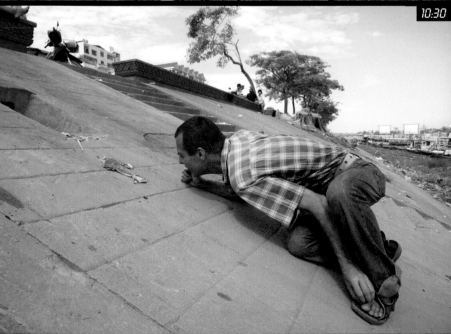

△ in **camera**

09:50 Bright curtains and decorations on the boats created strong patterns.

10:05 This boat was less colorful, but I liked the repeating verticals and square portholes.

10:30 Even a flattened piece of trash is worth looking at, as it could make an interesting shot.

11:30 Back in the streets, I went to a temple complex where building is under way—a potentially fruitful source of subjects.

11:40 I peered into an empty building, but I realized that it was too dark in there to shoot.

11:55 This was an apparently ugly little shack, but it had patterns that interested me.

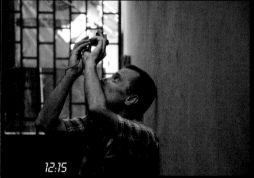

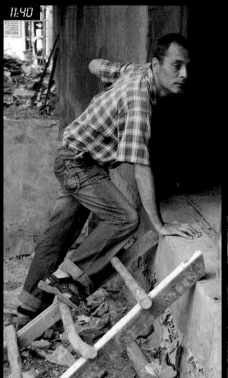

▽ in **camera**

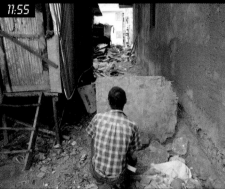

12:15 Light streaming in through a high window gave appealing tonal contrasts.

12:25 Wandering through town, I kept my eyes open for anything that would make an interesting pattern or shape.

12:35 My attention was caught by this brilliant saffron-colored fabric tied around a drainpipe, giving it curving folds.

12:40 I reviewed the shots that I had taken during the morning on the camera screen.

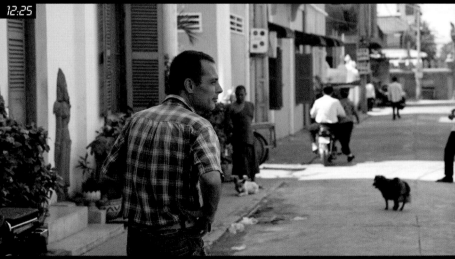

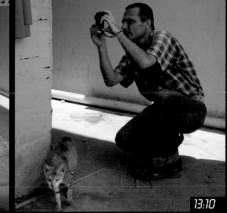

12:55 Finding more saffron robes that were hanging out to dry, I realized this was the monks' living quarters.

13:10 Adopting a different viewpoint, I took some more images of the robes.

12:55

13:10

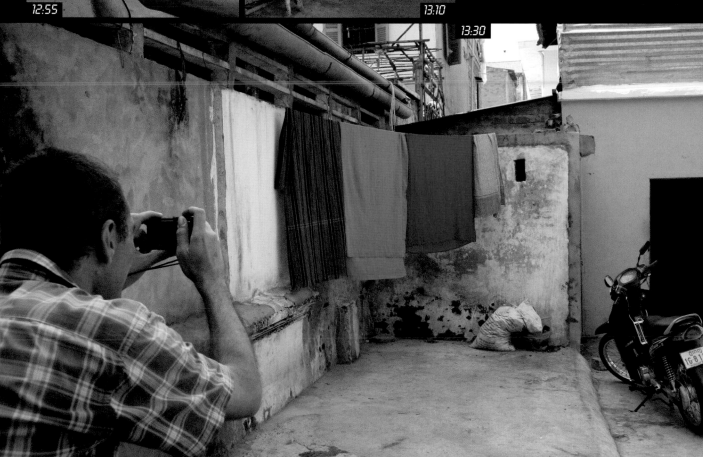

13:30

△ in **camera**

13:30 More laundry—a brilliant blaze of color set against a geometrical shape.

13:50 I walked along the roof, where sleeping platforms offered structural patterns.

13:50

portfolio

▷ rainy season,
Koh Samui, 2006

▽ first snow at Hirayama
lake, Sihanoukville, 2006

△ namib, Sihanoukville. 2007

◁ nude, Sihanoukville, 2006

tutorial: in-camera magic

There was a time when almost every special effect in color photography had to be created in the camera at the time of exposure. This taught photographers to be inventive, skilled, and precise, because errors could not be corrected. In this digitally dominated era, the same skills are still invaluable.

fundamentally speaking

The most fun and rewarding results from in-camera techniques come from having a sound grasp of the fundamentals of photography. That's one reason why learning how photography works is not merely a tech geek's hobby.

For instance, if you want the most out-of-focus blur you need minimum depth of field. If you know the fundamentals, you will be aware that you need a combination of maximum aperture, close working distance, long focal length, a large sensor area, and a lens with a fixed focal length. Unfortunately, blur effects are very hard to achieve with a point-and-shoot camera, as it has a serious deficiency (due to its very small sensor) that is hard to overcome—and impossible to overcome if the available range of focal lengths is limited.

range of magic

Use a systematic approach to investigate in-camera effects by studying each of your camera's controls, along with the results of using deliberately non-standard settings. Indeed, the only difference between a mistake in camera handling and an in-camera effect is whether it was intentional.

The fundamental effect is non-standard framing: tilt the camera or point it without looking, or turn off the auto-focus to deliberately force out-of-focus effects. This technique has a long history and produces a rich palette of effects varying with different lenses, aperture settings, exposure settings, contrast levels, and colors. It's most effective with lenses that have a long focal length: greater than 135mm and with large maximum apertures, preferably f/2 or wider. This effect depends on the quality of the out-of-focus blur spot, known as "bokeh." Generally, the most expensive lenses produce the best bokeh.

filmic ghost
A rich cocktail of close work with deliberate de-focus and a large aperture setting, plus exposing for the near infrared, gives a new slant to the pet portrait.

motion slickness
Motion-blur images work best when the blurred subject contrasts with sharp elements. This image is particularly striking thanks to the symmetrical composition.

swinging lights

City lights offer many opportunities for painting with light. Create random effects by allowing the lights to streak across the sensor: try throwing your camera into the air during a long exposure (but remember to hang onto the strap). Or place the camera onto a wheel or a loose tripod and rotate it during exposure.

Motion blur (see pp.190–91) results from the subject moving across the image during exposure. You can either keep the camera still while your subject moves or move the camera if your subject is static. Motion blur tends to look over-exposed because all light areas become lighter when added to bright areas, but dark areas don't become darker when added to another dark area. To compensate for this tendency, you can set one or two stops of under-exposure.

This technique is related to double-exposure (which also tends to cause over-exposure), in which separate exposures are superimposed.

The final in-camera effect is deliberate over- or under-exposure. Over-exposure opens up shadows and dilutes colors with light, while under-exposure intensifies colors by increasing saturation and improves contrast by intensifying black areas.

transforming exposure

An ordinary scene can be magically transformed by over-exposing by three or more stops, best done in manual mode. Soft lighting produces impressive results.

random effects

Double-exposure done in-camera brings an element of randomness and chaos into picture-making that can produce intriguing results.

tutorial: altered images

When image manipulation first became available, photographers could be divided into those who refused to touch it, and those who used every filter they could lay their hands on. Now that we better understand the techniques and their limitations, image effects take their place simply as tools of the trade.

fine art strategies

What distinguishes image manipulation in fine-art photography is that the effects are used as an integral element of the message or intention of the image. In fact, it's a feature of fine art photography that every element of the image—from the way it's captured and processed, to the paper it's printed on and how it's presented—are all separate visual gestures, each of which carries or shapes the overall meaning. For example, we may extract the color from the environment but leave the main subject fully colored in order to comment on the isolation or incongruity of our subject. Importing a foreign element from one image into another may be the artist's way to point out the tension between our trust in visual documents and accepting improbable images that look convincingly real.

art effects

One area of fine art that digital imaging has had limited success with is the imitation of brush- and pencil-stroked art materials, such as watercolor, oil pastel, or gouache. Some applications have modeled the behavior of brushes using art materials, but the effects usually fail to convince, serving only to remind us of the real thing. One problem is that standard 24-bit color—sufficient for much of photography—is not up to the task of describing paint.

New methods of randomization and digitally modeling brushwork are improving, and the next generation of applications will be far more convincing. At that point, expect to see more use of mixed-media images where photography meets drawing and painting. Past experience has shown that these are two difficult media to marry because their differences are very marked. But convincingly real digital effects will open the way for yet another dimension of image creation.

selective memory

Straightforward in concept, simple in execution, this project wears all its credentials on its sleeve. Its strength is that its subject-matter needs no explanation, yet the variety of composition and location of the images suggests deeper layers. To a child intent on ice cream, the trucks are all-important so his or her perception of color is heightened. At the same time, the trucks are incongruous, seemingly everywhere but belonging nowhere.

invisible hand

For many critics, the best image manipulation is imperceptible. For this reason, some artists choose effects specifically because they reference old photographic processes—such as color negative film/print—or obsolete darkroom techniques, such as sepia toning (a perennial favorite) and hand-coloring. However, if the image is produced digitally, even if it's turned into a high-quality print—and certainly if it's viewed on a screen or via projection—colors never reach the delicate, smoothly blending quality of true photographic or art processes.

total conversion

The captured image is only the beginning: you can then start to experiment freely. The artist who created this composite image has layered various urban scenes.

unreal reality

Ever since the first pronouncement that "a photograph never lies," artists have enjoyed thoroughly debunking it. Done with care, the results are worth looking at twice.

image analysis

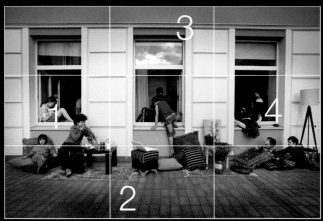

28MM ISO 100 1/60 SEC F/6.7

Art that imitates life shows that creativity owes everything to that which already exists. For this image, Angelika Sher used great patience and insight to imitate a slice of time improbably filled with events.

1 co-operation

Long and painful experience led to the adage "never work with animals or children," and that applies to photography too. But there are no fewer than seven children here. At least one child appears used to being photographed. Clearly, training helps.

2 preparation

Examine the props and you see there was been long and careful preparation for this shot. The foreground has been expressly kept clear, with only converging parallels to lead the eye into all the activity in the rest of the image.

3 distortion

The image is framed formally, but is not quite head-on. This relaxed element suggests that the shot is not intended to be a highly studied composition. The slight curvature of the lines due to distortion is perhaps another sign of relaxed technical control.

4 mini dramas

The delight of the image resides in its many rich layers, from the events on the outside of the house to those on the inside, with some children crossing between the two. This corner captures a little story that could stand perfectly well all on its own.

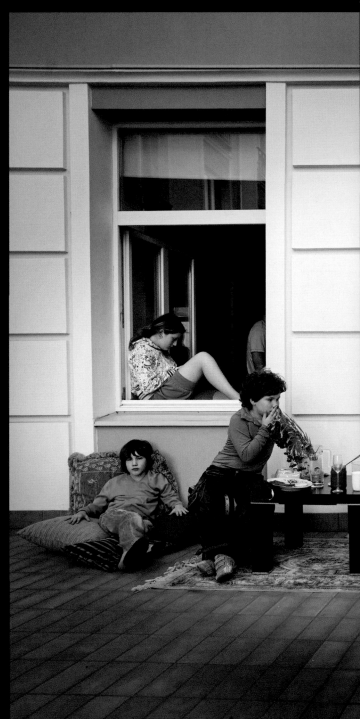

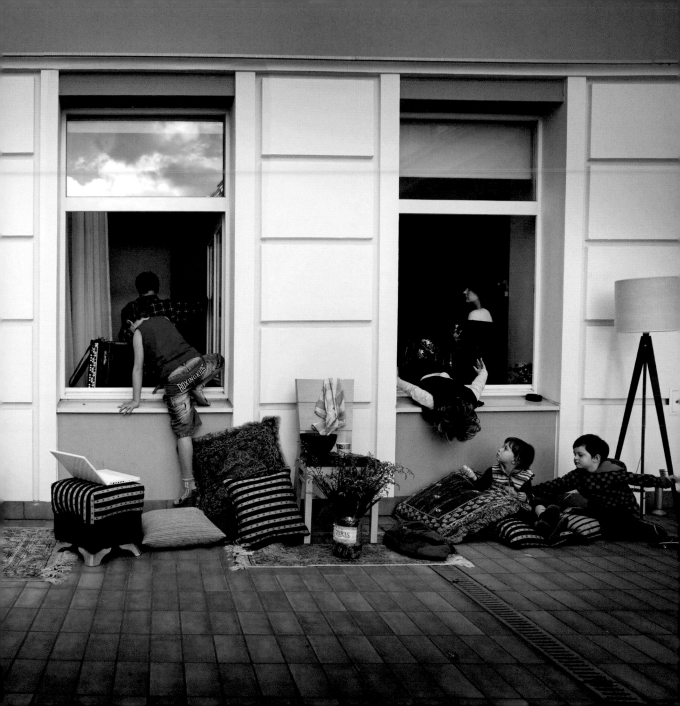

assignment:
constructing unreality

Since the earliest days, photographers have created theatrical tableaux using multiple exposure and printing to imitate painting. With digital techniques, the art of photography has become vastly easier, but the need for imaginative narratives and detailed staging to create a sense of mystery or curiosity is as central as ever to a good drama.

the brief
Plan, execute, and photograph an image that is in the main constructed—using models, artificial lighting, and props. Transform a space into another world, which may be unreal, historical, or belong to a fantasy.

bear in mind that you can easily combine multiple images if you always shoot from a tripod and ensure that the lighting is the same between shots. Use maximum depth of field to make blending easier.

try to capture an image that hides the clues that would reveal the scene is highly improbable in real life, in order to ensure the result is convincing at first glance—however fantastical.

must-see master ▶
Ryan Schude
USA (1979–)

Born in Chicago, Schude moved to California to study for a business degree in 1997. Realizing that the corporate world wasn't for him, he switched to a photography course at The San Francisco Art Institute, before working for *The Daily Bread*, a San Diego magazine. His work reinvents the tableau using rich imagery that contains multiple stories in a single shot. Based in Los Angeles, his acclaimed work blurs the edges between editorial, advertising, and fine-art photography.

career highlights
2003 Creates his first tableau image, *Colin vs Lamp*, a re-enactment of a friend fighting a light.

2008 Receives the PX3 Discovery of the Year award.

2008 Releases a short film, *Bunny Suits*, made with his brother Collins.

The Diner, Sun Valley, California, 2008: Featuring a large cast, including a cat, a pig, and a marching band, Schude constructs a moment at a diner but leaves the viewer to decipher the stories within.

think about...

1 suitable locations
Choose a location that already has some of the mood that you wish to work with, so that you only need to reinforce the atmosphere.

2 montage
To try out variations, lock off your camera and frame generously to shoot each version: this allows you clone good parts of one shot onto another.

3 realism
Weird compositions or juxtapositions are most successful when they look entirely possible, so that the viewer is suspended between reality and disbelief.

4 blend options
Combining two images may be sufficient to make a point, but to make a narrative you may need to composit other elements.

5 keeping it simple
You don't have to shoot elaborate stage sets: a shadow-play with props backlit against a sheet can be highly effective and simple to set up and enact.

6 planning ahead
Brief your models thoroughly before the shoot begins, so that you don't have to give detailed instructions in noisy, public areas.

akira kai

Akira graduated from Nippon University with a photograpy degree in 1972, and in 1988 established Foton Inc., Japan's first photography company specializing in digital imaging. A winner of the Japan Advertising Photographer's Association Award, he has published two photography collections—*Hoobiom* and *The Dancing Wind*.

nationality
Japanese

main working location
Japan

website
www.akirakai.com

◄ for this shot

cameras
Canon EOS-1Ds Mark III and
Mamiya 645 AFD11

aperture and shutter setting
composite image

sensor/film speed
composite image

for the story behind this shot see over …

in conversation…

What led you to specialize in fine-art photography?
I'm not certain, but I lost two friends in high school and had a near-death experience myself. I can't explain in terms of the real world the strange experience I had at that time. I decided that one day I'd like to express the images I saw.

Please describe your relationship with your favorite subject. Are you an expert on it?
In Japanese the term *kachofugestu* refers to flowers, birds, wind, and moon, and many painters take up this subject. The aesthetic side of me pushes me in this direction, too.

Do you feel you have succeeded in being innovative in your photography, or do you feel the shadows of past masters over you?
I'm opening a fresh page in photographic expression. There is the photography of the past but I'm aiming for the photography of the future. My work is clearly different because it goes beyond the constraints of the camera. I'm aiming for an expression of a "spiritual landscape."

How important do you feel it is to specialize in one area or genre of photography?
I don't think it's important at all. I'm creating art and the important thing is to be true to myself.

What distinguishes your work?
I don't often analyze my own work objectively, but I think it's definitely unique. My subjects don't exist in the real world and no one can photograph them except me.

As you have developed, how have you changed?
For a long time I made a living in the world of analog photography, but I lived in hope that a method would be developed that could record dreams. I've always considered photography a means not of recording the outside world, but of recording the inner one.

What has been the biggest influence on your development as a photographer?
The inspiration I felt 25 years ago when the marriage of computers and photographic technology became possible.

What would you like to be remembered for?
I was probably the first person to say—over 20 years ago—that photography was about to evolve into an art form.

Did you attend a course of study in photography?
I majored in photography at Nippon University in Japan. However, my academic background has practically no relevance to either the philosophy or the technical aspects of my current photography. Everything about it I developed on my own. For people like me, school education had very little meaning at all.

How do you feel about the tremendous changes in photographic practice in the past 10 years? Have you benefited or suffered from the changes?
Naturally these are changes that should be welcomed. For me, there's a sense that during the past 10 years, although it's been a gradual process, the times have finally caught up with what I'm doing. I've been saying for the past 20 years that a great change is about to take place in the world of photography.

Can photography make the world a better place? Is this something you personally work toward?
I'm envious of the power that music has. It was impossible to match it in the past but I'm hopeful that we can in the future. I think photography will not only move away from paper, but shift to electronic panels. Then, the genre of "moving photographs" as opposed to "video" will emerge, gathering overwhelming power as it incorporates 3D computer graphics. I imagine that one day electronic panels around the globe will be linked up, causing the entire world to become intoxicated over a single photograph.

Describe your relationship with digital post-production.
For me, both computers and cameras are simply tools to help me express myself. They are indispensable.

Could you work with any kind of camera?
The equipment I use is not particularly special. It's all the kind of thing you can buy anywhere. Nor is there anything remarkable about the way I go about taking photographs. I approach it as if I were going out to gather "ingredients." If there is something special, it occurs during the "cooking" stage when these ingredients are actually used.

Finally, to end on not too serious a note, could you tell us what non-photographic item you find essential?
Japanese tea.

behind the scenes

The image shown on the previous spread is a composite of five photographs shot at different times of year in very different conditions. Using digital processes, I can then create my final artworks in the studio.

12.15

15.55

12.15 **March: I photographed the cranes** at Kushiro Marsh in eastern Hokkaido, using my Canon 1Ds Mark III with a 100–400m lens.

15.55 **The sun was sinking** and the movement of the cranes was highlighted just as I wanted.

△ in **camera**

11:45 April: Every spring I photograph the cherry blossom, which Kyoto is famous for. This time, I used my Canon with the telephoto zoom.

12:15 The weather conditions needed to be exactly right—if the sun were too bright the color would be bleached from the petals, and even a breath of wind would ruffle them.

▽ in **camera**

12:15

11:45

13:40

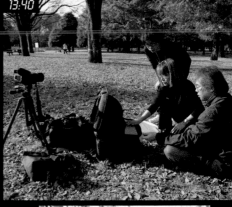

14:30

13:40 Together with my assistant and retoucher, I checked the images on the MacBook and made back-ups.

14:30 I set up a dark background for the blossom—it makes the process of creating a Photoshop mask easier.

14:40 To get a high resolution for these shots I used my Mamiya 645 AF with a Phase One P45 digital back.

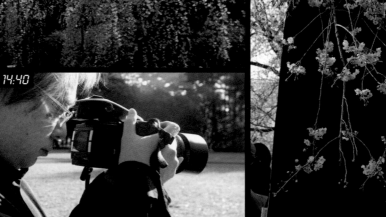

14:40

▽ archive **shot**

`10:30`

`10:45` `12:30`

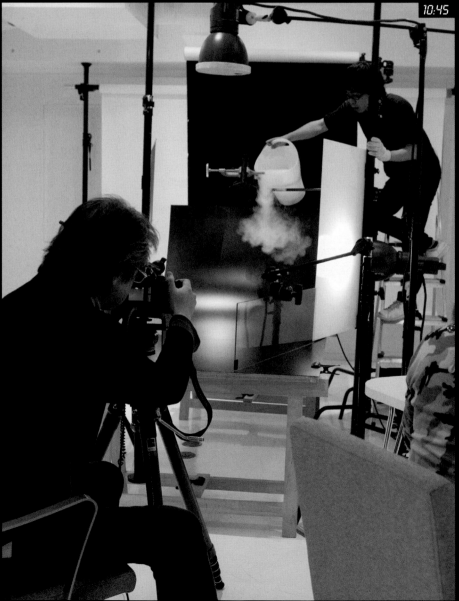

`10:30` **Next day: I wanted to have mist** in the lower part of the image, so I made a backdrop using a shot from my archive.

`10:50` **My assistant, Shunichi Morisawa,** created mist with dry ice and hot water, while I took pictures.

`12:30` **I made numerous printouts of** the background with varying color.

14:30 Once I had decided on the base color I wanted I sat down with my retoucher, Kei Nishiyama, to build the final artwork from four different images: the crane, the blossom, the archive landscape shot, and the mist.

16:40 I used my Canon A2 printer to check the final image. My exhibition prints are up to 10ft (3m) wide, so I work with very large files.

14:30

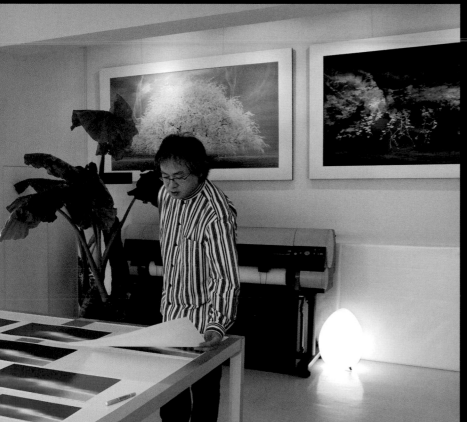

16:40

original background, cropped

color changed and mist added

crane superimposed on background

final image

portfolio

▷ waving in the breeze
This is my attempt to recreate an unearthly, beautiful vision—when I saw this peacock he seemed to be emitting a mysterious light. I did not know it at the time, but in Buddhism the peacock symbolizes enlightenment.

◁ the rhyming wind

Emotions and inner visions inspire my artwork. These spiritual landscapes seem to be a naturally programmed into my mind. This artwork expresses "*Yugen*," a word that relates to mystery, depth, beauty, and darkness—and also a touch of sadness.

△ reflection of wind

There are no physical laws in the universe of the imagination. Glorious autumn leaves set against a freezing, glittering world of ice may seem incongruous, but this scene is a very natural reality for me.

▽ wind of ambience

Sometimes my soul goes on a journey—and this artwork represents what I see there. The cheetah in the wilderness could be me.

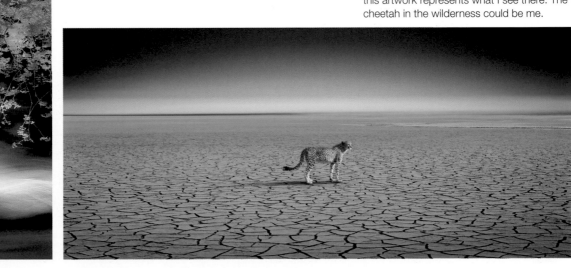

and
finally...

1 cunning collages
Image manipulation applications enable you to make collages as complicated as you like, but the most effective are those with a strong unifying theme or treatment.

2 fantasy colors
A direct way to suggest a fantasy world is to distort colors so that they appear unnatural. But elements of the recognizable ensure clarity of meaning.

3 beauty in the prosaic
Any subject can be turned into an object of fine-art photography: keep your eyes and mind open, and discount nothing.

4 formal features
Approaches to portraiture that are driven by art-critical concepts or that emphasize role play or personal identity are regarded as fine art photography.

5 open season
In fine-art photography, anything goes. Experimentation with techniques can lead to unexpected results. This image actually shows people standing on a bridge.

6 driven by ideas
While it's easy to modify images until they look like art, the most successful will convey a concept or thought: they will be meaningful and thought-provoking.

7 building sets
You can construct images from the smallest objects, such as household items, to very large ones. But don't be too ambitious at first; start small and manageable.

8 extracting abstracts
Every small detail counts when you make abstracts so ensure you have no distractions such as blur or distortion.

index

acknowledgments

My warmest and biggest thanks go to the Project Editor Nicky Munro, who led a brilliant team through a most complicated project, which required negotiations with photographers scattered over six continents and the coordination of numerous other contributions. Project Art Editor Sarah-Anne Arnold led design and picture research with her usual consummate and reliable skill. The team members, namely Sharon Spencer, Ros Walford, Diana Vowles, Scarlett O'Hara, Joanne Clark, and Laura Mingozzi, were also a complete joy to work with. Nigel Wright worked with the international photographers and completed a grueling program of travel and photography for the behind-the-scenes sections with great skill and thoroughness. In addition, I would like to thank all the photographers who contributed to the book, with special thanks to those who demonstrated their professionalism and commitment through their reliable, cooperative communications and by contributing superb photography, shot specially for the book. Finally, I reserve special thanks for my wife, Wendy Gray, without whose constant support little, if any, of my work would be possible.
Tom Ang
Auckland 2010

Dorling Kindersley would like to thank the following for their invaluable contributions: Neil Mason for research and editorial assistance; Richard Gilbert for editorial assistance; Vish Mistry for design assistance; Dave Jewell for retouching; Margaret McCormack for compiling the index; and Gareth Lowe for coming up with the title of the book. Very special thanks to "Sir" Nigel Wright, for his behind-the-scenes photography and his boundless good humor throughout the project.

Picture Credits